Lauri Ln Kocher

Our *Hearts* Are in
FRANCE

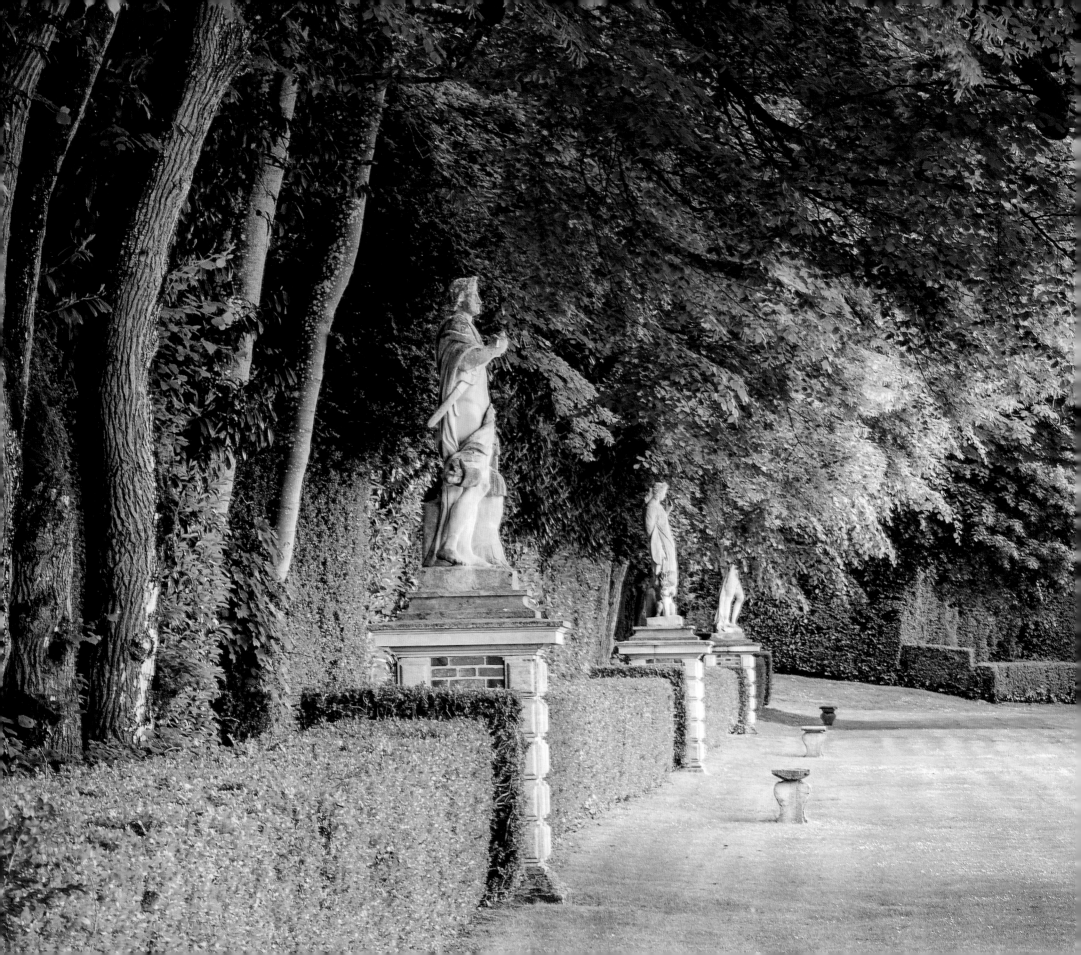

Our *Hearts* Are in FRANCE

JORDAN MARXER

83 PRESS

Hoffman Media
1900 International Park Drive, Suite 50
Birmingham, Alabama 35243
hoffmanmedia.com

ISBN # 978-1-940772-77-6
Printed in China

83
PRESS

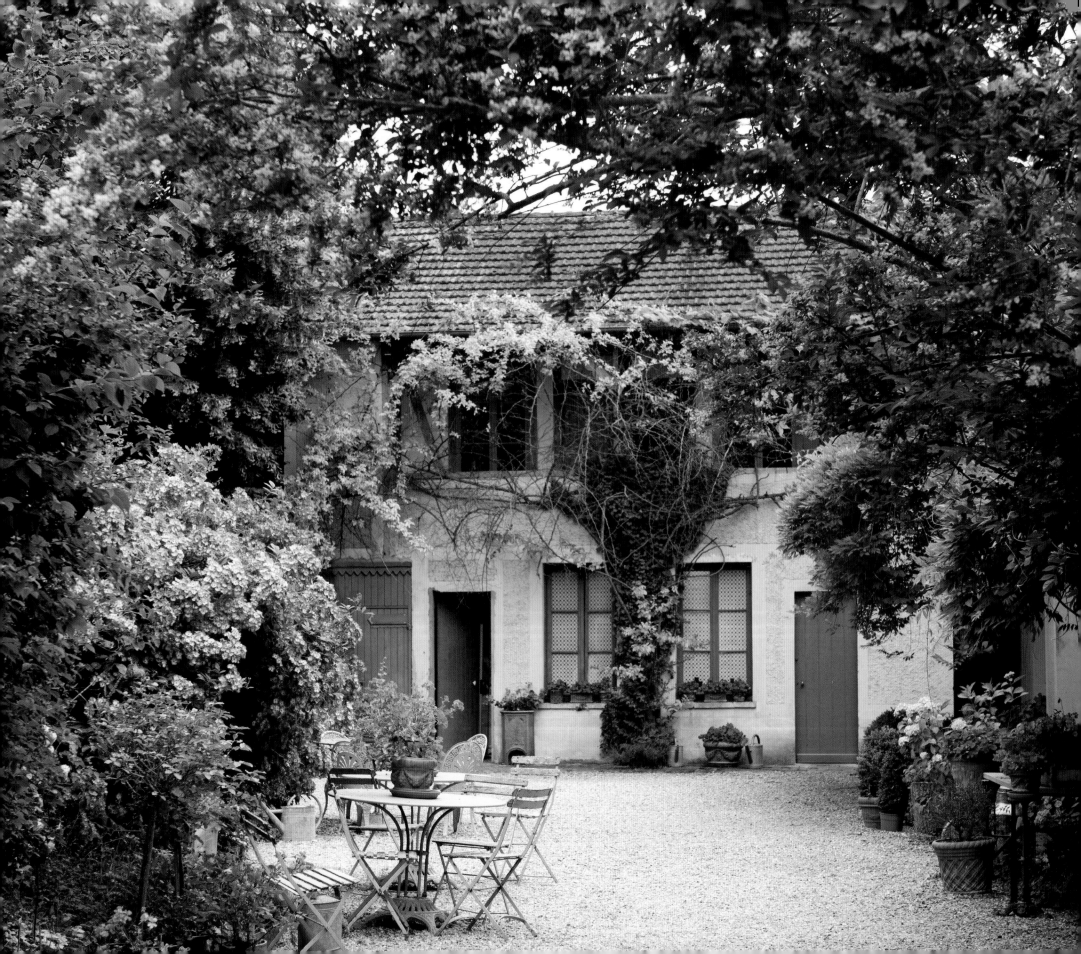

CONTENTS

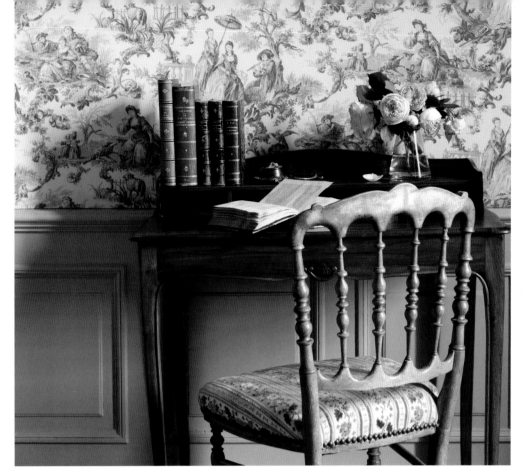

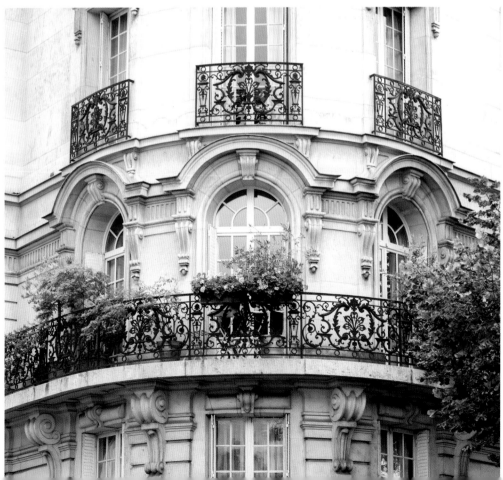

FOREWORD

Even when my travels don't spirit me away to France, the pages of *Victoria* transport my imagination. Over the years, the magazine has uncovered the signature charms of each region. Offering insights into local culture, we introduce readers to a vibrant array of creatives—among them artists, chefs, and designers—whose passion and talent not only satisfy but richly reward our quest for beauty. Whether meandering rows with a vintner whose family has tended grapes for generations, perusing a shopkeeper's brimful *brocante*, or stepping into a homeowner's lovingly restored *maison*, I am reminded that many hands have woven threads into the vibrant tapestry that is *l'art de vivre*.

Filled with lush photography and enchanting prose, this volume is certain to inspire your own stirrings. As you become immersed in each chapter, dream with me of meeting the people and exploring the places that draw us back time and again to this country of incomparable splendor.

Jordan Marxer
Editor

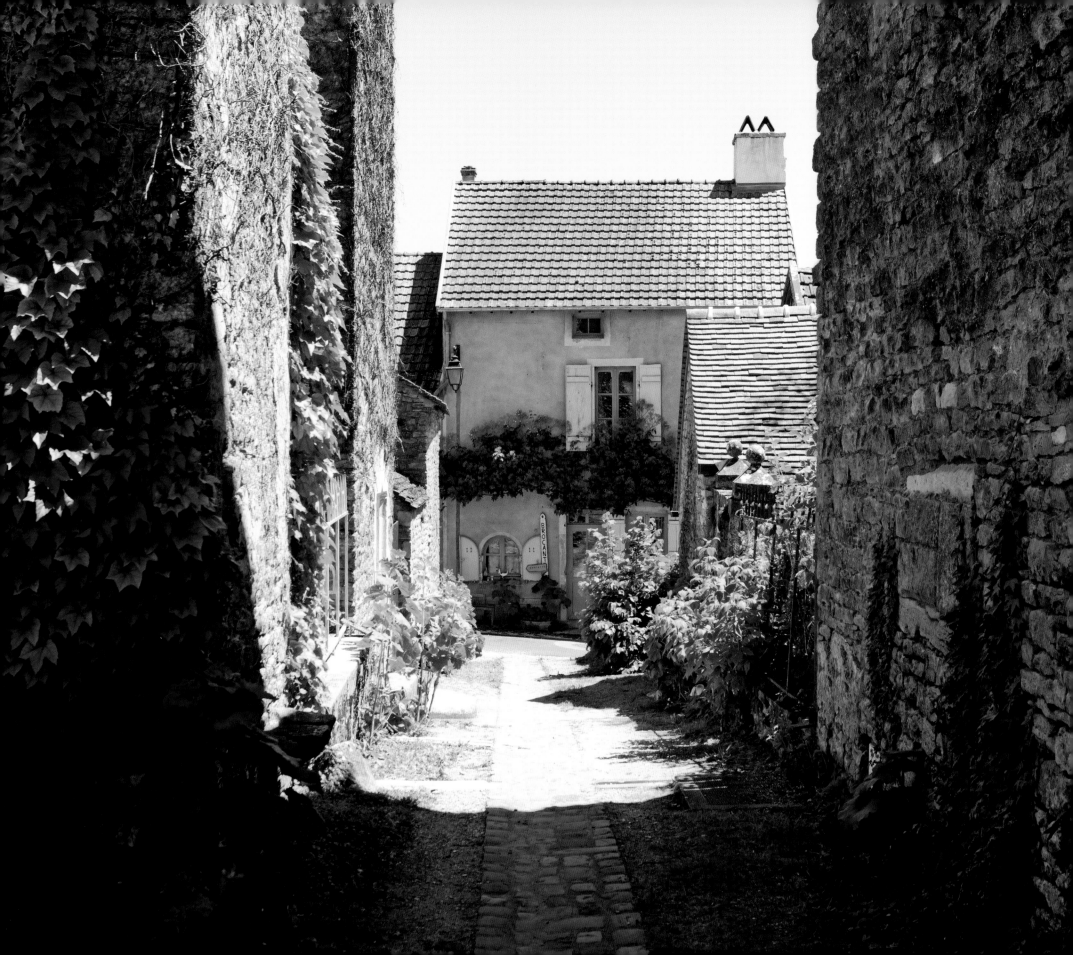

INTRODUCTION

From the history-cloaked towns of Normandy and the fragrant lavender fields in Provence to the dew-kissed vineyards of Burgundy, nothing compares with the romance of France. In this latest offering from the editors of *Victoria* magazine, we take readers on a journey through this majestic country, where centuries-old châteaux rise from the riverbanks, and snowy mountains give way to rolling hills and fertile valleys sprinkled with tiny villages, each one more enchanting than the last. We visit the eternally alluring City of Light, where Parisians stroll pocket gardens brimming with roses, and love blooms beneath the graceful curves of the Eiffel Tower.

Our Hearts Are in France is replete with page after page of beautiful interiors, from the idyllic retreat of Marie Antoinette and a pastoral farmhouse in Provence to the quaint quarters of an American in Paris, as well as with ideas for creating personal Gallic-inspired sanctuaries. And should one's palate long for a taste of French cuisine, we offer a cache of delectable recipes that are certain to delight both sweet and savory yearnings. Equal parts travel guide, design compendium, and tribute to treasured heritage, this volume honors and celebrates the exquisite beauty of this magical land.

Romantic DESTINATIONS

From the bustle of light-filled Paris to the rural roads that meander through fertile countryside, French havens bid the heart to come stay. Grand châteaux and charming cottages call with equal allure—each site as breathtaking and storied as the last.

THE CITY
OF LIGHT

As morning breaks over Paris, the sun's burgeoning rays enfold the cityscape in a celestial rose-gold shade found only in this extraordinary place. The French capital's nickname first referred to its connection to the dawning of the Age of Enlightenment, but it could easily apply to the luminescent quality it possesses both day and night, whether it's the prismatic sunrise or the neon-lit evening.

As steady as a pâtisserie chef's hand, the river Seine arcs its way through the center of town, its dependable rhythm a certainty through the ever-changing ebb and flow of life. More than three dozen bridges span the waterway. The Pont Neuf is the oldest of the lot; its graceful arches have stood for centuries—a symbol of the city's enduring resilience.

Paris brims with places to explore and cultural events to experience, from gazing in awe at the Eiffel Tower and strolling through the Jardin des Tuileries to retracing the footsteps of such notable names as Julia Child, Marcel Proust, and Claude Monet. Sipping an espresso at a sidewalk café is more than mere refreshment—it is a chance, however brief, for a tourist to become Parisian, to toss off the cares of the world, and simply savor the day.

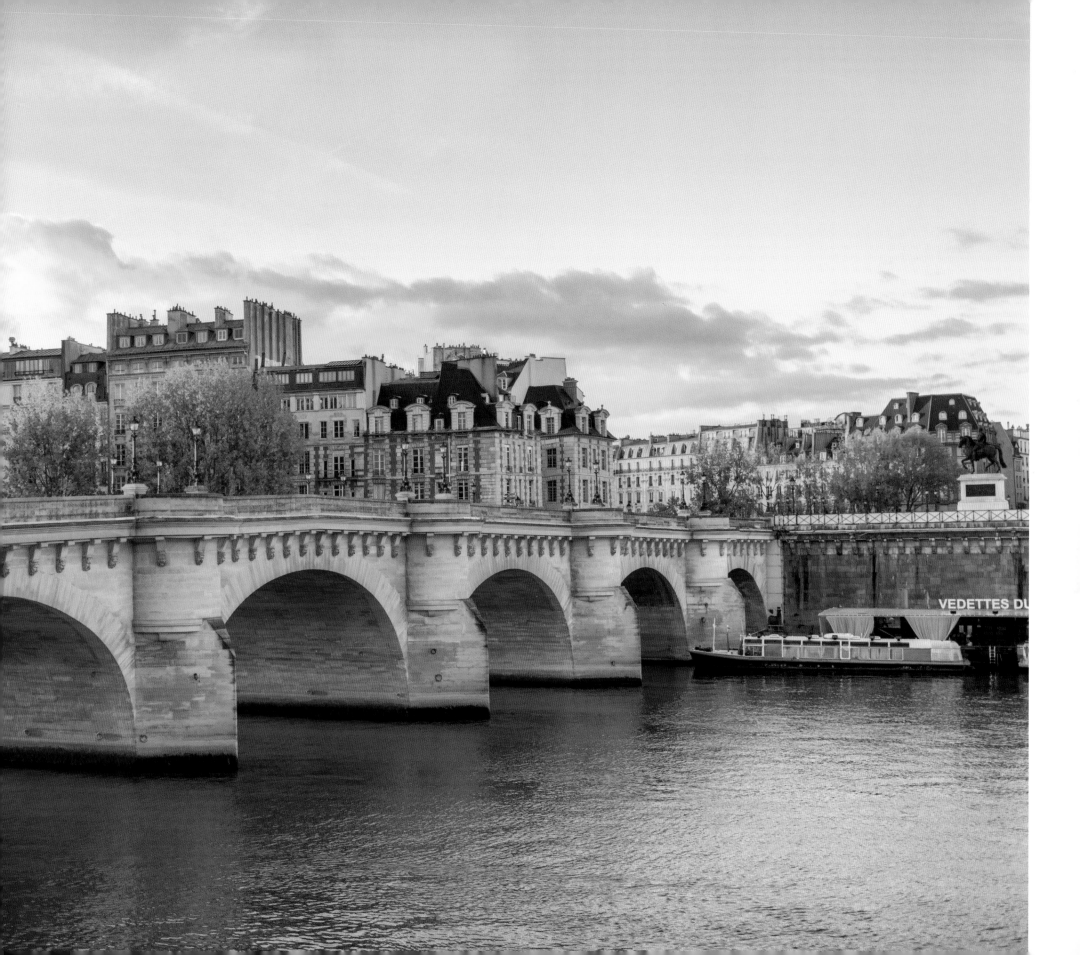

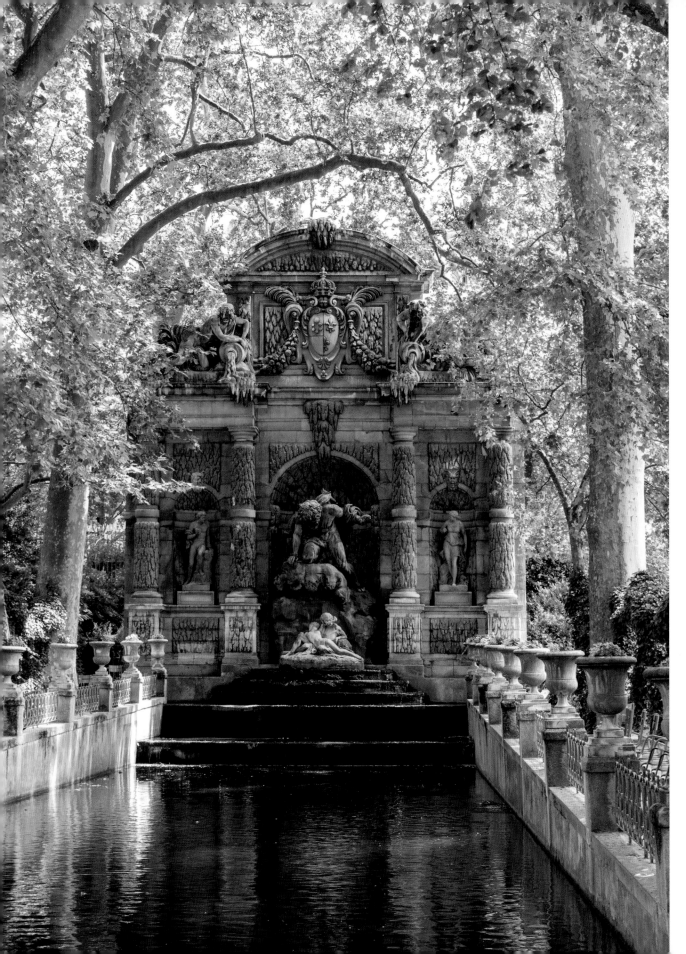

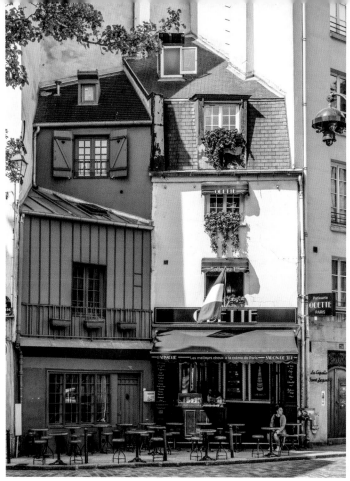

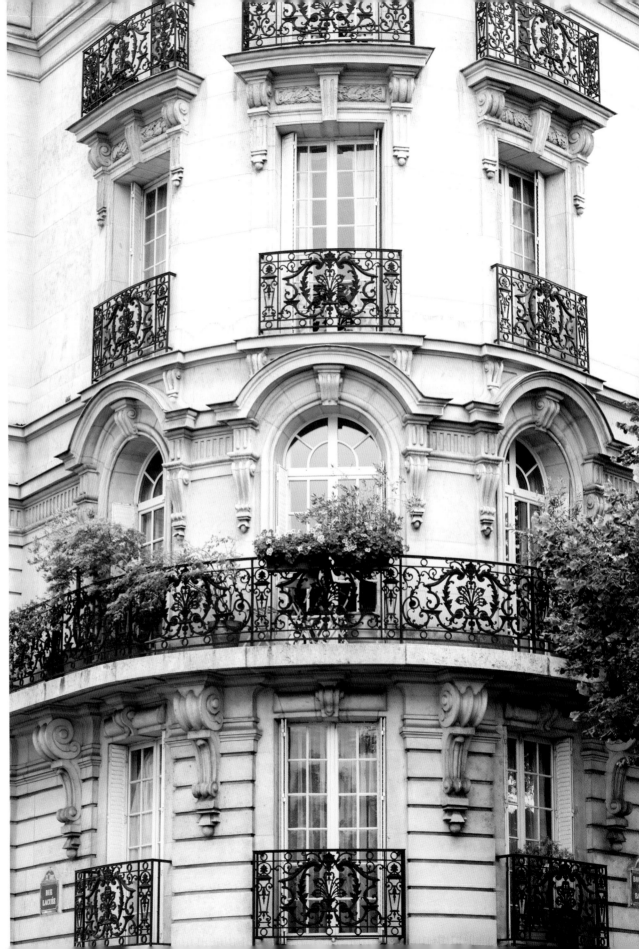

Opposite, left and below right:
Surrounding the palace commissioned
in the early 1600s by Marie de Médici,
the picturesque Jardin du Luxembourg
features the much-photographed
Médici Fountain, where classical figures
are rendered in stone, bronze, and
marble. Above right and this page:
Paris is a treat for the eyes at every
turn. An amble down streets such as
Rue de Rosiers or Rue Montorgueil
reveals buildings bearing the curves and
curlicues of wrought-iron balconies, both
functional and decorative.

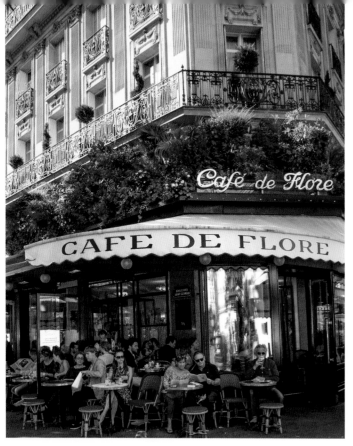

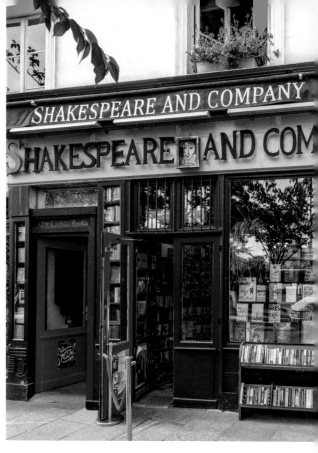

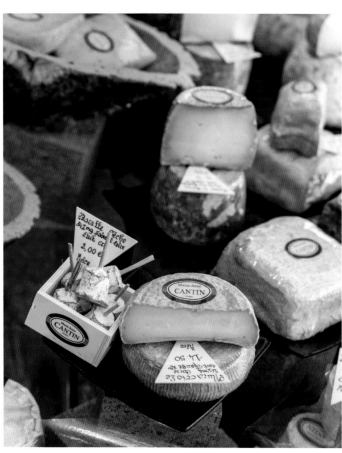

Opposite, clockwise from above left: Since the 1880s, the Café de Flore coffeehouse has been a favorite of literati, celebrities, and locals alike. Perusing the myriad antiques shops yields vintage treasures from all over France. A stop at English-language bookstore Shakespeare and Company, tucked into a seventeenth-century building, is sure to provide inspiration. Parisians adore the heavenly fragrances found in signature perfumeries, such as the House of Caron. As the city is the heart of the couture industry, fashionably clad ladies are a common sight. Fromager Marie-Anne Cantin follows in her father's footsteps with traditional French cheese-making.

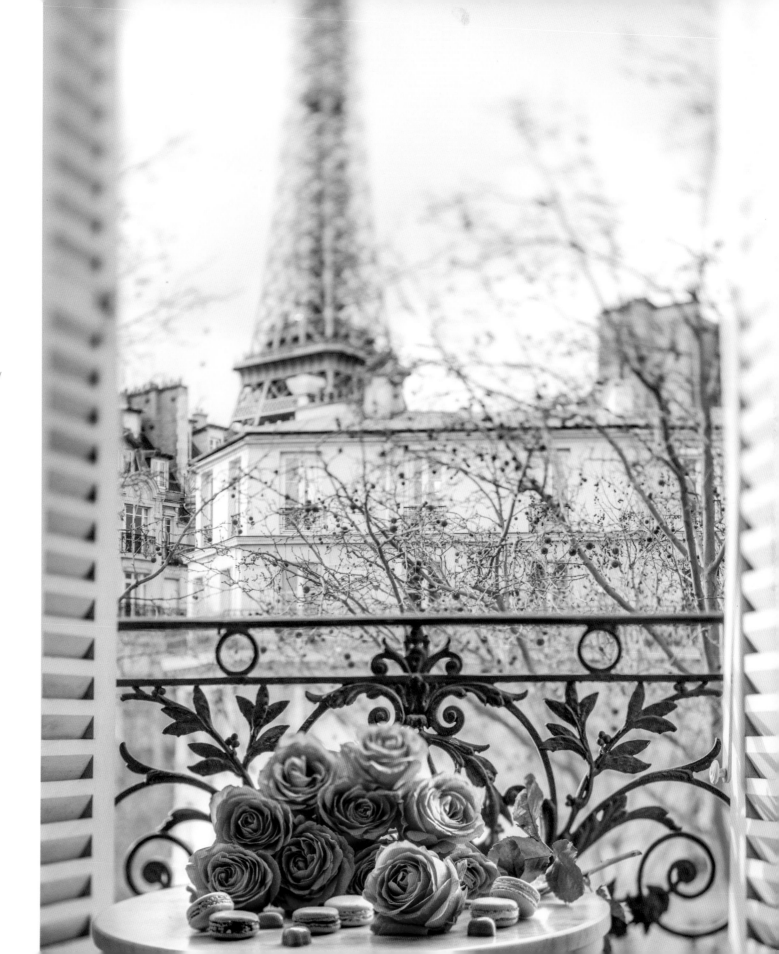

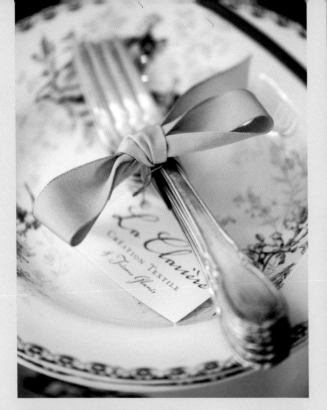

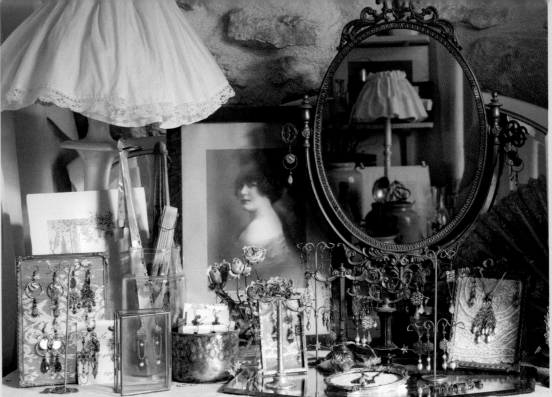

Beauty in a Place of Light

The narrow cobblestone streets of Paris's bustling Butte-aux-Cailles neighborhood are lined with dozens of quaint bistros and boutiques, but Sharon MacDonald's tiny shop on Rue l'Espérance holds special allure. She was smitten with the city's romantic allure from the moment she arrived for a project related to her architectural studies.

"I loved living where there was such a bond to the past," explains this Nova Scotia native. "I loved the streets of Paris, the French way of life, the commitment to all things beautiful and all things delicious." After a few years as an architect, she yearned to express her creativity in a different way, which ultimately led her to open La Clarière, meaning "the place of light."

The carefully orchestrated displays brim with items Sharon finds at Parisian *brocantes*. Among the meticulously curated goods are antique homewares, fabrics, and clothing, as well as assorted *mercerie* (haberdashery), such as handmade lace and buttons. Engravings, watercolors, and oil paintings also make their way into her enviable inventory, and as a fervent collector of old books, she knows firsthand the joy of discovering a timeworn item that touches the heart. Sharon says wistfully, "Oh! If only these treasures could talk!"

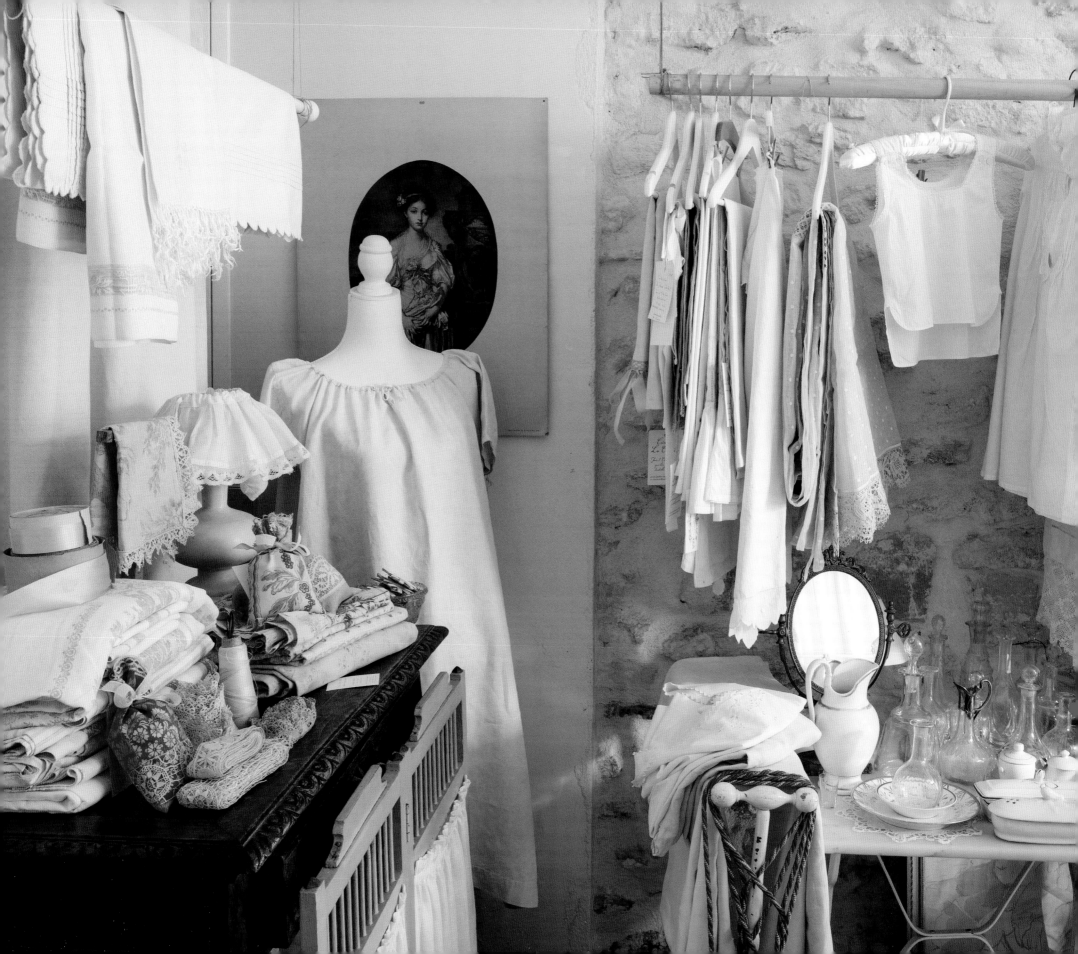

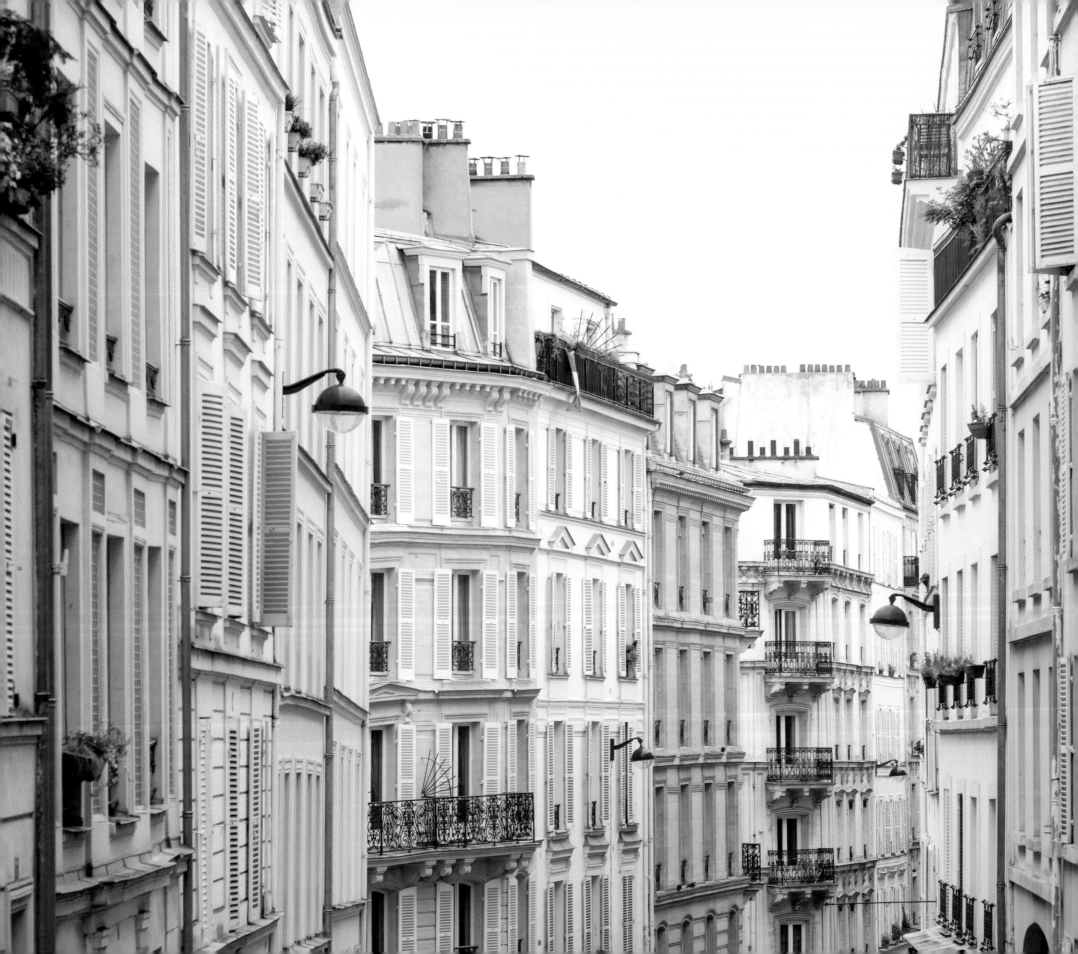

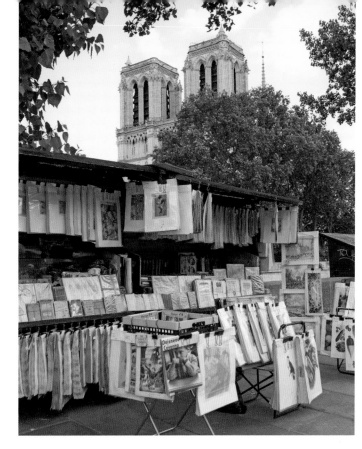

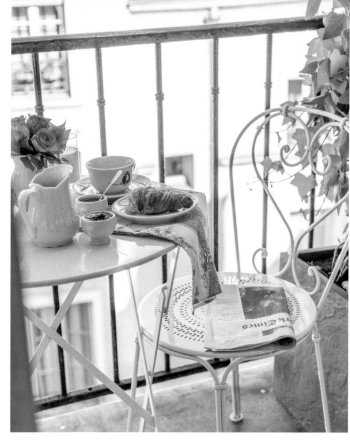

Clockwise from above left: The iconic towers of the Notre Dame Cathedral rise over a market along the Seine. The chic Marais district is home to the charming Hôtel Caron de Beaumarchais, as well as the famed beauty dispensary Buly 1803. Commissioned by Marie Antoinette's brother-in-law, the Comte d'Artois, in 1775, the breathtaking Parc de Bagatelle boasts more than a thousand varieties of roses.

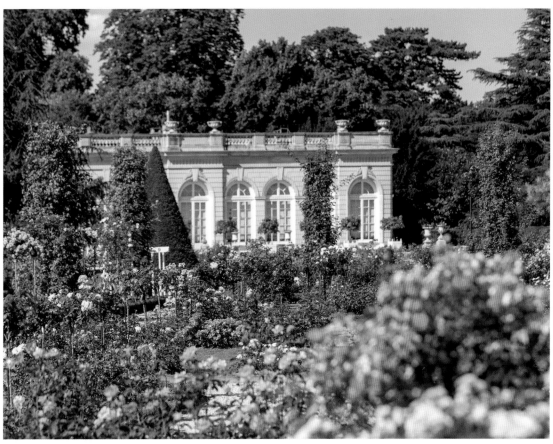

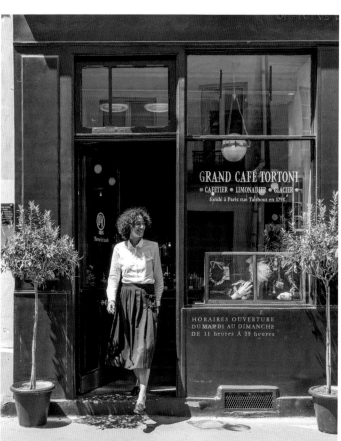

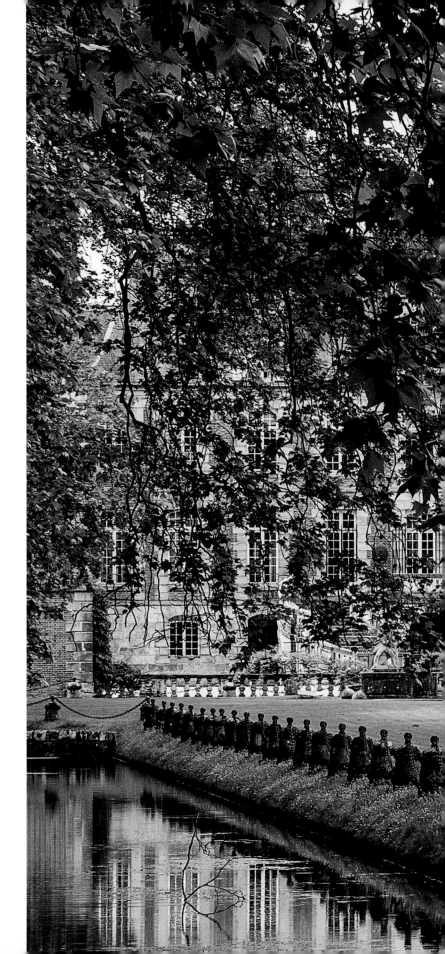

THE ESSENCE OF
HOSPITALITY

An avenue of graceful plane trees edges the placid canal leading to the entrance of the circa 1630 Château de Courances, a name derived from the French phrase *eau courante*, meaning "running water." Though its location is but a stone's throw from the ever-thrumming activity in Paris, this place exudes serenity from the moment it comes into view.

Baron Samuel de Haber rescued the neglected edifice from derelict status in 1872, overseeing an extensive renovation. The addition of red brick with stone quoins and trim gave the original exterior a Louis XIII-style façade, while a horseshoe-shaped staircase, modeled after the one at nearby Château de Fontainebleau, brought interest to the left wing.

The surrounding parkland has also undergone several transformations in its long history. Though the gardens were originally laid out according to medieval preferences, the emphasis on the water features that so beautifully define the grounds dates to the Renaissance. It was the abundance of natural springs and the presence of the river École that gave the property its melodic name. Through the years, seventeen ornamental pools were installed to further enrich the tranquil vistas.

The de Ganay family currently owns Courances, and although it is a private residence, they graciously welcome visitors to peruse the gardens on weekends and holidays from

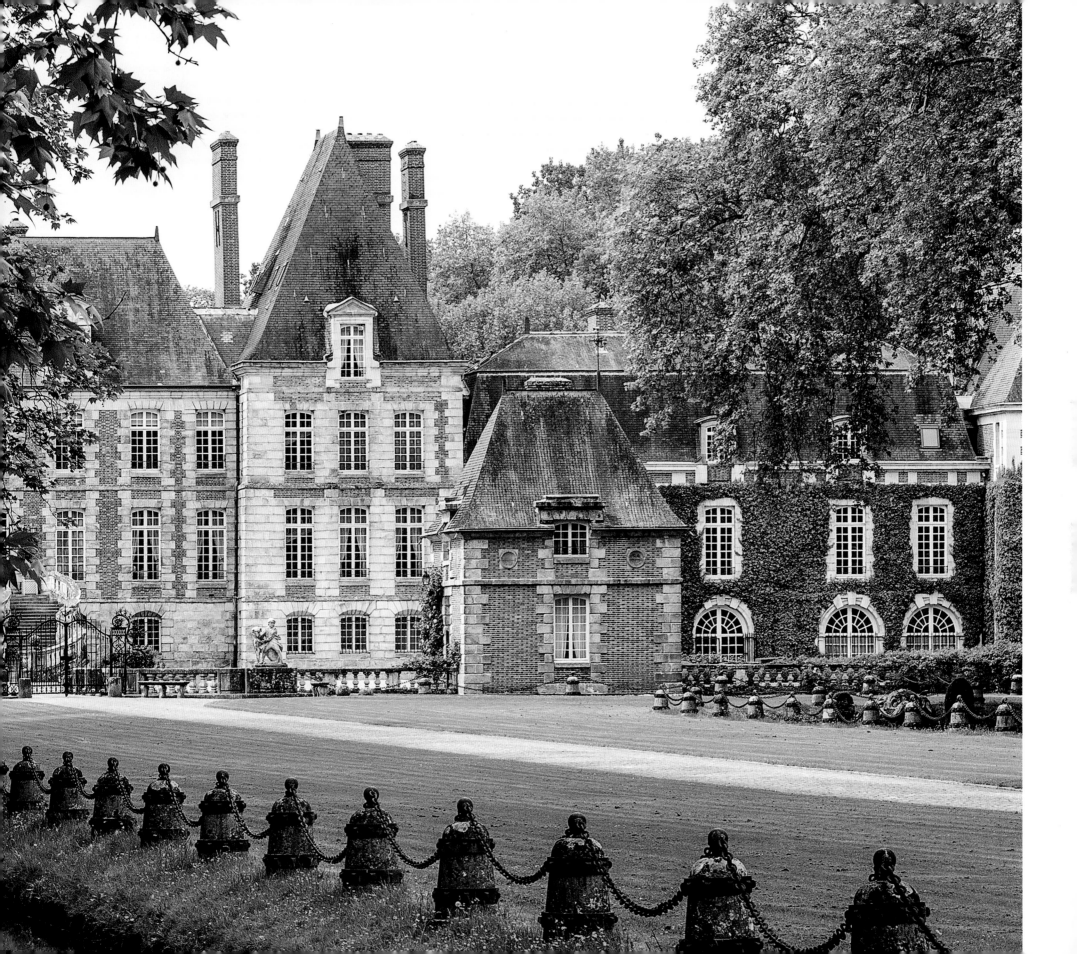

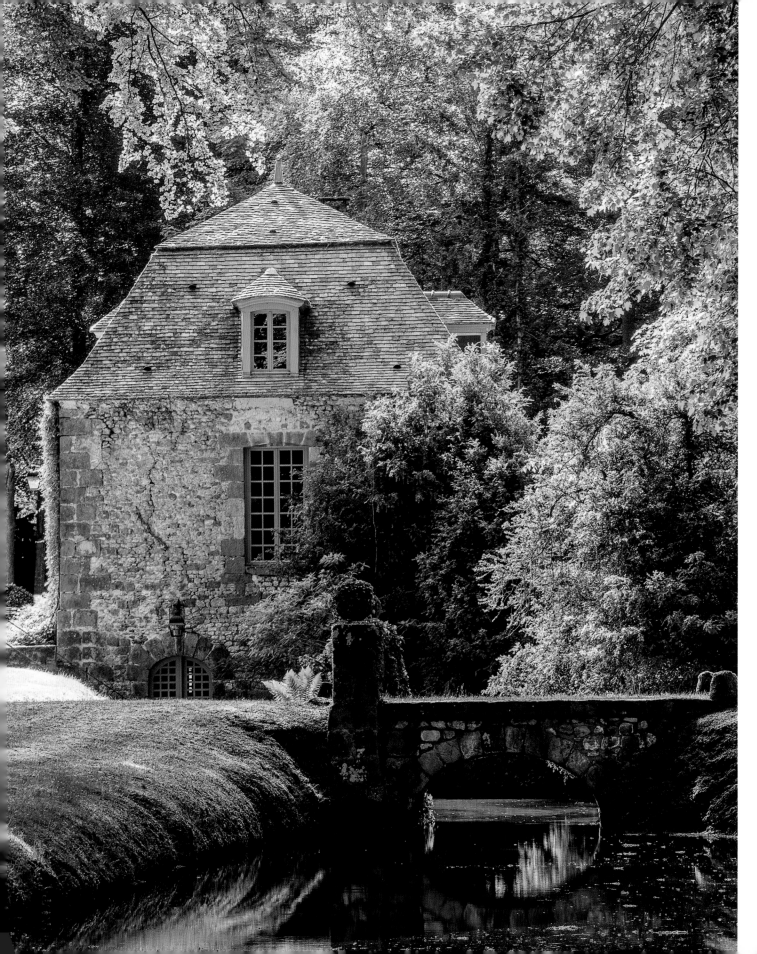

Left: The La Foulerie tearoom belies its humble beginnings as a hemp mill. Above and opposite: A beautifully appointed table stands in the château's spacious wood-paneled dining room, its crisp white linens, gleaming silverware, and crystal goblets befitting the grandeur of this centuries-old residence, now home to the de Ganay family.

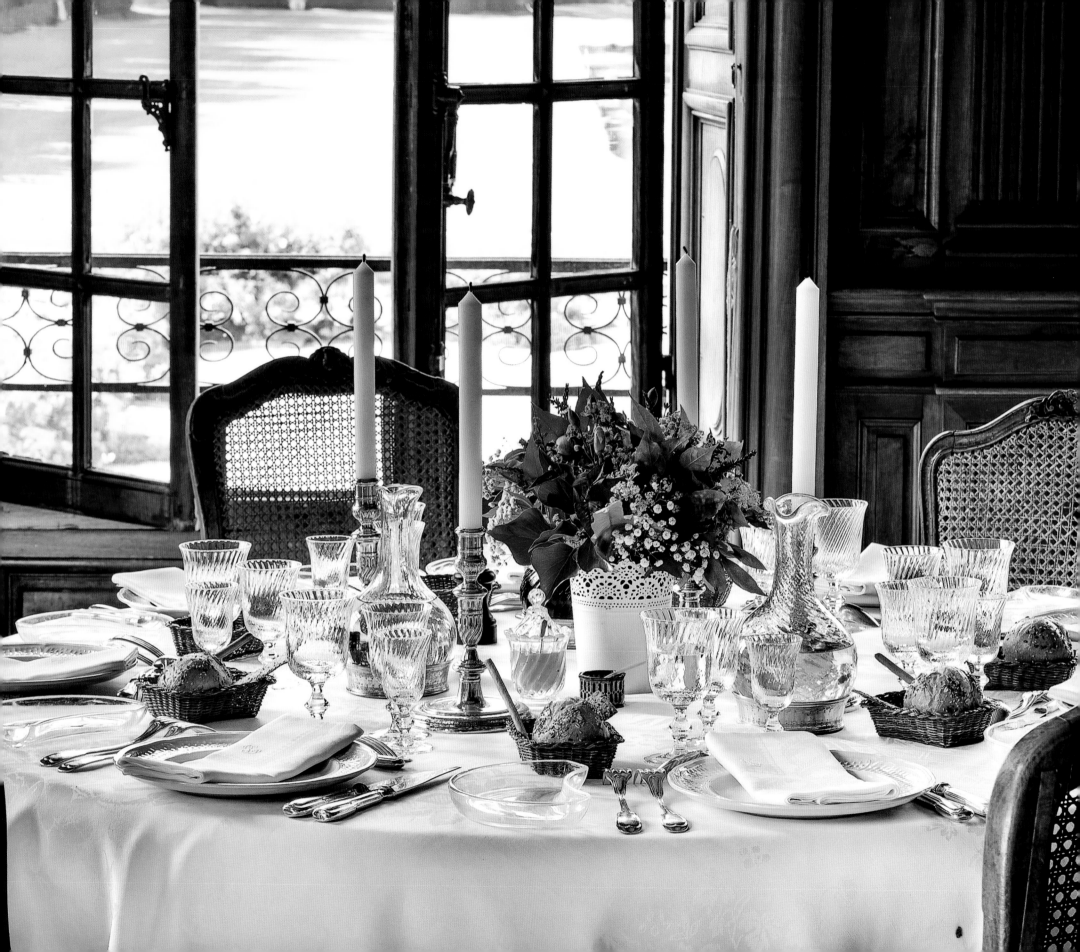

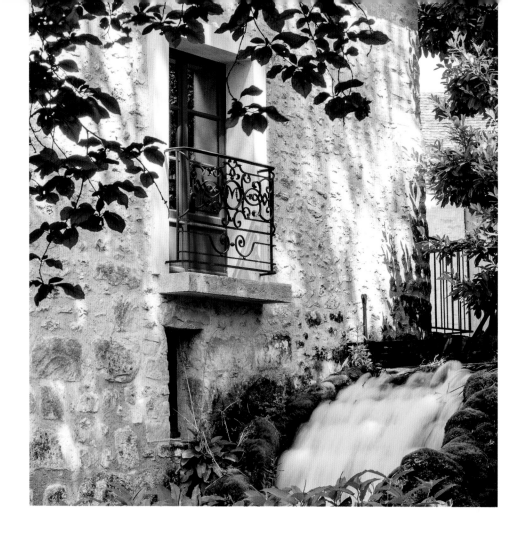

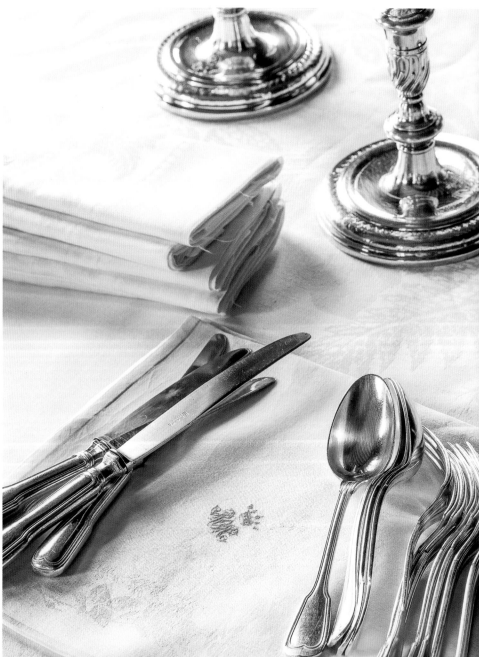

Opposite: Patrons of the La Foulerie tearoom may sip tea and sample refreshments while enjoying garden views. This page, left: The running water that inspired Courances's apropos name appears throughout the estate's vast property, from fountains and springs to the river École itself.

April to November. It is an invitation to marvel at centuries of dedication to preserving and enhancing the natural beauty found in abundance on this resplendent parcel of French countryside.

Created by Berthe de Ganay during the 1920s, the Japanese Garden also borrows elements from English-style plots. Berthe worked with Kitty Lloyd Jones, a student of British gardening maven Gertrude Jekyll, to mingle trees shaped with the traditional "cloud" pruning method favored in Japanese design with colorful border plantings.

Perhaps the best way to view this area is over a steaming cup of Darjeeling at the estate's tearoom, La Foulerie, which originally served as a hemp mill. Also facing the Japanese Garden, three cottages, forming a tiny hamlet, are available for let, for those who wish to linger amid these pastoral surrounds.

Several years ago, the estate peeled back layers of overgrowth in the walled garden and planted a variety of vegetables, sold under the Les Jardin de Courances brand at the on-site farm shop. With plans to expand its arable acreage, Courances proves that the estate is still thriving as it approaches the fifth century of its remarkable narrative.

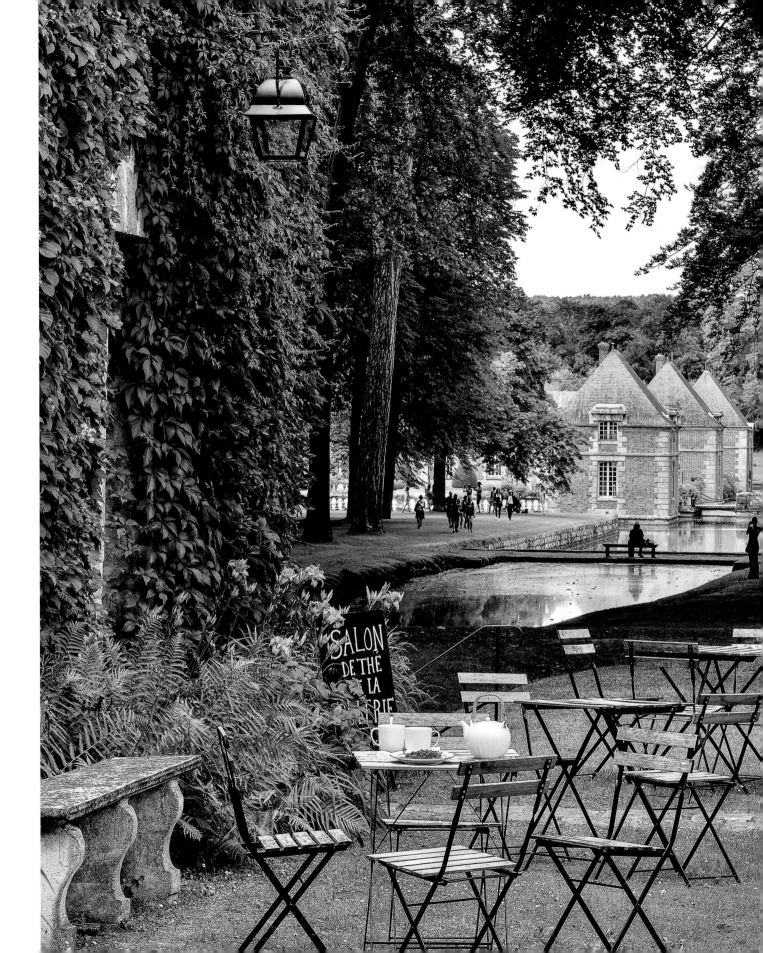

"For thou, water,
art a proud divinity
… . And the joy
thou spreadest is an
infinitely simple joy."

—Antoine de Saint-Exupéry

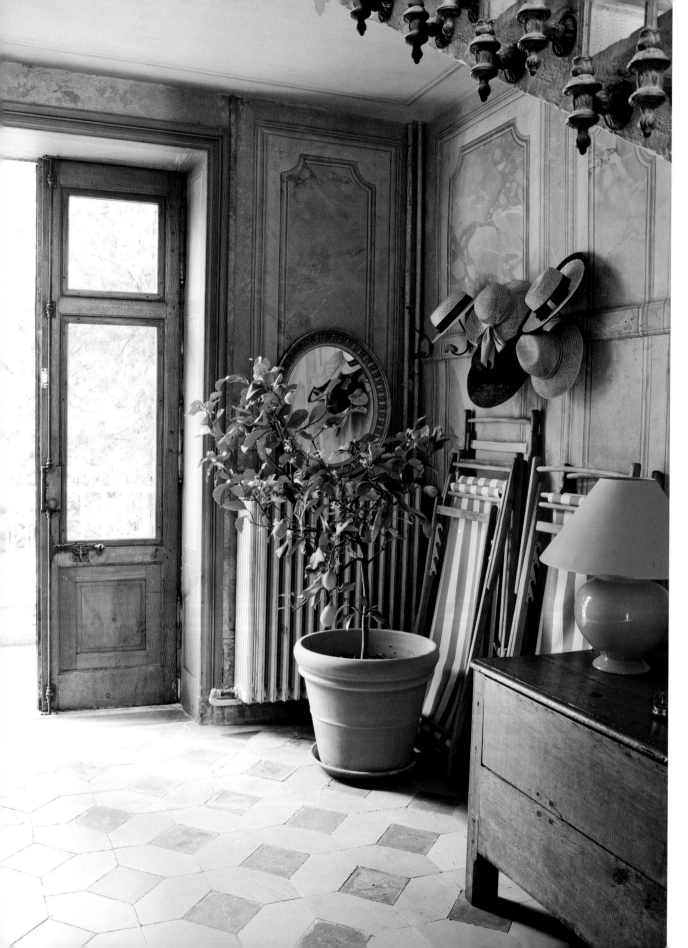
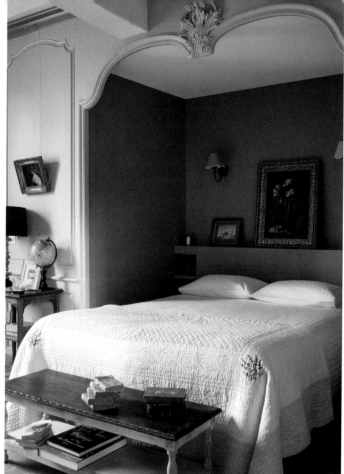

Château de Buffavent

Like the tawny clay-limestone prevalent in France's southern Beaujolais province, the multifaceted Château de Buffavent captivates visitors with its many charms. Built in 1539, the castle beckons travelers to the heart of the Rhône-Alpes region with the promise of halcyon days spent sampling delights of countryside, culture, and cuisine. Furnished with four-star amenities and period antiques, spacious quarters overlook the gardens, while gently sloping vineyards draw one's eye toward majestic mountain peaks in the distance. Owners Marie-Agnès and Denis Chilliet especially enjoy introducing wine enthusiasts to the house label but believe the most rewarding aspect of opening their doors is helping wanderers uncover the riches of the Beaujolais area.

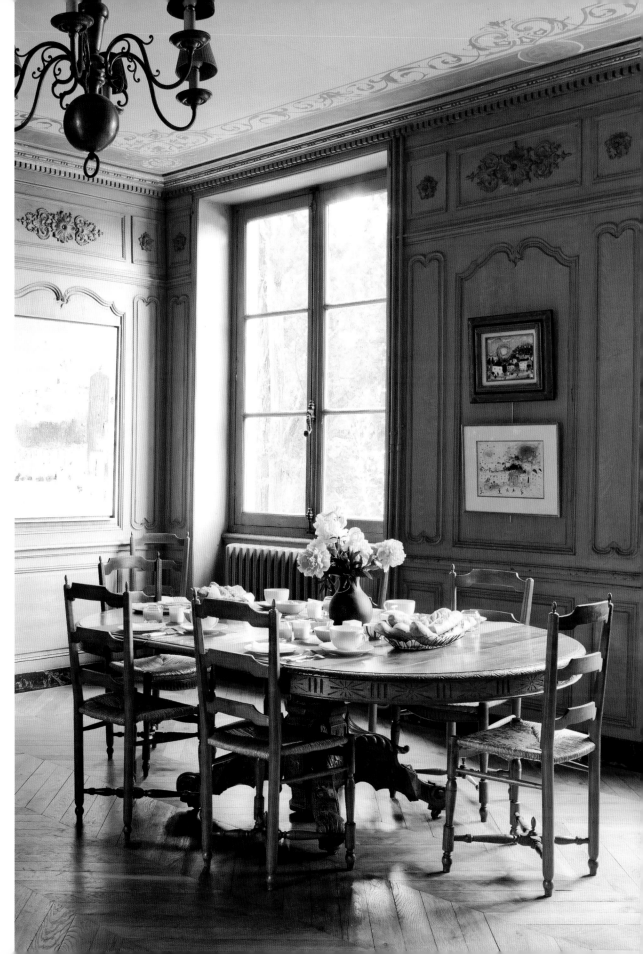

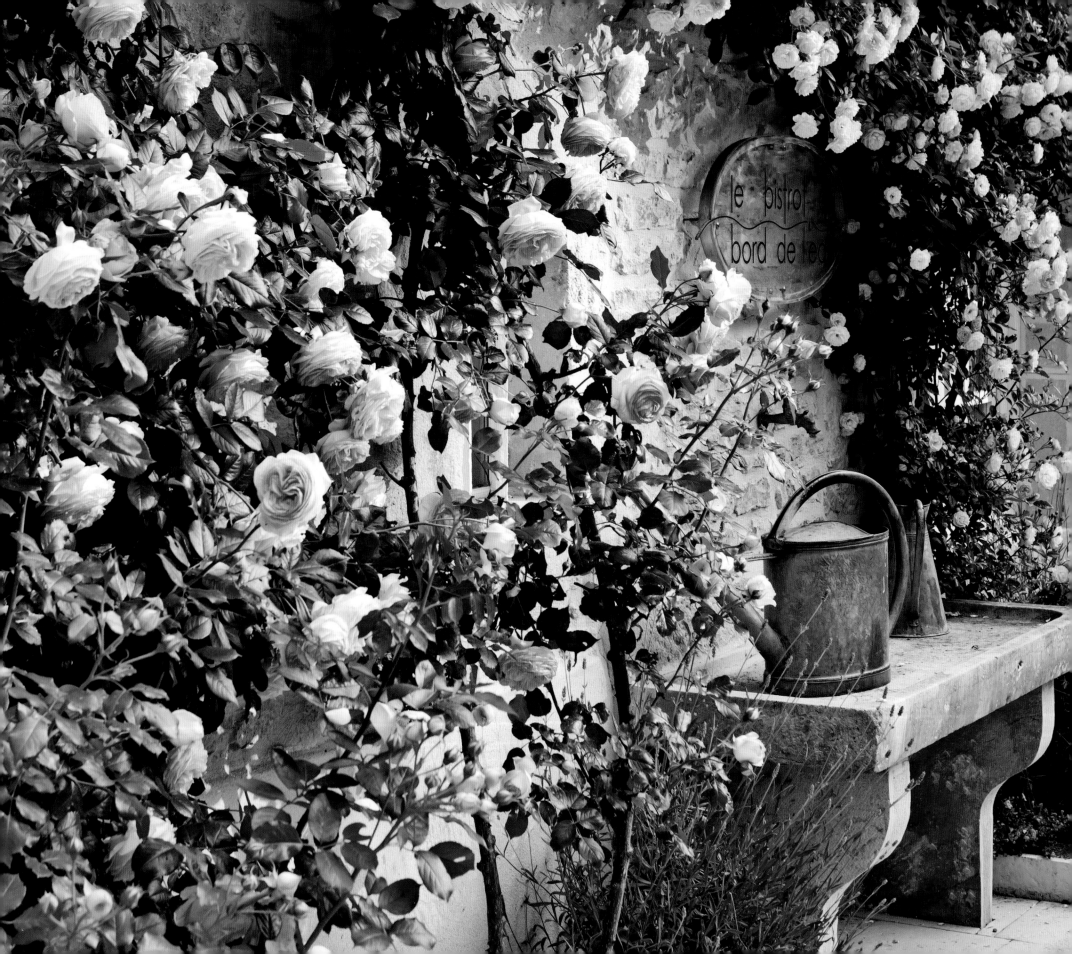

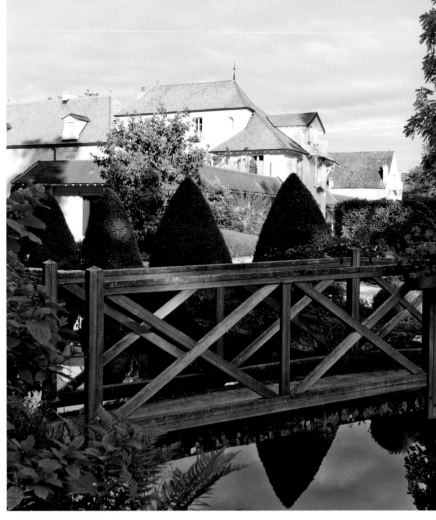

Hostellerie de Levernois

Listed among Relais & Châteaux properties for a quarter century, the five-star Hostellerie de Levernois provides a gateway to the Burgundian town of Beaune. Lulled by birdsong, visitors roam formal gardens along the Bouzaize, a small waterway that meanders through the city. Roses outside the café welcome patrons to the mansion's eighteenth-century kitchen. Elegance and simplicity distinguish this retreat tucked within a lush 12-acre park.

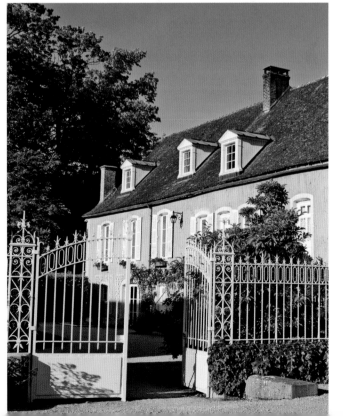

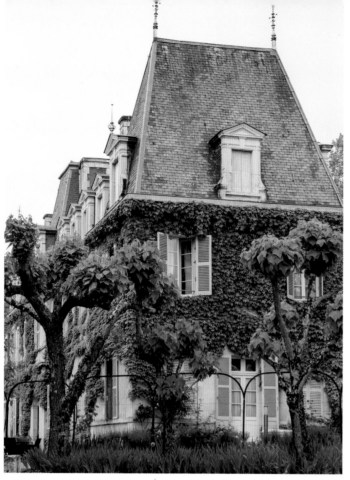

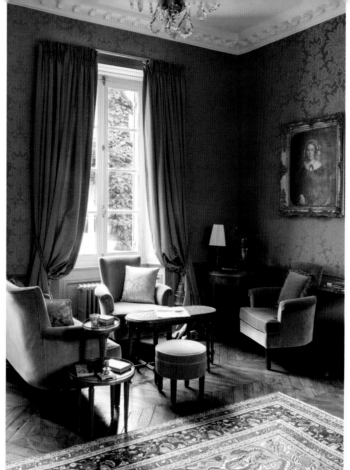

Château de Lalande

The renovation of Château de Lalande, near the ancient town of Périgueux in the Dordogne region, maintains the manor's charming Old-World features while offering polished interiors and modern amenities. Each guest room features heirloom furniture, antique parquet flooring, and luxe bedding, ensuring comfort *par excellence*. A gourmet restaurant celebrates regional fare, such as the truffles and foie gras the area is known for, and the tranquil setting beckons visitors to experience the serenity of nature.

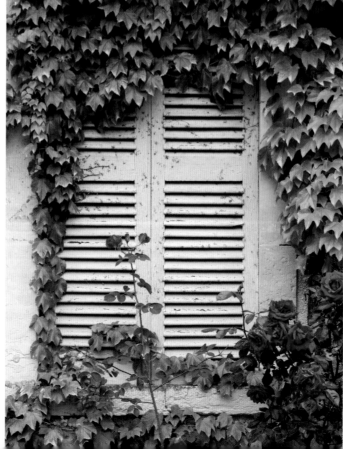

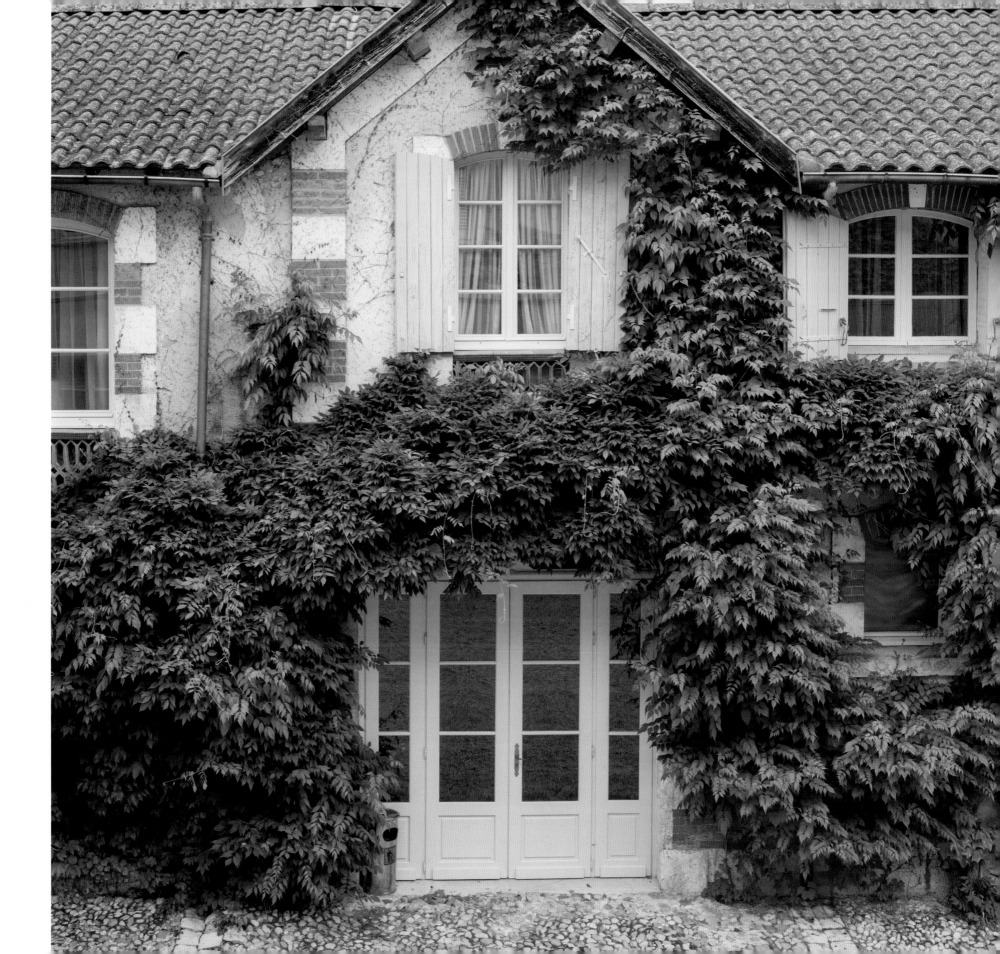

ENCHANTING
SOJOURNS

The onset of lavender season enrobes the countryside of Provence in fragrant purple blooms, and golden sunflowers stand tall in the fields— the very landscapes that inspired artists such as Paul Cézanne and Vincent van Gogh to capture the beauty on canvas. Produce stands in every community overflow with fresh offerings, and ladies in pretty cotton dresses fill string shopping bags with everything from cherries and currants to carrots and courgettes. It is summertime in southern France, and an unmistakable joie de vivre washes over every acre, from the redolent meadows to the majestic Montagne Sainte-Victoire and every lovely spot in between.

Provence has always held a special allure for those who seek the slower pace and simple pleasures found here. Scores of quaint villages are sprinkled about, each with its own personality and flavor. Eygalières, with its cache of enticing shops and cafés, sits on a hilltop with breathtaking views toward the Alpilles, whereas the narrow cobblestone streets of Gordes begin at a tenth-century château and wind their way down the foothills of the Monts de Vaucluse. Graveson typifies a small Provençal town, with tree-shaded squares and a history dating to medieval times. Once a private residence, La Villa Augustine now welcomes guests to savor luxe accommodations amid a peaceful setting.

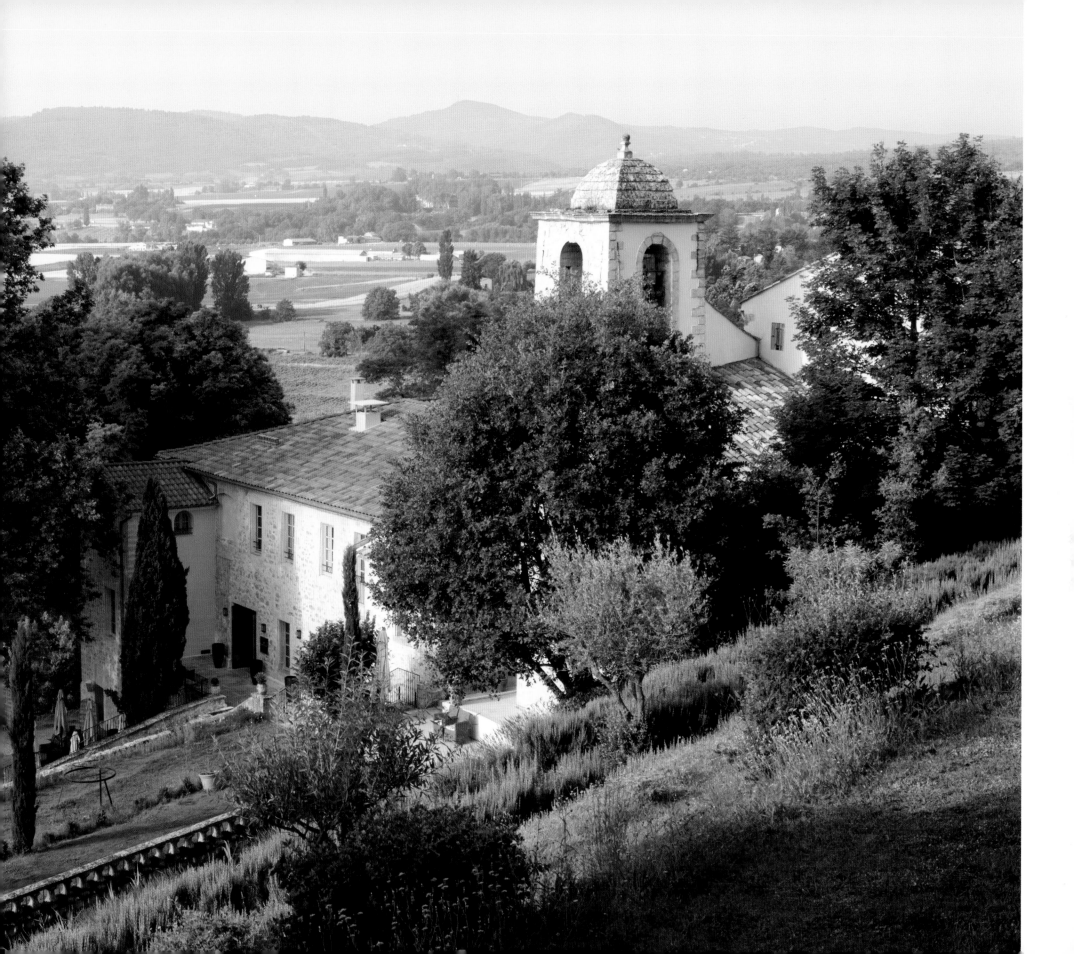

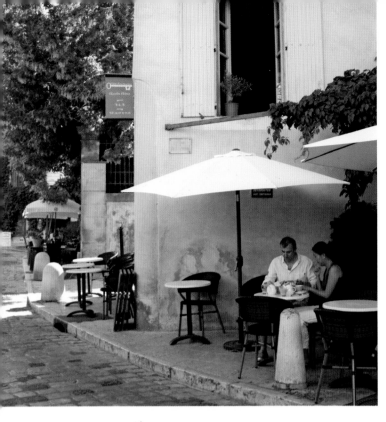

Opposite and this page, below: The winding streets of Eygalières are bordered with charming stone houses and petite shops, including Chez Emily Fromager Affineur, with its array of tempting gourmet cheeses and charcuterie items. Above, left and right: Architecture in Simiane-la-Rotonde typically dates from the seventeenth and eighteenth centuries. Fromagerie de Banon, a local cheese farm that has been offering its products since 1958, makes an ideal spot for lunch.

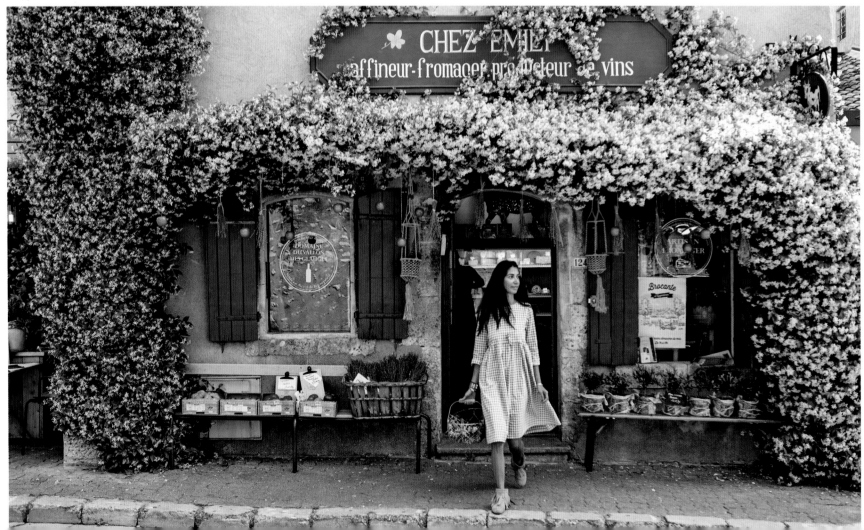

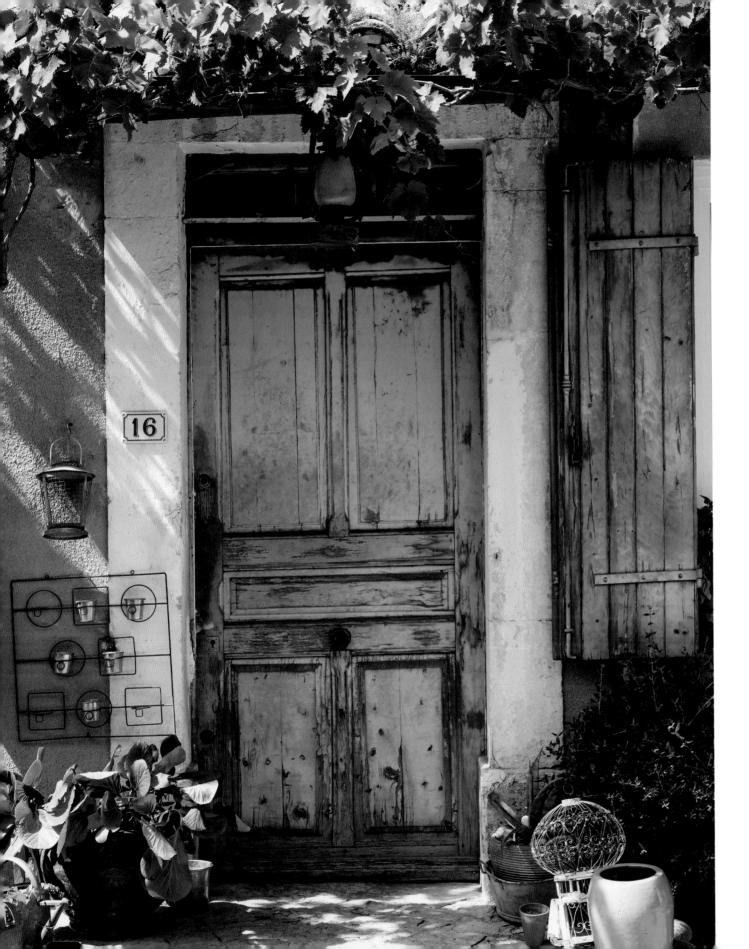

"We love to slow down, and France requires us to do so."

—Marcia DeSanctis

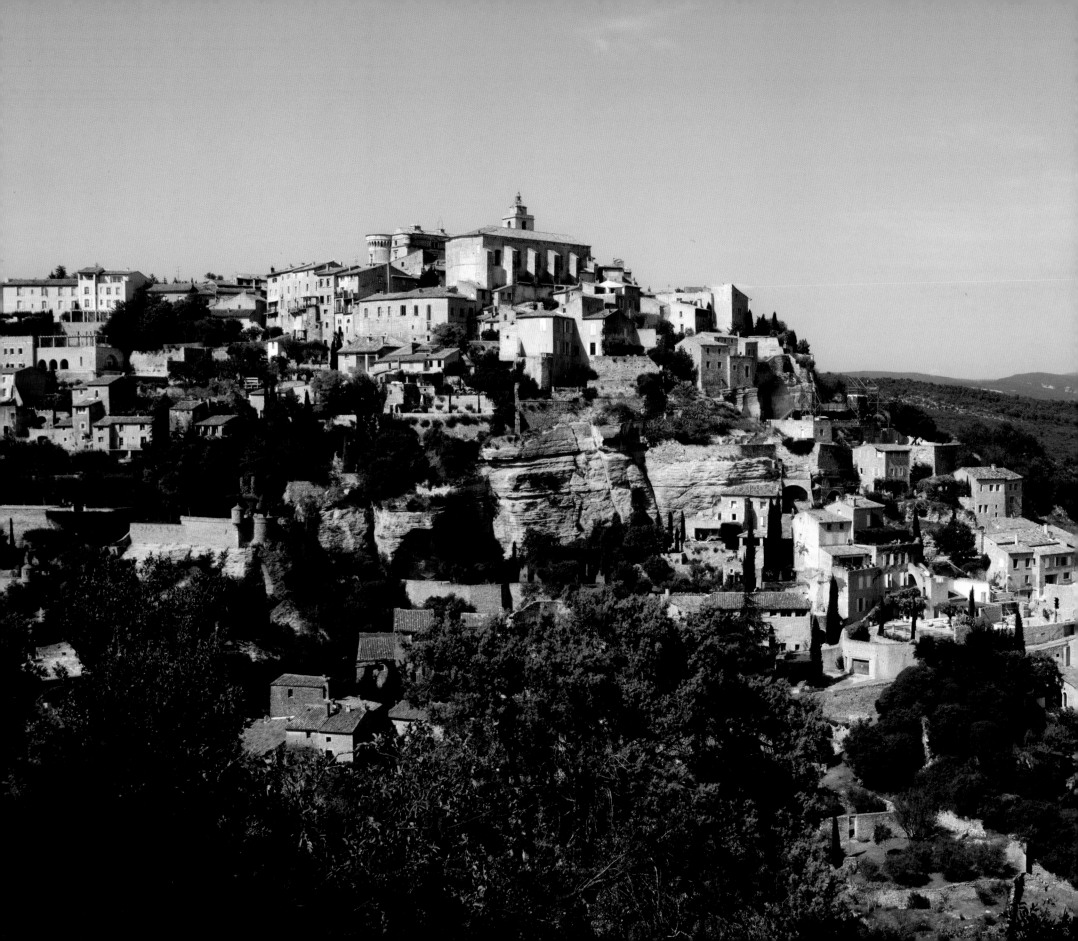

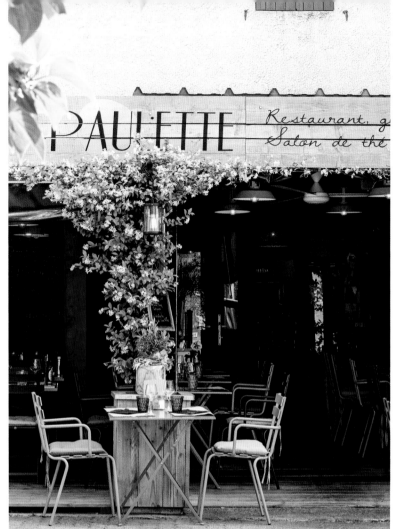

France has plenty of other attractive destinations beyond Provence that beg exploration. Within the Rhône-Alpes region, Beaujolais is known far and wide for its wines, and vineyards roll out like lush green carpets across the hills and valleys. History-steeped northern France has gone through a remarkable renaissance after bearing the brunt of destructive wars; poignant memorials dot the sylvan terrain. In the southwestern corner of the country, the Aquitaine region brims with picturesque pockets of serenity, whether it's an enchanting auberge settled alongside a dawdling river or a renovated château where dining on truffles and foie gras is de rigueur. Or perhaps a trip to Burgundy suits one's wishes. Tucked amid the verdant vineyards are secluded retreats and ancient abbeys, where monks once toiled in tranquil surroundings.

Whether it's a longing for lavender-scented breezes, a saunter through flower-strewn fields, or simply a crisp glass of Champagne sipped on a tree-shaded terrace, France awaits, with arms open wide, to bequeath its myriad charms to all who wish to share in the enchantment.

Opposite: The picturesque village of Gordes presides from its hilltop throne. This page, above left: Patrons of Chez Paulette in Eygalières are treated to an ever-changing menu that features the area's seasonal offerings. Above right: Every Tuesday, residents of Gordes turn out for market day in the village square.

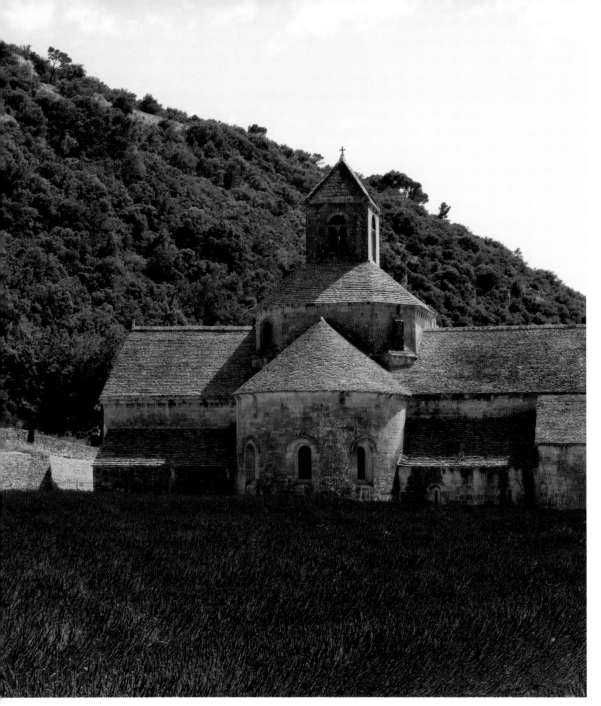

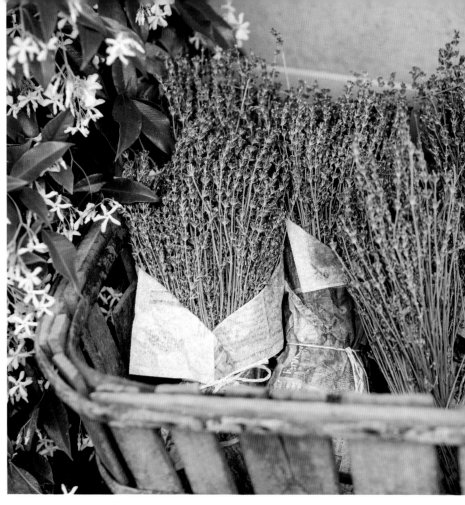

Above: Just beyond Gordes are the famed lavender fields of Sénanque Abbey, a weathered stone structure founded in the twelfth century. The Romanesque building is a monument to austerity, and its unadorned beauty honors the modest lifestyle of the Cistercian monks who live here.

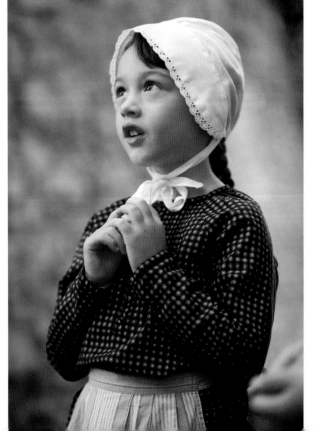

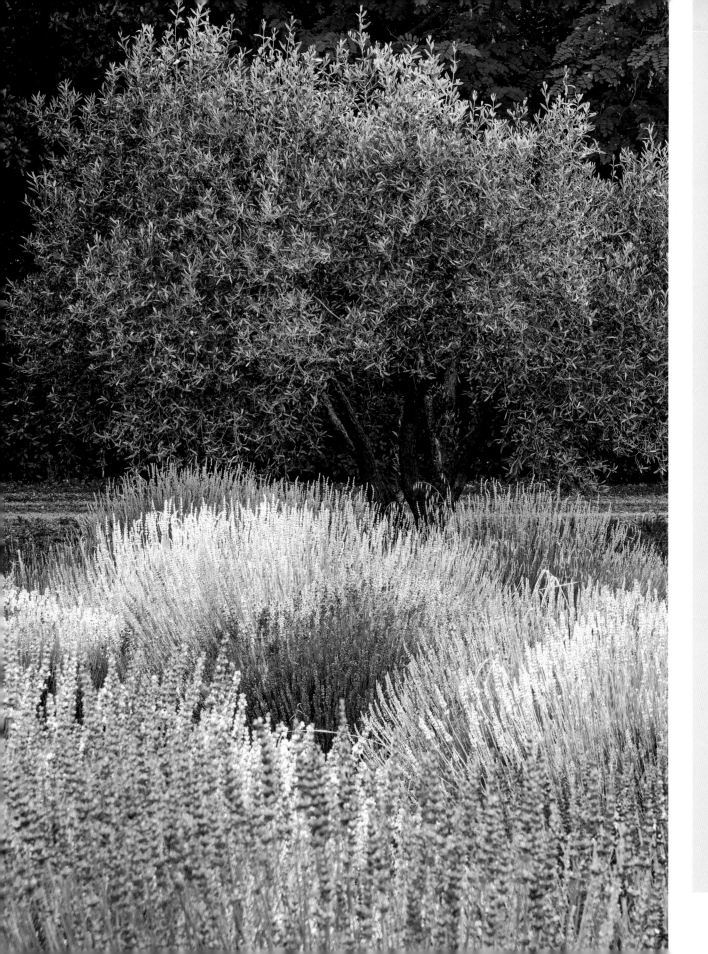

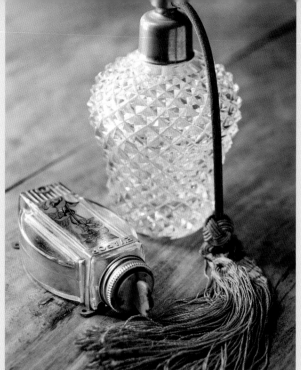

Perfume of Provence

Expansive fields of lavender paint the Provençal landscape in shades of purple, imparting both color and fragrance—a flower so captivating, the locals call it "blue gold." Since the eighteenth century, French monks have grown the sweet-smelling blooms and distilled the essential oils for their healing properties, while perfumers found the calming scent to be a perfect base for their products. At the Musée des Arômes et du Parfum in Graveson-en-Provence, visitors learn about the history of this aromatic industry through an array of displays. Among its attractions are traditional distilling flasks, perfume bottles created by master glassmakers, and a scenting table where guests may sample a variety of ambrosial compositions.

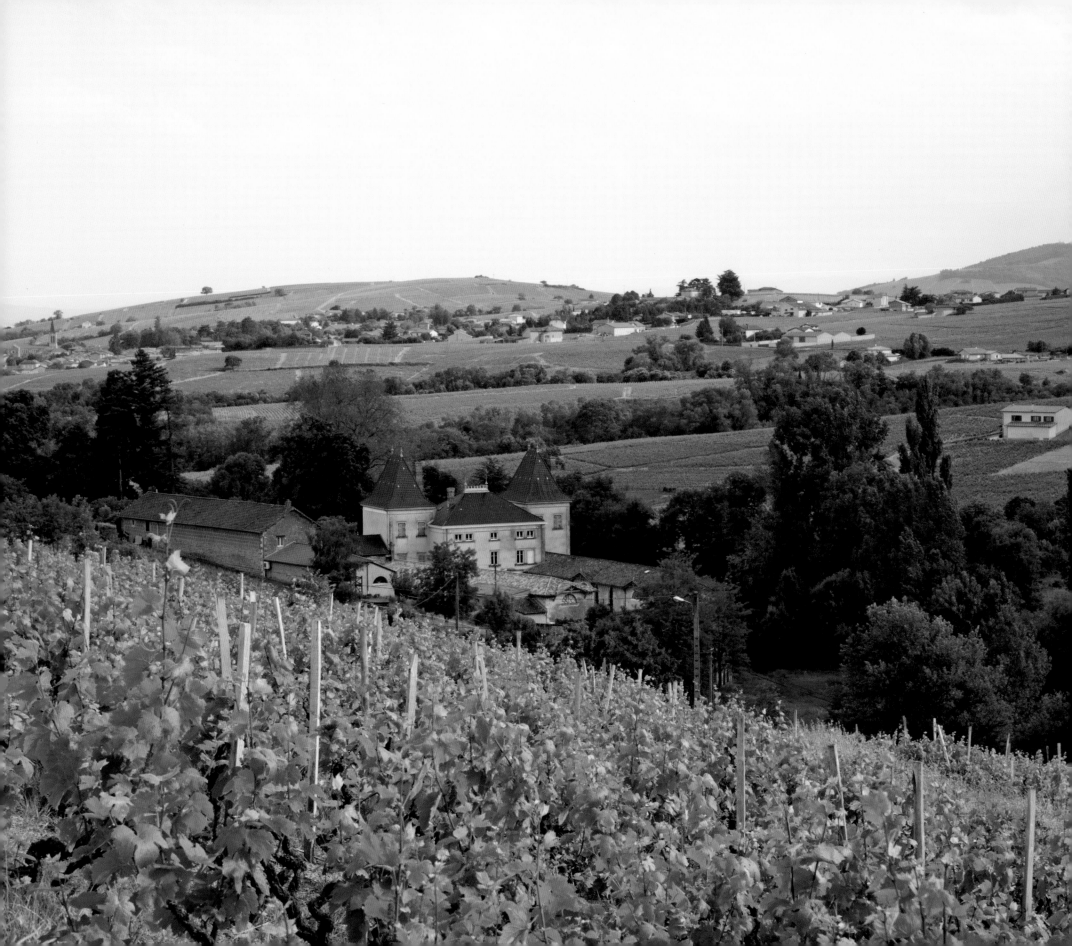

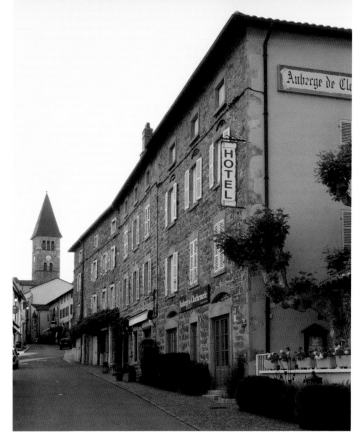

Worthwhile Visits

Above right: Auberge de Clochemerle, in Vaux-en-Beaujolais, features delectable cuisine and cheerful guest rooms. Below left: The town of Ambierle is not to be missed. The intimacies of everyday rural life from 1840 to 1940 are portrayed at the Musée Alice Taverne d'Ambierle. Among the interesting re-creations are a seamstress's quarters, complete with lacemaking accoutrement, and the village grocery.

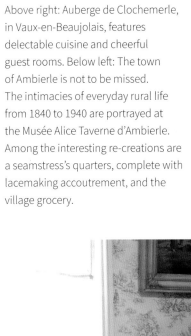

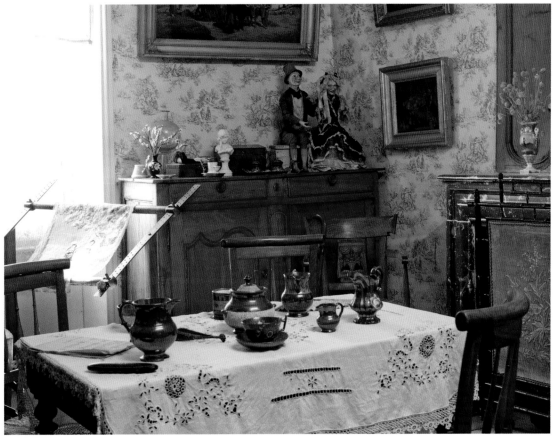

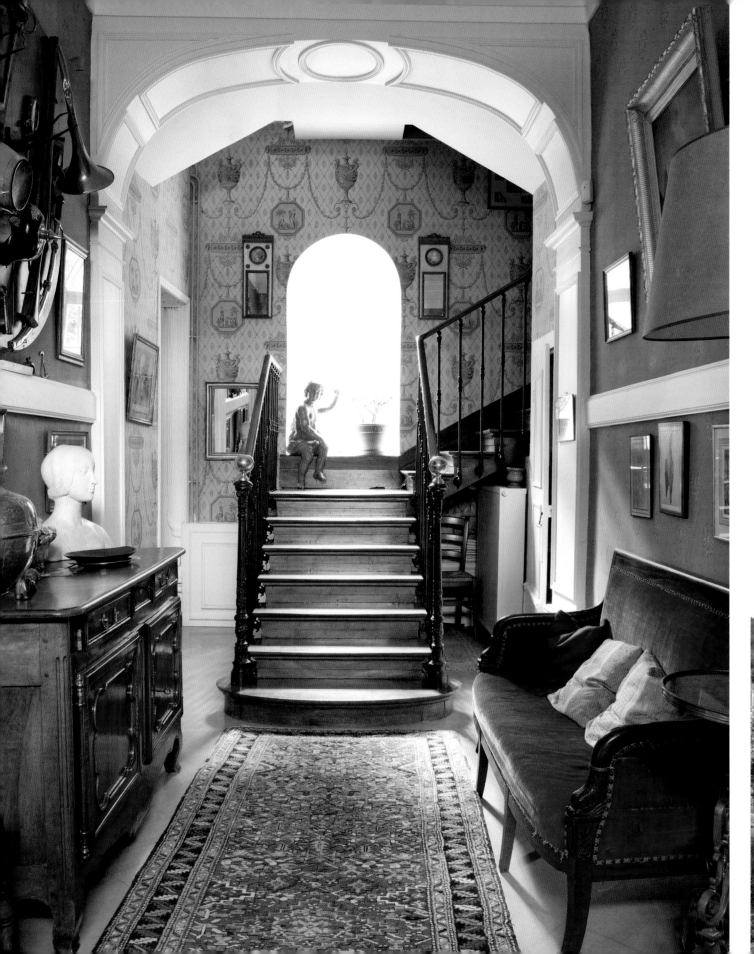

In the heart of Beaujolais Crus, near Chiroubles, a winding road leads to Château de Javernand. Five generations of one family have tenderly minded the vines here with an abiding love of the earth and responsible care of the land. Arthur Fourneau, the current keeper of the grapes, operates the estate alongside his cousin Mathilde Penicaud and friend Pierre Prost. The vineyard yields bright, fruity Les Gatille and award-winning Vieilles Vignes, with notes of ripe fruits and spices. The eighteenth-century manor, layered with history and richly appointed interiors, is open for tours.

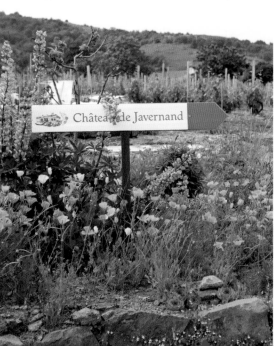

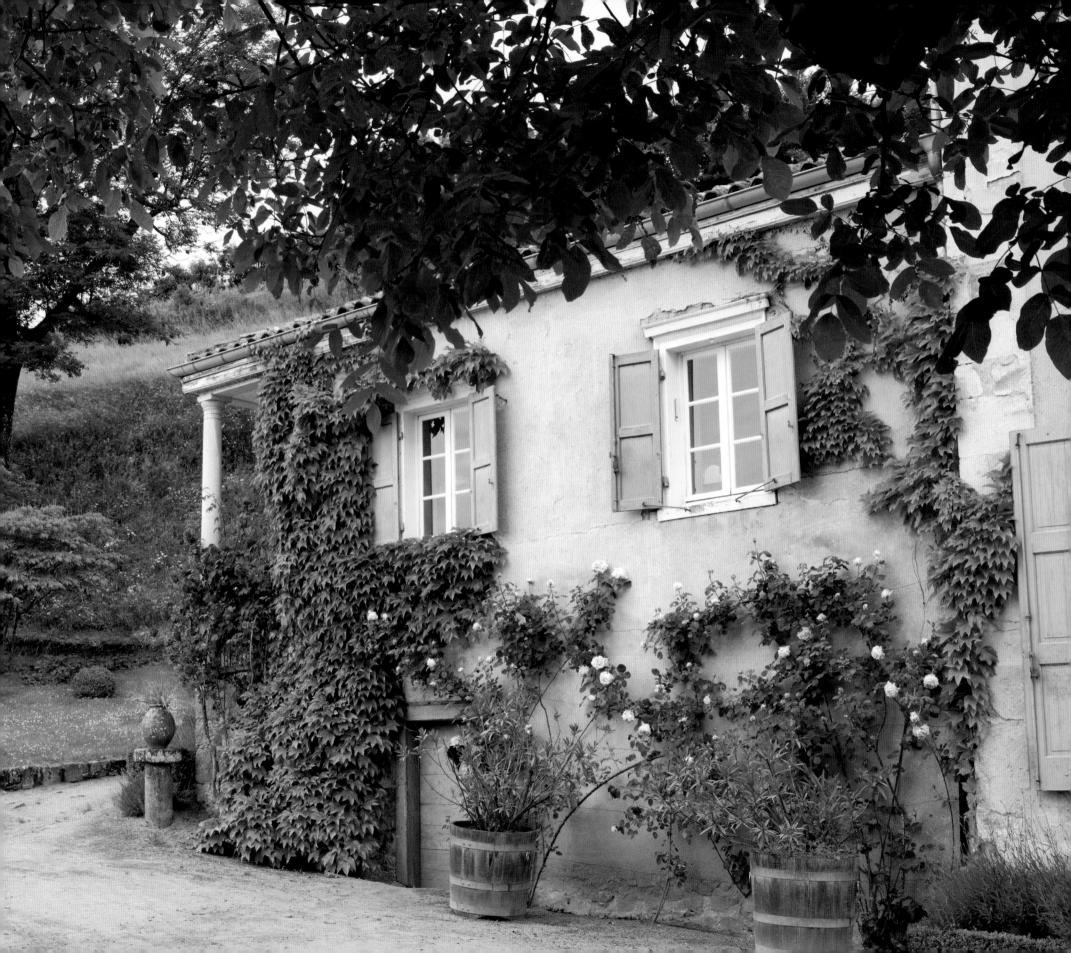

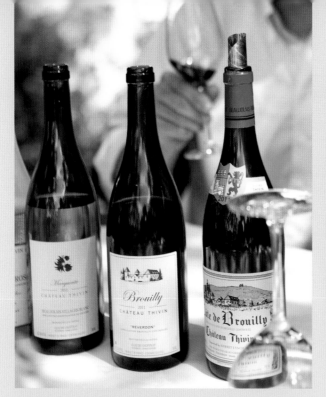

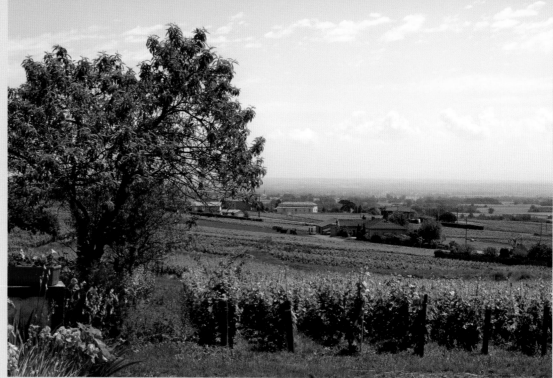

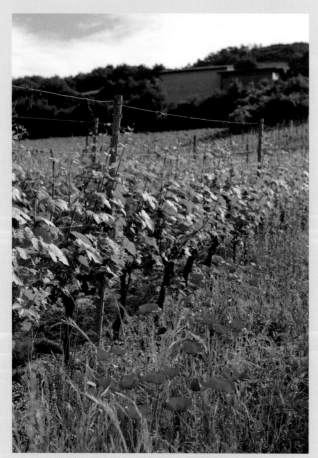

Winemaking & Tasting

Beaujolais is an exciting destination for both experienced and novice oenophiles. The artisan winemakers here are passionate people who are pleased to share their considerable knowledge about the wines they produce and sell.

Conveyed directly from those who work the fields, there is a fuller understanding of the French term *terroir*—the mysterious word that encompasses the earth, the air, the sweetness of life here. These combine to create the ideal conditions that give grapes (and, thus, the wines) their remarkable taste.

The Beaujolais region has twelve distinct appellations: Beaujolais, Beaujolais-Villages, and ten Beaujolais Crus, which produce

thoughtfully crafted wines that form the region's upper echelon. The ten Crus (a premier wine classification) of Beaujolais include Brouilly, Chénas, Chiroubles, Côte de Brouilly, Fleurie, Juliénas, Morgon, Moulin-à-Vent, Régnié, and Saint-Amour.

As individual as the vintages they produce, each vineyard boasts its own special offerings. Château Thivin, for example, shown left, above left, and opposite, dates to the twelfth century. The family's dedication to the craft of organic winemaking is evident in its Côte de Brouilly and Brouilly wines. A tour of the region allows the unique flavor of each destination to be sipped and savored.

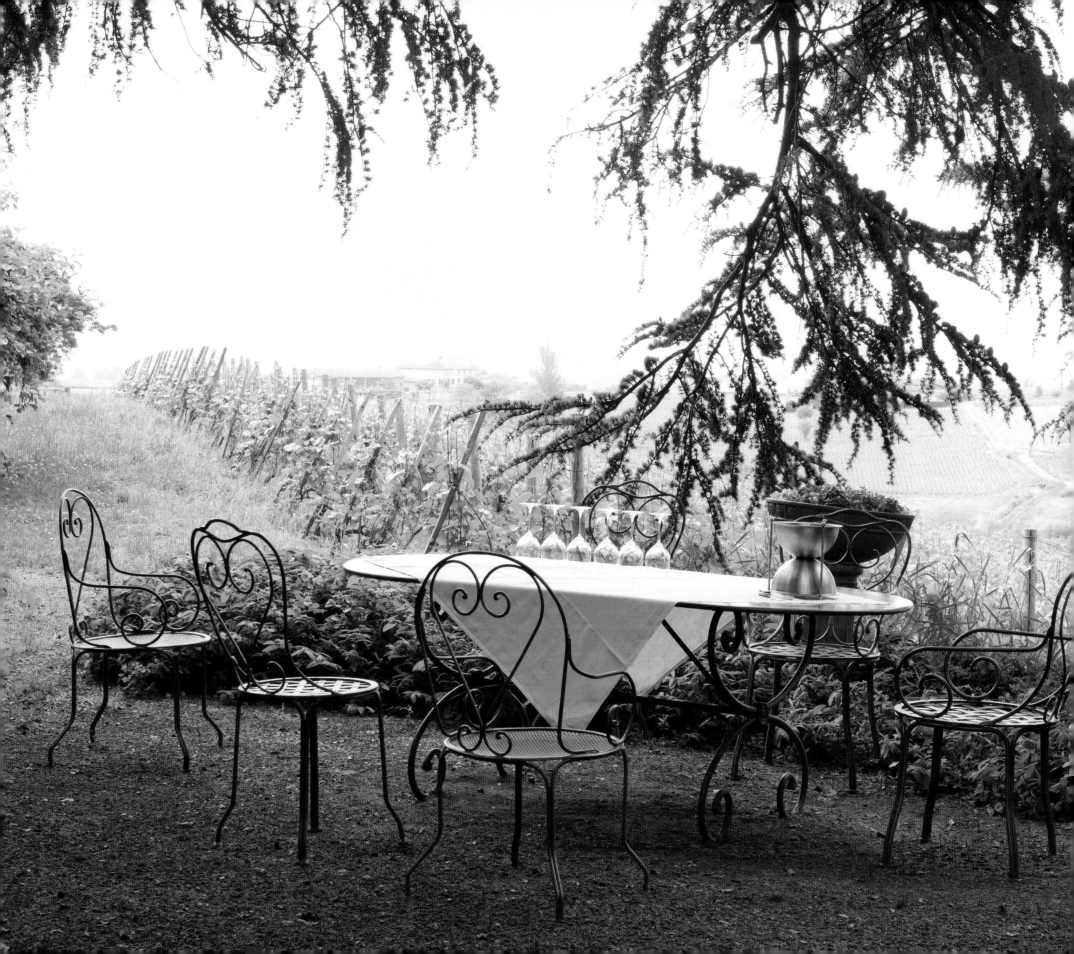

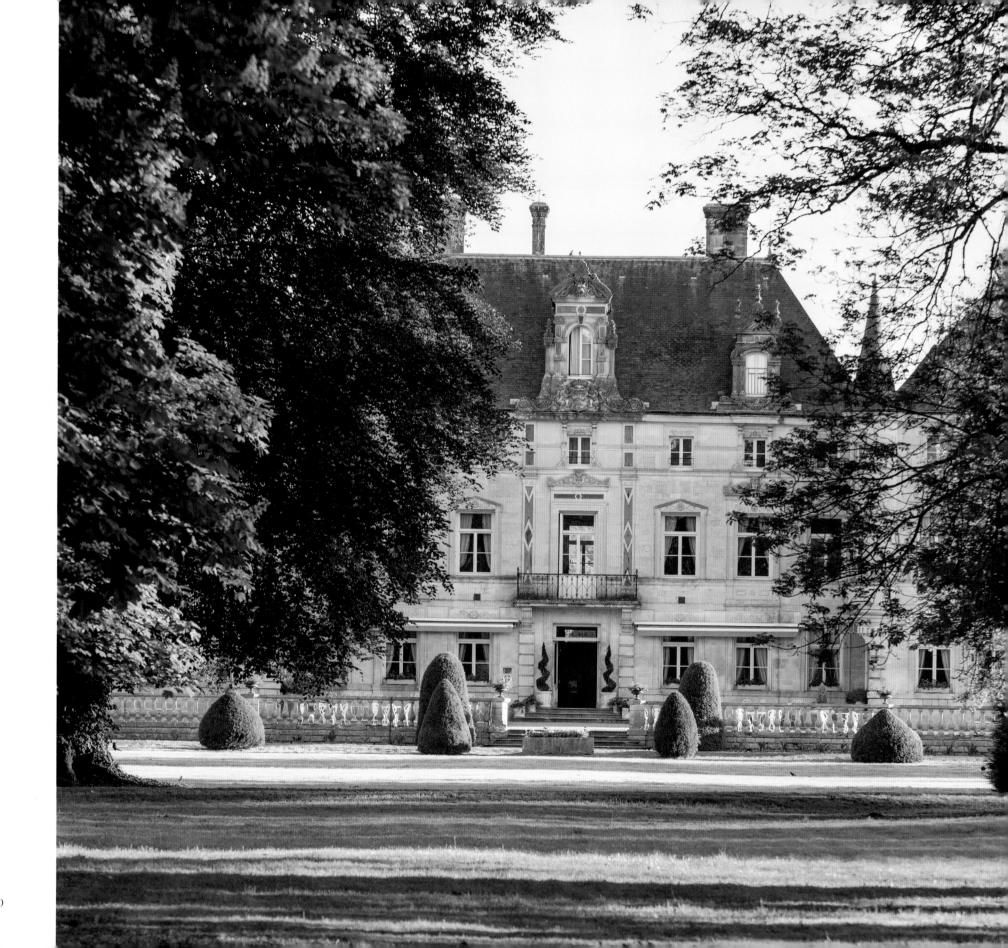

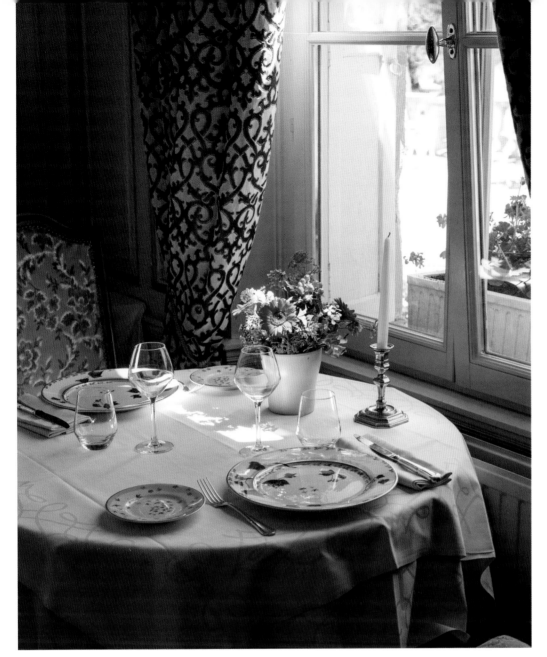

Splendid Stops

Opposite and this page, above left: Built on the site of a former feudal residence, the quintessentially French rooms of the Hostellerie du Château des Monthairons provide views of the grounds. Above right: Called the "Crowned Mountain," the medieval city of Laon, with its spectacular gold-gated cathedral, perches along a limestone ridge overlooking farmland.

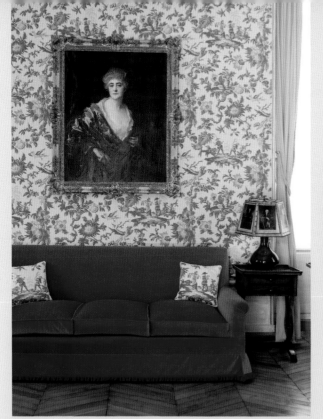

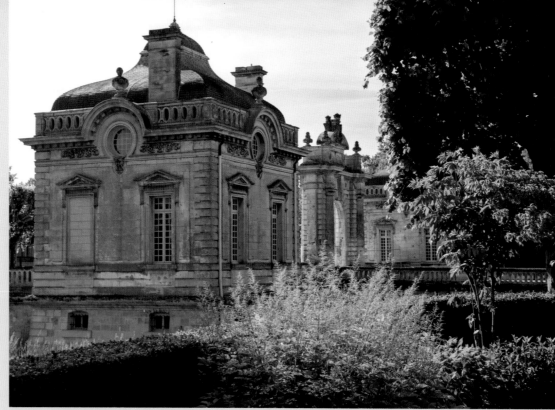

A Return to Former Glories

When France was embroiled in the First World War, United States citizens wanted to help this longtime ally in ways both big and small. New York philanthropist Anne Morgan, daughter of financier J. P. Morgan, joined other Americans to help the country. She was spurred to action by the destruction of the lovely Gallic villages laid waste by battle and was determined to assist with their recovery.

Anne founded the American Committee for Devastated France and purchased the ruined seventeenth-century Château de Blérancourt in Aisne for its headquarters. Along with her dedicated corps of female volunteers, she traveled to devastated areas, setting up makeshift hospitals and dispensaries, as well as handing out seeds, gardening tools, and hope.

Anne continued her humanitarian efforts after the war, creating libraries, agricultural cooperatives, and community centers to aid in renewal. Today, a new building constructed on the site of the former castle houses the Franco-American Museum. Though Anne never sought any recognition for her good deeds, she was appreciated all the same, and the museum honors this remarkable woman and her commitment to the people and places of northern France.

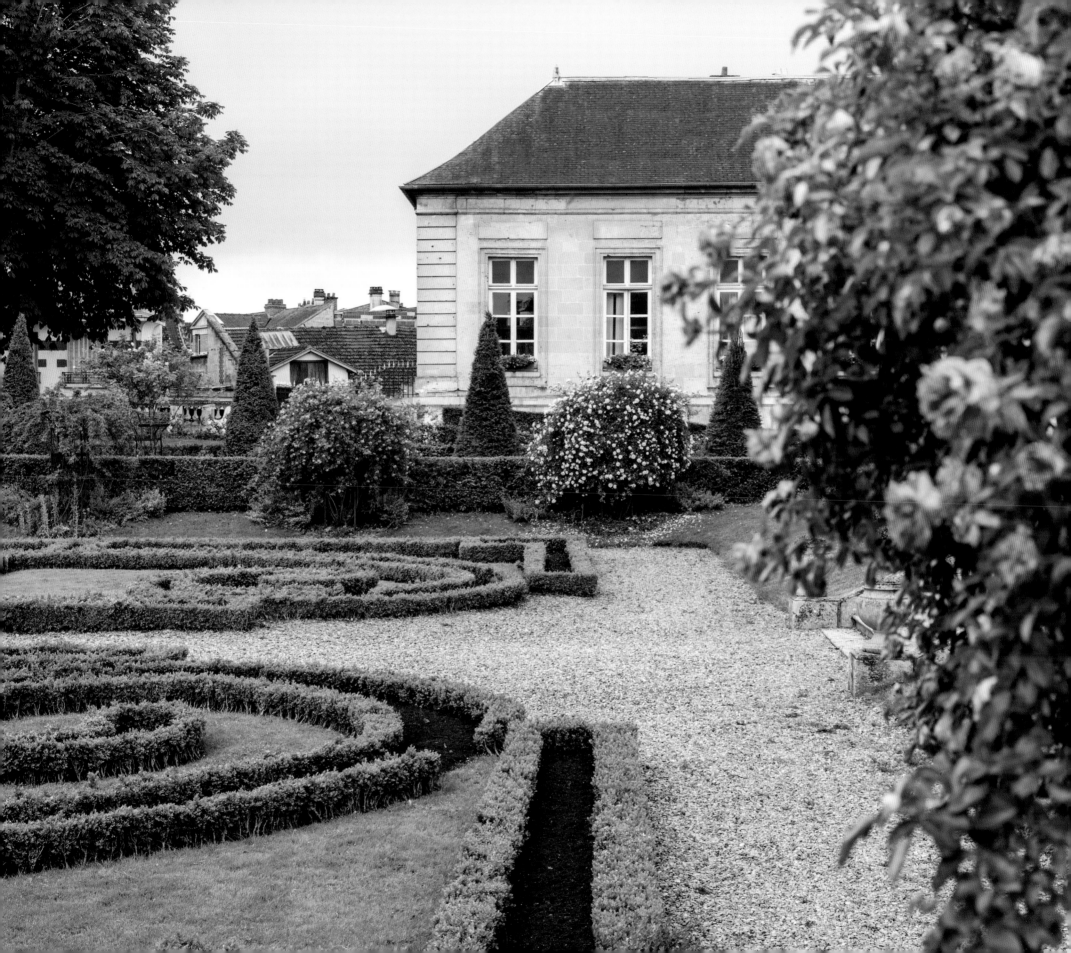

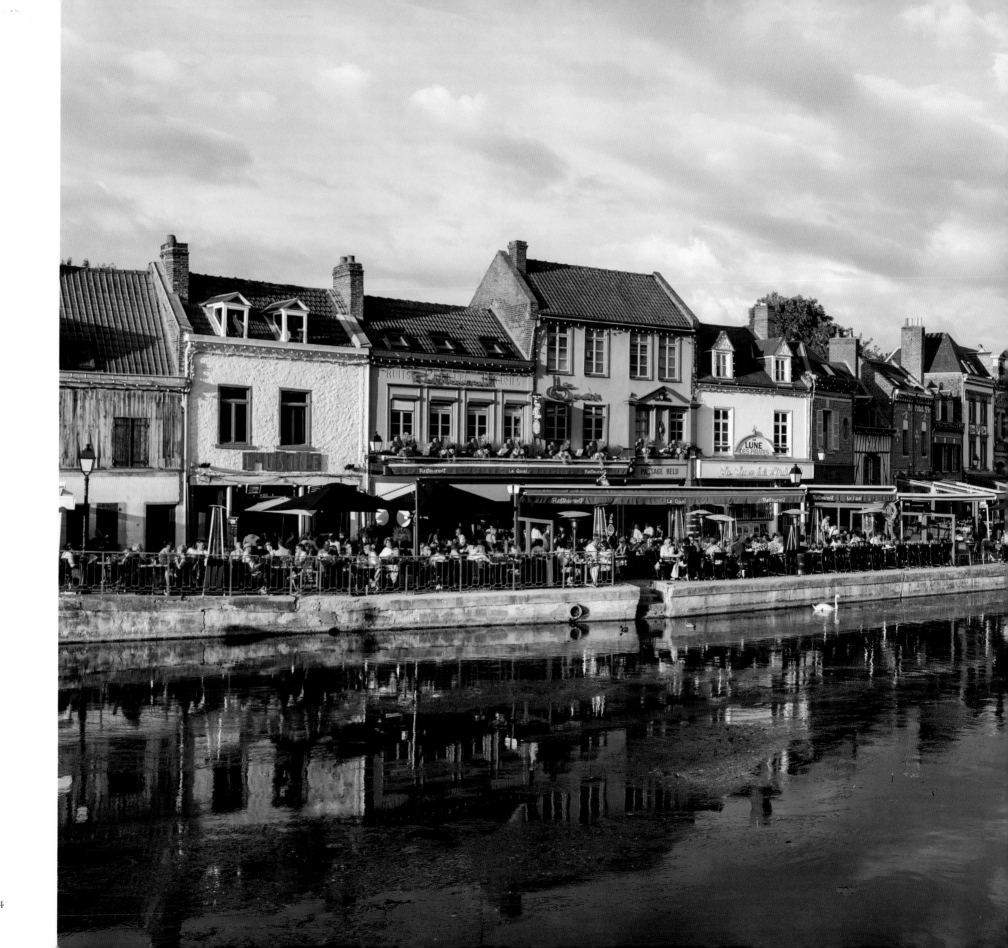

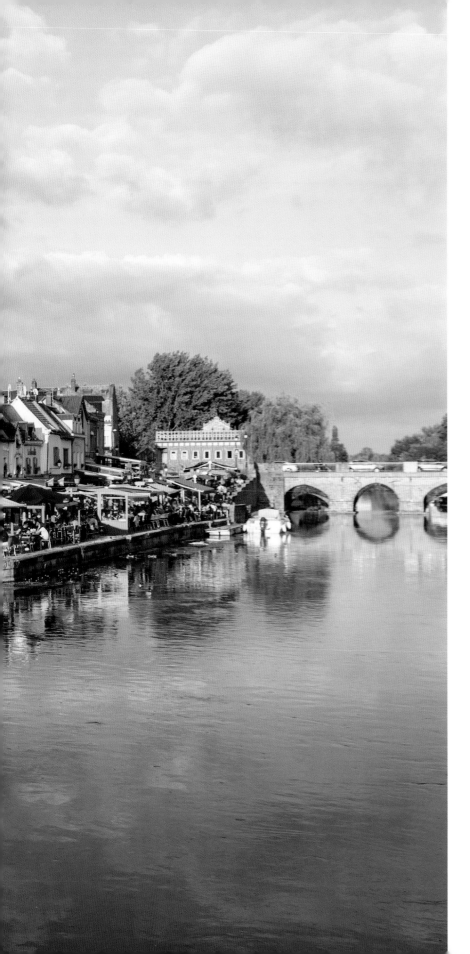

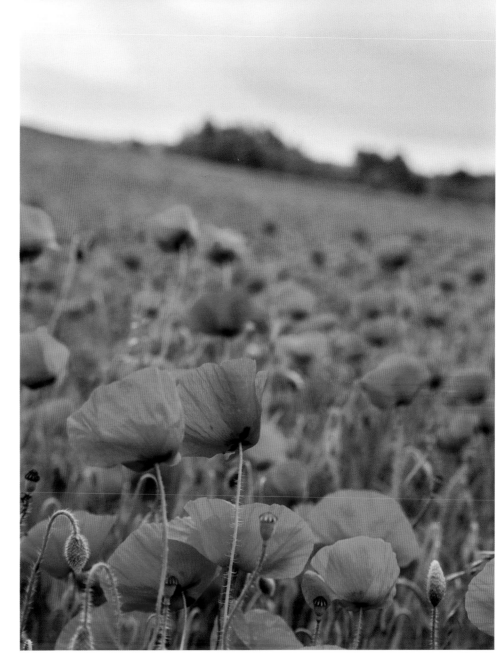

"Through the dancing poppies stole a breeze, most softly lulling to my soul."

—John Keats

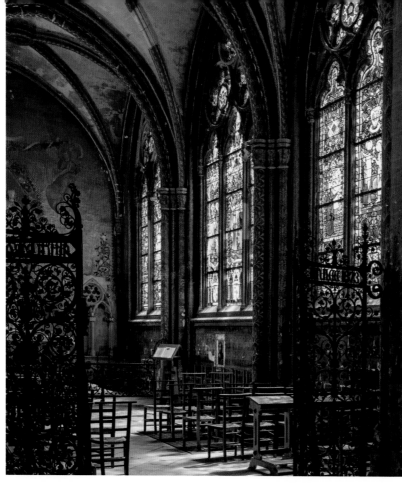

Opposite: In addition to memorable World War I sites, such as Belleau Wood and the Côte 204 monument, the town of Château-Thierry boasts beautiful public gardens. This page, above left: The main part of the Cathedral of Notre Dame de Verdun dates to AD 990; subsequent additions brought Renaissance- and Gothic-style touches to the architecture.

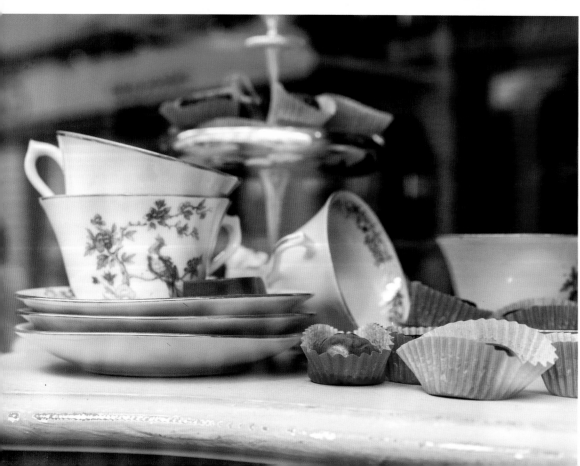

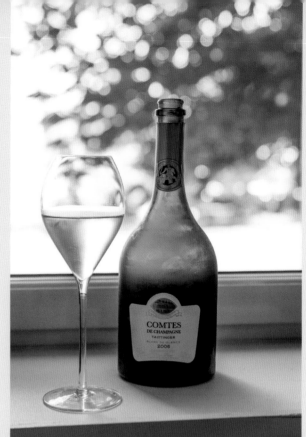

A Sip of Champagne

The province of Champagne lies in northeastern France, and though others may claim the designation, only the sparkling white wines produced in this region may legally bear the name Champagne. In the city of Reims, the Taittinger family capitalizes on the area's unique terroir to create its bubbly libations, including its renowned Comte de Champagne blend. A premier house in the industry, Taittinger offers guided tours down into its ancient cellar, formerly used by Benedictine monks of the long-gone Saint-Nicaise Abbey, where visitors may glimpse maturing bottles of the company's inventory.

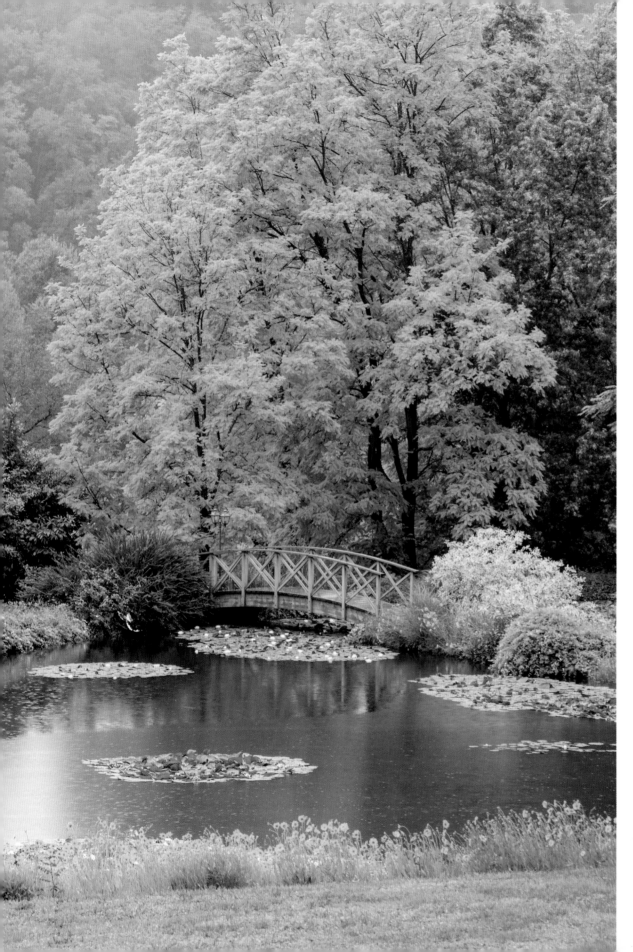

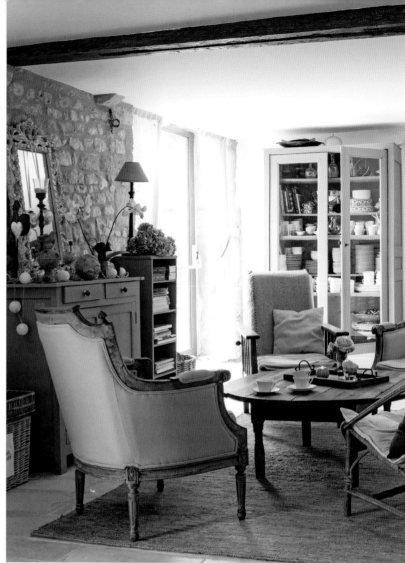

Exploring Aquitaine

Opposite: The quintessentially French village of Saint-Léon-sur-Vézère greets visitors with an exuberance of flowers at every turn. This page: Nestled into the commune of Carsac-Aillac in the Dordogne River Valley, luxury hotel La Villa Romaine and its surrounding grounds are the very picture of tranquility. The hostelry's name hearkens back to the area's ancient past, when Romans farmed the fertile soil. Just a short drive from here lie the famous cave paintings in Lascaux and the Troglodyte Village of La Madeleine near Tursac.

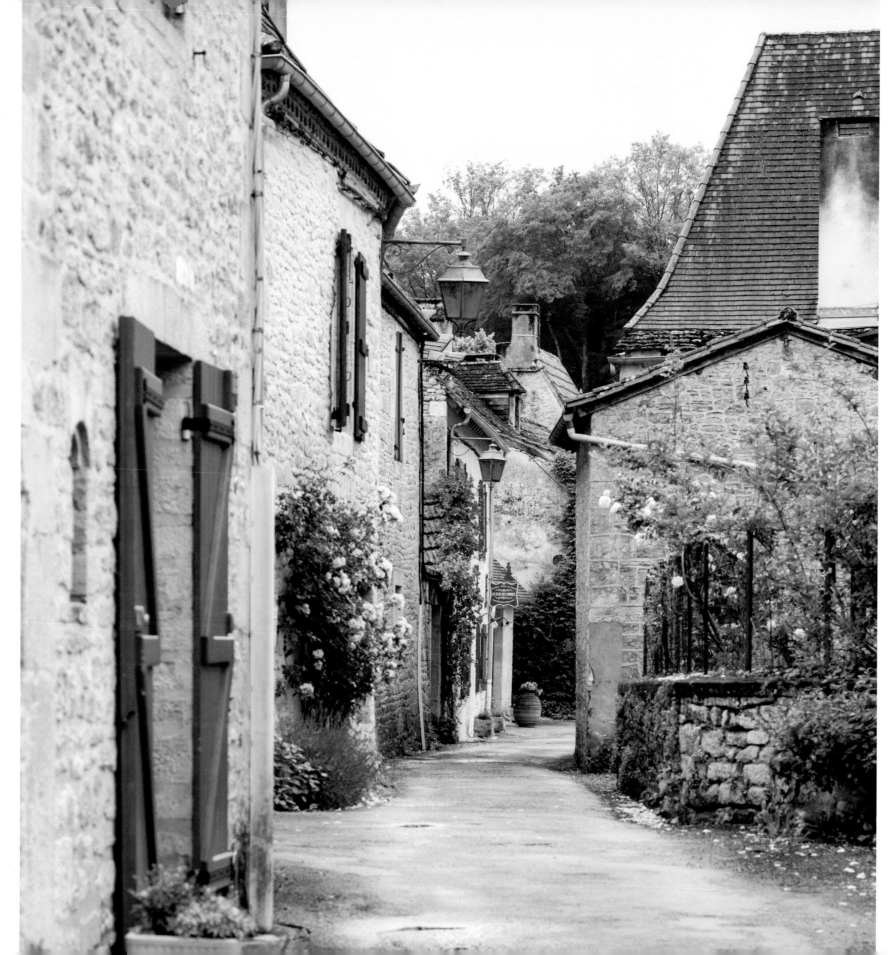

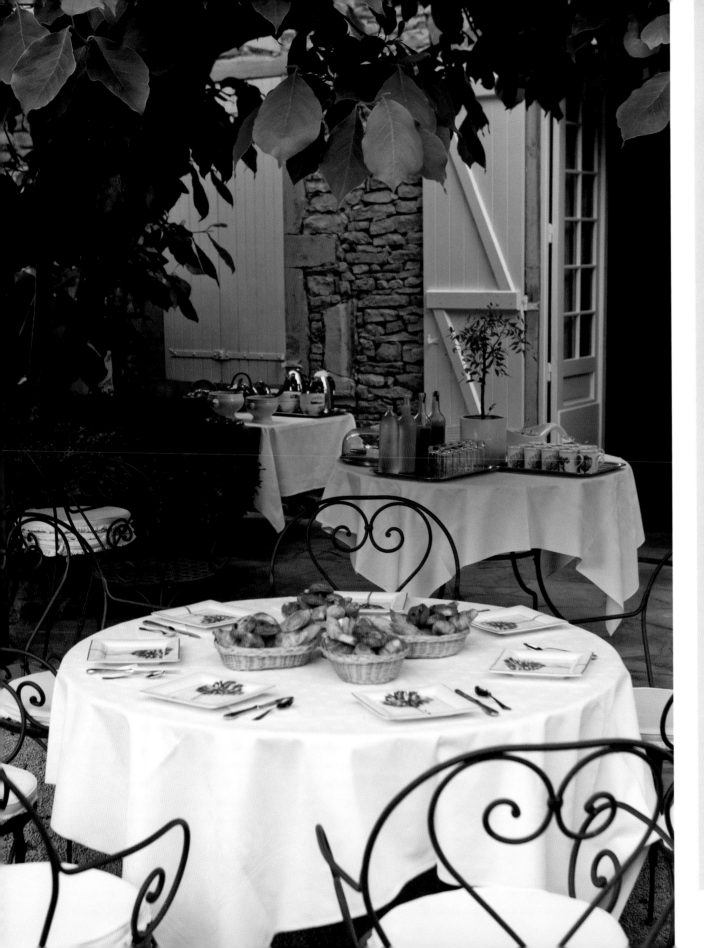

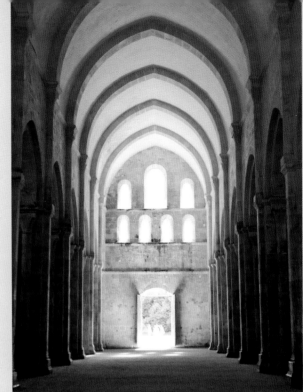

L'Abbaye de Fontenay

No trip to Burgundy would be complete without a visit to L'Abbaye de Fontenay, near Montbard. The monastery remained self-sufficient until the sixteenth century—in its heyday boasting a community of more than two hundred monks. Vast yet simple in its architecture, Fontenay endures as a masterpiece of Cistercian values. Although the cloisters languished for a time as a paper mill, politician Édouard Aynard bought the property in 1906 and immediately commenced restorations. Under his family's oversight, the abbey became a UNESCO World Heritage Site, and its landscape is noted among France's *Jardins Remarquables* (Remarkable Gardens).

Crème
DE LA CRÈME

Enjoy a satisfying taste of French culture, both in the famed wineries
and extraordinary kitchens of this culinary nation and in the
studios of skilled artisans who use their immeasurable talents to
create an imaginative and memorable feast for the eyes.

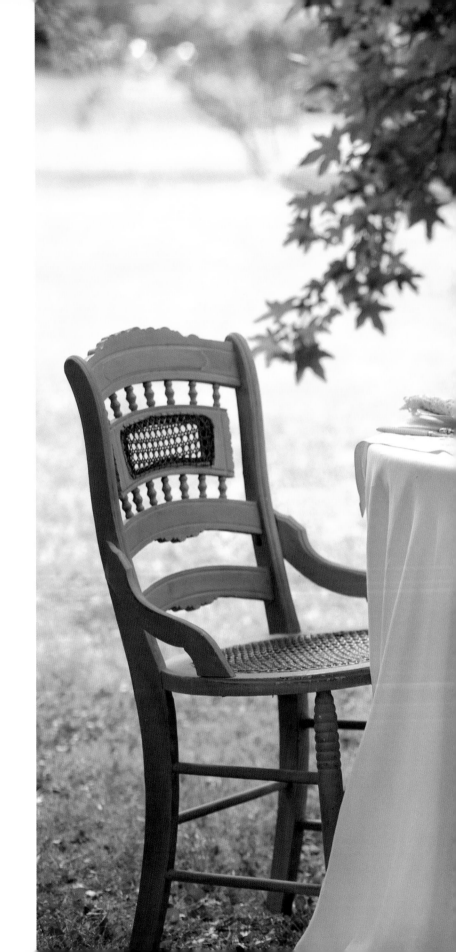

AT THE TABLE

The heart of French style is imbued with a refined sensibility—a keen devotion to the pleasures of taste, smell, and touch. Its expression is as simple as an invitation for teatime. Whether staged in a Paris garden or in your own backyard, an enchanting setting is inspired by joie de vivre, the carefree enjoyment of living that makes an everyday cup of tea or a glass of wine a delightfully special occasion.

Warm weather invites you to pull a table beneath a sheltering tree to create a relaxing, cool sanctuary. Focus on simplicity when arranging a scene for entertaining *en plein air*. Remix what you already have, including eclectic comfortable seating, layers of vintage linens, and elegant silver utensils and serving pieces with timeworn appeal. Here, gold-rimmed plates mix casually with alabaster cups and saucers. Blue hydrangeas and sweet white roses combine in unassuming small bouquets to evoke the essence of a perfectly beautiful day. Touches of Gallic blue bring the serenity of a summer sky to the gathering.

Ethereal specialties, such as Miniature Meringue Tarts with Raspberry Filling, make the afternoon sublime. To complement this dessert brimming with fruit, our light-as-air trio of pâtisserie treats includes pale green Pistachio Macarons with a decadent milk chocolate filling, fragrant Lavender Macarons with honey buttercream, and blushing Rose Macarons with a Champagne frosting.

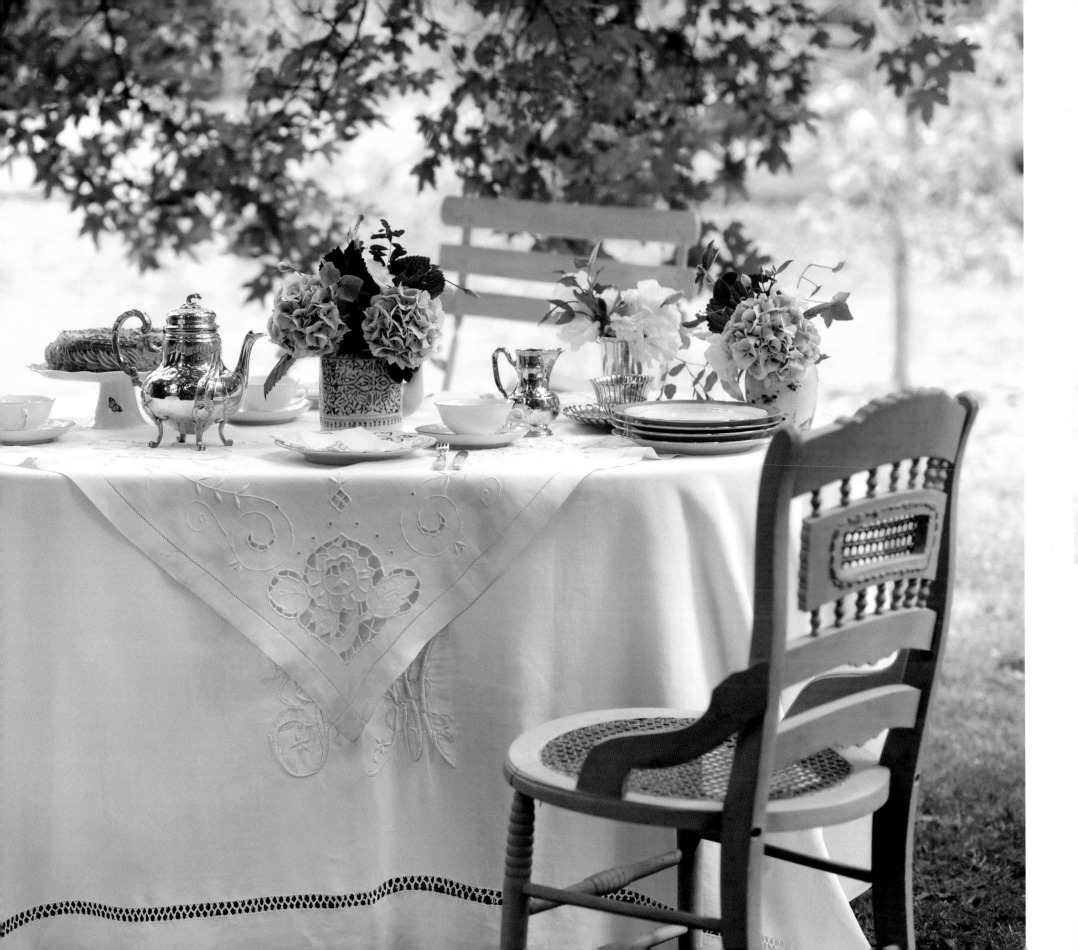

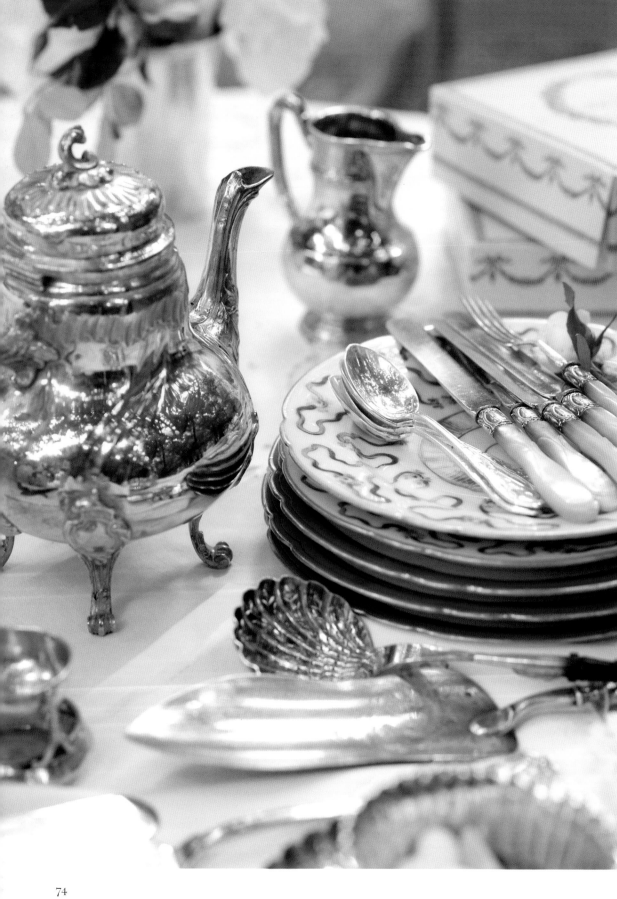

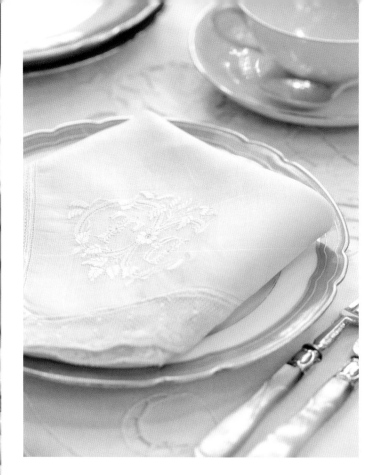

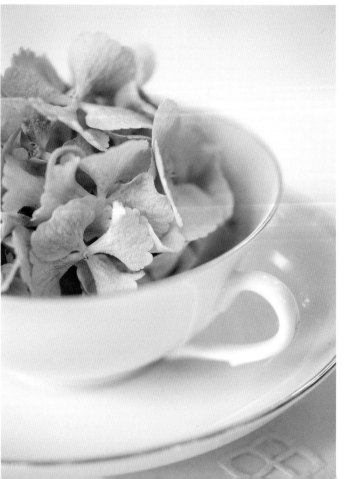

Miniature Meringue Tarts with Raspberry Filling
Makes 10 servings

8 egg whites
½ teaspoon cream of tartar
1½ cups granulated sugar
1 teaspoon vanilla extract
Red gel food coloring
Raspberry Filling (recipe follows)
Garnish: fresh raspberries, fresh mint

1. Preheat oven to 250°. Line baking sheets with parchment paper.
2. In a large bowl, beat egg whites and cream of tartar with a mixer at high speed until foamy. With mixer running, gradually add sugar to egg white mixture, beating at high speed until stiff peaks form. Stir in vanilla extract and desired amount of food coloring.
3. Spoon egg white mixture into 10 mounds on prepared pans, making a well in each with the back of a spoon.
4. Bake for 1½ hours. Turn off oven, and let stand in oven with door closed for 4 hours.
5. Just before serving, pipe Raspberry Filling into meringues. Garnish with raspberries and mint, if desired.

Raspberry Filling
Makes approximately 4 cups

2 cups fresh raspberries
½ cup granulated sugar
1 tablespoon fresh lemon juice
1½ teaspoons unflavored gelatin
¼ cup cold water
1 cup heavy whipping cream

1. In the work bowl of a food processor, process raspberries until smooth.
2. Strain purée through a fine-mesh sieve into a bowl, pressing on mixture with the back of a spoon; discard solids. Stir in sugar and lemon juice.
3. In a small saucepan, sprinkle gelatin over ¼ cup cold water; let stand for 1 minute. Stir over low heat until gelatin is completely dissolved. Stir into raspberry mixture.
4. Refrigerate until slightly thickened, about 1 hour.

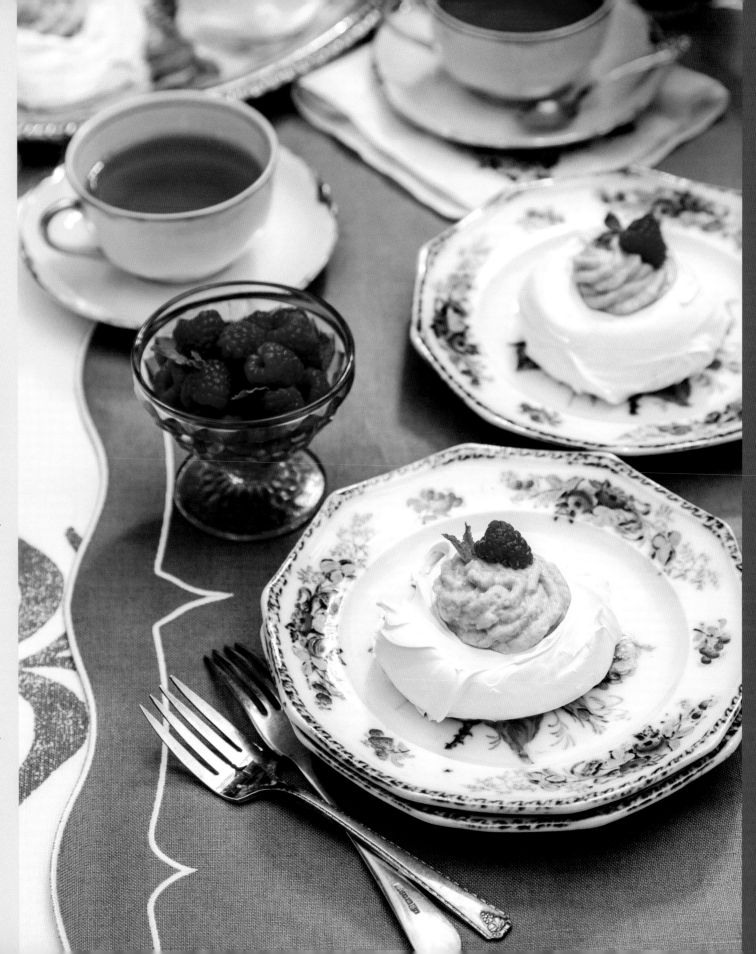

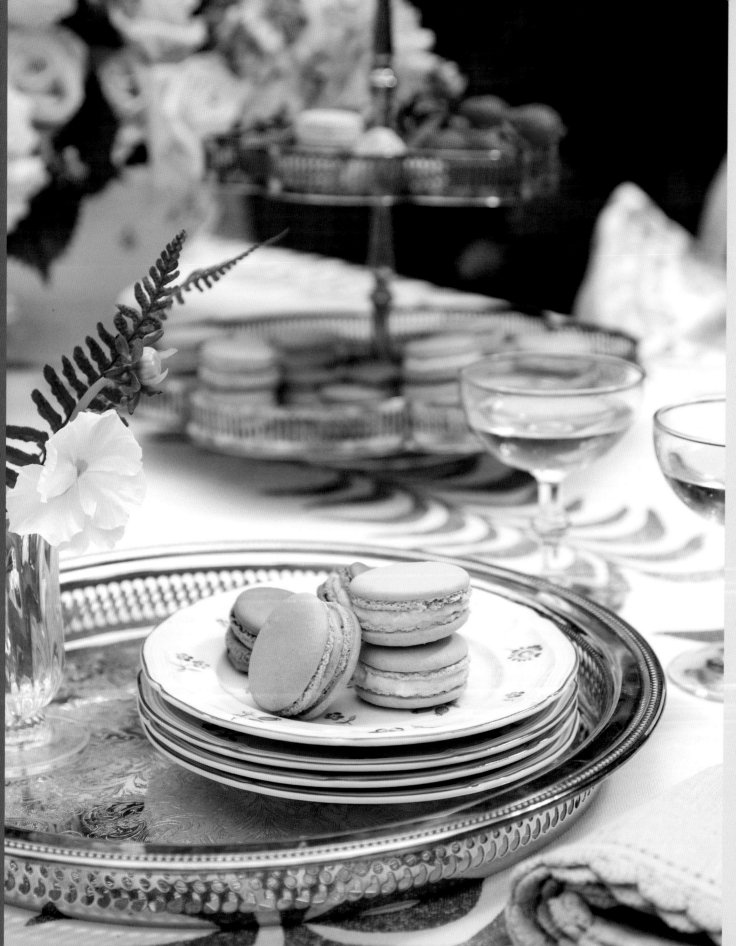

5. Transfer raspberry mixture to a large bowl. Beat with a mixer at high speed until foamy. Gradually add cream, beating until thickened, about 2 minutes. Cover and refrigerate for up to 3 days.

Pistachio Macarons
Makes approximately 25

3 egg whites
1 cup roasted, salted pistachios
2 cups confectioners' sugar
2 tablespoons granulated sugar
Green gel food coloring
Milk Chocolate Buttercream (recipe follows)

1. Place egg whites in a medium bowl, and let stand at room temperature for exactly 3 hours. (Aging egg whites in this manner is essential to creating perfect macarons.)
2. Line baking sheets with parchment paper. Using a pencil, draw 1½-inch circles 2 inches apart onto parchment; turn parchment over.
3. In the work bowl of a food processor, pulse together pistachios and 1 tablespoon confectioners' sugar. Pulse until pistachios are finely ground (about the consistency of coarse beach sand). Add remaining nearly 2 cups confectioners' sugar, pulsing until just combined.
4. In a large bowl, beat egg whites with a mixer at medium-high speed until frothy. Gradually add granulated sugar, beating until stiff peaks form, 3 to 5 minutes. (Egg white mixture will be thick, creamy, and shiny.) Gently fold pistachio mixture into beaten egg whites. Stir in desired amount of food coloring. Let batter stand for 15 minutes.
5. Spoon batter into a pastry bag fitted with a medium round tip*, and pipe batter onto drawn circles on prepared pans. If peaks form on circles, gently press down with a moist fingertip. Tap pans on counter 5 to 7 times to release air bubbles.
6. Let stand at room temperature for 45 minutes to 1 hour before baking to help develop the macaron's crisp exterior when baked. Macarons should feel dry to the touch and not stick to the finger.
7. Preheat oven to 275°.
8. Bake until firm to the touch, 18 to 20 minutes. Let cool on pans completely. Remove from pans, and place in airtight containers; refrigerate for up to 3 days until ready to

fill and serve. Pipe or spoon Milk Chocolate Buttercream over flat side of half of macarons. Place remaining cookies, flat sides down, on top of filling.

We used a Wilton #1M decorating tip.

Milk Chocolate Buttercream
Makes approximately 1½ cups

½ cup butter, softened
2 ounces milk chocolate, melted
1 cup confectioners' sugar
1 tablespoon heavy whipping cream

In a medium bowl, beat butter and melted chocolate with a mixer at medium speed until creamy. Gradually beat in confectioners' sugar until mixture is smooth. Beat in cream. Use filling immediately, or cover and refrigerate for up to 3 days. Let come to room temperature before using.

Lavender Macarons
Makes approximately 25

3 egg whites
1 cup almond meal
1½ cups confectioners' sugar
1 tablespoon dried lavender
3 tablespoons granulated sugar
Lavender gel food coloring
Honey Buttercream (recipe follows)

1. Place egg whites in a medium bowl, and let stand at room temperature for exactly 3 hours. (Aging egg whites in this manner is essential to creating perfect macarons.)
2. Line baking sheets with parchment paper. Using a pencil, draw 1½-inch circles 2 inches apart onto parchment; turn parchment over.
3. In the work bowl of a food processor, pulse together almond meal, 2 tablespoons confectioners' sugar, and lavender. Pulse until lavender is finely ground (about the consistency of coarse beach sand). Add remaining nearly 1½ cups confectioners' sugar, pulsing until just combined.
4. In a large bowl, beat egg whites with a mixer at medium-high speed until frothy. Gradually add granu-

lated sugar, beating until stiff peaks form, 3 to 5 minutes. Gently fold almond mixture into beaten egg whites. Stir in desired amount of food coloring. Let batter stand for 15 minutes.
5. Spoon batter into a pastry bag fitted with a medium round tip*, and pipe batter onto drawn circles on prepared pans. If peaks form on circles, gently press down with a moist fingertip. Tap pans on counter 5 to 7 times to release air bubbles.
6. Let stand at room temperature for 45 minutes to 1 hour before baking to help develop the macaron's crisp exterior when baked. Macarons should feel dry to the touch and not stick to the finger.
7. Preheat oven to 275°.
8. Bake until firm to the touch, 18 to 20 minutes. Let cool on pans completely. Remove from pans, and place in airtight containers; refrigerate for up to 3 days until ready to fill and serve. Pipe or spoon Honey Buttercream over flat side of half of macarons. Place remaining cookies, flat sides down, on top of filling.

We used a Wilton #1M decorating tip.

Honey Buttercream
Makes approximately ¾ cup

½ cup butter, softened
1 cup confectioners' sugar
2 tablespoons honey

In a medium bowl, beat butter, confectioners' sugar, and honey with a mixer at medium speed until creamy. Use immediately, or cover and refrigerate for up to 3 days. Let come to room temperature before using.

Rose Macarons
Makes approximately 25

3 egg whites
1 cup almond meal
1½ cups confectioners' sugar
1 teaspoon rose water
3 tablespoons granulated sugar
Red gel food coloring
Champagne Buttercream (recipe follows)

1. Place egg whites in a medium bowl, and let stand at room temperature for exactly 3 hours. (Aging egg whites in this manner is essential to creating perfect macarons.)
2. Line baking sheets with parchment paper. Using a pencil, draw 1½-inch circles 2 inches apart onto parchment; turn parchment over.
3. In the work bowl of a food processor, pulse together almond meal and 1 tablespoon confectioners' sugar. Pulse until combined. Add remaining nearly 1½ cups confectioners' sugar, pulsing until just combined.
4. In a large bowl, beat egg whites and rose water with a mixer at medium-high speed until frothy. Gradually add granulated sugar, beating until stiff peaks form. Gently fold almond mixture into beaten egg whites. Stir in desired amount of food coloring. Let batter stand for 15 minutes.
5. Spoon batter into a pastry bag fitted with a medium round tip*, and pipe batter onto drawn circles on prepared pans. If peaks form on circles, gently press down with a moist fingertip. Tap pans on counter 5 to 7 times to release air bubbles.
6. Let stand at room temperature 45 minutes to 1 hour before baking to develop the macaron's signature crisp exterior when baked. Macarons should feel dry to the touch and not stick to the finger.
7. Preheat oven to 275°.
8. Bake until firm to the touch, 18 to 20 minutes. Let cool on pans completely. Remove from pans, and place in airtight containers; refrigerate for up to 3 days until ready to fill and serve. Pipe or spoon Champagne Buttercream over flat side of half of macarons. Place remaining cookies, flat sides down, on top of filling.

We used a Wilton #1M decorating tip.

Champagne Buttercream
Makes approximately ¾ cup

½ cup butter, softened
1½ cups confectioners' sugar
2 tablespoons Champagne

In a medium bowl, beat butter, confectioners' sugar, and Champagne with a mixer at medium speed until creamy. Use immediately, or cover and refrigerate for up to 3 days. Let come to room temperature before using.

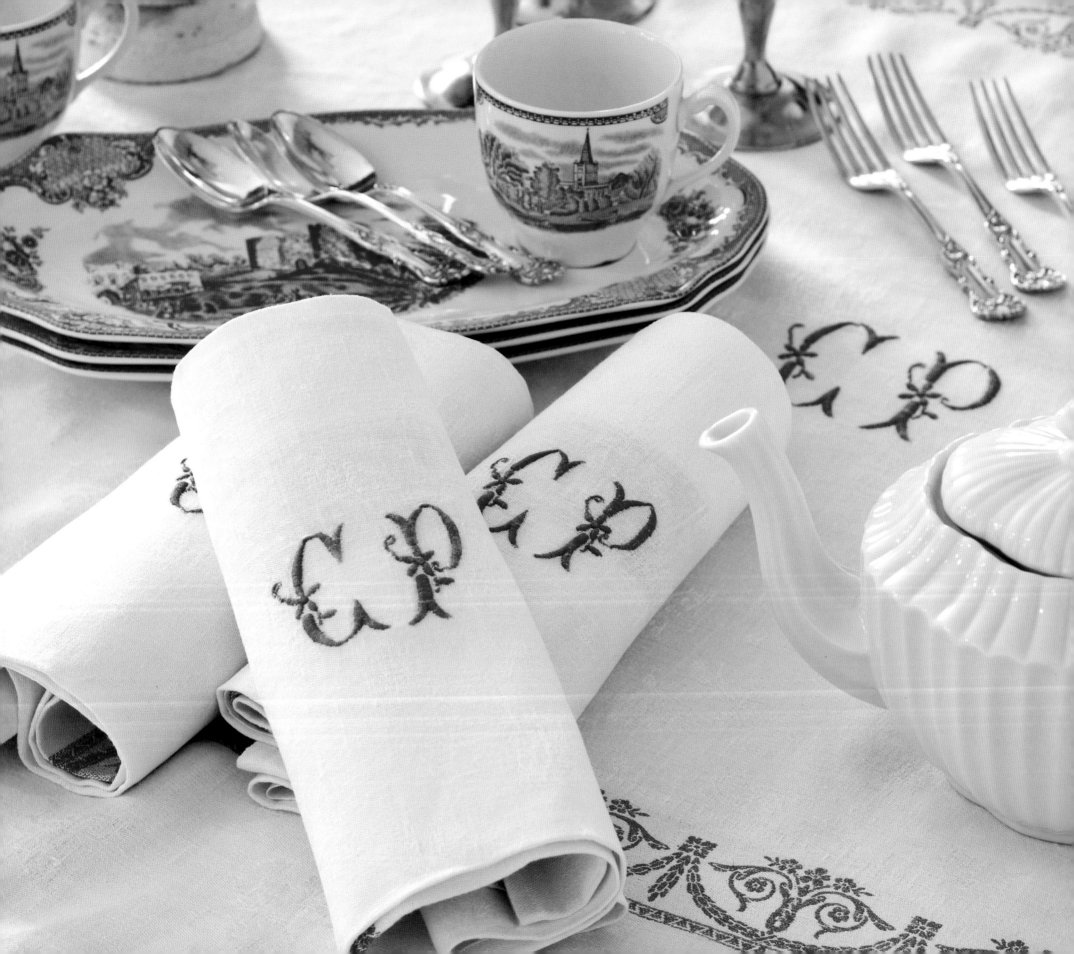

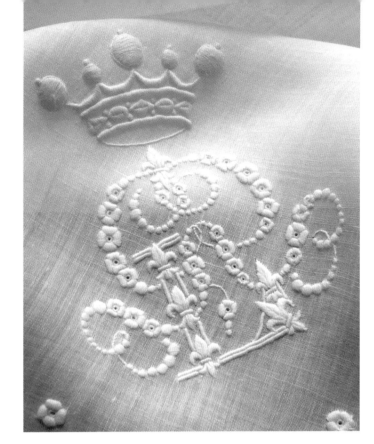

A Royal Lineage

The linens used in dining today were introduced to the general public by a French queen in the sixteenth century. When Catherine de Médici arrived in Marseille from her native Florence, soon to marry Henry II, she introduced the napkin to the French table, and the generously sized serviette quickly became de rigueur. Above left: This finely wrought monogram boasts noble provenance, indicated by its viscount crown and multiple fleurs-de-lis.

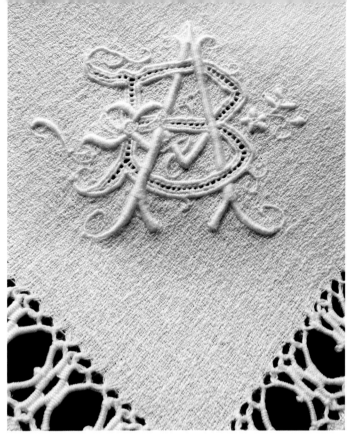

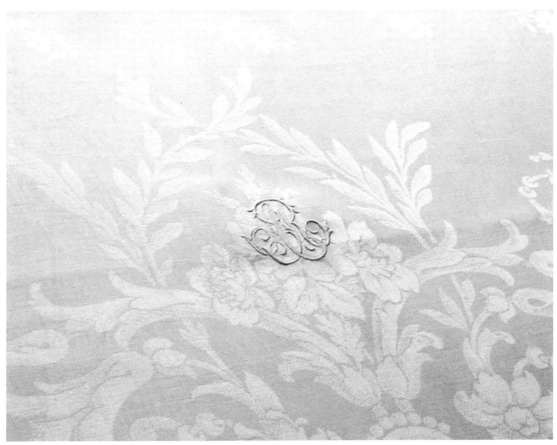

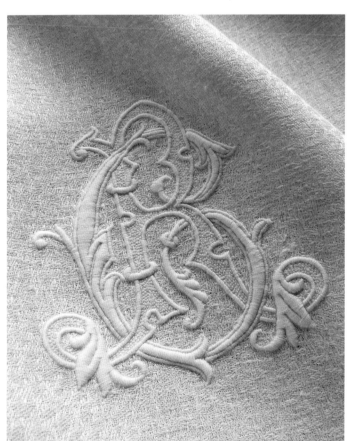

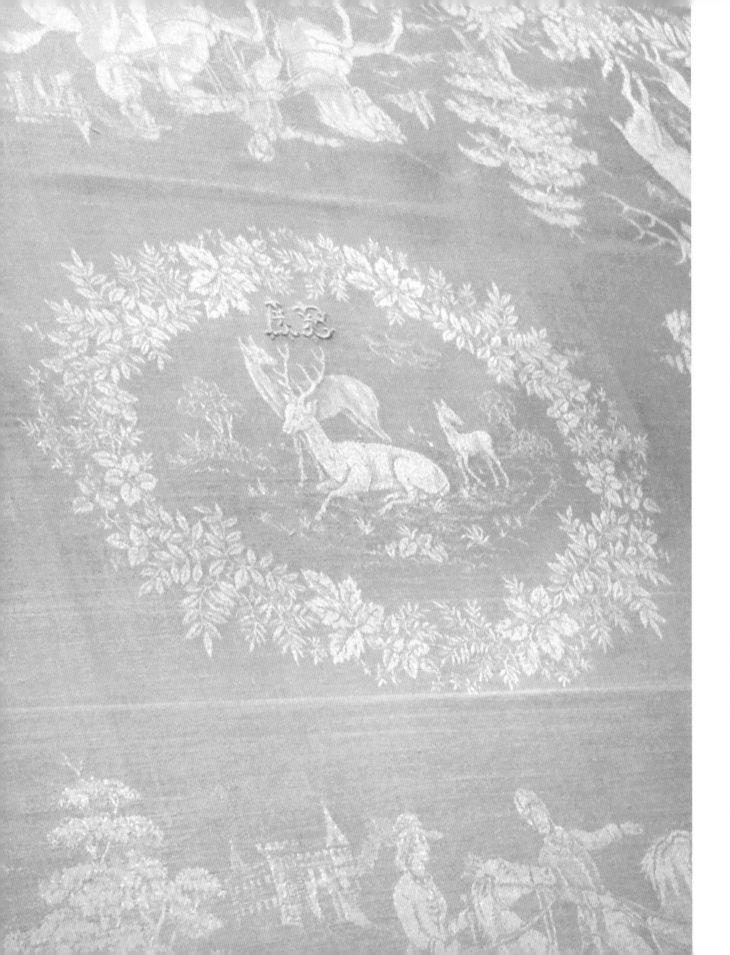

"Madame, beauty
is always queen,
and the whole world
her empire."

—Joseph II

For centuries, white linen damask
has provided a fertile ground upon
which textile designers could unleash
their imaginations, giving rise to
extraordinary white-on-white motifs.
Left: This napkin was reserved for the
celebratory feast and culmination of a
hunting party. Opposite: The ancient art
of needlework attained an unparalleled
level of proficiency in eighteenth-
and nineteenth-century France, as
evidenced by this rare tablecloth
featuring colorful Beauvais embroidery,
made popular during the Napoleon III
period of the 1850s and 1860s.

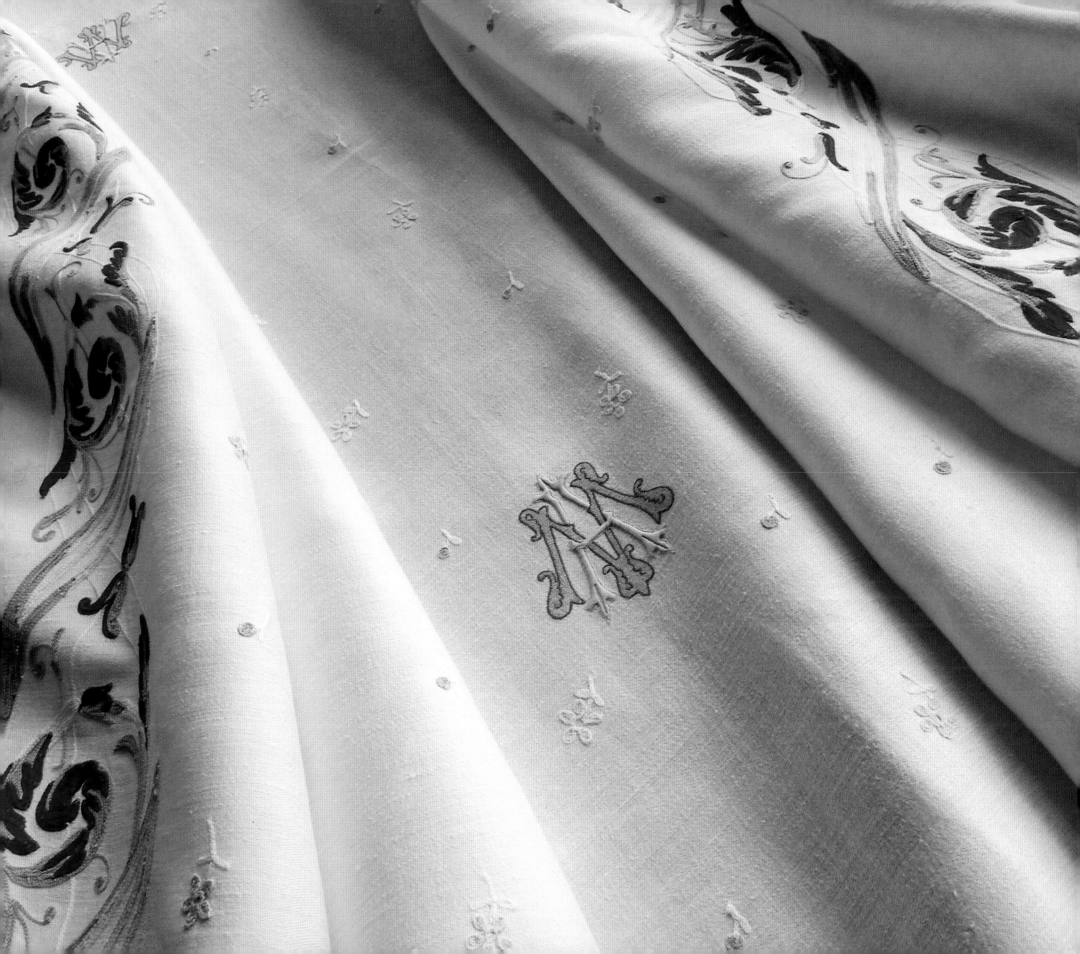

SAVORING A FLAVOR OF FRANCE

The cedar-lined gardens of Fort Saint-André, a medieval fortress just across the river from Avignon, France, offer a breathtaking view of the beloved Provençal town that embraces its celebrated history—and epicurean sophistication. Sheltered in the shadow of Avignon's Palais des Papes, La Mirande is a boutique hotel almost as old as the city itself. The quaint building stands on the site of the former Cardinal's Palace; in fact, the basement is part of the original fourteenth-century structure.

The hotel was purchased by the Stein family more than three decades ago and renamed La Mirande after the grand room where visiting dignitaries were once received. A meticulous renovation followed, replicating the aura of an eighteenth-century aristocratic residence. "The owners are collectors who are passionate about everything in antiques and art," explains hotel spokesperson Rozenn Le Goff. "All fabrics and wallpapers are based on drawings of art in the eighteenth century."

Cuisine is central to the La Mirande experience. Guests may dine at the gourmet restaurant, enjoy demonstrations at the chef's table, sample sweets and savories over breakfast, or hone their culinary skills at the popular on-site cooking school. With its myriad amenities, the hotel is the pièce de résistance of any visit to Avignon, where past and present intertwine for an unforgettable sojourn in the heart of Provence.

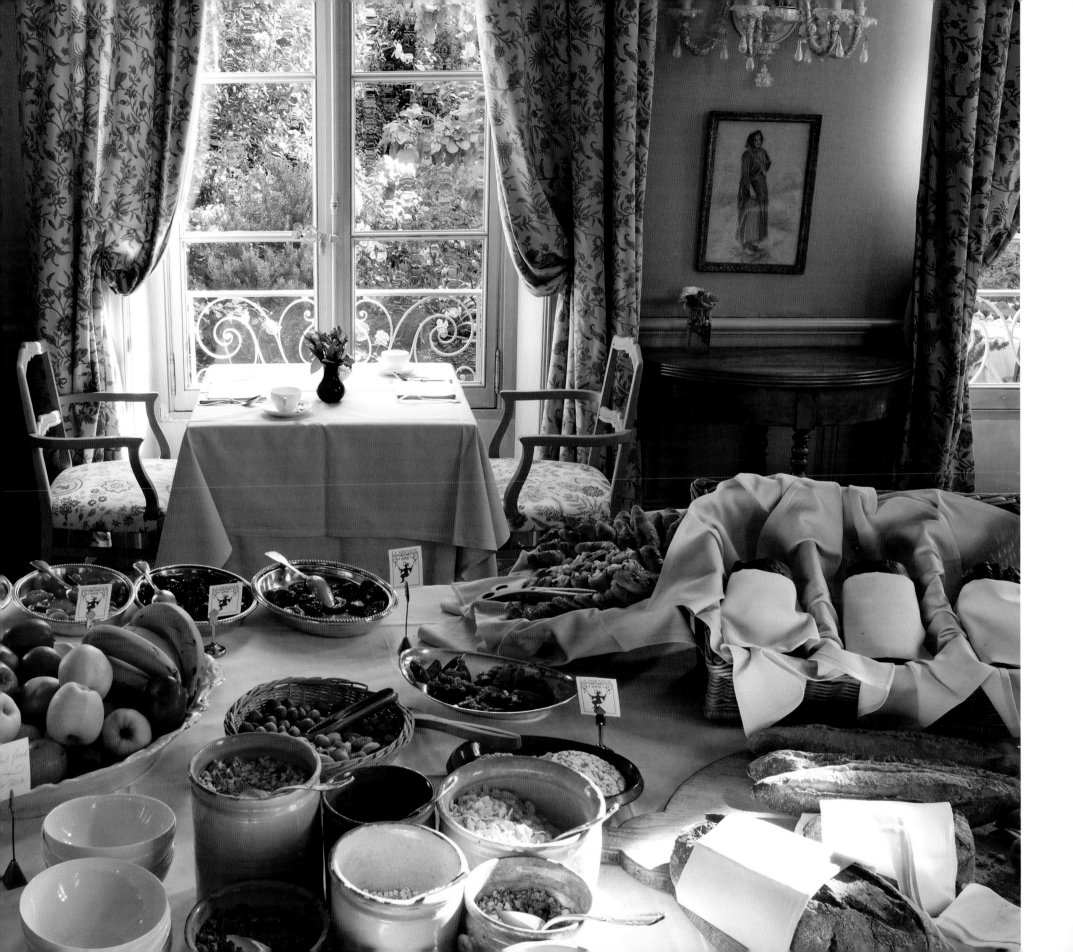

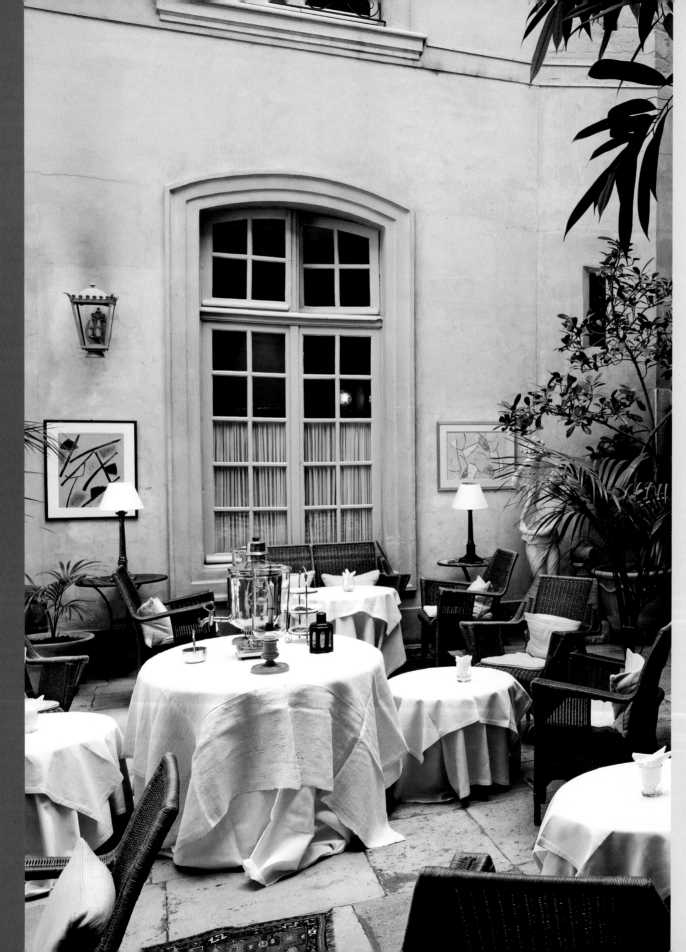

Pear-Vanilla Jam

Makes approximately 3 cups

Adapted from a recipe courtesy of Hôtel La Mirande

3 half-pint jars, lids, and bands
2¼ pounds fully ripe pears*
2 cups castor sugar, divided
½ (1.75-ounce) package pectin*
2 vanilla beans, split lengthwise, seeds scraped and reserved

1. Just before using, sterilize cleaned jars, lids, and bands for 10 minutes in simmering water or in the dishwasher. Using tongs, remove one at a time when ready to fill. Place a small heatproof plate in the freezer.

2. Peel and core pears; finely chop and place in a medium bowl. Using a potato masher, coarsely mash pears. Measure enough pears to yield exactly 2¾ cups.

3. In a small bowl, whisk together ¼ cup castor sugar and pectin. Transfer to a large saucepan. Stir in pears, blending well. Add vanilla beans and reserved seeds. Bring to a full rolling boil (that does not stop bubbling when stirred) over high heat, stirring constantly. Stir in remaining 1¾ cups castor sugar; return to a full rolling boil, and boil for exactly 1 minute, stirring constantly. Remove from heat.

4. Place a spoonful of boiling jam onto chilled plate from freezer. Let stand for 1 minute. Using finger, gently push jam. If the surface of jam has formed a skin and wrinkles when pushed, then it is set. (If jam is still quite liquid, return to pan. Return pan to heat, and boil for 2 to 3 minutes before testing again.) Using a metal spoon, skim off any foam. Using tongs, discard vanilla beans.

5. Immediately ladle jam into prepared jars, filling to ½ inch of rims. Wipe rims with a clean, damp cloth, and seal jars with lids and bands. Let stand at room temperature for 24 hours. Refrigerate for up to 3 weeks.

We used Bartlett pears and the variety of Sure Jell Premium Fruit Pectin formulated for use in lower- or no-sugar recipes.

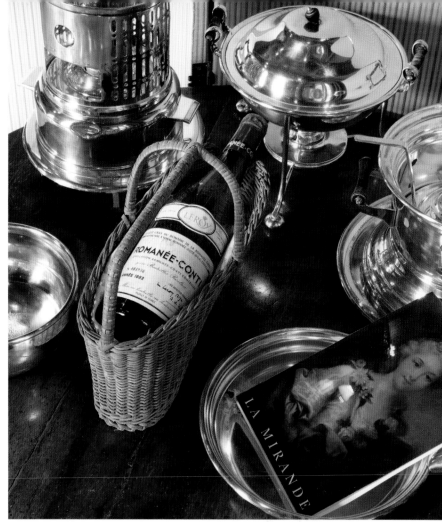

Culinary delights at La Mirande include pausing every afternoon for refreshments on the terrace, opposite, or preparing regional meals with area chefs as students of Le Marmiton, the hotel's monthly, weeklong cooking school, this page, above left. Below right: Homemade specialties brimming with freshly plucked fruit highlight daily menus. The hotel's tawny Pear-Vanilla Jam offers a mild yet flavorful accompaniment to fresh-baked pastries.

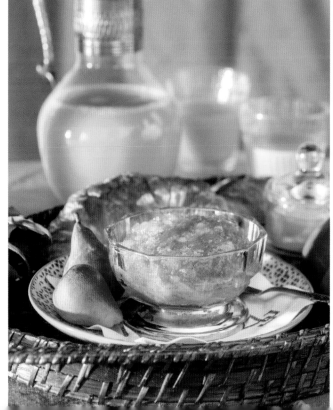

In Her Footsteps

When Julia Child and her husband, Paul, moved to Paris in 1948, she was introduced to French cuisine—an experience akin to untying the ribbons on a gift that spoke straight to her heart. A meal at France's oldest restaurant, La Couronne, changed the focus of her life. She enrolled at the city's famed Le Cordon Bleu cooking school and, thus, began her journey as chef, author, and host of her acclaimed cooking show, *The French Chef*, which premiered in 1963. Right and opposite, below right: Le Grand Vefour, a favorite of the couple, dates to 1763 but still offers gourmet fare.

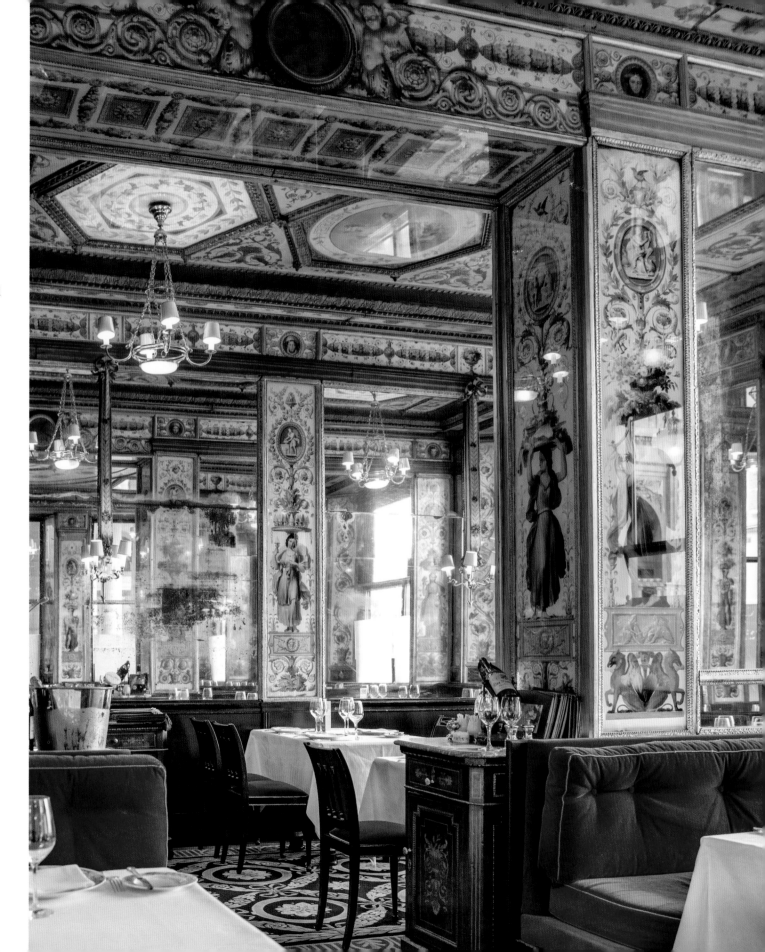

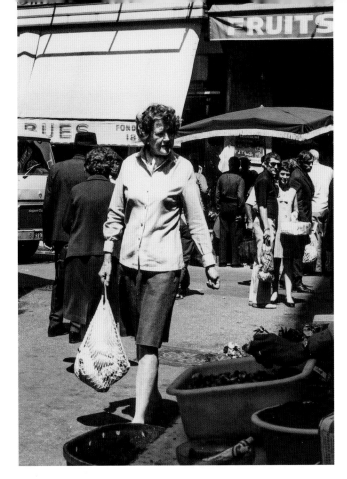

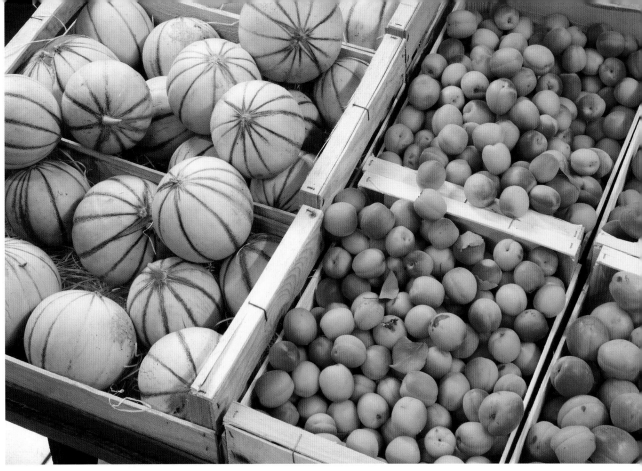

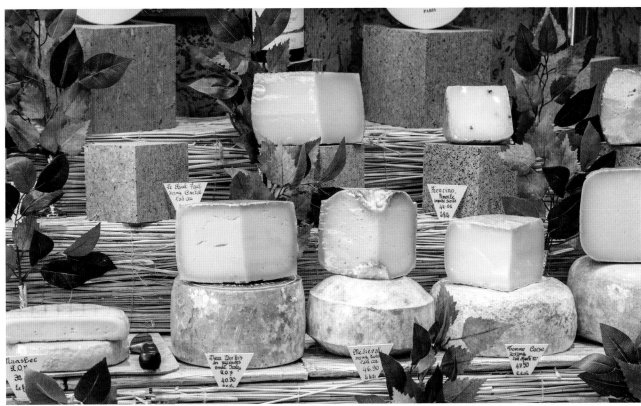

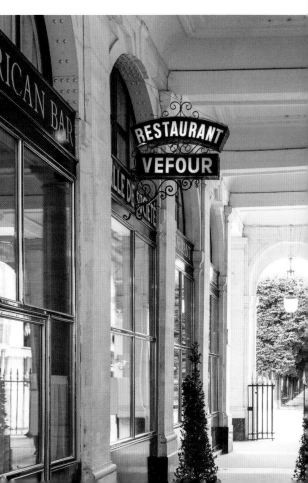

Clockwise from below right: Though it has been many years since Julia's awakening in the City of Light, many of the shops that fed her culinary endeavors remain, including family-owned meat shop Jeusselin, a vibrant array of open-air markets offering fresh produce, and brimful delicatessen L'Epecerie Fine, also shown opposite.

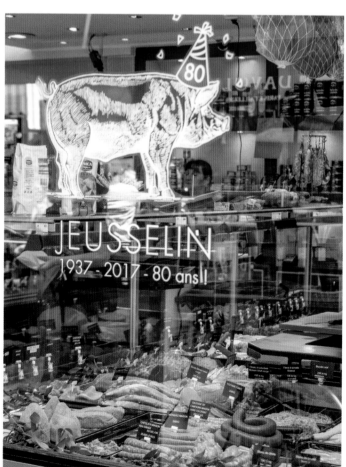

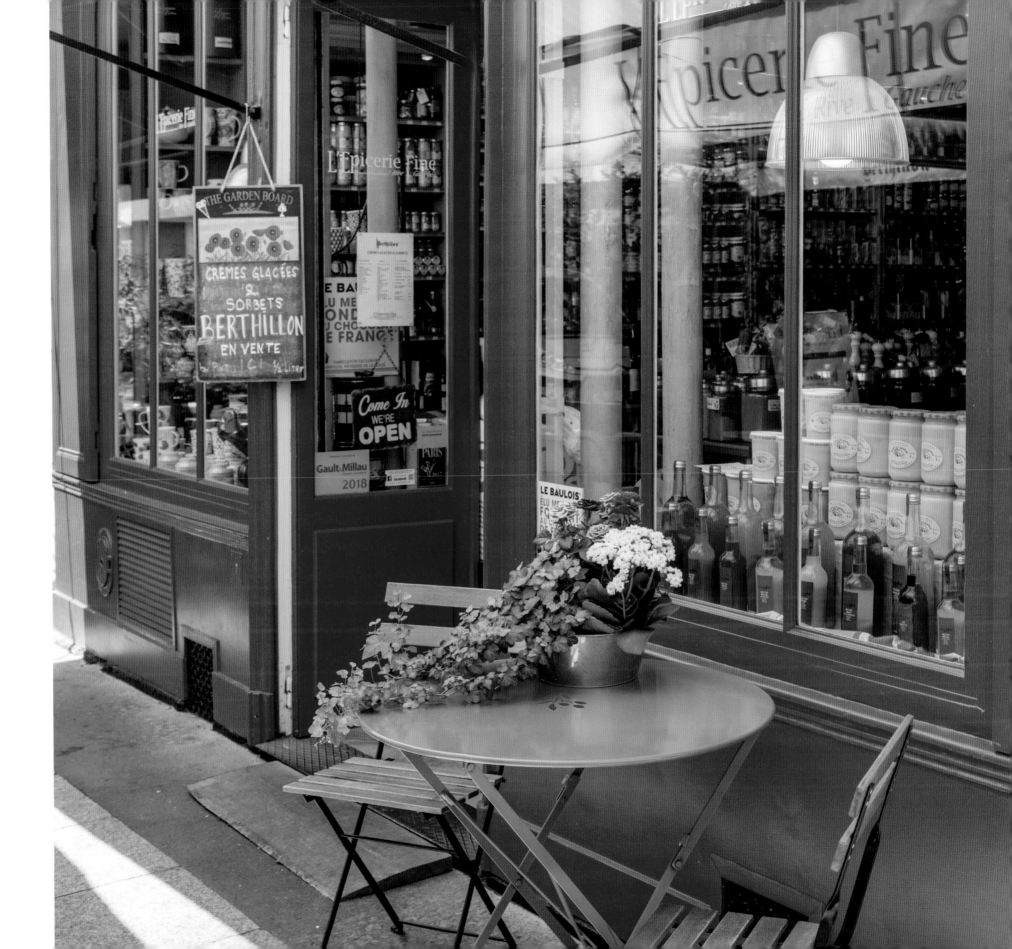

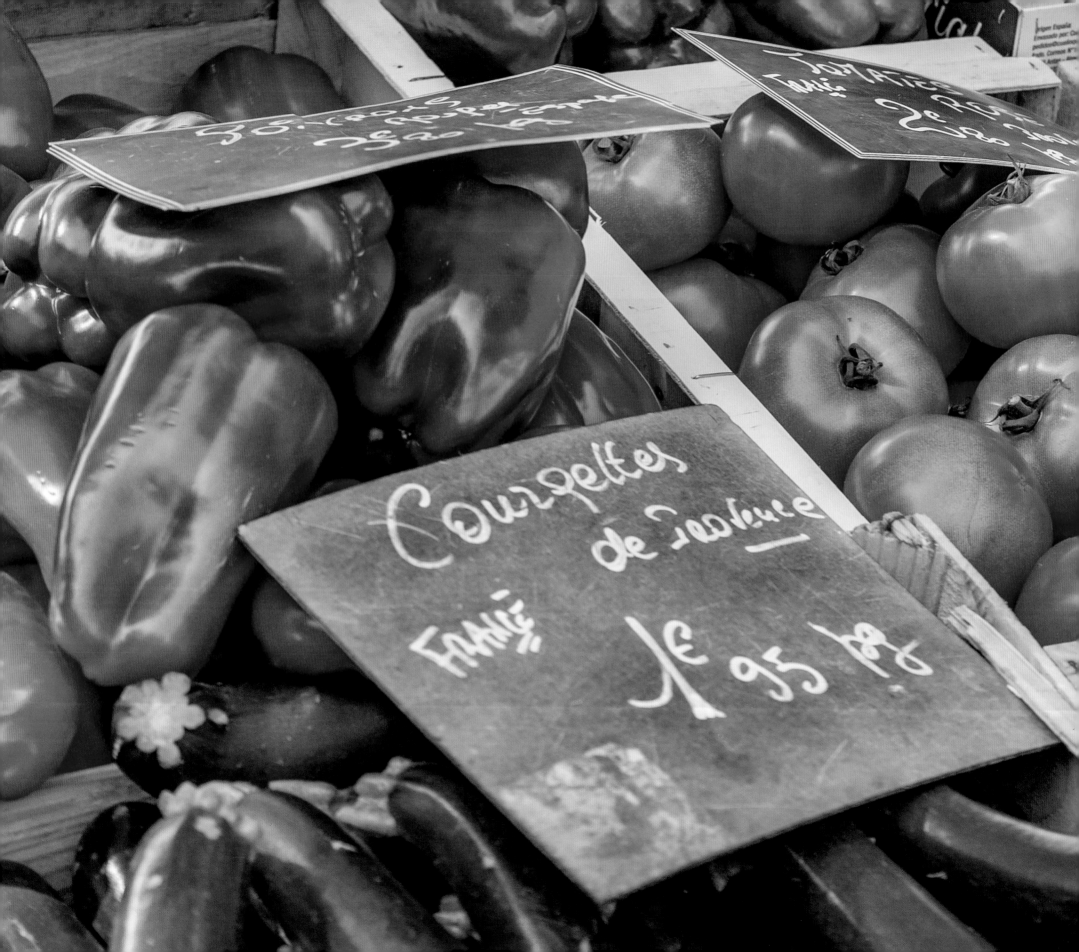

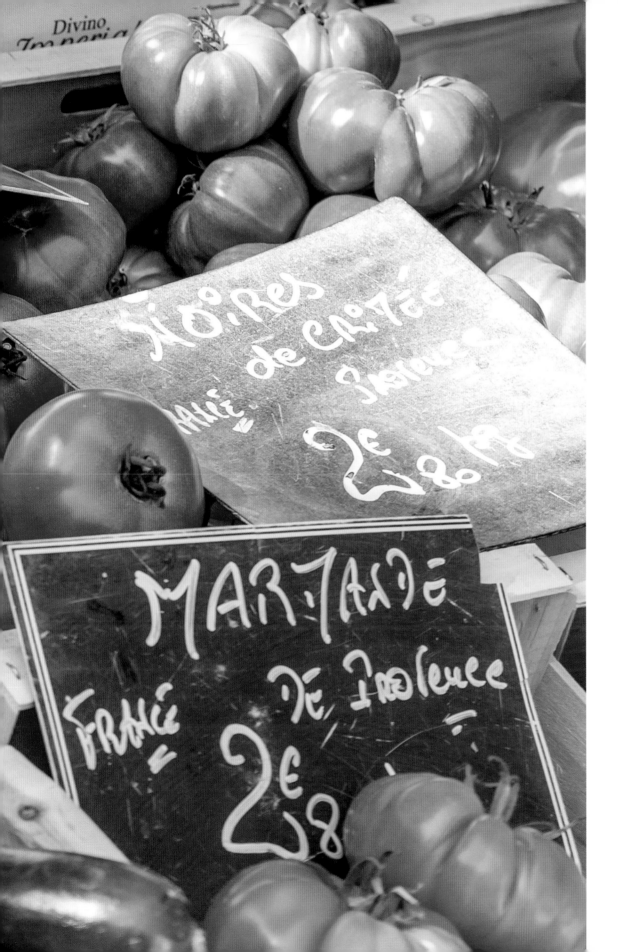

"The Parisian grocers insisted that I interact with them personally: If I wasn't willing to take the time to get to know them and their wares, then I would not go home with the freshest legumes or cuts of meat in my basket. They certainly made me work for my supper—but, oh, what suppers!"

—Julia Child

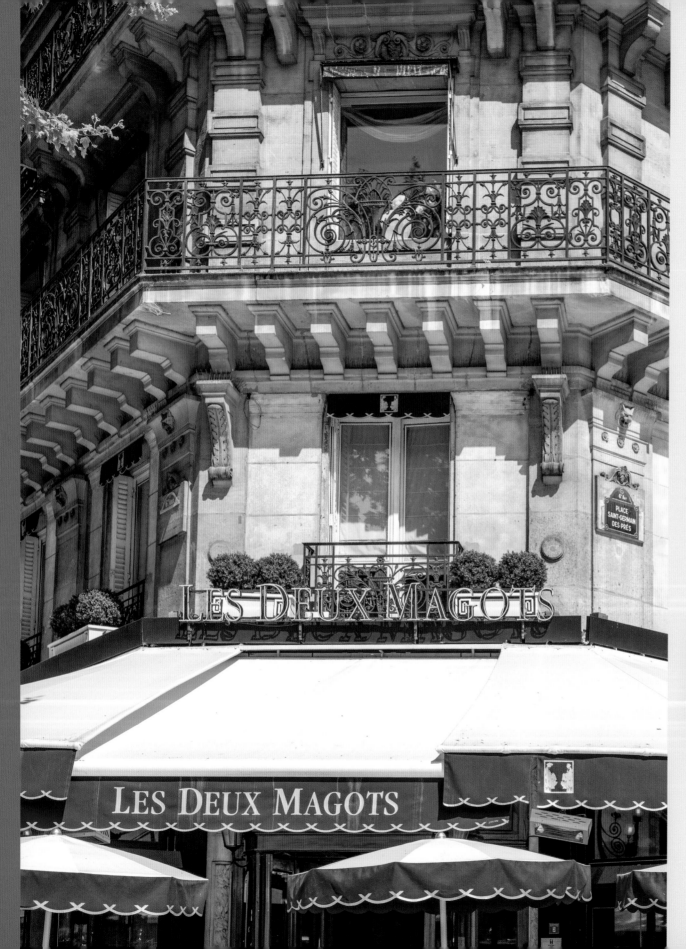

Parisian Hot Chocolate

Makes 4 servings

2 cups whole milk
4 ounces 60% cacao chocolate, finely chopped
2 teaspoons granulated sugar
¼ teaspoon vanilla extract

In a small saucepan, bring milk just to a boil over medium heat. Whisk in chocolate and sugar until blended. If necessary, cook over low heat, stirring constantly, until completely smooth and heated through. (Do not allow to boil). Stir in vanilla extract. Divide among demitasse, espresso, or tea cups; serve immediately.

Note: For easy pouring, the hot chocolate can be made in a 4-cup glass measuring cup using a microwave.

"Find something you're passionate about and keep tremendously interested in it."

—Julia Child

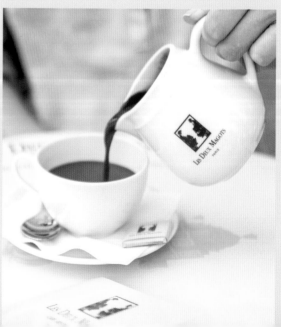

Opposite: On their first Saturday
in Paris, Julia and Paul enjoyed
café complet—coffee and croissants—
at Les Deux Magots, a gathering spot
for the city's cultural society, also
known for its heavenly hot chocolate.
This page: While she was a student at
Le Cordon Bleu, Julia often shopped
for cooking accessories, like this
eye-catching array of copper pots at
E. Dehillerin, a kitchenware vendor
that opened in 1820.

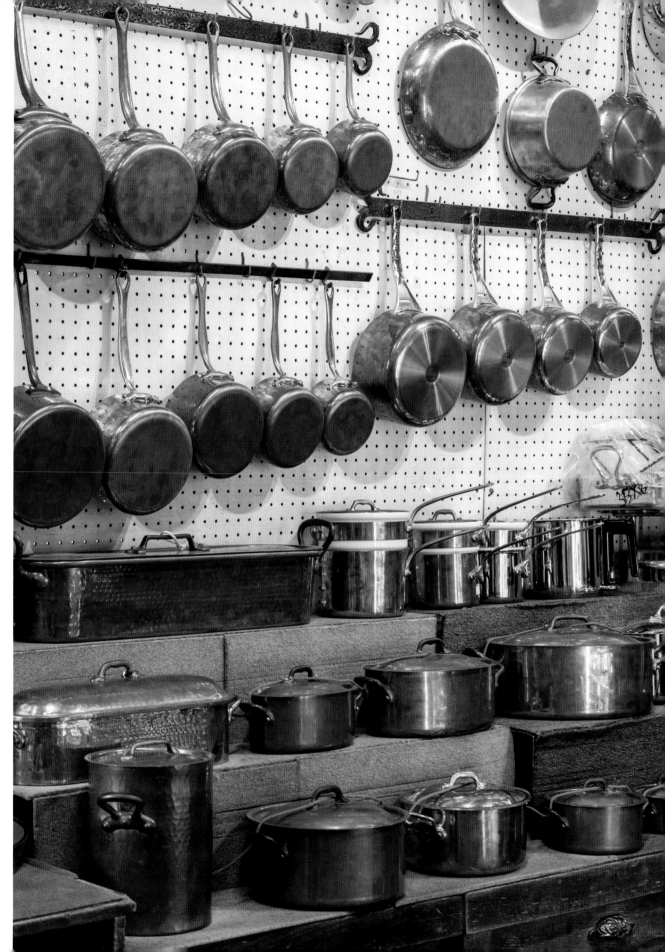

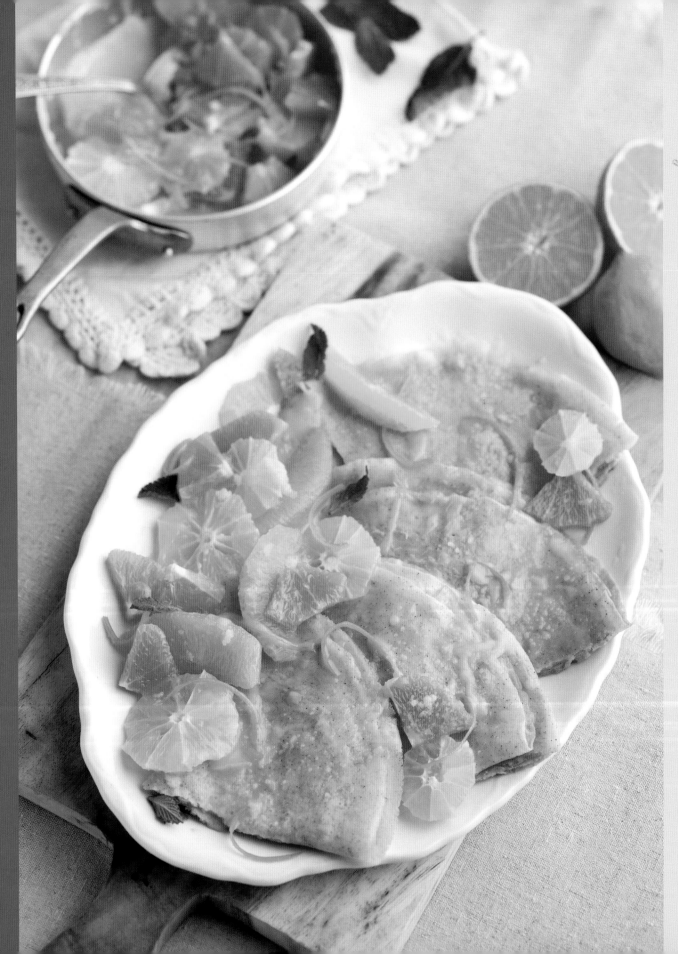

Buttermilk Crêpes Suzette with Mixed Citrus

Makes 12 crêpes

2 large eggs
1½ cups whole buttermilk
1½ cups all-purpose flour
½ cup plus 2 tablespoons granulated sugar, divided
10 tablespoons unsalted butter, melted and divided
1 teaspoon vanilla extract
1 teaspoon ground cinnamon
1 teaspoon baking powder
¼ cup finely chopped orange zest
2 navel oranges, peeled and sectioned
2 Cara Cara oranges, peeled, cut in ¼-inch circles, and quartered
2 lemons, peeled, cut in ¼-inch sections, and seeded
6 tablespoons brandy
3 tablespoons Grand Marnier
Garnish: mint leaves

1. In the container of a blender, combine eggs, buttermilk, flour, ½ cup sugar, 2 tablespoons melted butter, vanilla extract, cinnamon, and baking powder; process until combined.

2. Transfer batter to a large bowl, cover, and refrigerate for at least 1 hour or up to 1 week. Stir well before using.

3. Heat an 8-inch nonstick pan over medium-low heat. Spray with cooking spray. Pour ¼ cup batter into pan, and quickly swirl to coat entire surface of bottom of pan. Cook until top of crêpe appears dry, 1 to 2 minutes. Transfer to a wire rack to let cool. Repeat procedure with remaining batter. Store crêpes between layers of parchment paper to prevent sticking.

4. In a large sauté pan, heat 4 tablespoons melted butter, 2 tablespoons orange zest, and 1 tablespoon sugar over medium-high heat. Add 6 crêpes, folded into quarters. Using two forks, carefully turn crêpes in butter to coat. Place in an even layer, and add half of navel oranges, Cara Cara oranges, and lemons; 3 tablespoons brandy; and 1½ tablespoons Grand Marnier. Remove from heat. Using a long-handled lighter, carefully ignite brandy mixture; stir gently until flames subside. Transfer to a serving platter; repeat process with remaining ingredients. Garnish with mint leaves, if desired. Serve immediately.

Note: Crêpes can be made up to 1 day ahead.

Chocolate-Amaretto Crêpes with Chocolate Whipped Cream

Makes 12 crêpes

3 large eggs

1½ cups whole milk

1½ cups all-purpose flour

¾ cup unsweetened cocoa powder, divided

¼ cup granulated sugar

3 tablespoons amaretto

2 tablespoons canola oil

1¾ teaspoons vanilla extract, divided

⅛ teaspoon kosher salt

4 cups heavy cream

1 cup confectioners' sugar

Garnish: fresh raspberries, fresh blackberries, fresh blueberries, confectioners' sugar

1. In the container of a blender, combine eggs, milk, flour, ¼ cup cocoa powder, granulated sugar, amaretto, oil, 1½ teaspoons vanilla extract, and salt; process until combined.

2. Transfer batter to a large bowl, cover, and refrigerate for at least 1 hour or up to 1 week. Stir well before using.

3. Heat an 8-inch nonstick pan over medium-low heat. Coat with cooking spray. Pour ¼ cup batter into pan, and quickly swirl to coat entire surface of bottom of pan. Cook until top of crêpe appears dry, 1 to 2 minutes. Transfer to a wire rack to let cool. Repeat procedure with remaining batter. Store crêpes between layers of parchment paper to prevent sticking.

4. In the work bowl of a stand mixer fitted with a whisk attachment, whip cream until slightly thickened, about 2 minutes. Add confectioners' sugar, remaining ½ cup cocoa powder, and remaining ¼ teaspoon vanilla extract; continue to whip until stiff peaks form, 1 to 2 minutes.

5. Spread approximately ¼ cup whipped cream over half of crêpe; fold in half and then into quarters. Repeat with remaining crêpes and whipped cream. Garnish with raspberries, blackberries, blueberries, and confectioners' sugar, if desired.

Note: Crêpes and filling can be made up to 1 day ahead.

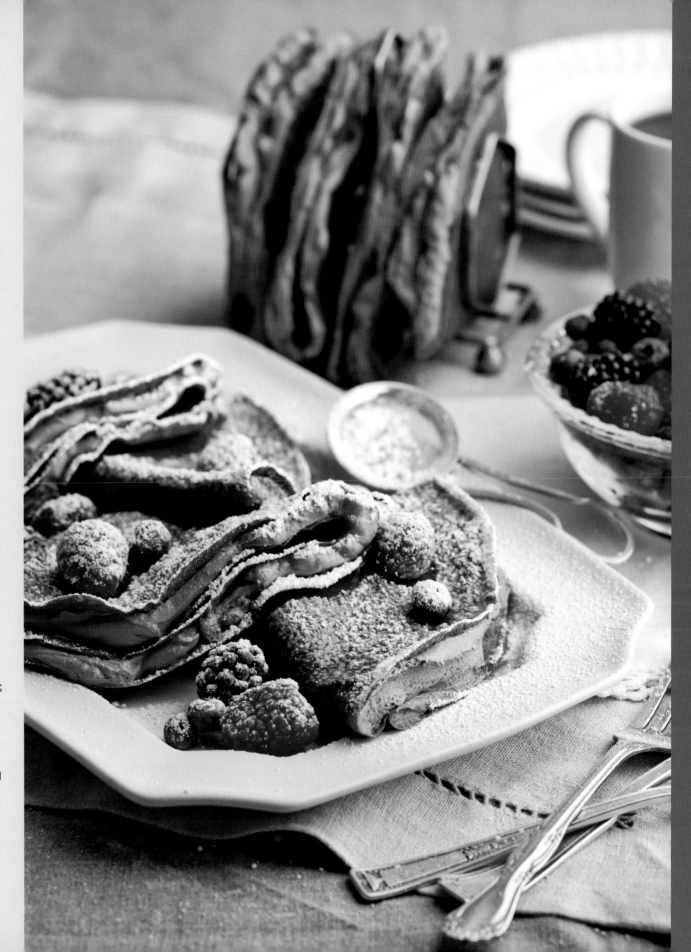

"A good macaron is
the successful sum of
many small details."

—Pierre Hermé

Second Serenade

Borne from a lyric in a popular
French song from the sixties, the
original Café Pouchkine debuted in
Moscow to the delight of tourists
who had searched in vain for the
fabled restaurant. Today, a flagship
location in the City of Light brings
the dream full circle. Opened in 2017,
the three-story Paris *maison* includes
a gleaming pastry shop and lovely
wood-paneled salons appointed with
keen attention to detail.

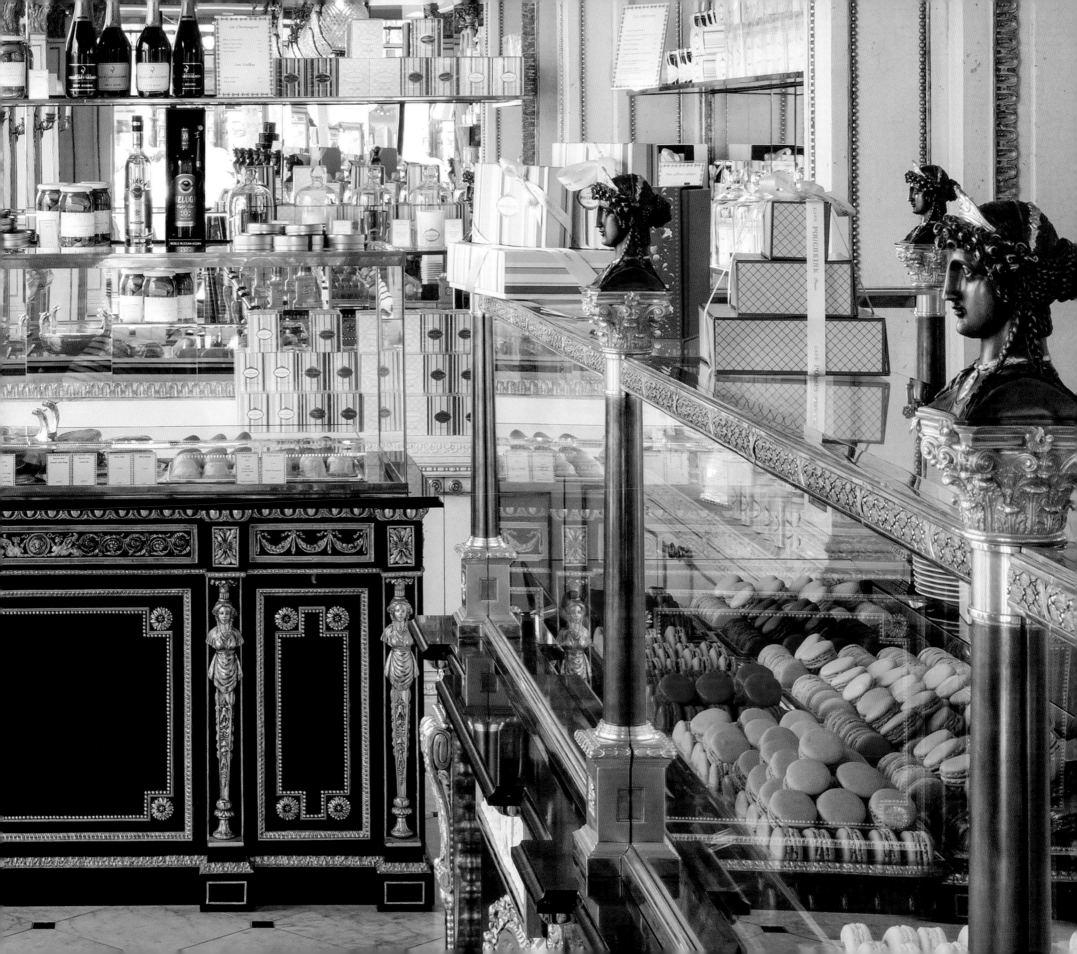

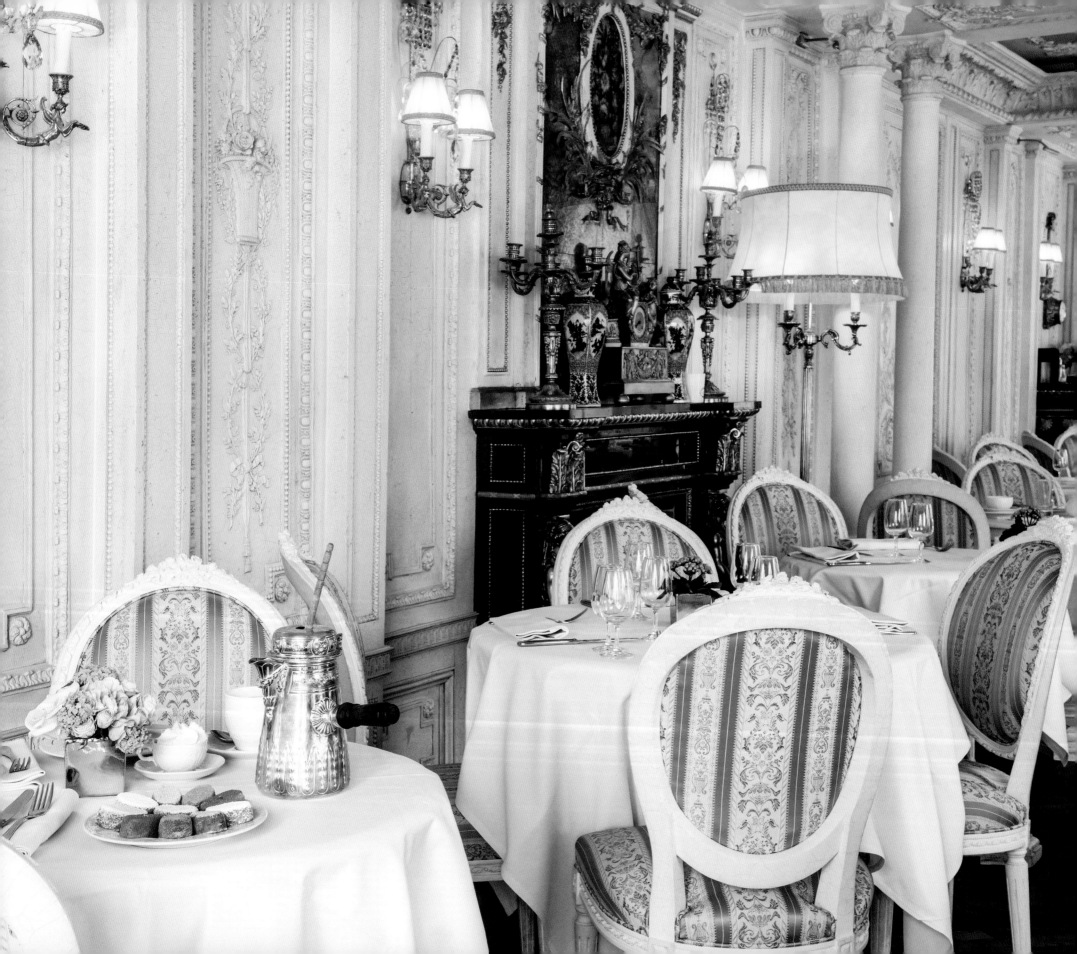

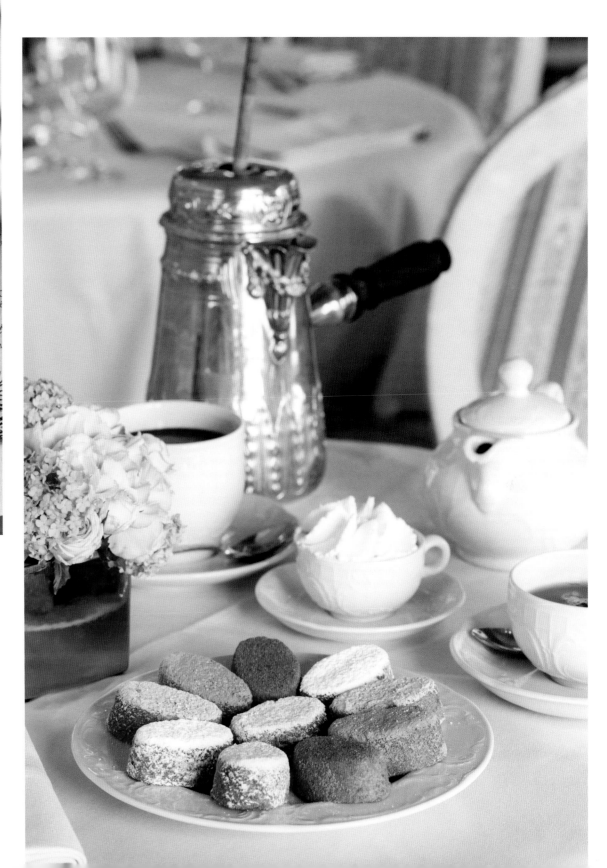

Boissons chaudes

- Café espresso ou décaféiné 3.40
- Café noisette . 3.40
- Café double espresso . 6.80
- Café « Pouchkine » gourmand du moment 8.50
- Pot de lait (chaud ou froid) 2.00
- Coupe de chantilly . 2.00
- Café Viennois . 7.20
- Cappuccino . 6.50
- Chocolat chaud « Pouchkine » 7.00
- Chocolat chaud « Pouchkine » à la viennoise 7.50
- Chocolat chaud à l'orange 7.00
- Café glacé . 8.00
- Café glacé Viennois . 8.50

Opposite: Proprietor Andrei Dellos brought in Moscow's most esteemed craftsmen to carry out his vision for bespoke cabinetry, plasterwork, and decorative painting. Furnished with antiques, the interiors reflect the eclecticism of the late eighteenth and early nineteenth centuries. This page: The restaurant's Médovic presents the classic Russian honey cake in a pleasingly petite form.

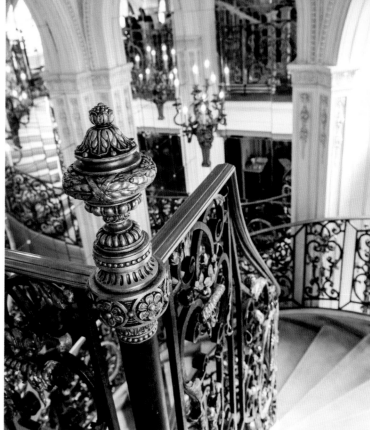

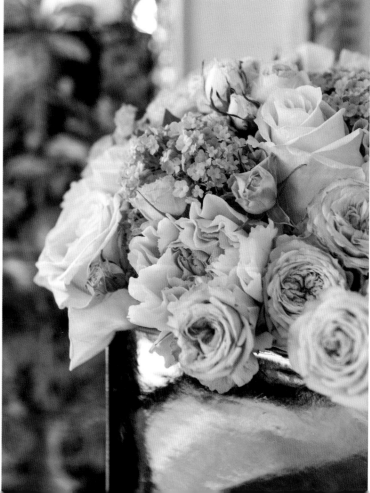

With its sweeping staircases and lofty proportions, Café Pouchkine gives a grand impression. Perhaps it can be said, due to its mythical roots in musical history, that reputation preceded the introduction of the establishment, but the restaurant has proven a star in its own right.

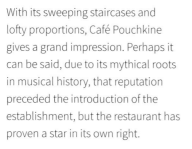

Olivier Salad

Makes 2 servings

Adapted from a recipe courtesy of Café Pouchkine

For sauce:

6 tablespoons mayonnaise

2 tablespoons honey Dijon mustard

1 tablespoon lemon zest

1 tablespoon fresh lemon juice

Pinch fine sea salt

For salad:

1 quart water

3 tablespoons finely diced Yukon Gold potatoes

2 tablespoons finely diced carrots

3 tablespoons shelled fresh peas*

2 hard-cooked eggs, halved lengthwise

3 tablespoons finely diced cooked chicken breast

3 tablespoons finely diced smoked chicken breast

2 tablespoons finely diced beef pastrami

2½ tablespoons finely diced Granny Smith apples

20 cornichons, finely diced

2 tablespoons minced fresh chives

2 tablespoons minced fresh dill

1 teaspoon grapeseed oil

6 large or 12 medium frozen cooked crawfish tails, thawed

Pinch fine sea salt

1 tablespoon plus 1 teaspoon cognac

For serving:

12 leaves endive lettuce

8 small leaves butter lettuce

2 teaspoons olive oil

Pinch fleur de sel

Pinch freshly ground black pepper

6 sprigs flat leaf parsley

1. For sauce: In a medium bowl, stir together mayonnaise, mustard, lemon zest, lemon juice, and sea salt. Cover and refrigerate until ready to use.

2. For salad: In a large bowl, prepare an ice water bath.

3. In a medium saucepan, bring 1 quart water to a boil over medium-high heat. Add potatoes and carrots, and blanch for 3 minutes in boiling water. Using a slotted spoon, transfer vegetables to ice water bath to stop the cooking process. Add peas to saucepan, and blanch for 1½ minutes in boiling water. Using a slotted spoon, transfer peas to ice bath to stop the cooking process. Drain vegetables well.

4. Separate egg yolks from whites. Using a spoon, push egg yolks through a fine-mesh sieve into a separate large bowl. Finely chop egg whites, and add to bowl with yolks. Add cooked and smoked chicken breast, pastrami, apples, cornichons, chives, dill, blanched vegetables, and sauce, gently stirring to combine. Divide chicken salad mixture into 2 portions.

5. In a medium skillet, heat grapeseed oil over medium-high heat. Add crawfish, and cook for 2 minutes, stirring frequently. Season with sea salt. Stir in cognac, and cook for 2 to 3 minutes, scraping browned bits from bottom of pan with a wooden spoon. Remove from heat. Cover skillet and let rest for 3 minutes. Let crawfish cool slightly. Transfer meat to a small bowl; discard any bits of shell.

6. For serving: In a large bowl, add endive leaves and butter lettuce leaves. Drizzle with olive oil, and season with fleur de sel and pepper. Toss gently.

7. In the center of a shallow serving bowl, place a 3-inch round cutter. Arrange 6 endive leaves along interior wall of cutter, slightly overlapping, if necessary. Fill center of endive with a large scoop of 1 portion chicken salad mixture. Place a small scoop of chicken salad mixture in each of 4 butter leaves, and arrange, evenly spaced, around cutter. Gently remove cutter. Place 1 or 2 pieces seasoned crawfish in each of the 4 open areas between chicken salad–filled butter lettuce leaves. Repeat process with remaining endive leaves, chicken salad mixture, butter lettuce leaves, and crawfish pieces. Garnish with parsley, if desired. Serve immediately.

Thawed frozen peas may be substituted for fresh; reduce blanching time to 30 seconds.

Note: For a smoother consistency, transfer chicken salad mixture to the work bowl of a food processor. Cover and pulse mixture until desired texture is achieved.

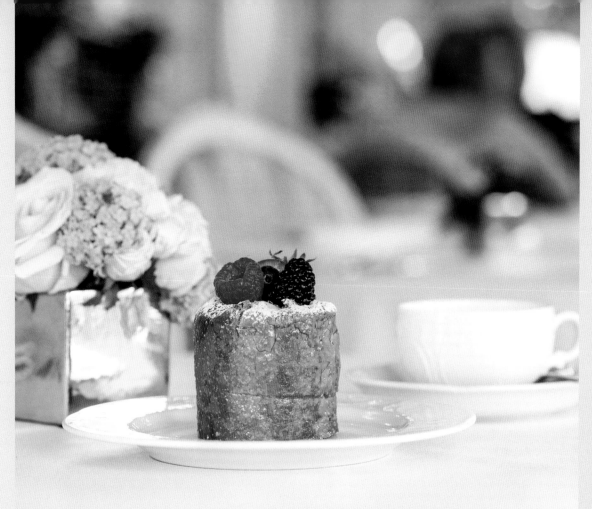

Napoleons

Makes 12

Adapted from a recipe courtesy of Café Pouchkine

24 Croissant Rounds (recipe follows)
½ cup Orange Butter (recipe follows)
¾ cup Vanilla Cream (recipe follows)
12 Phyllo Shells (recipe follows)
2¼ cups Vanilla Mousse (recipe follows)
Garnish: confectioners' sugar, assorted fresh berries

To assemble, spread 12 Croissant Rounds with
2 teaspoons each Orange Butter; top each round with
1 tablespoon Vanilla Cream; cover each with
1 Croissant Round. Place stacks on serving plates, and
carefully cover each stack with 1 Phyllo Shell. Fill the
center of each Phyllo Shell with 2 to 3 tablespoons
Vanilla Mousse. Garnish with confectioners' sugar and
berries, if desired. Serve immediately.

Croissant Rounds

Makes 24 pastry rounds

1 cup warm whole milk (105° to 110°)
1 tablespoon active dry yeast
4 cups bread flour
⅓ cup castor sugar
1¼ cups unsalted butter, softened and divided
1 large egg
4 teaspoons kosher salt

1. In the bowl of a stand mixer, whisk together milk
and yeast by hand. Place flour over top; let stand for
15 minutes. Add castor sugar, 3 tablespoons softened
butter, egg, and salt. Using the dough hook attachment,
knead at low speed for 4 minutes, stopping to scrape
down sides of bowl occasionally.
2. Place dough in a lightly greased bowl, turning once to
grease top. Cover and let rise in a warm, draft-free place
(75°) until doubled in size, about 1 hour.

3. Meanwhile, to shape butter block, draw a 12x9-inch
rectangle on a sheet of parchment paper using a pencil;
turn parchment over. Place remaining 1 cup plus 1 table-
spoon butter on parchment; top with a second sheet of
parchment. Shape butter to a 12x9-inch rectangle, mak-
ing straight and even edges. (If butter becomes too soft,
refrigerate for 5 minutes before continuing.) Wrap butter
and parchment with plastic wrap; refrigerate overnight.
4. Line a sheet pan with parchment; dust lightly with flour.
5. Punch down dough. On a lightly floured surface, shape
dough into a 10x8-inch rectangle. Place on prepared pan;
cover securely with plastic wrap. Refrigerate overnight.
6. Remove dough from refrigerator, and freeze for
15 to 20 minutes. Meanwhile, let butter block stand at
room temperature until malleable, 10 to 15 minutes.
7. On a lightly floured surface, roll dough to a 16x12-inch
rectangle. Unwrap butter and place crosswise in center
of dough. Fold ends of dough over butter, pinching
seams to enclose butter completely. Turn dough 90°;
immediately roll dough into an 18x12-inch rectangle.
Fold crosswise into thirds, like a letter. Repeat turning,
rolling, and folding two more times. Wrap dough in
plastic wrap; freeze for 15 minutes.
8. Repeat rolling and folding of dough once more. Wrap
in plastic wrap, and refrigerate for 1½ hours.
9. Line 2 half-sheet pans with parchment.
10. On a lightly floured surface, roll dough to ⅜-inch
thickness. Using a lightly floured 2¼-inch round cutter,
cut 24 rounds of pastry. Place 2 inches apart on pre-
pared pans. Using the tines of a fork, prick each round
twice in parallel about ½ inch from edges of pastry.
Cover with greased plastic wrap; let rise in a warm, draft-
free place (75°) until slightly risen, about 1½ hours.
11. Preheat oven to 400°.
12. Remove plastic wrap from rounds of dough, and
place two inverted quarter-sheet pans side by side over
the top of each half-sheet pan. These will allow room for
dough to rise but not fall over.
13. Carefully place stacked pans in oven. Bake until
golden brown, 12 to 15 minutes. Transfer to a wire rack,
and let cool completely.

*Note: This recipe yields approximately 2.5 pounds of
dough. After pastry rounds are cut, remaining dough can
be saved for another use. Trim edges evenly, and wrap
dough in plastic wrap. Freeze for up to 3 months. When*

ready to use, let thaw in refrigerator overnight.

Orange Butter
Makes approximately ½ cup

⅓ cup unsalted butter, softened
2 tablespoons castor sugar
2 tablespoons orange marmalade
1 tablespoon orange zest

In a small bowl, whisk butter, castor sugar, marmalade, and orange zest until blended. Cover and refrigerate until needed.

Vanilla Cream
Makes approximately ¾ cup

½ cup heavy whipping cream
2½ tablespoons castor sugar
2½ tablespoons light corn syrup
⅛ teaspoon kosher salt
1 teaspoon cornstarch
1 vanilla bean, split lengthwise, seeds scraped and
 reserved
¼ cup crème fraîche
1 tablespoon unsalted butter

1. In a medium saucepan, bring cream, castor sugar, corn syrup, and salt to a boil over medium heat, stirring occasionally. Remove from heat.
2. Place 2 tablespoons hot cream mixture in a small bowl. Add cornstarch, and whisk until smooth.
3. Stir cornstarch mixture into cream mixture, and bring to a boil. Cook for 1 minute, stirring frequently. Remove from heat; stir in vanilla bean seeds and crème fraîche. Let stand to let cool slightly, about 10 minutes. (Mixture still needs to be a little warm to emulsify the butter.) Stir in butter until blended. Cover and refrigerate until very cold, about 4 hours.

Phyllo Shells
Makes 12

6 (3-inch high x 2¾-inch diameter) metal pastry moulds*
8 sheets frozen phyllo dough (14x9-inch), thawed, divided
¼ cup unsalted butter, melted, divided

5 tablespoons plus 1 teaspoon Quick Vanilla Sugar, divided
 (recipe follows)

1. Preheat oven to 425°. Line a baking sheet with parchment paper. Lightly spray pastry moulds with cooking spray; place on prepared pan.
2. Place 1 sheet of phyllo dough on a work surface. Brush lightly with approximately ½ tablespoon melted butter; sprinkle with 2 teaspoons Quick Vanilla Sugar. Cover with another sheet of phyllo; brush with butter, and sprinkle with 2 teaspoons vanilla sugar. (Keep remaining phyllo covered with plastic wrap and a damp towel to prevent it from drying out.) Cut the two layered sheets into three 14x2½-inch strips. Wrap each stack of strips around the outside of a mould, pressing ends to seal. Lightly brush the end of strip with additional melted butter to seal. Repeat with 2 additional phyllo sheets, melted butter, and vanilla sugar to cover remaining 3 moulds.
3. Bake shells until golden brown, 6 to 8 minutes. Let cool on pan for 30 minutes. Carefully remove shells from moulds.
4. Repeat process to make a total of 12 shells. Let cool completely before assembling desserts.

We used J. B. Prince Tall Cake Rings.

Quick Vanilla Sugar
Makes approximately ½ cup

½ cup castor sugar
½ vanilla bean, split lengthwise, seeds scraped and
 reserved

In the work container of a blender, process castor sugar and vanilla bean seeds just until blended. Store, covered, for up to 2 weeks.

Vanilla Mousse
Makes approximately 2¼ cups

1 teaspoon unflavored gelatin
3 tablespoons cold water
3 tablespoons whole milk
1 cup and 3 tablespoons heavy whipping cream, divided
3 vanilla beans, split lengthwise, seeds scraped and
 reserved

2 teaspoons Quick Vanilla Sugar (recipe this page)
1 large egg yolk
1 ounce white chocolate, finely chopped
1 tablespoon amaretto liqueur

1. In a small, microwave-safe bowl, sprinkle gelatin over 3 tablespoons cold water; let stand for 1 minute. Microwave on high for 30 seconds. Stir and let stand until gelatin is completely dissolved, about 1 minute.
2. In a small saucepan, bring milk, 3 tablespoons cream, vanilla bean seeds, and Quick Vanilla Sugar to a boil over medium heat.
3. In a small bowl, whisk a small amount of hot cream mixture into egg yolk; transfer egg mixture to pan, whisking constantly. Cook and stir until cream mixture reads 185° on a candy thermometer and has thickened, 2 to 3 minutes. Stir in gelatin mixture. Remove from heat; stir in white chocolate until melted.
4. Transfer to a medium bowl; place in an ice water bath to let cool completely, stirring frequently, about 4 to 5 minutes. Remove from ice water bath.
5. Meanwhile, in a separate medium bowl, beat remaining 1 cup cream with a mixer at medium speed until soft peaks form.
6. Stir amaretto into white chocolate mixture. Fold in whipped cream.

PRESERVING A HERITAGE

The tapestry of French culture is woven with traditions that have been a part of the country's narrative for centuries. In addition to a strength and a resilience forged through wars and revolutions, the Gallic people possess an abiding appreciation for the finer things in life, whether it's a Cézanne painting, perfectly pressed coffee, or simply a carefree afternoon in the Côte d'Azur.

History has shown that the value of beautifully stitched items cannot be underestimated, from the cache of monogrammed napery, lace-edged handkerchiefs and white-on-white embroidered bedding that compose a bride's traditional trousseau to the exquisite, hand-beaded couture gowns that turn heads on a fashion runway. Needlework skills are, and always have been, a prized possession in France.

This captivating country also has a heritage of wine production that reaches back to the sixth century BC. With so many years devoted to honing the craft, it is no wonder that French wine is consistently considered the best in the world. Vineyards sprawl across the countryside in regions such as Burgundy and Aquitaine, taking advantage of the unique terroir formed from gentle rains and sun-warmed soil.

The past is never far from the present in France, and the legacies that form the very fiber of the nation still hold fast.

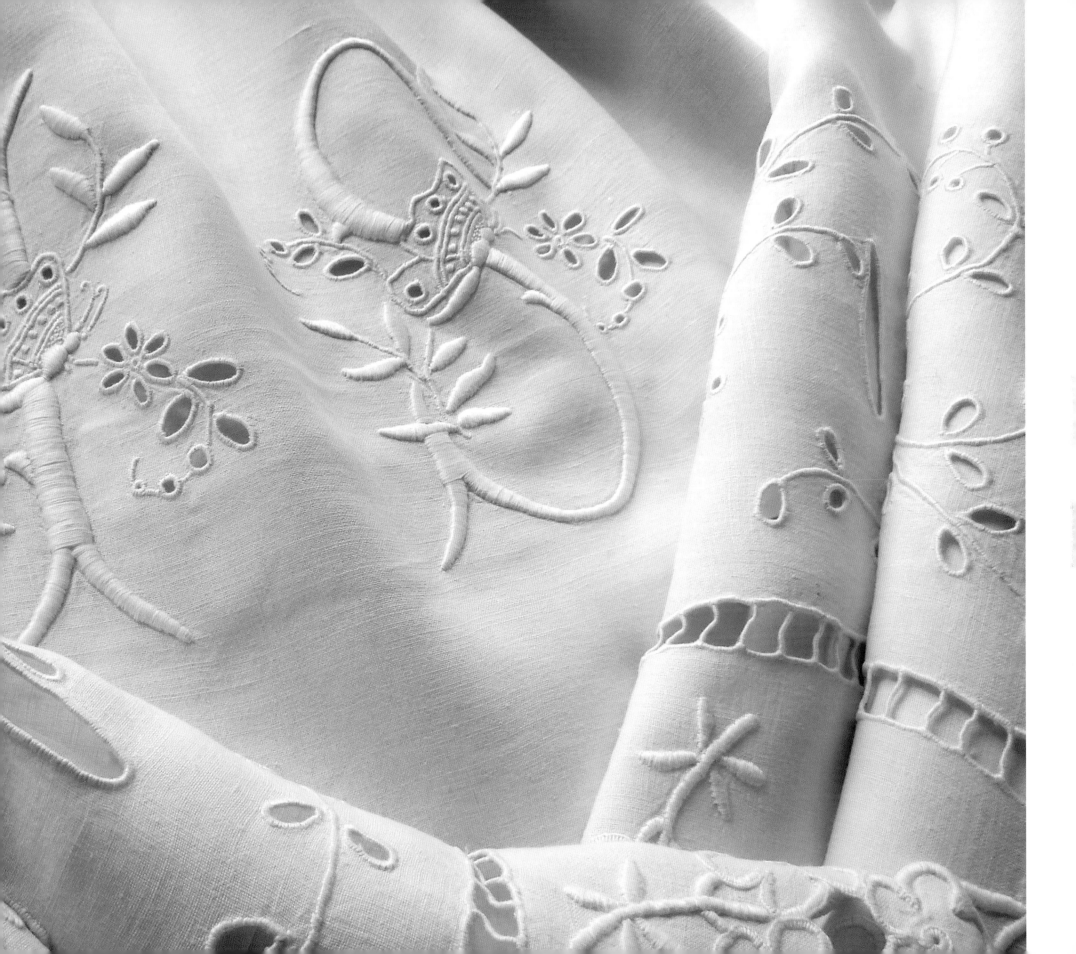

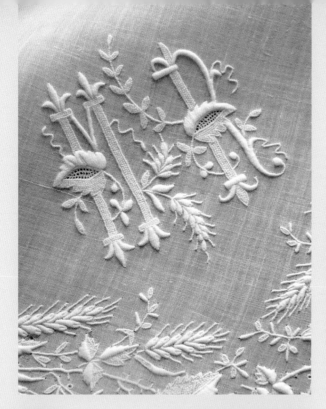

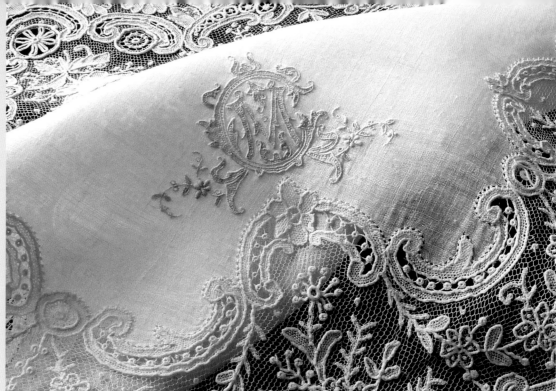

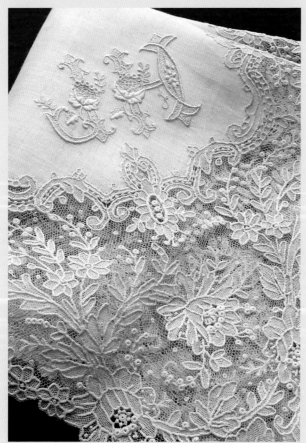

The Wedding Handkerchief

Originating in France more than two centuries ago, exquisitely embellished bits of cloth took pride of place in bridal trousseaus. These were the canvases upon which a couple's union was proudly commemorated.

However fanciful it might seem to pay so much attention to such a small piece of fabric, the handkerchief was the vehicle for some of the world's most extraordinary lace and embroidery. In the mid-nineteenth century—the heyday of the production of French lace—it was not uncommon for a well-to-do young woman to have six dozen beautifully adorned handkerchiefs lining her trousseau. In the hundred or so years following the Renaissance, there existed lengths of highly prized lace with which a château could be purchased.

Typically made of the finest gossamer-like lawn, marriage handkerchiefs were traditionally either embroidered around the contour, edged in lace, or both. The custom of adding the combined initials of bride and groom debuted in the mid-nineteenth century. Often, the letters were gracefully superimposed or interlaced, symbolizing the union of two families and the marriage knot. Because these keepsakes were so treasured, collectors can still find examples of these antique whimsies in mint condition.

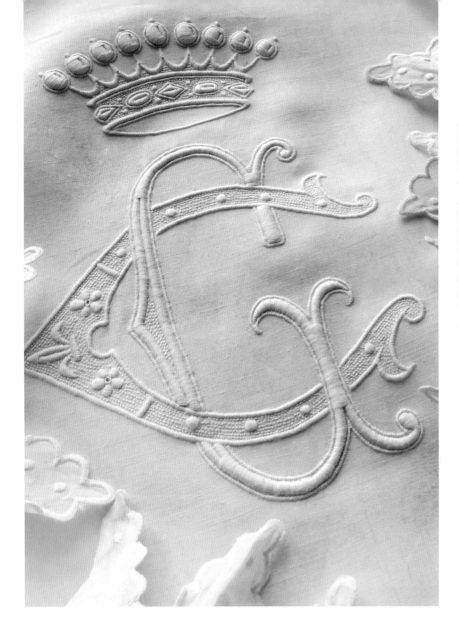

Opposite, above right: Undoubtedly created for a wedding, this stunning piece features the jewellike monogram *MC* and dates from the 1850s. Its floral Brussels *point de gaze* border is among the most sought-after laces in the world. This page, above: This lovely find, appropriately feminine and delicate, served as a *drap d'accouchée*—the ceremonial half-sheet that was spread over a new mother's bed, enabling her to receive visitors and to introduce her newborn child with elegance and style.

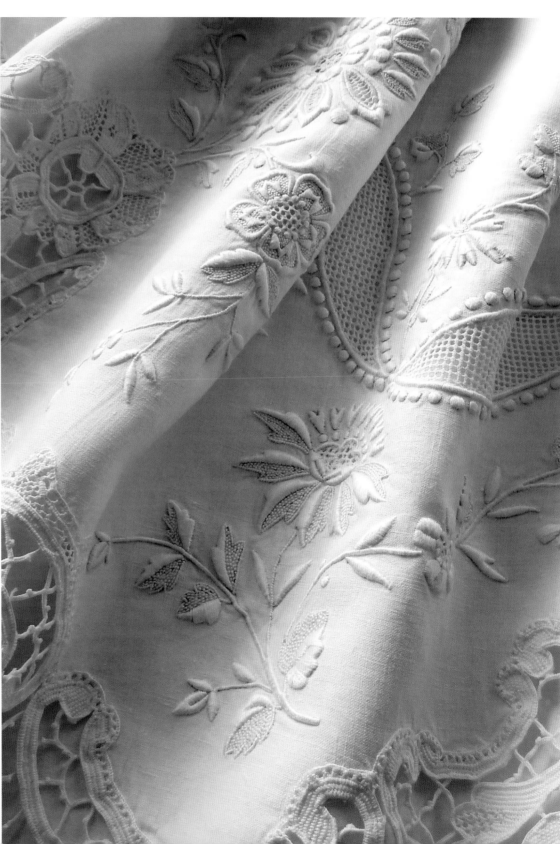

The Legacy of La Chaize

Tradition and innovation converge on the slopes of Burgundy's wine country—the setting for Château de la Chaize in Odenas. Built for François d'Aix de La Chaize, captain of the Lyon regiment, the seventeenth-century castle was inspired by drawings of the Palace of Versailles. Remarkably, the estate has remained in the same family since 1667. In 1967, when current owner Marquise de Roussy de Sales took over, the grounds were a shadow of their former glory. She resolved to refurbish the declining villa, and within five years, the home, the landscape, and the wine cellar were designated historic monuments. Daughter Caroline manages the estate today; her approach to winemaking melds modern techniques for increasing quality with time-honored customs of Beaujolais. La Chaize epitomizes the proud heritage of Burgundy—the castle, the gardens, and the winery cultural treasures that chronicle more than three centuries of life among the vines.

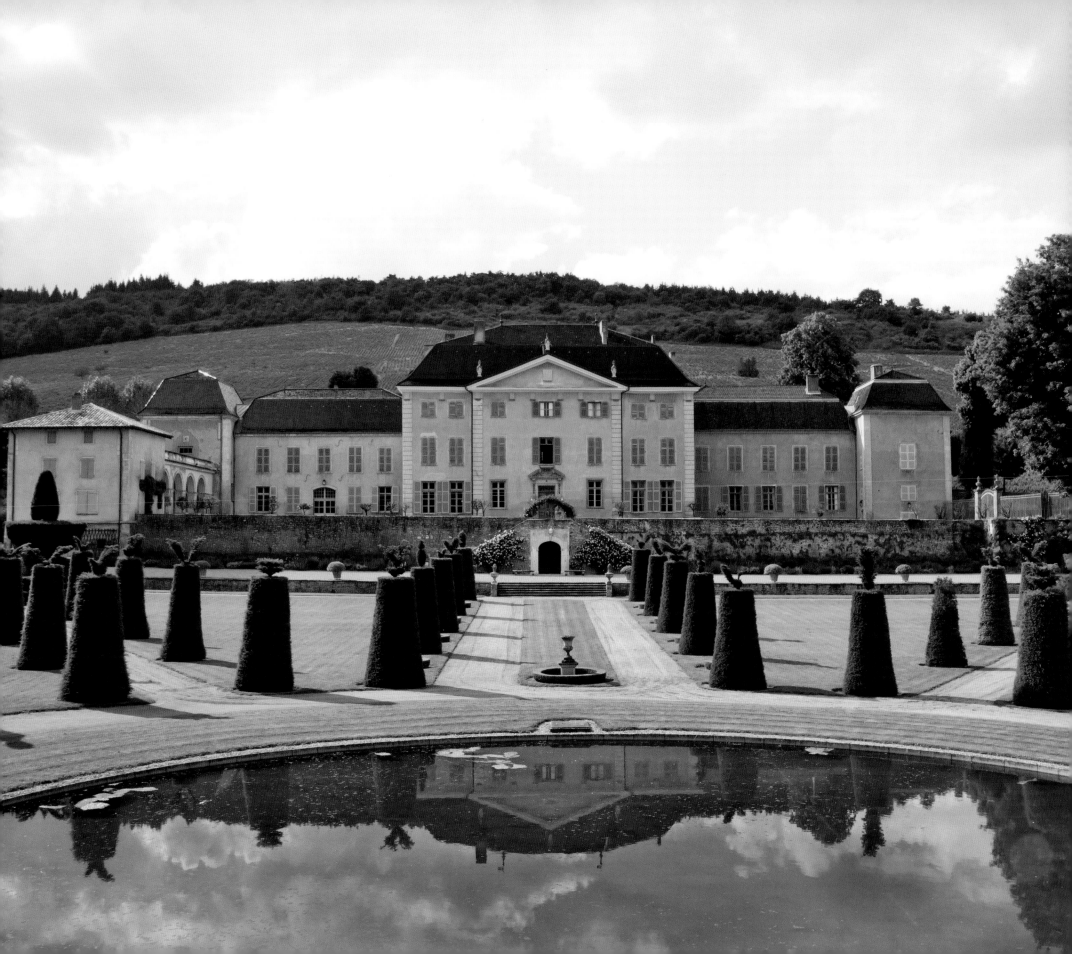

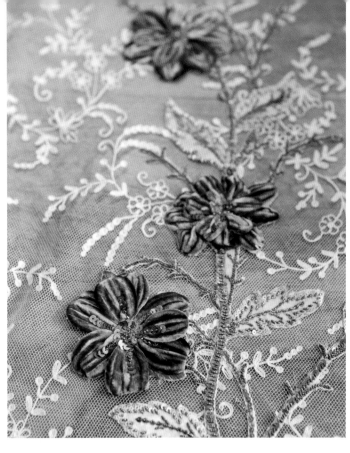
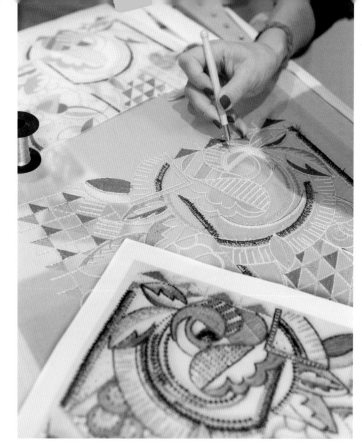

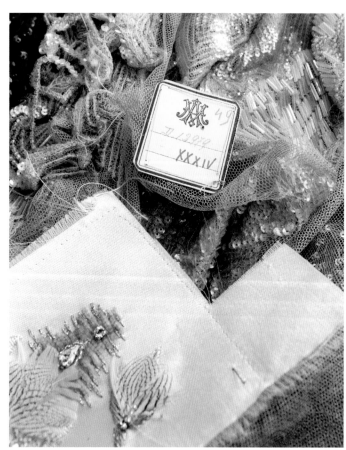

Artistry in Haute Couture

In northeastern Paris, Maison Lemarié's artisans work amid yards of gossamer fabrics, sparkling trims, and assorted plumage. As one of the last remaining plumassiers and decorative florists, Lemarié is known not only for its feather and floral creations, but also for exquisite tailoring that incorporates ruffles, pleats, inlays, and smocking. Nearby, at the Maison Lesage atelier, masterly hands move with expert ease as a piece of *broderie d'intérieur* (interior embroidery) takes shape. Silver and gold threads shimmer amid bright turquoise and amethyst strands arranged into flowers and foliage—bouquets that soon will embellish couture gowns.

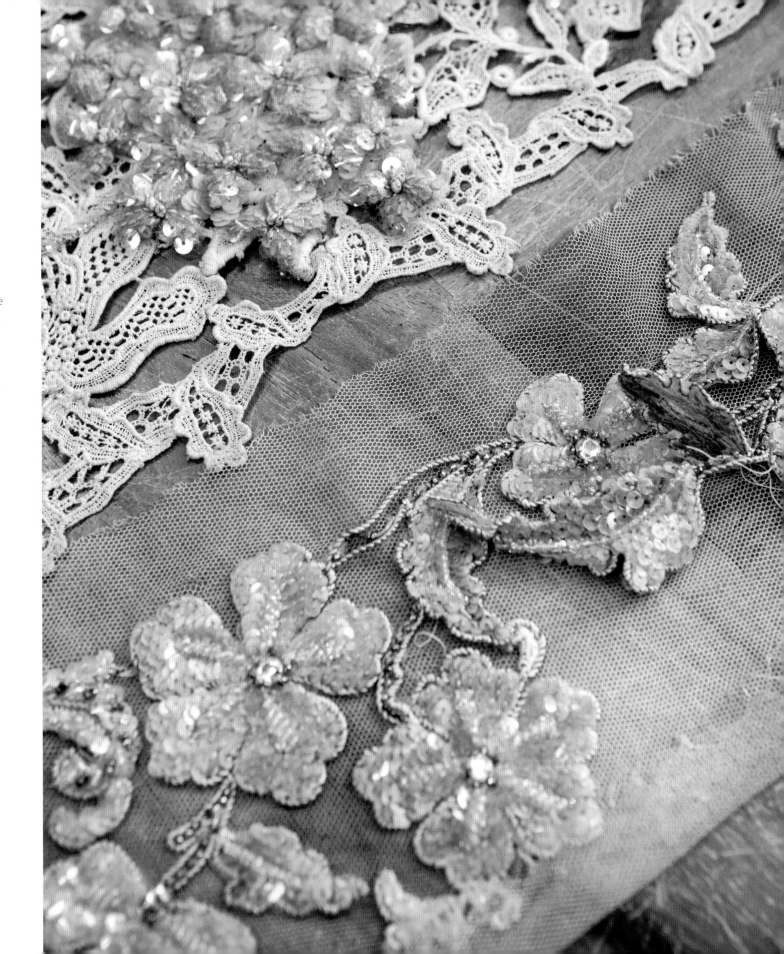

Pieces of the Past

Weathered objects hold a certain fascination, offering a tactual connection to times experienced only through the pages of books. The legendary *brocantes* and fairs of France are veritable meccas for antiques hunters, who patiently sift through the seemingly endless mélange of wares in search of these hidden treasures. Some of the most coveted items are salvaged architectural fragments—tangible emblems of the country's long and fascinating narrative—and there are many ways to incorporate these ageless gems into home décor.

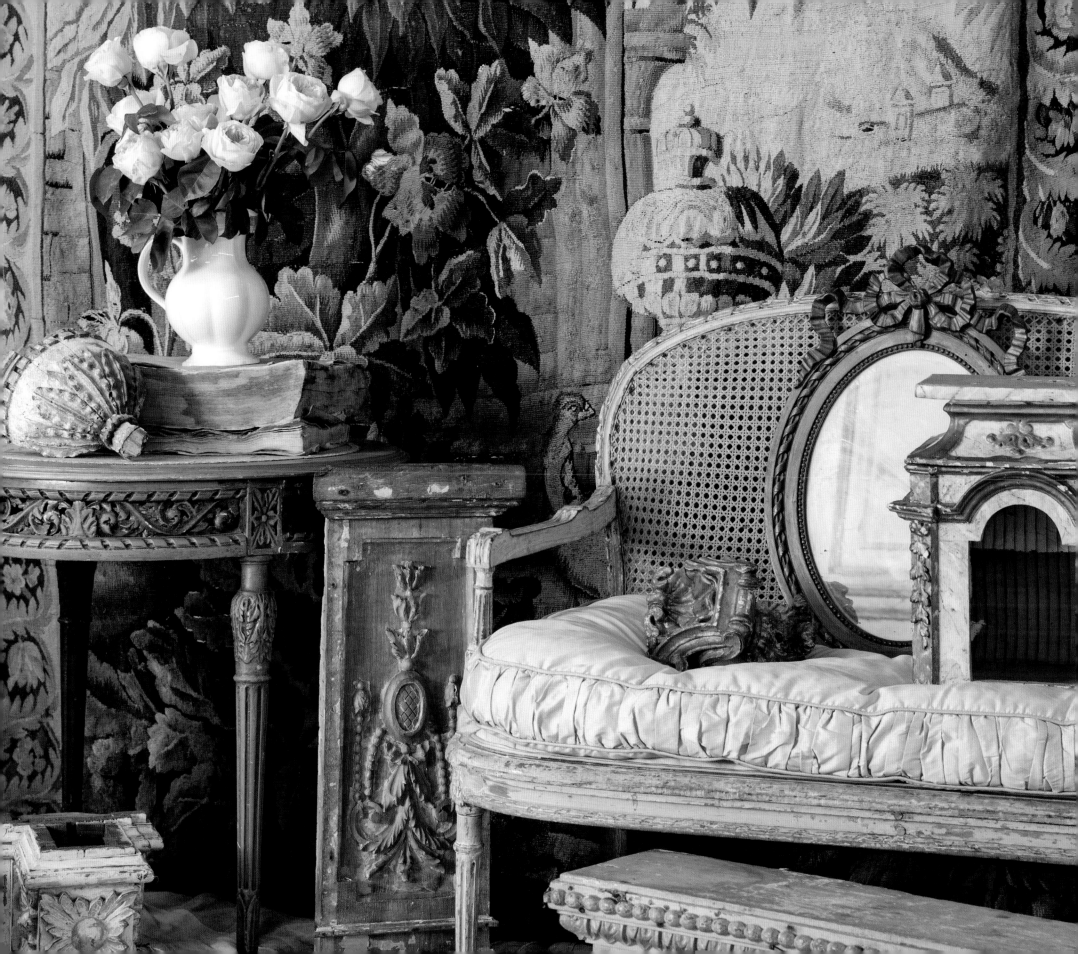

"Simplicity is the keynote
of all true elegance."

—Coco Chanel

Ancient churches are a common
source for many timeworn bits
and pieces; crumbling altars offer
exquisitely carved cherubs, pillars,
and more. Gold leaf was often
chosen for embellishment, evident
on several of the pieces displayed
in the bookcase, shown right. The
inevitable age-related chipping and
peeling does nothing to diminish the
desirability of the fragments but, in
fact, increases their appeal.

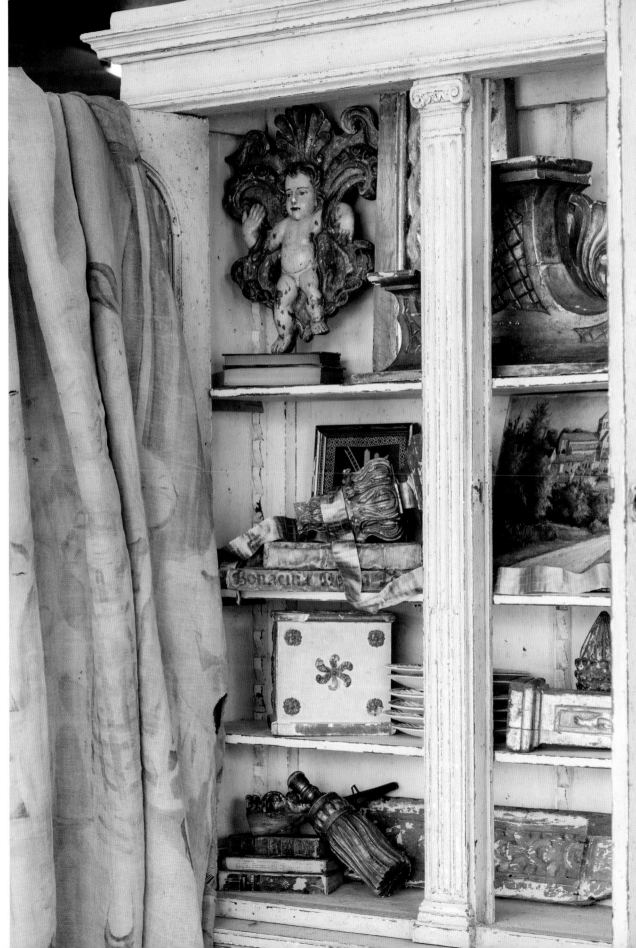

AN APPRECIATION FOR ART

Famous for the domed Basilica of the Sacré-Cœur at its summit, and perhaps infamous for the Moulin Rouge cabaret, Paris's Montmartre district retains the atmosphere that has attracted creatives and romantics for generations.

At the beginning of the twentieth century, the arts flourished in France, and Montmartre became a thriving hub of music, theater, literature, and art, as the finest talents in their fields flocked there for work and revelry.

During the Belle Époque (beautiful era), the oldest building in the district, Bel Air House—now Le Musée de Montmartre—became a residence and meeting place for many artists, including Suzanne Valadon, Maurice Utrillo, Émile Bernard, Raoul Dufy, and, perhaps most notably, Pierre-Auguste Renoir.

Renoir moved to the Bel Air House in 1876, where he painted two of his most famous works: *Bal du moulin de la Galette*, a colorful depiction of a Sunday afternoon dance in Montmartre, and *La Balançoire*, a girl on a swing, painted in the cottage's gardens.

Suzanne Valadon, regarded as one of the first female painters of her generation, lived here from 1912 to 1926, along with her son, painter Maurice Utrillo. Suzanne, who was self-taught, is known for her female portraits, vibrant still lifes, and landscapes, while Maurice specialized in cityscapes, especially of his beloved Montmartre.

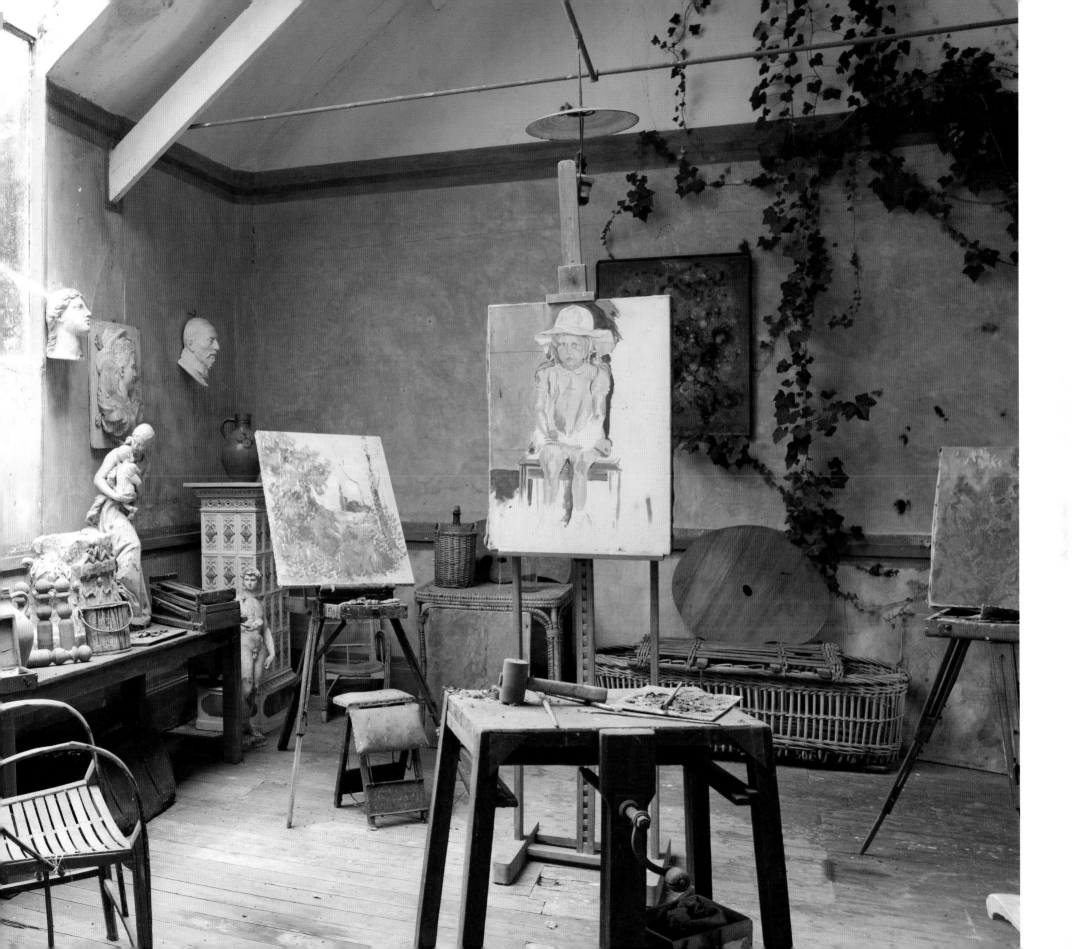

Opposite: If walls could talk, this captured-in-time studio apartment would tell of artists it housed through Montmartre's boom in the early twentieth century. This page: The back of the Musée de Montmartre overlooks Clos Montmartre, a picturesque pocket vineyard.

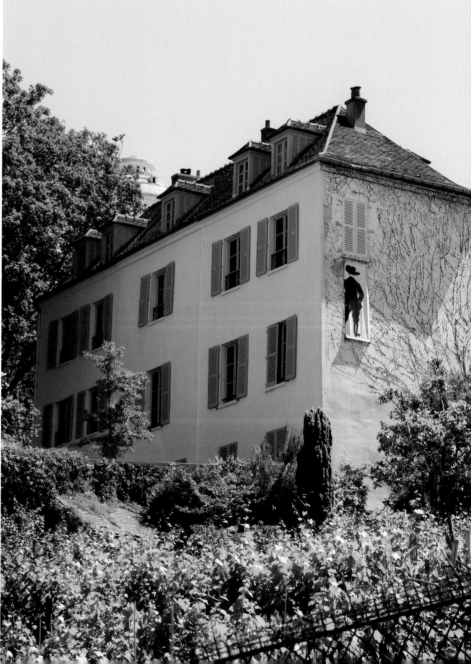

Musée de Montmartre was founded in 1960 and houses a permanent collection focused on the history of Montmartre, including its buzzing artistic life, its cabarets, even its popular French Cancan. Other rotating exhibitions highlight artists who made their mark during Montmartre's heyday. Not to be missed are three surrounding gardens dedicated to Renoir.

Just a short stroll away, Le Bateau-Lavoir was another landmark gathering place. Pablo Picasso was credited for beginning the Cubist movement and for painting *Les Demoiselles d'Avignon* while residing there. In recent time, Musée de Montmartre has taken special interest in revitalizing Le Bateau-Lavoir.

The second highest point in the city—shadowed only by the Eiffel Tower—this is indeed a district for dreamers, with a history ever lauded by the Musée de Montmartre and its elegant Jardins Renoir.

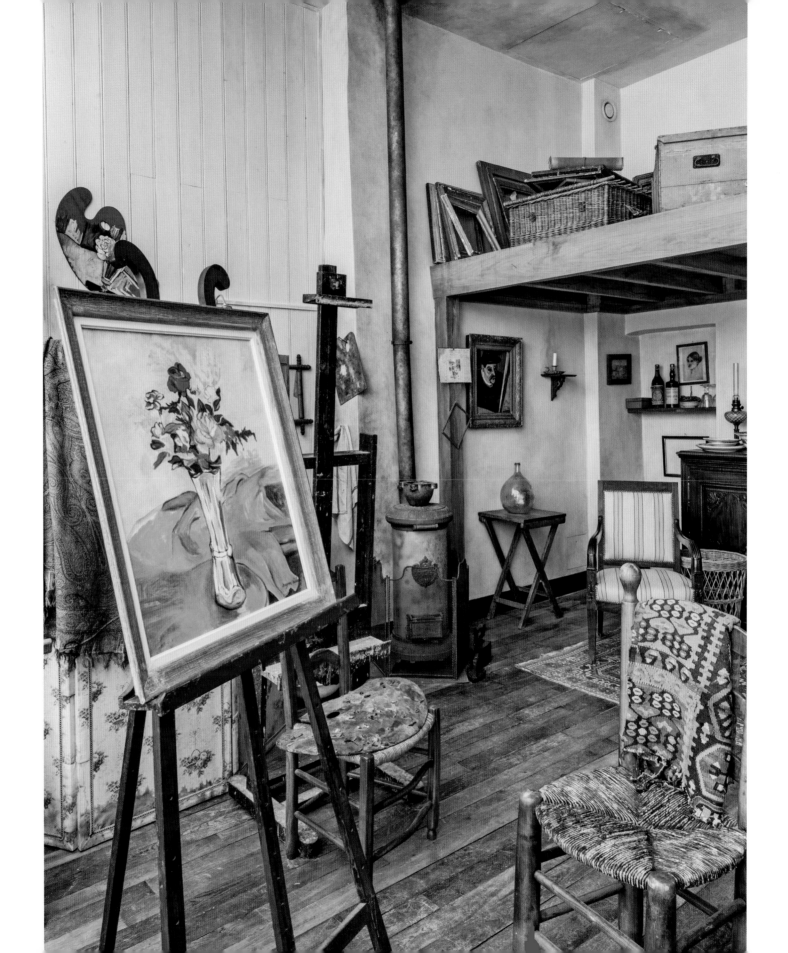

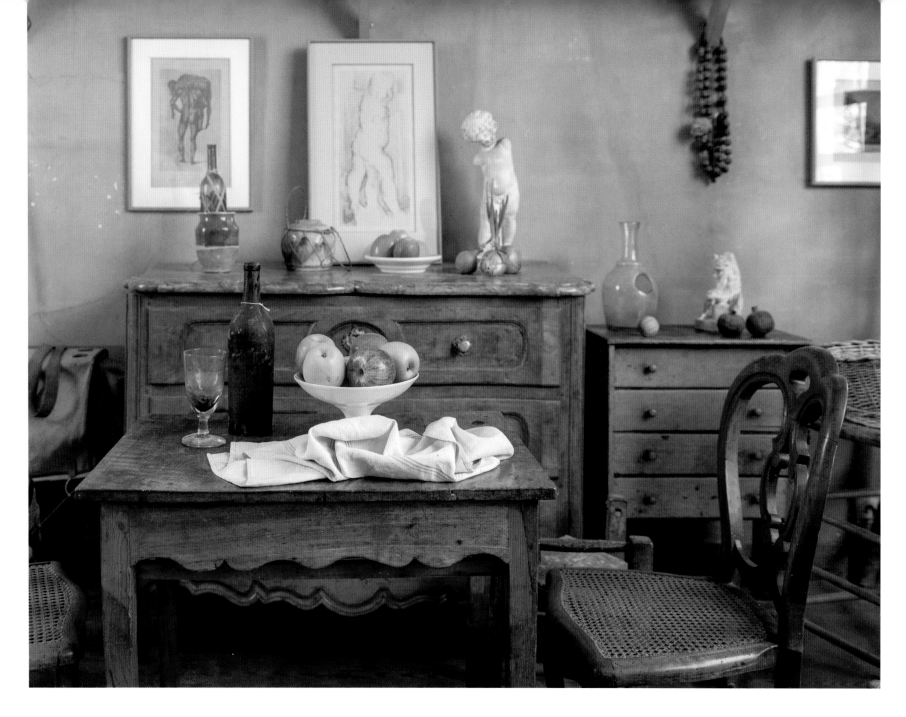

Cézanne's Atelier

As the scenic backdrop for the charming town of Aix-en-Provence, Montagne Sainte-Victoire often served as Post-Impressionist painter Paul Cézanne's muse and was the subject of numerous works of art. His home and studio, nestled on the Lauves hill, allow visitors to view the area through his perspective, as well as get a glimpse of his life in his beloved birthplace.

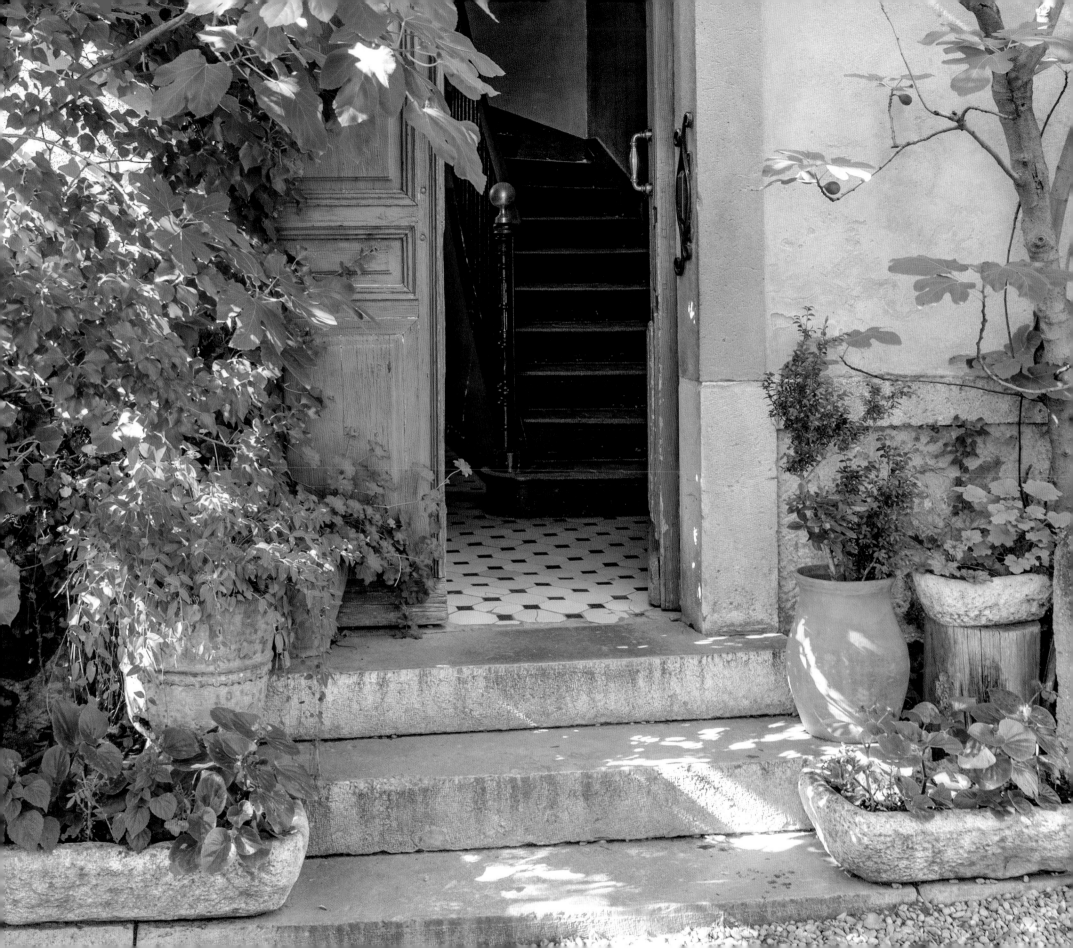

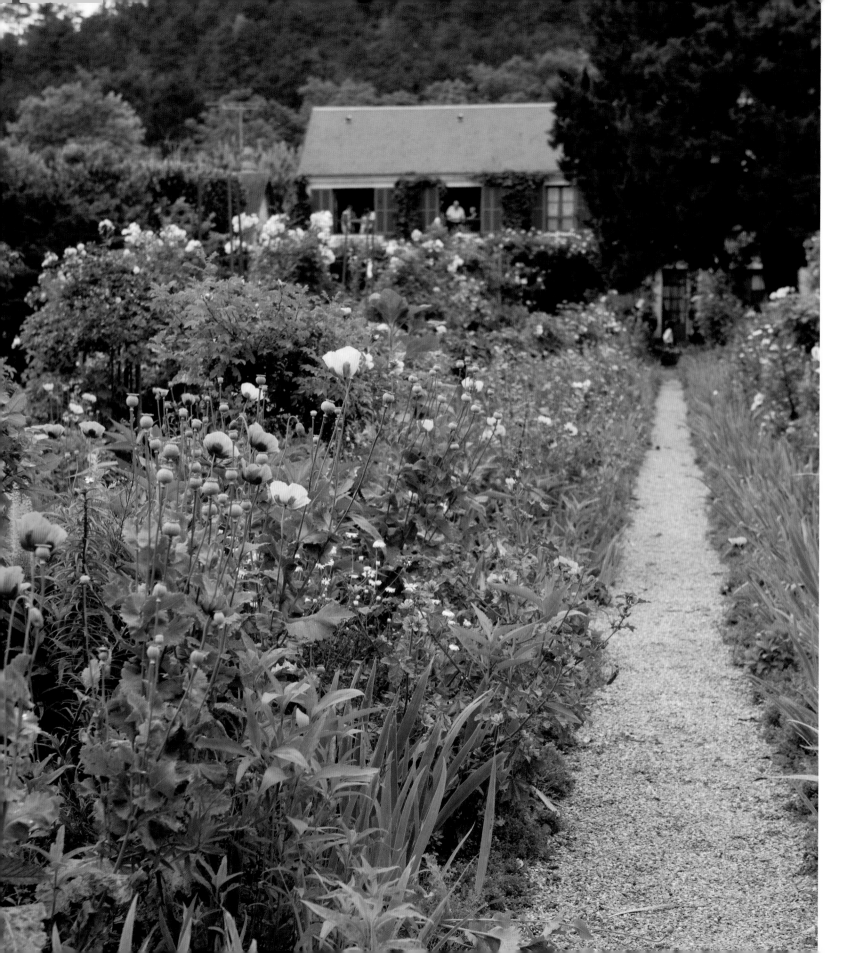

Poetry of Giverny

Lauded French Impressionist artist Claude Monet lived in Giverny, France, from 1883 to 1926. He constructed his home to befit his family and professional needs, as well as to embody his personal taste, and his unconventional artistic vision was apparent throughout the residence. The painter's studio, shown opposite, and his bedroom were private sanctuaries, where he worked and slept in solitude after tending his beloved flower beds and water lily pond. Dedicated to cultivating his subjects in nature before rendering them on canvas, Monet was able to profoundly impact the emotional depth and intensity of his many heart-stirring works.

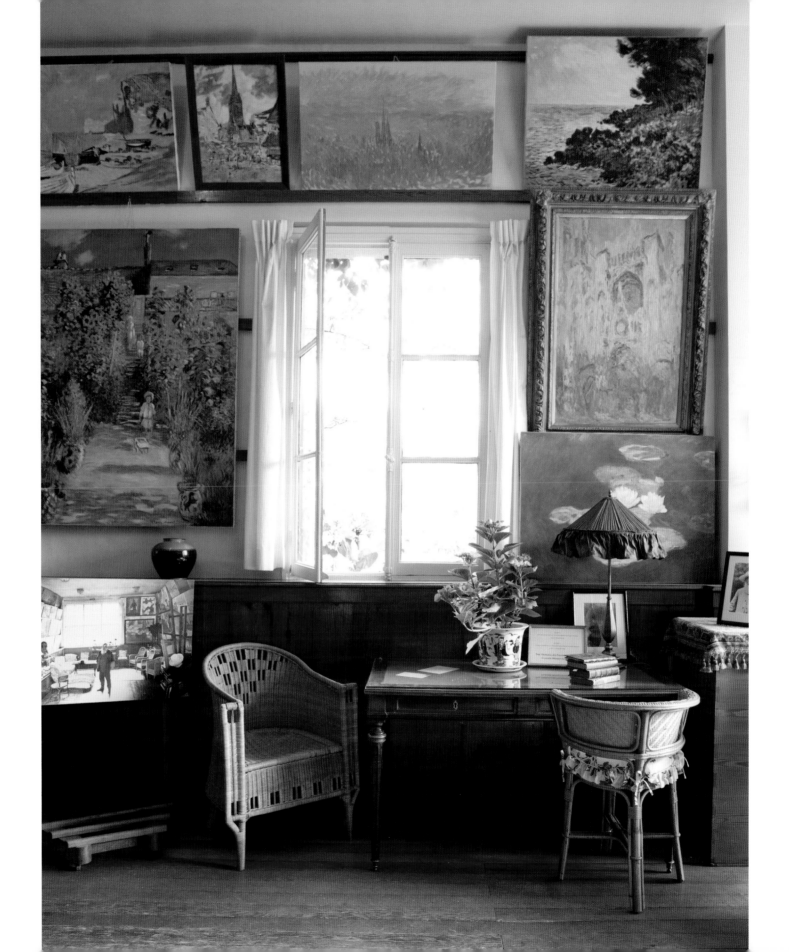

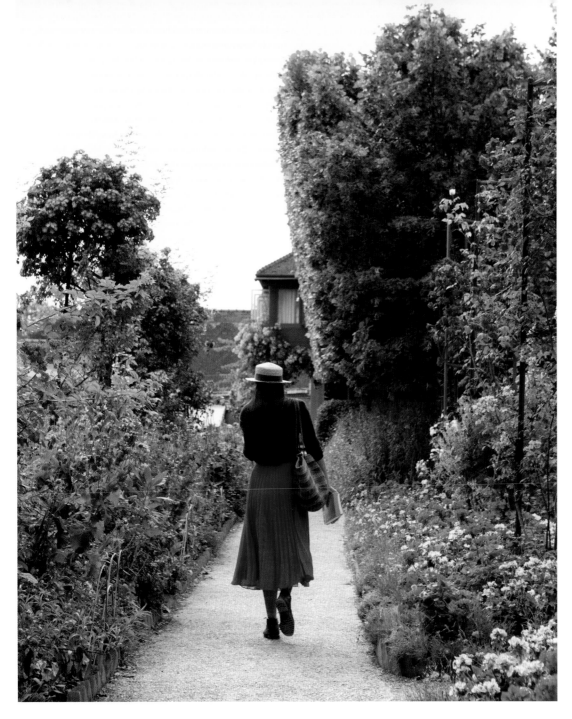

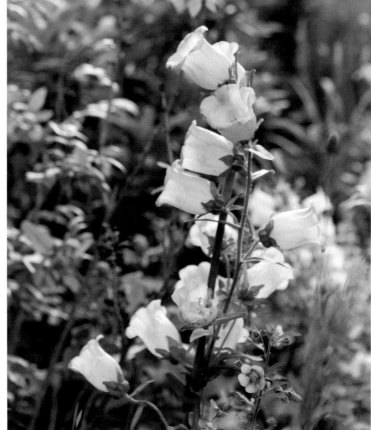

Above: Riotous sprays of seasonal blooms enthrall visitors strolling the pathways at Monet's Giverny. Below right: Reproductions of the artist's paintings now line the walls of his studio. Although he displayed works by Renoir, Cézanne, and Manet in his home, he considered views to his gardens to be equally captivating.

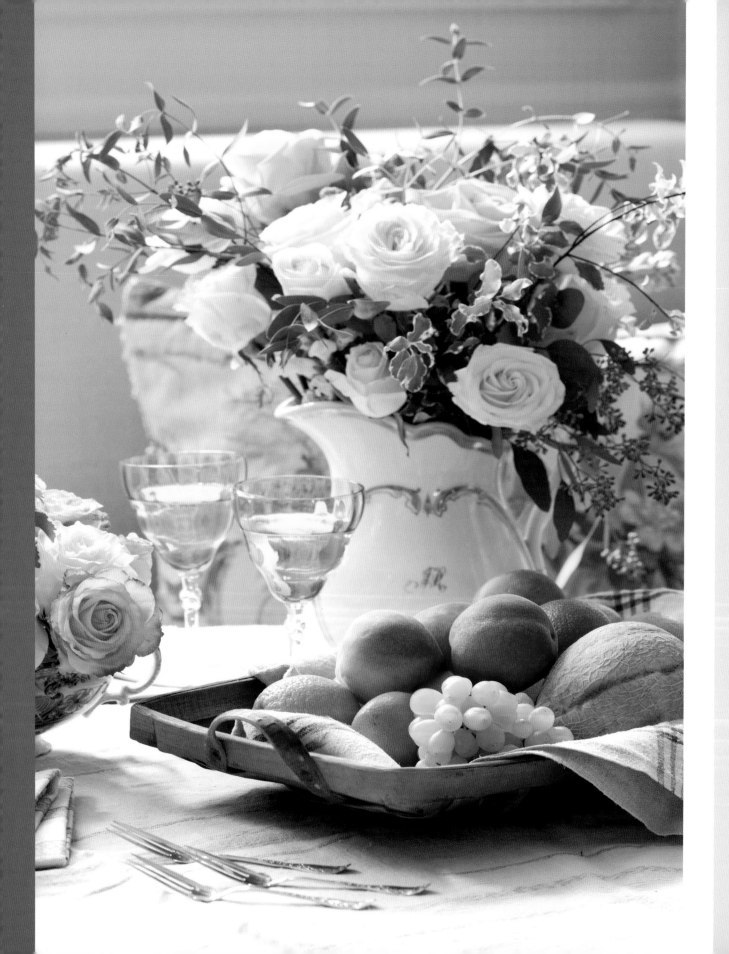

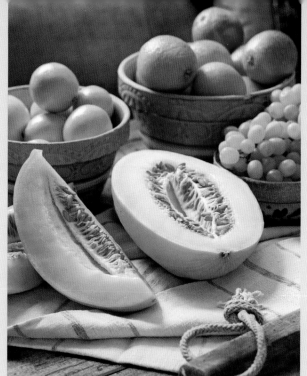

A French Impressionist Repast

A lavish table invites friends to enjoy the simple pleasures of sociability and delicious food. The Impressionist artists, who observed joyful outdoor gatherings with food more than a century ago, captured the custom in paint with an exuberance that beckons us still.

The young group famously included Renoir, Monet, Manet, and Toulouse-Lautrec, as well as two women—Berthe Morisot and Mary Cassatt, an American who lived and worked in France. In contrast to the establishment, these rebels who burst upon the Paris art scene in the 1860s favored depictions of everyday life. And they often painted outdoors, developing quick brushstrokes to capture exquisite landscapes and people suffused in sunlight.

At his home in Giverny, Claude Monet took an avid interest in the culinary arts, from organizing the vegetable gardens and orchards to raising poultry to marketing, cooking, and, of course, dining. Henri de Toulouse-Lautrec also loved to prepare festive meals for friends. He insisted on eating at midday when, he said, the senses are most alive. He also placed goldfish in the water carafes on his table to encourage guests to drink wine with the food, as he believed water ruined the palate.

Our abundant menu celebrates the enduring impressionist legacy of enjoying sustenance and companionship, indoors or *en plein air*. We offer succulent duck confit with a zesty array of accompaniments, roasted vegetables, and, to conclude, a confection of almonds and cream—a tribute to Monet's favorite cake. *Bon appetit!*

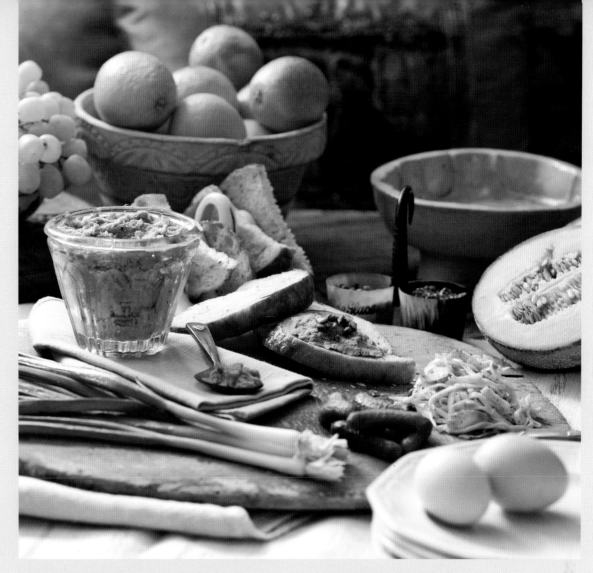

Duck Confit Rillettes
Makes 2 cups

2 (8-ounce) packages duck confit legs with thighs*
½ teaspoon kosher salt
½ teaspoon ground black pepper
¼ cup duck fat, room temperature
Toast points
Whole-grain mustard
Cornichons
Capers
Celeriac Slaw (recipe follows)
Garnish: capers

1. Using your hands, shred meat from legs and thighs, discarding bones and skin.
2. In the work bowl of a food processor, pulse meat, salt, and pepper until combined and meat is processed. Add fat, and pulse until mixture holds together.
3. Transfer mixture to an airtight container. Cover tightly and refrigerate for up to 2 weeks. Serve with toast points, mustard, cornichons, capers, and Celeriac Slaw. Garnish with capers, if desired.

Duck confit is available from many butchers and specialty grocery stores.

Note: Another option is to combine shredded meat, salt, and pepper and spoon mixture into a container. Top with fat, cover tightly, and refrigerate for up to 2 weeks.

Celeriac Slaw
Makes 4 to 6 servings

1 pound celery root, washed, trimmed, peeled, and julienned
1½ teaspoons kosher salt, divided
¼ cup fresh lemon juice
1 cup mayonnaise
2 tablespoons Dijon mustard
1 tablespoon whole-grain mustard
1 tablespoon Champagne vinegar
1 teaspoon ground black pepper
½ teaspoon granulated sugar
1 tablespoon mustard seed
1 tablespoon fresh chopped dill
2 stalks celery, sliced thin

1. In a medium bowl, combine celery root, ½ teaspoon salt, and lemon juice. Let stand at room temperature for at least 20 minutes.
2. In a separate medium bowl, whisk together mayonnaise, Dijon mustard, whole-grain mustard, vinegar, pepper, sugar, mustard seed, dill, and remaining 1 teaspoon salt.
3. Add celery to celery root mixture, stirring to combine. Add mayonnaise mixture to celeriac mixture, stirring to combine. Cover and refrigerate for up to 3 days.

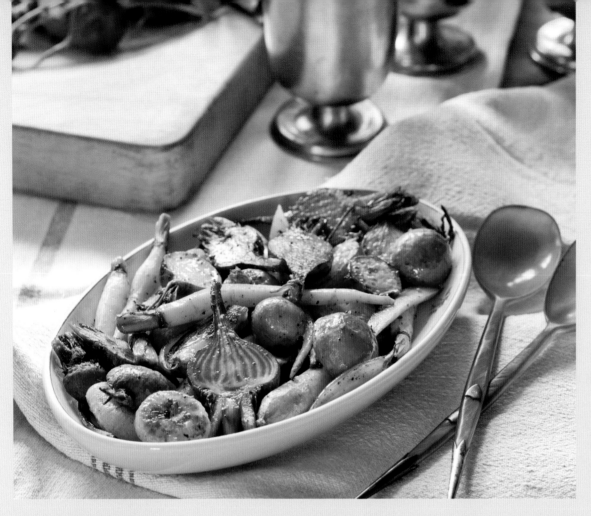

1. Line a rimmed baking sheet with parchment paper.
2. In a medium bowl, stir together Almond Pastry Cream and Frangipane Filling until combined.
3. On a lightly floured surface, roll each sheet of puff pastry to a 12-inch circle and trim to a 10-inch circle. Spoon almond mixture onto center of round, leaving a 1-inch border.
4. In a small bowl, whisk together 1 egg and 1 teaspoon water. Using a pastry brush, brush 1-inch border of first puff-pastry round.
5. Top with second puff-pastry round, and press with fingertips to seal edges. Extending a hand over pastry and using the first two fingers in a V formation, press edges with fingertips and hold. Using your other hand and a sharp paring knife, cut a small notch in the dough between fingertips of first hand. Continue all the way around pastry.
6. Using the same knife, cut a design in top of galette.
7. In a separate small bowl, whisk together milk and remaining egg. Using a pastry brush, brush galette on top and sides. Freeze for at least 30 minutes.
8. Preheat oven to 400°.
9. Bake for 15 minutes. Reduce oven temperature to 375°; bake until deep golden brown, 10 to 15 minutes more. Let cool slightly on a wire rack. Brush warm galette with melted marmalade. Serve warm or at room temperature. Cover and refrigerate for up to 3 days.

Honey-Roasted Radish Medley

Makes 6 servings

2 tablespoons honey
2 tablespoons garlic-infused olive oil
2 tablespoons butter, melted
2 tablespoons Champagne vinegar
1 pound radishes with green tops, washed, trimmed, and halved
1 bunch white carrots with green tops, washed and trimmed
1 (10-ounce) package Cipollini onions*, peeled and blanched
2 small Chioggia beets, halved lengthwise
1½ teaspoons kosher salt
1 teaspoon ground black pepper

1. Preheat oven to 425°. Line a rimmed baking sheet with foil.
2. In a small bowl, whisk together honey, olive oil, melted butter, and vinegar.
3. In a large bowl, combine radishes, carrots, onions, and beets. Add honey mixture, tossing to coat all vegetables. Spread onto prepared pan, cut side down, in a single layer. Season with salt and pepper.
4. Roast until tender, 15 to 20 minutes. Serve warm. Cover and refrigerate for up to 3 days.

Pearl onions can be substituted, if desired.

Almond and Browned Butter Galette

Makes 1 (10-inch) cake

Almond Pastry Cream (recipe follows)
Frangipane Filling (recipe follows)
1 (17.3-ounce) package frozen puff pastry, thawed (2 sheets)
2 large eggs, divided
1 teaspoon water
1 teaspoon milk
½ cup orange marmalade, melted

Almond Pastry Cream

Makes approximately 1½ cups

1 cup half-and-half
⅓ cup granulated sugar
½ cup chopped toasted almonds
3 egg yolks
1 teaspoon vanilla extract
½ teaspoon almond extract
1 tablespoon cornstarch
1 tablespoon all-purpose flour
¼ teaspoon salt
2 tablespoons browned butter*, softened

1. In a large saucepan, bring half-and-half, sugar, and almonds to a boil over medium-high heat. Cook, whisking often, until sugar is dissolved. Remove from heat.
2. In a small bowl, whisk egg yolks, vanilla extract, and almond extract.

3. In a separate small bowl, whisk cornstarch, flour, and salt. Combine cornstarch mixture with egg yolk mixture.
4. Whisking constantly, add approximately ½ cup hot almond mixture to egg-yolk mixture. Add tempered egg-yolk mixture to remaining hot almond mixture in pan, whisking to combine.
5. Strain mixture through a fine-mesh sieve, discarding solids. Return liquid to pan. Reduce heat to medium. Cook, stirring constantly, until mixture is thickened, 5 to 7 minutes. Add browned butter, whisking until combined. Transfer mixture to a container; cover surface of pastry cream with plastic wrap. Refrigerate for at least 1 hour or up to 5 days.

In a small saucepan, melt butter over medium heat. Cook until butter turns a medium-brown color and has a nutty aroma, about 10 minutes. Remove from heat, and let cool to room temperature. Use immediately or cover and refrigerate for up to 1 week.

Frangipane Filling
Makes approximately 1 cup

¼ cup browned butter*, softened and divided
¼ cup granulated sugar
1 large egg
1 teaspoon vanilla extract
½ teaspoon almond extract
¼ cup almond flour
1 tablespoon cornstarch
½ teaspoon salt

1. In the work bowl of a food processor, combine browned butter and sugar; pulse until smooth. Add egg, vanilla extract, and almond extract, pulsing to combine.
2. In a small bowl, whisk together almond flour, cornstarch, and salt. Add almond flour mixture to egg mixture, pulsing to combine. Transfer mixture to an airtight container, and refrigerate for at least 45 minutes or up to 5 days.

In a small saucepan, melt butter over medium heat. Cook until butter turns a medium-brown color and has a nutty aroma, about 10 minutes. Remove from heat, and let cool to room temperature. Use immediately, or cover and refrigerate for up to 1 week.

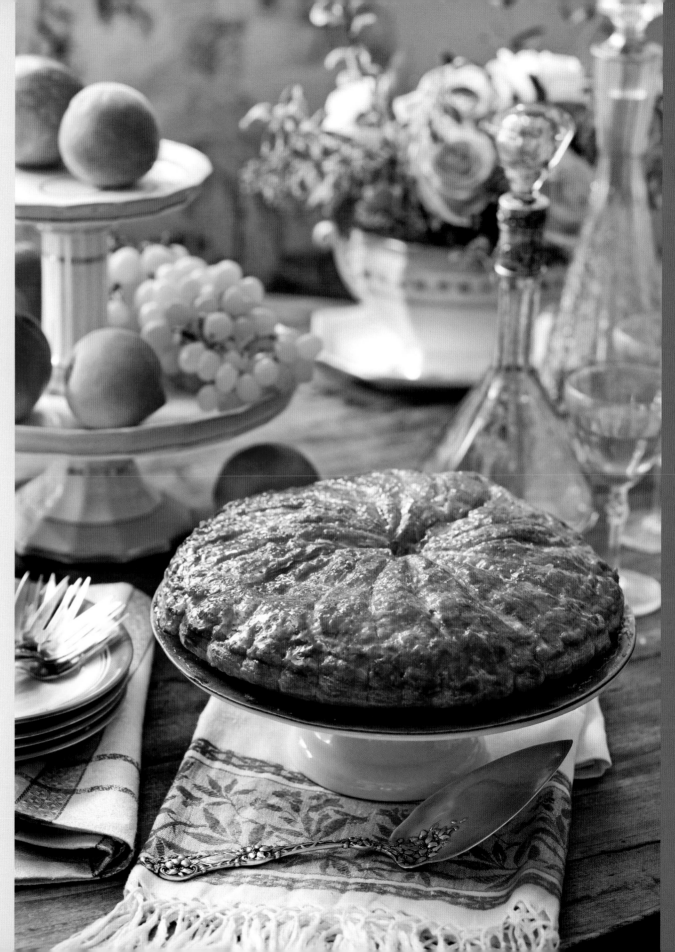

La Vie EST BELLE

The enchantments of France are inseparable from thoughts of royalty. From gilded adornments in palace halls to strolls through brimful gardens or luxurious attire accented by couture fans and frills, each detail of noble life boasts beauty in its finest form.

A SOVEREIGN SANCTUARY

When most people think of Marie Antoinette, they picture her dressed in an ornate silk gown with her hair swept up in an elaborate, powdered coif—a royal who indulged in excess and had no real understanding of the everyday life of her subjects. But there was another side to this young queen, one that yearned for a simpler life away from the pomp and political turmoil of the times.

The sovereign found respite in an outlying area of the Versailles domain known as the Trianon estate. Though it was a mere thirty-minute walk from the palace, its rural setting was worlds away in terms of appearance and ambiance. Her husband, King Louis XVI, gifted his bride with the Petit Trianon château, the smaller of two residences on this property. Enamored with the freedom here, she soon commissioned architect Richard Mique to design a further development that became known as the Queen's Hamlet.

Built around a small lake, the sprinkling of bucolic cottages combined French, Flemish, and Norman architectural styles, and as it was a functioning farm, included a barn, a working dairy, and a dovecote. It was not unusual to spot a carefree Marie, casually dressed in peasant's clothing, ambling about the pastoral grounds with her children to teach them about the natural world. Now fully restored and open to the public, the hamlet gives visitors a glimpse of this lesser-known aspect of her life.

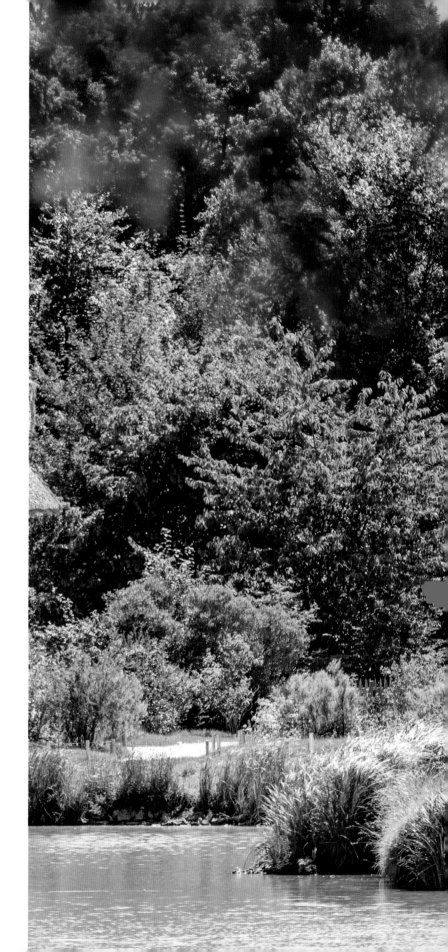

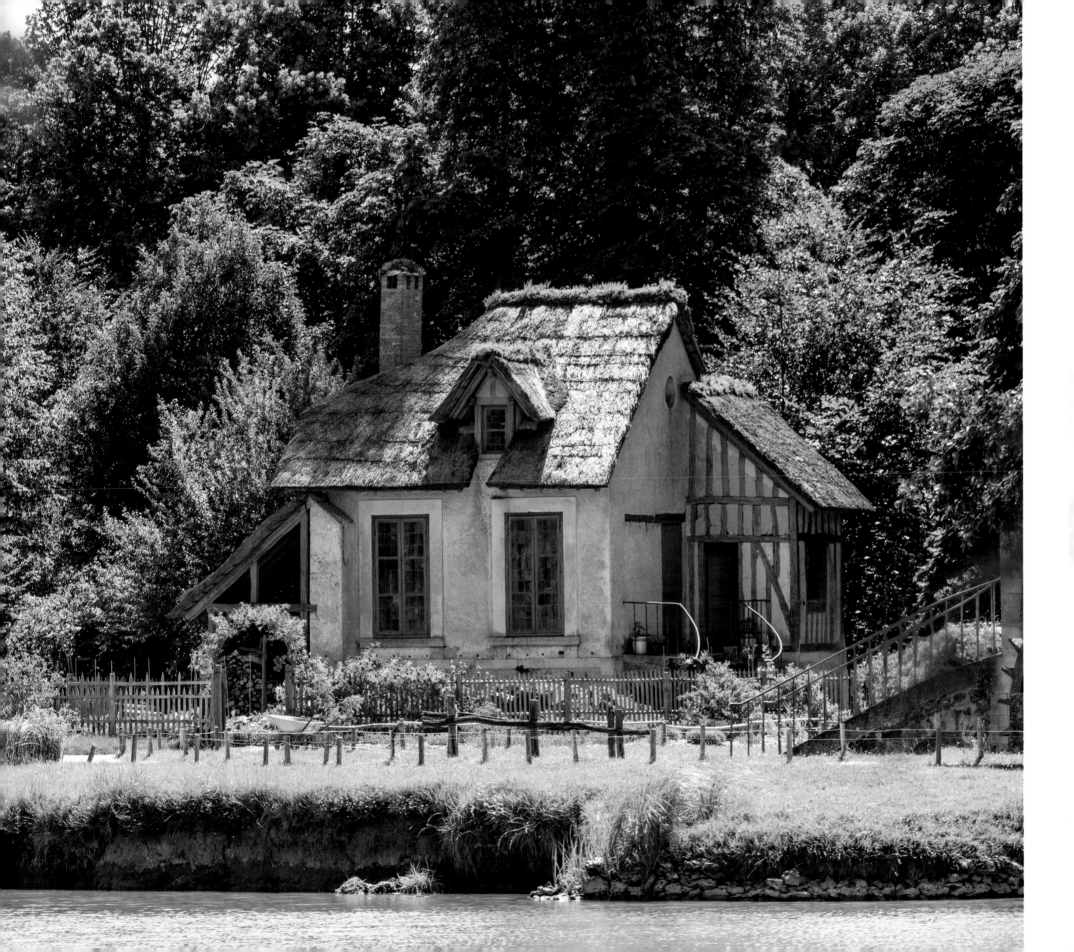

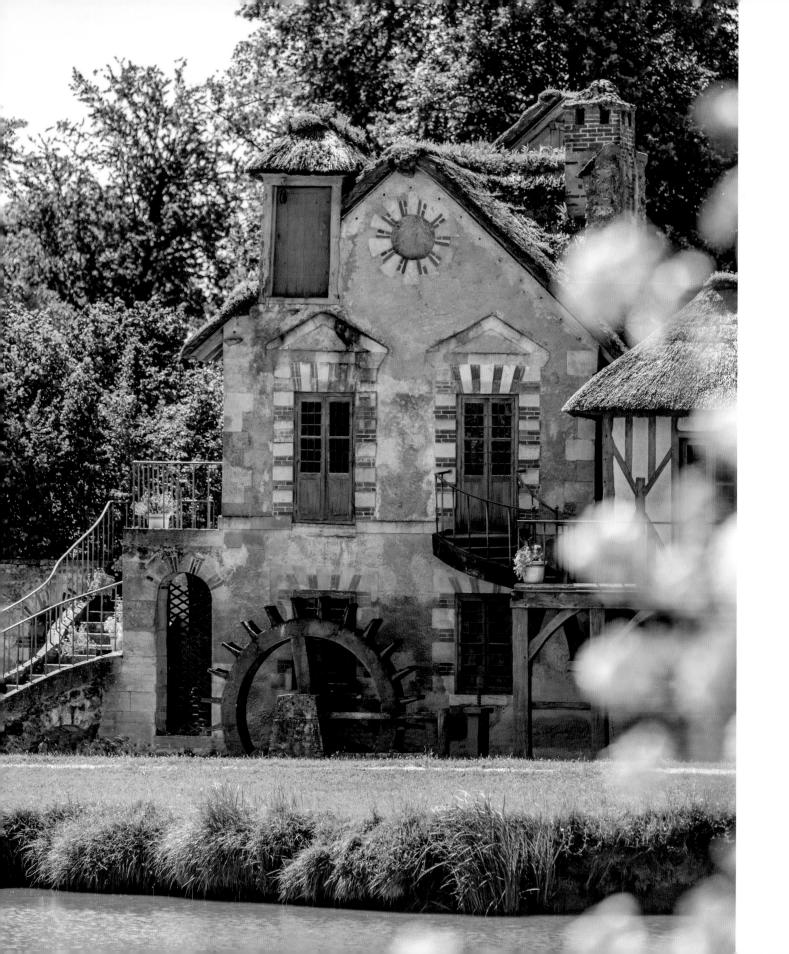

"One's enjoyment is doubled when one can share it with a friend."

—Marie Antoinette

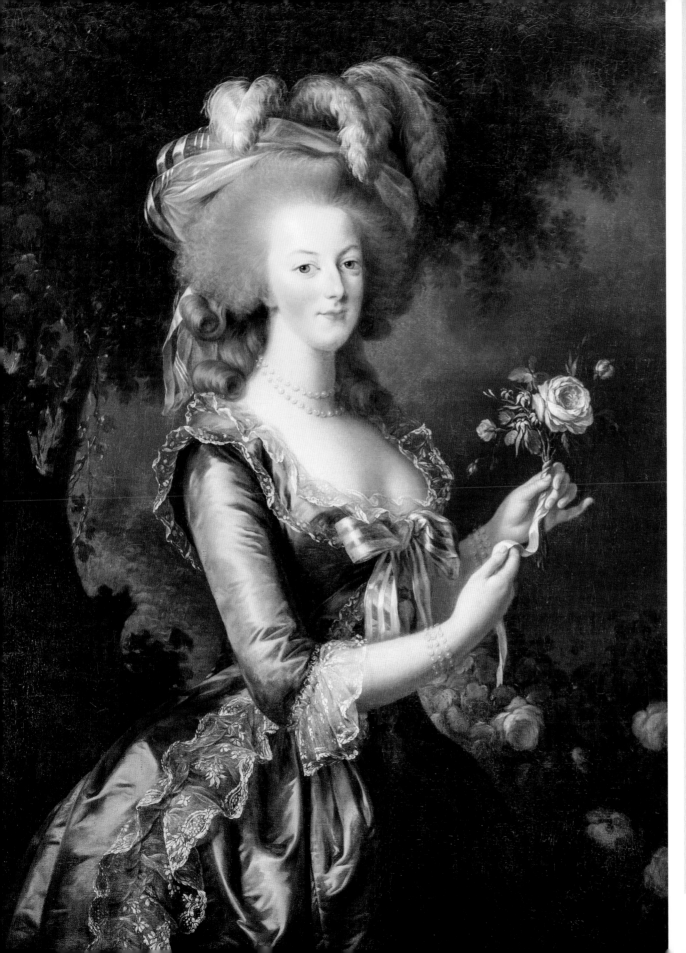

Nina's Marie-Antoinette Tearoom

This delightful stop in the City of Light hearkens to 1672, when Pierre Diaz founded La Distillerie Frères, the first perfumery to successfully capture the essences of rose and lavender. Heralded as "the aroma magician," he supplied fragrances for King Louis XIV and his court. Later, Marie Antoinette became a devoted customer.

The salon's name is a nod to the perfumer's wife, Nina, who created the Ninasette cake, a recipe passed down through her family and first served to the queen in 1778. The pink frosted confection is offered here, along with the house's signature tea blends, to give patrons a moment of sweet repose during an eventful afternoon of sightseeing.

Located in Place Vendôme, a historic square in the heart of Paris, the venue also displays a number of fascinating artifacts related to Marie Antoinette, including a letter penned by her hand, a replica of a shoe she lost in 1793, and a marble bust sculpted by Felix Lacomte.

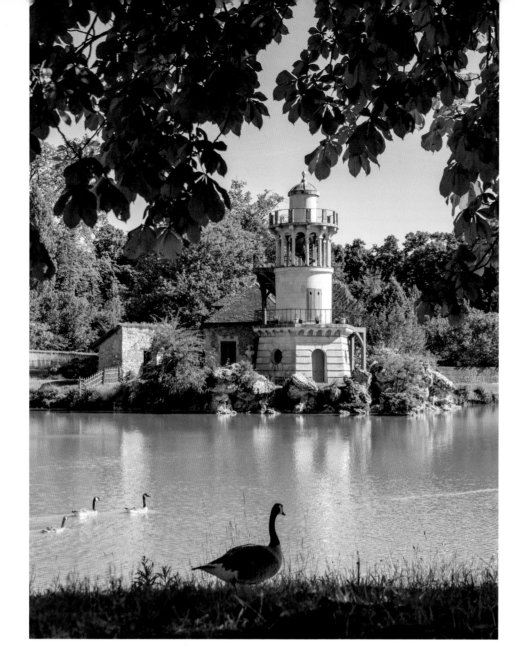

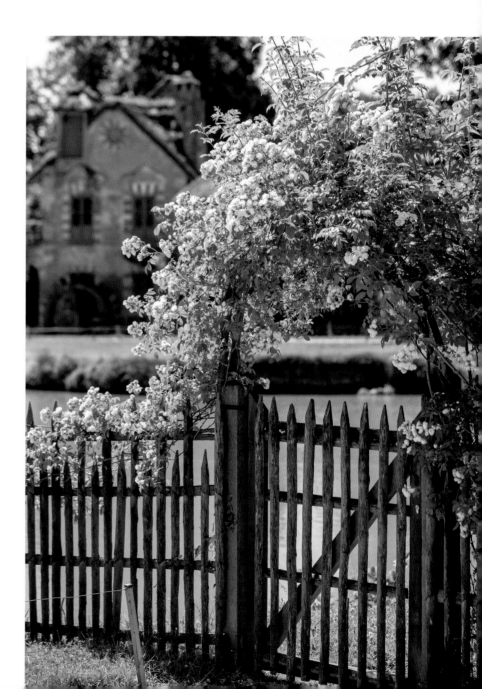

Not far away, located in the center of Paris, Nina's Marie-Antoinette tearoom honors the former queen in a cheerful and genteel venue, ideal for enjoying a slice of cake and a quiet cup of her namesake tea—a Ceylon black flavored with apples and roses grown in the gardens of Versailles.

Liberal doses of pink and gold bring a feminine feel to the salon's décor, where portraits and statuettes of the renowned queen cast imperial gazes at patrons as they peruse an assortment of pretty wares, from blush-hued canisters to dainty china cups. A visit to Nina's for afternoon tea is the crowning touch to a day spent exploring the rustic retreat of France's much-celebrated monarch.

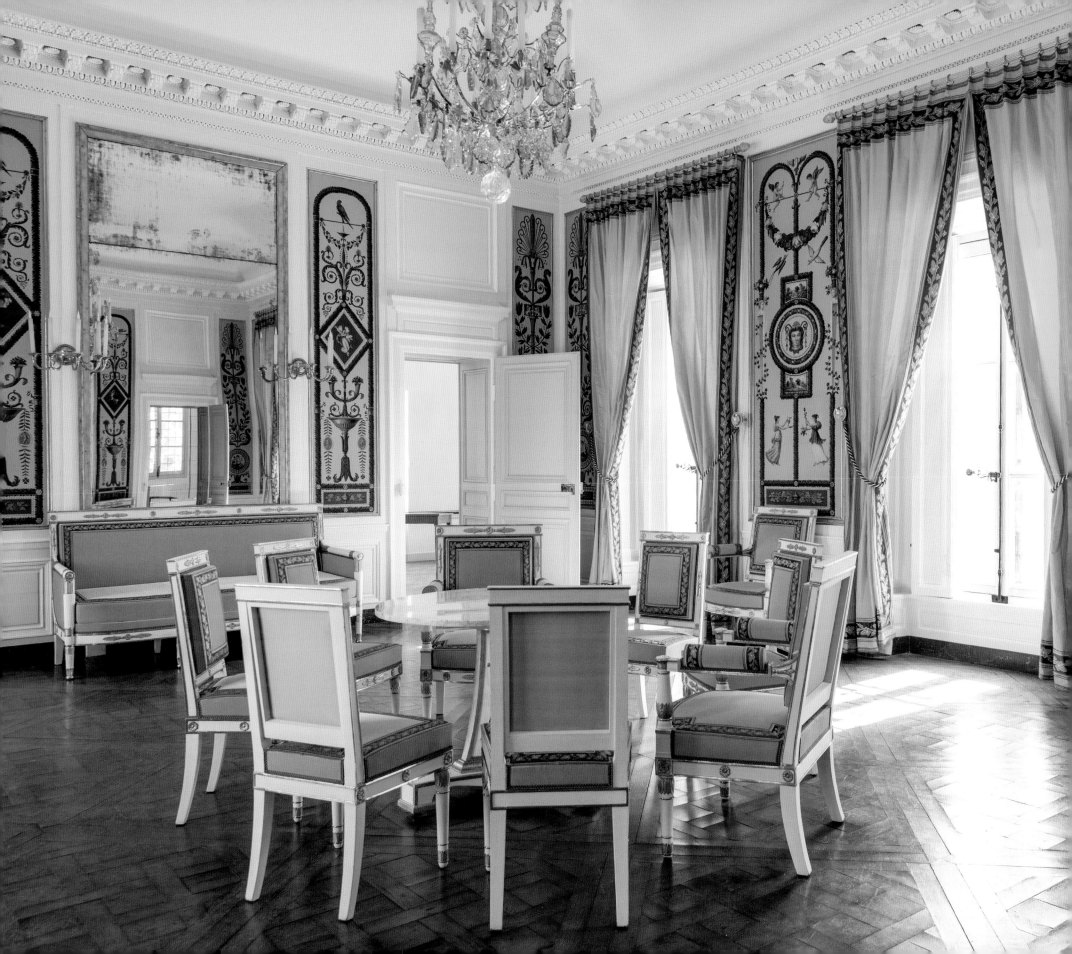

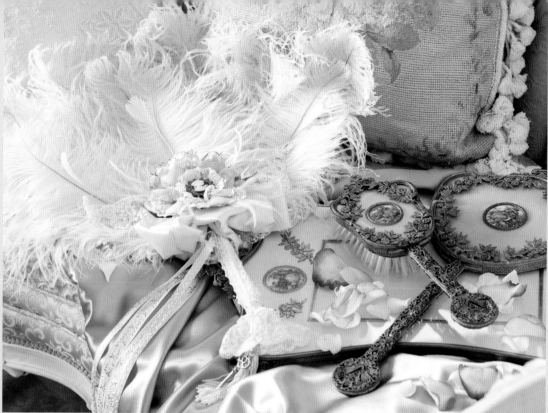

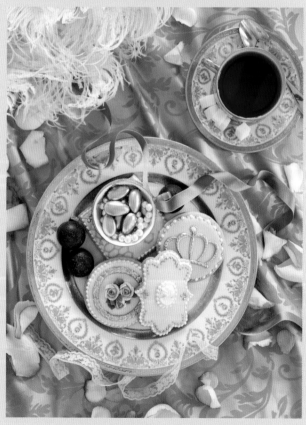

Joie de Vivre of a French Queen

Lauded as a true icon of fashion in her day, Marie Antoinette still holds court in the hearts of those who admire her extravagant style. Amid the priceless luxuries of amity and repartee, toast guests in a manner she would encourage with an array of desserts presented with regal flair.

Arranging elegant and intriguing vignettes for such a soirée is easier than one might guess. Clockwise from above left, painterly petals draw the eye to Glastonbury-Lotus stemware, while a beribboned fan and an antique vanity set lend a sense of romance. With its encrusted borders and delicate buds, the Chas Field Haviland vintage pattern Marie Antoinette provides the ideal background for showcasing confections.

Masterful designs from Amber Spiegel call to mind the artistic prowess lauded at Versailles. The pastry chef's frosted cookies—flavored with orange zest, vanilla bean, and cardamom—reach their pinnacle with hand-piped icing bouquets, cameos shaped from gum paste, and accents painted with gold luster dust and vodka.

In the setting shown opposite, blooms from palest blush to vibrant magenta form a lavish centerpiece, and tempting pâtisserie treats befit the last queen of France.

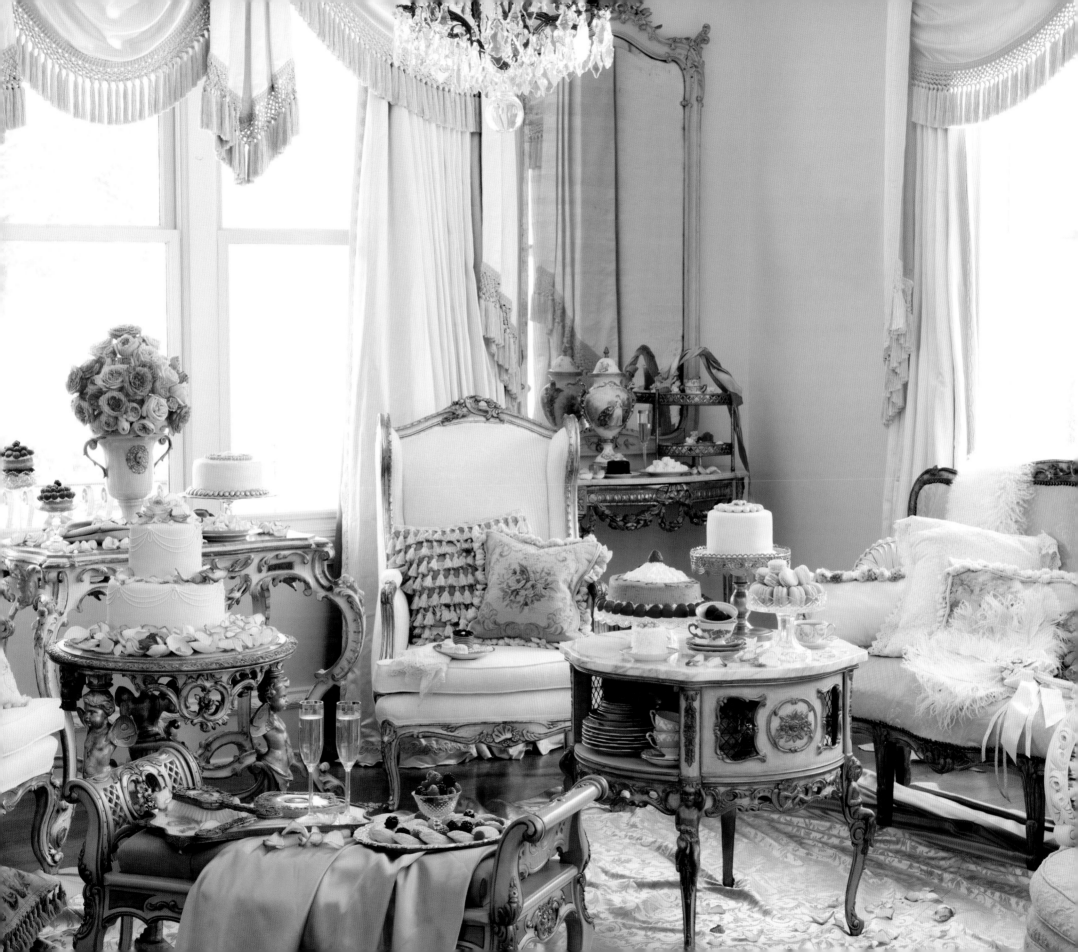

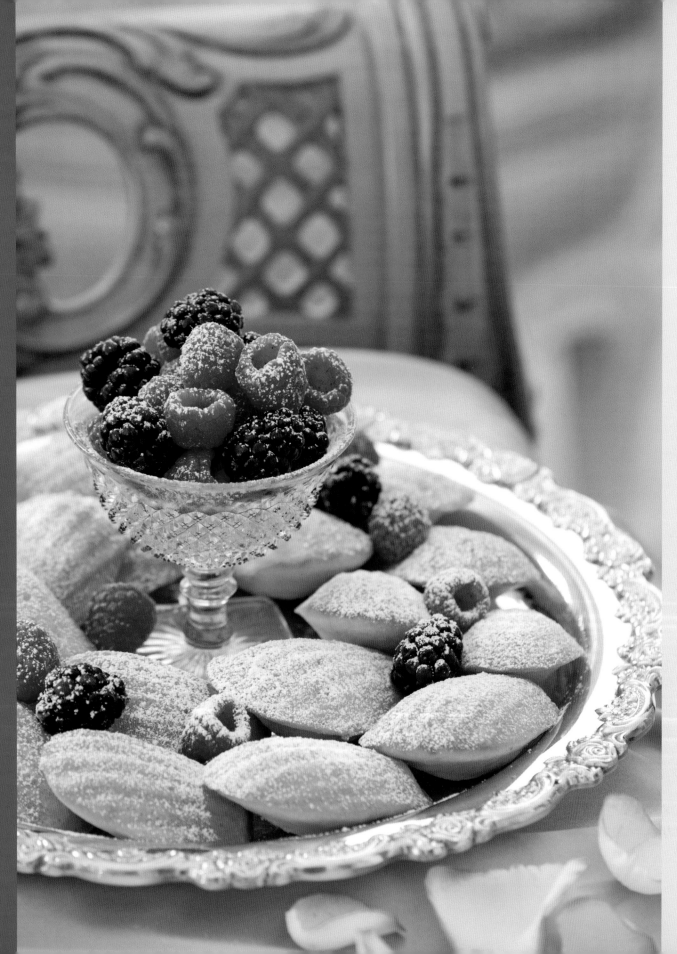

Orange Blossom Honey Madeleines

Makes 24

1 cup all-purpose flour
½ teaspoon baking powder
½ teaspoon ground ginger
¼ teaspoon salt
½ cup unsalted butter, softened
¾ cup orange-blossom honey
2 large eggs
1 egg white
1 tablespoon grated orange zest
½ teaspoon vanilla extract
Garnish: confectioners' sugar

1. Preheat oven to 325°. Spray 2 (12-well) madeleine pans with baking spray with flour.
2. In a medium bowl, whisk flour, baking powder, ginger, and salt.
3. In a separate medium bowl, beat butter with a mixer at medium speed until fluffy. Gradually add honey and beat until smooth. Add eggs, one at a time, and egg white, beating well after each addition. Add orange zest and vanilla extract, beating until combined. Reduce mixer speed to low, and gradually add flour mixture to butter mixture, beating until incorporated.
4. Spoon batter by heaping tablespoonfuls into each well of prepared pans.
5. Bake until lightly golden brown, 12 to 15 minutes; transfer to wire racks and let cool in pans for 5 minutes. Remove from pans and let cool completely. Garnish with a dusting of confectioners' sugar, if desired. Store in an airtight container for up to 3 days.

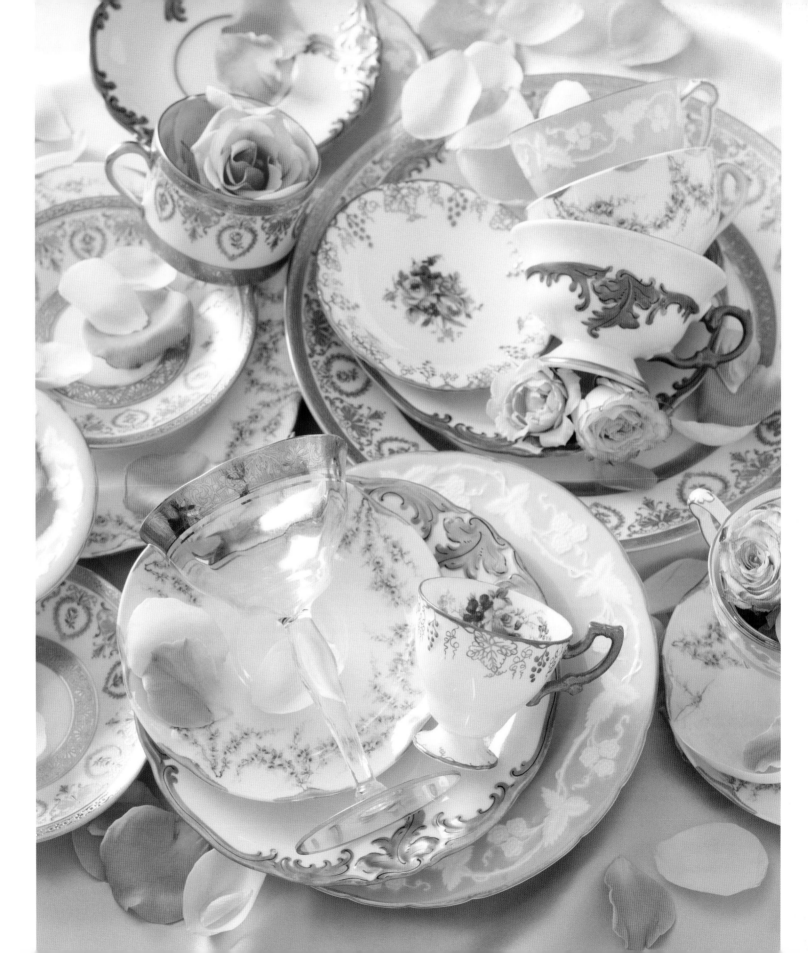

Right: Festive occasions provide the perfect opportunity to use beloved china. Layering pieces from such makers as Royal Crown Derby, Haviland, and Wawel adds interest to our grouping. Opposite: The tartness of fresh berries offers the perfect complement to lightly sweet Orange Blossom Honey Madeleines.

PERCHANCE
TO DREAM

When Marie Antoinette draped her private
quarters at Versailles in layers of brocade, toile, and silk, she wished to surround herself
with the most beautiful of furnishings. Taking inspiration from that elegant neoclassical
period, as well as from the queen who breathed life into visions of splendor, encourages the
imagination to take wing, allowing the creative freedom necessary for designing, curating,
and bringing to fruition the ultimate French-style interiors.

The boudoir perhaps affords the most natural capacity for expressing the gracious
and romantic sensibility associated with France. Awash in the softest neutral shades, the
welcoming retreat shown at right boasts accents of gold, which add regal flair. A hand-
crafted canopy incorporates an authentic relic in its composition. Curtains billow softly
from this crowning feature, and an array of sumptuous linens bid one to rest in supreme
comfort. Lending elegance to the milieu, carefully chosen lighting includes glittering
sconces, shapely lamps, and a beaded chandelier. Timeworn antiques and prized family
photos, placed here and there, make the space truly feel like home.

This haven also serves as a tranquil retreat, with daily pleasures considered in every
detail of the layout. A crescent-shaped Louis XVI-style vanity affords a gracious area for
carrying out morning routines, while a nearby table offers a cozy breakfast for two.

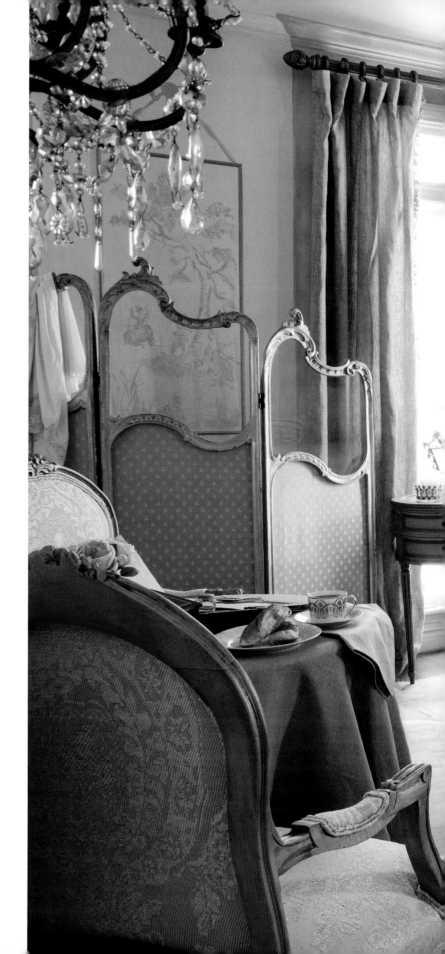

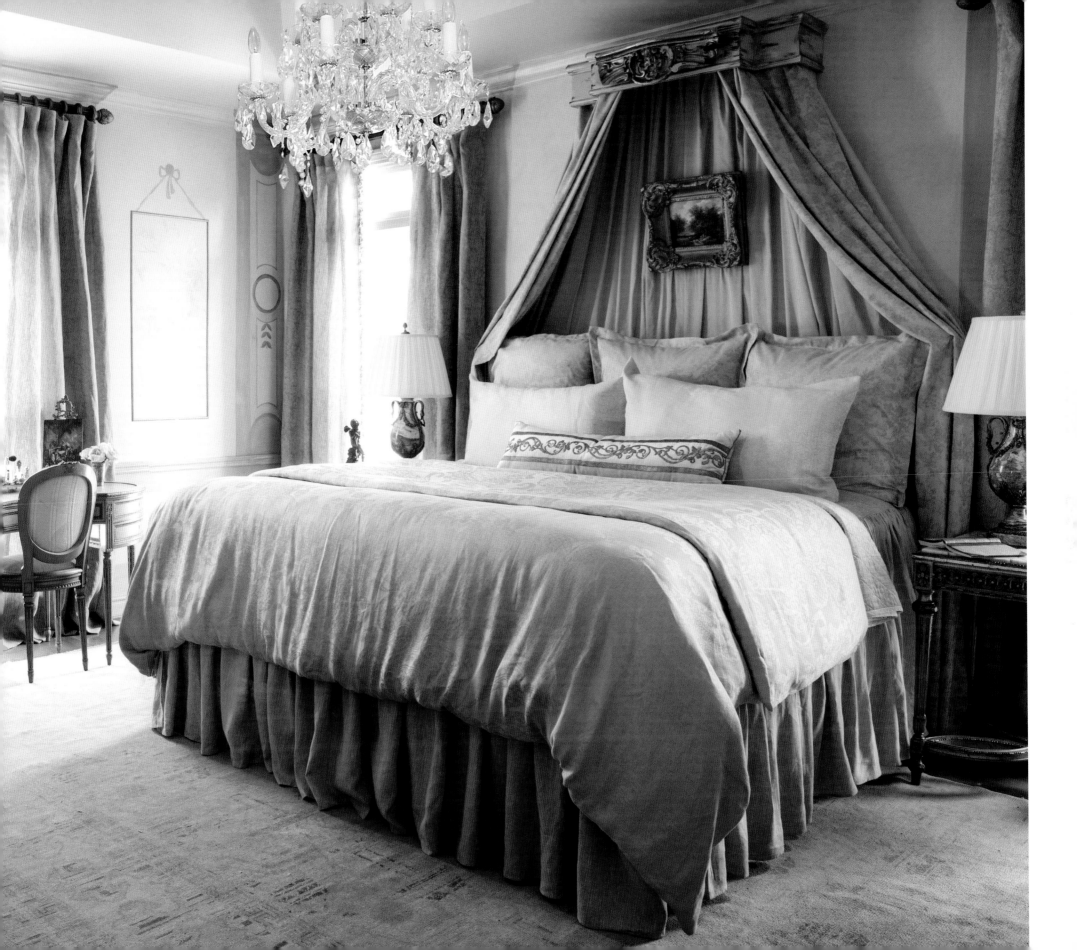

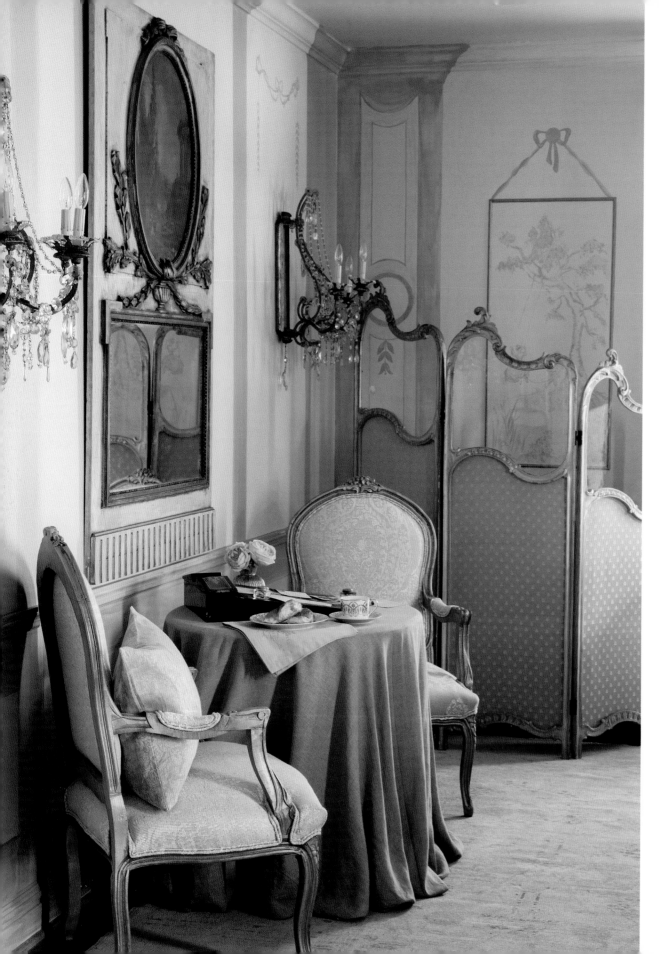

Left: Though smoke from burning candles once obscured the reflective surface of the trumeau mirror that hangs above this intimate gathering spot, the antique has been restored to its former glory and is now flanked by a pair of gilt-bronze crystal-adorned sconces. Opposite: A mirrored tray holds a lovely assemblage of perfume bottles in a mélange of interesting shapes and sizes.

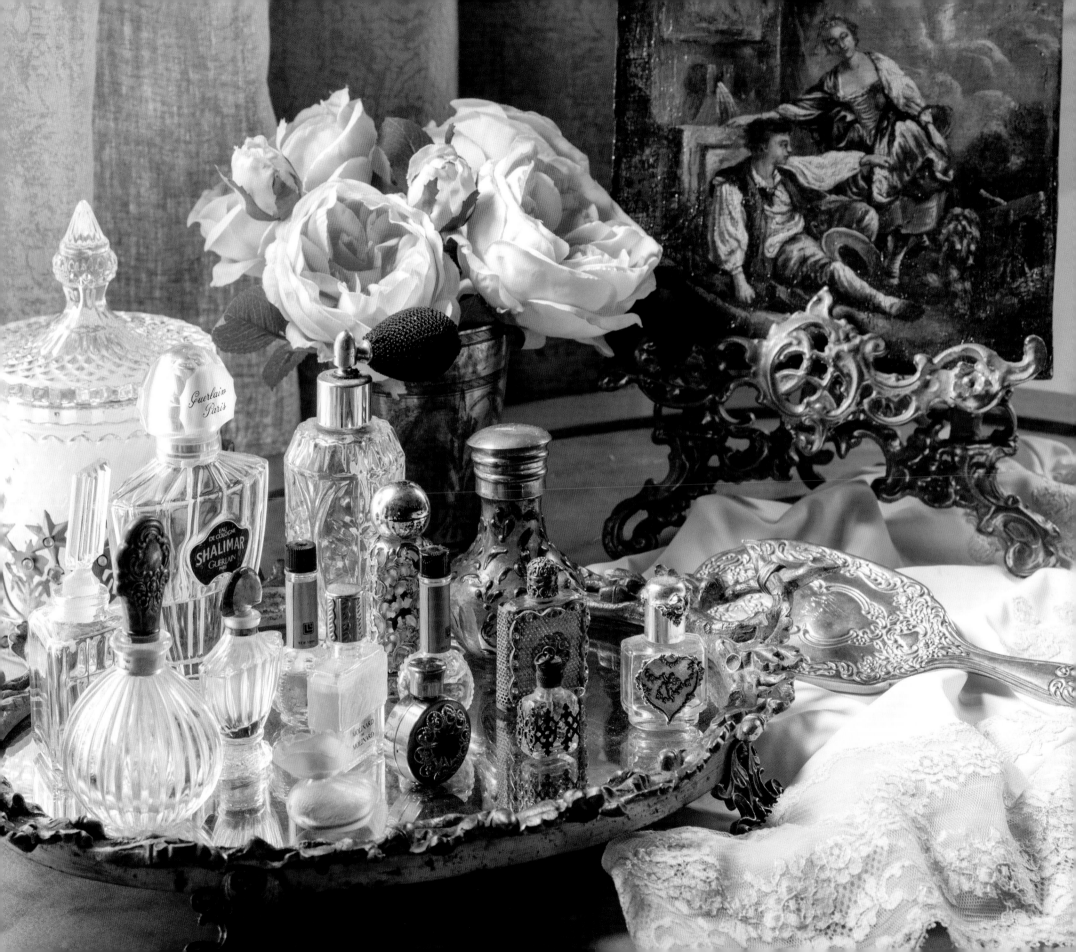

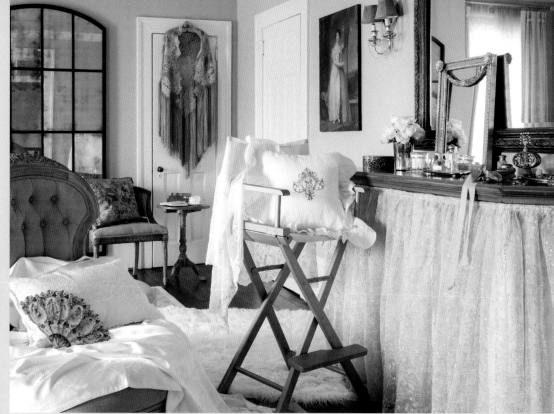

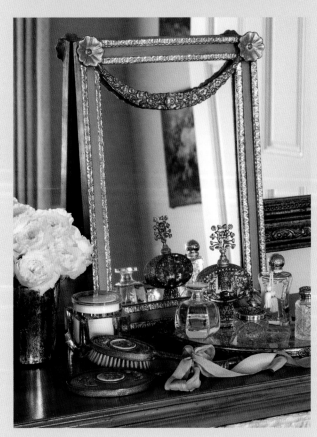

Adorning the Dressing Table

Stealing away to nourish the skin, apply makeup, or enjoy quiet reflection refreshes both body and spirit. The radiance cultivated during these treasured moments often lasts far longer than the modicum of time set aside for self-care. Daily pampering is made all the more enjoyable when carried out in surroundings where thoughtful attention has been given to establishing a gentle cadence for the day.

Clockwise from above right, an exquisite vanity becomes an elegant focal point, whether organized for carrying out beauty routines or arranged for taking in the beauty of everyday routines. An aqua mirror with accents of gold leaf offers a lovely backdrop for antique accessories, including a hand mirror and brush placed alongside a tray of gleaming vessels. An array of perfumes and dusting powders assure that fine fragrances are always at the ready. Placed on the corner, a posy of delicate cream-colored blossoms adds softness.

Tucking jewelry within a drawer protects time-burnished pearls and other baubles from damage while keeping them within easy reach. Also placed here, lacy vintage slips promise rest and comfort at the close of day.

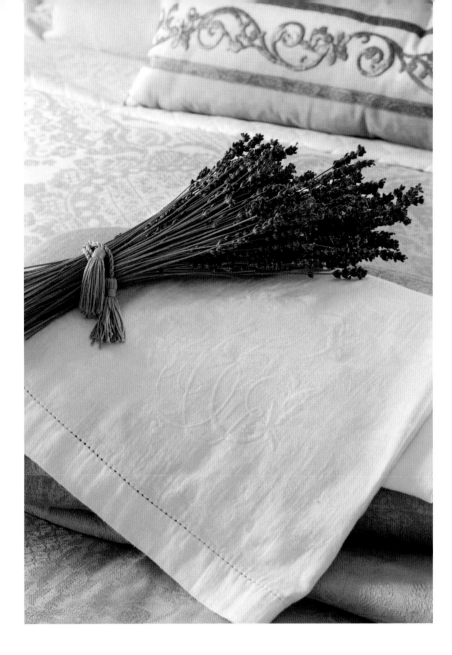

Clockwise from above: Stems of lavender infuse bed linens with a calming scent. Adding a distinctly personal touch to the corner of the boudoir, the French painting technique of trompe l'oeil was used to create the look of panels; the framed art "hanging" on the wall replicates a scene from the toile fabric used throughout the room.

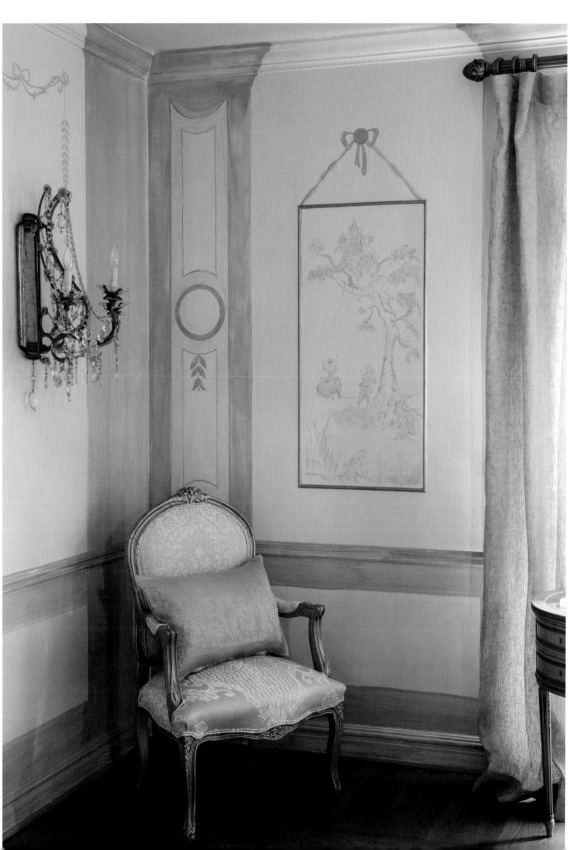

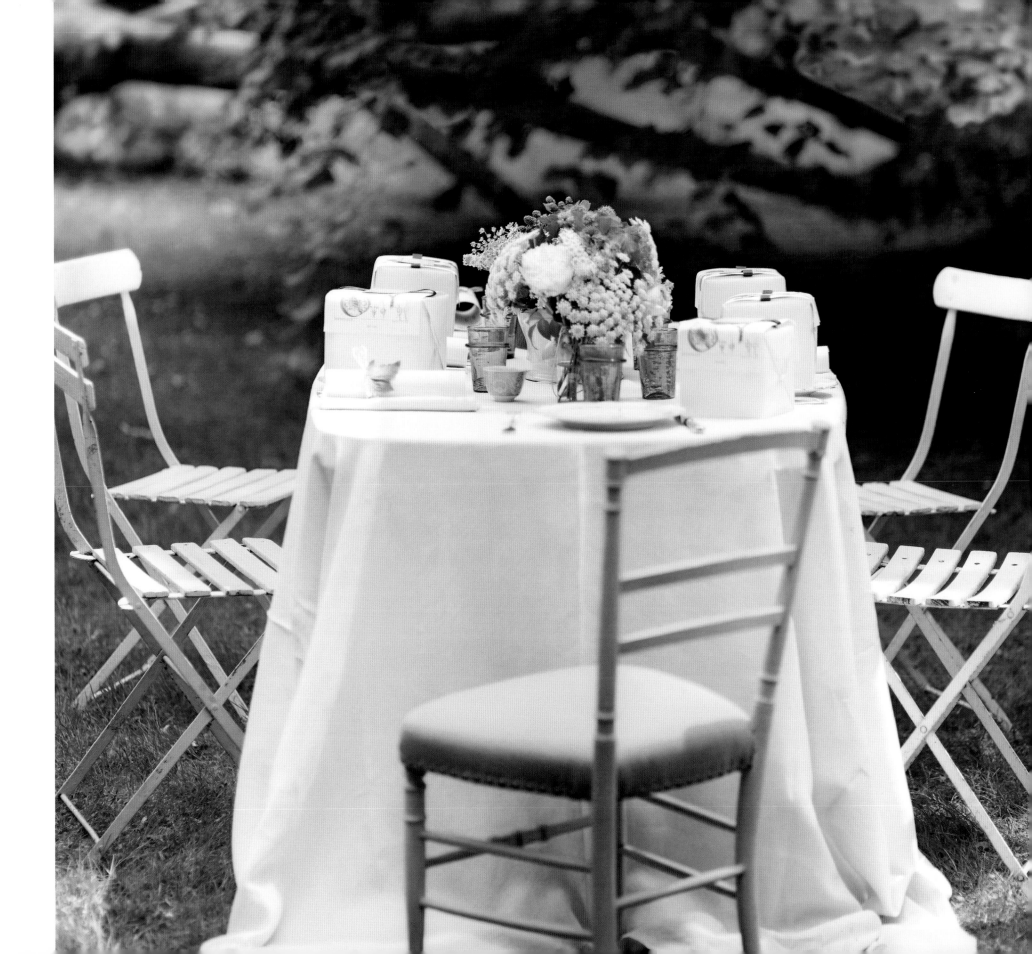

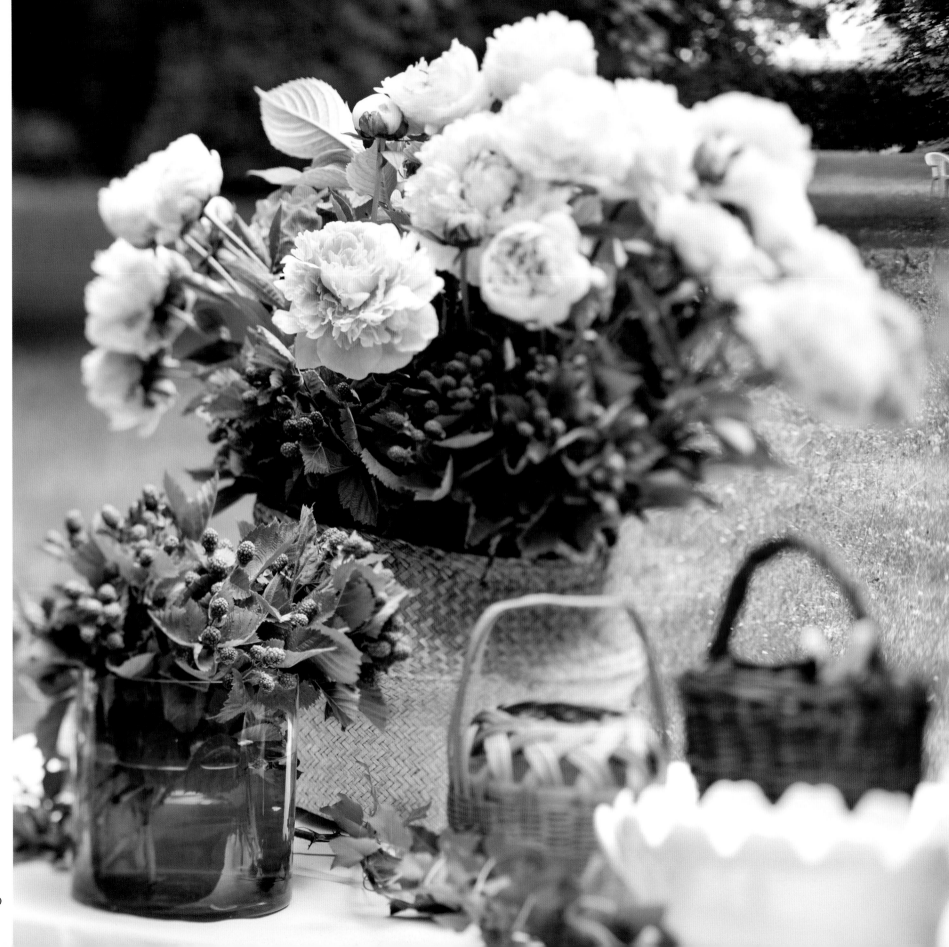

"Happiness flutters in the air whilst we rest among the breaths of nature."

—Kelly Sheaffer

Above: Attendees are sent home with a small gift—usually garnered from an area *brocante*—as a reminder of their special experience. Right: The pleasing balance of sophistication and simplicity that characterizes Marie-Paule's tableaux also informs her menus. Here, a rustic cheese tray offers chèvre from a local farm.

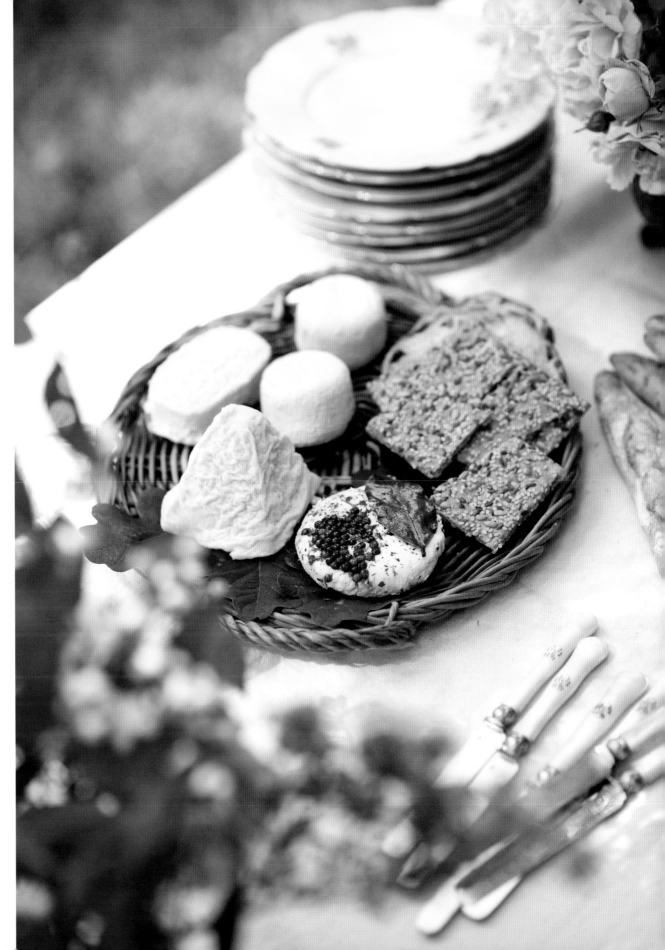

Effortless ÉLAN

An elevated sense of style seems to spring forth from this fair realm, miraculously transforming plain interiors into beautiful spaces filled with troves of pleasing curios and relics, often collected from shops that specialize in cultivating such history-steeped, tasteful environs.

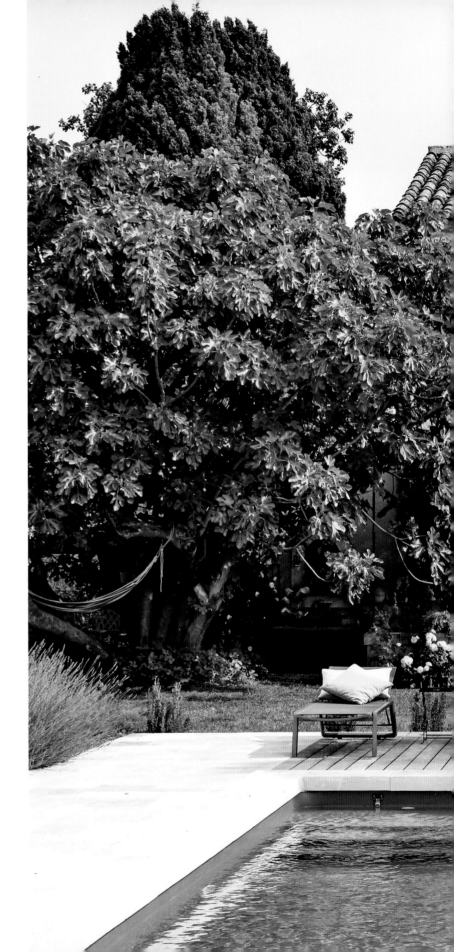

A PLACE
IN THE SUN

Much like artists Paul Cézanne and Vincent van Gogh, Anne and Philippe Poutoire were drawn to the sweeping lavender fields, fertile vineyards, and beguiling villages of the renowned Provence region. Several years ago, the couple purchased a circa 1850 *mas* (farmhouse) near the town of Saint-Rémy-de-Provence and embraced these beloved environs.

The two-story main house embodies quintessential Provençal architecture, with a locally sourced stone façade crowned by a multihued tile roof. Slate-gray shutters lend a contemporary touch, and the annex was transformed into a luxe holiday let. The couple added a swimming pool, edged in a fine-grained white stone known as *pierres des baux*, along with wooden decking that has silvered in the sun.

Anne turned her avid interest in decorating into a business, and her talents as a designer are evident throughout the home's interiors. Her color scheme of beige, white, and gray is cool and calming—the perfect foil for summer's heat. This ethereal palette begins at the front entry, where a console table from the Poutoires' prior home is lined with objets d'art, including a pair of vases filled with olive branches gathered from the garden.

Many of the furnishings in both the home and the annex were found in Paris or in Perche—a hidden gem replete with antiques dealers—as well as at markets closer to home.

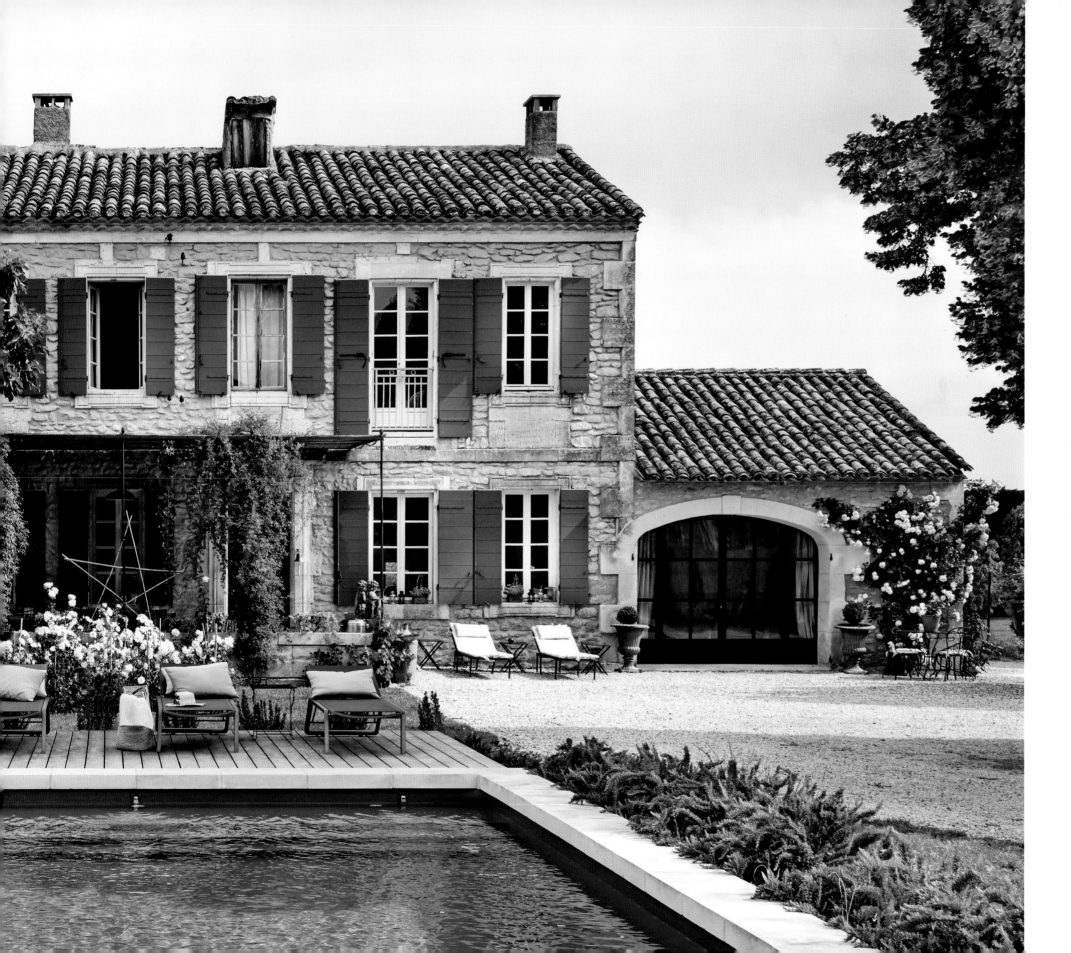

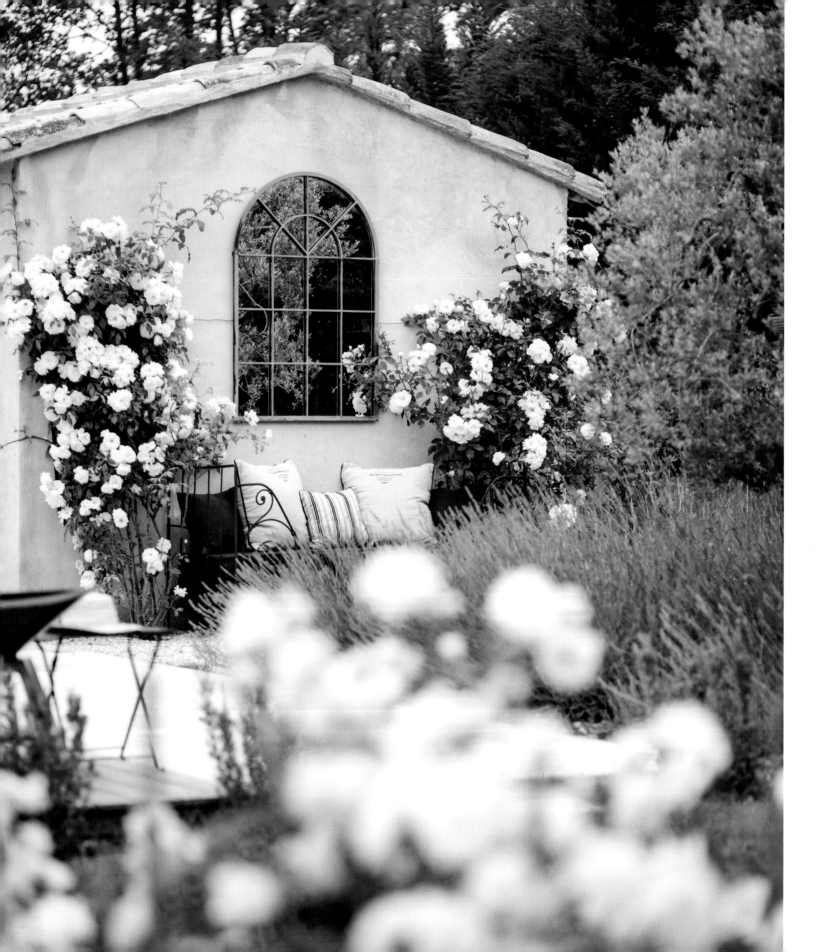

Left: 'Fairy Snow' roses frame a child's bed–turned–reading spot outside the pool house. Opposite, clockwise from right: Whitewashed pine covers the walls in the annex's main room. Owner and designer Anne Poutoire decorated this retreat with a mélange of furnishings found at antiques dealers and *brocantes* in Paris, Provence, and Perche. She even turned a collection of empty frames into an eye-catching display. Gravel pathways delineate her organic vegetable garden; the plot brims with berries, heirloom tomatoes, and more.

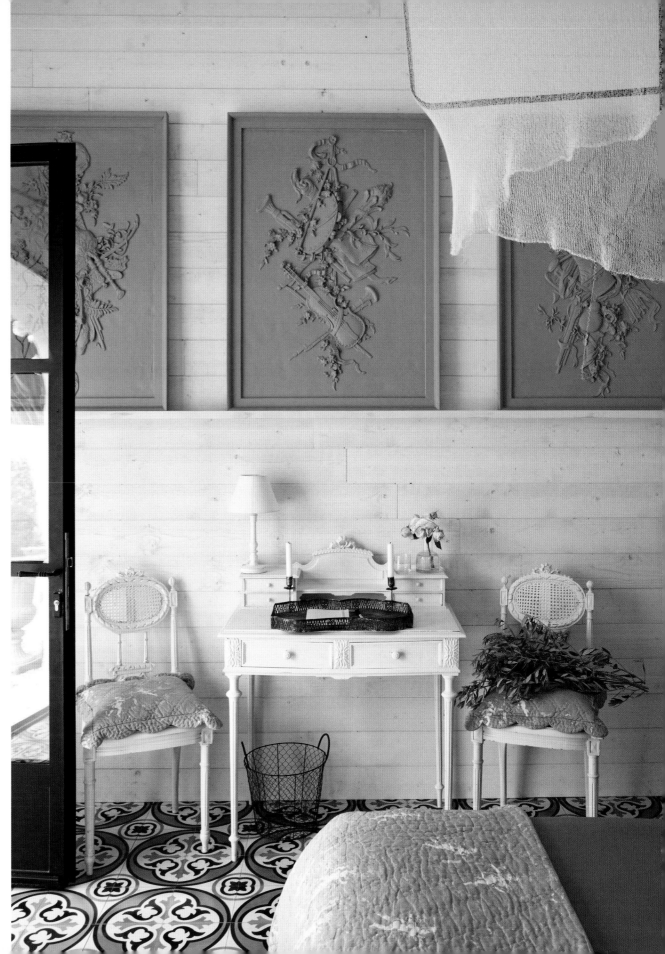

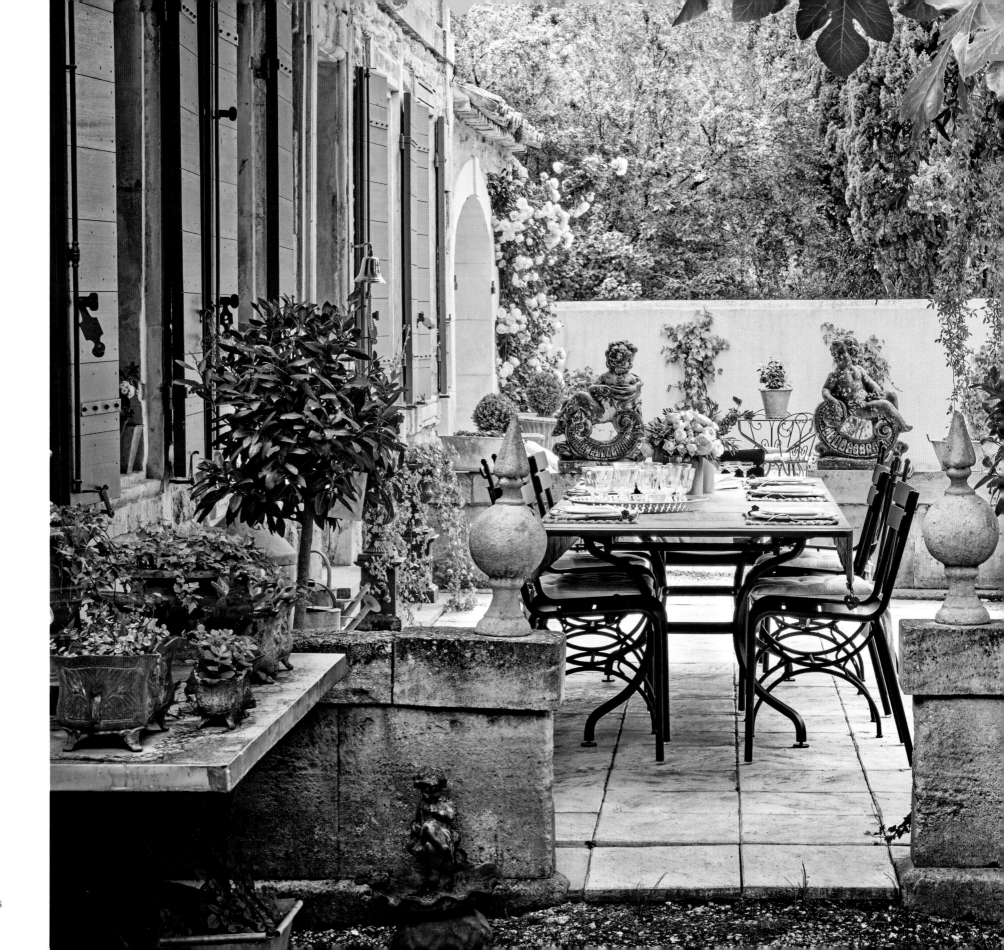

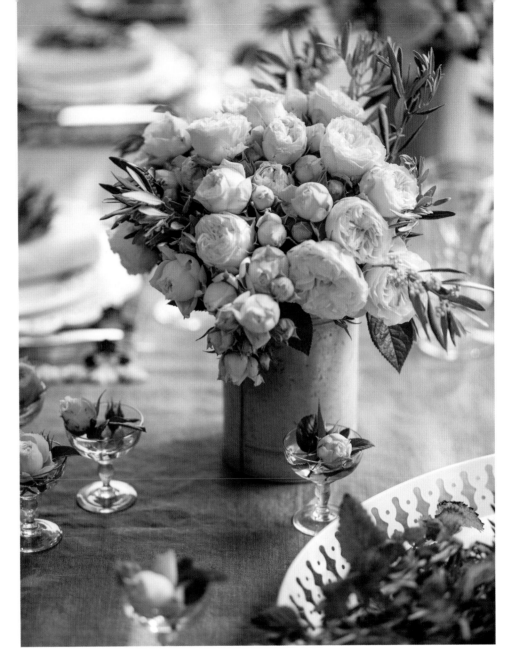

"My wish is to always stay like this, living quietly in a corner of nature."

—Claude Monet

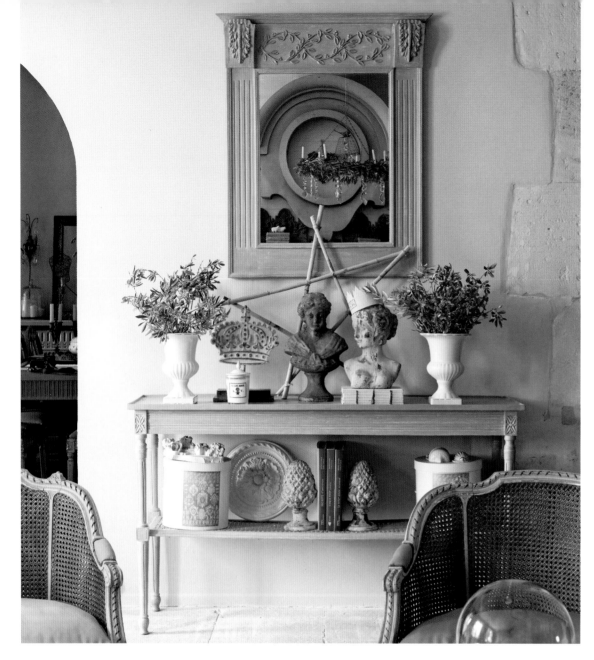

Left: Anne chose a serene color scheme of white, beige, and gray for both the main house and the annex. The front entry's vignette comprises a collection of objects in that same hushed palette, punctuated with fresh flowers and foliage gathered from the verdant grounds. Below: Sun hats bearing the estate's name were made in Morocco. Opposite: Nestled among the property's olive trees, the old-fashioned vegetable garden is home to the couple's brood of gray Silkie chickens.

In the annex, a lovely white-painted desk is framed with a brace of Louis XVI chairs that Anne discovered in a *brocante*, and two timeworn doors were given new lease on life with a coat of gray paint.

Taking advantage of the property's beauty, the indoor living space spills outside, with a dining room on the main terrace and a cozy reading area beside the pool house. An outdoor kitchen, where the couple takes their meals on balmy days, is also used as a workspace for assembling fresh-cut bouquets. Combined with an organic vegetable garden brimming with berries, vegetables, and heirloom tomatoes, and gray Silkie chickens pecking about, Anne and Philippe are truly living *la belle vie* in the heart of Provence.

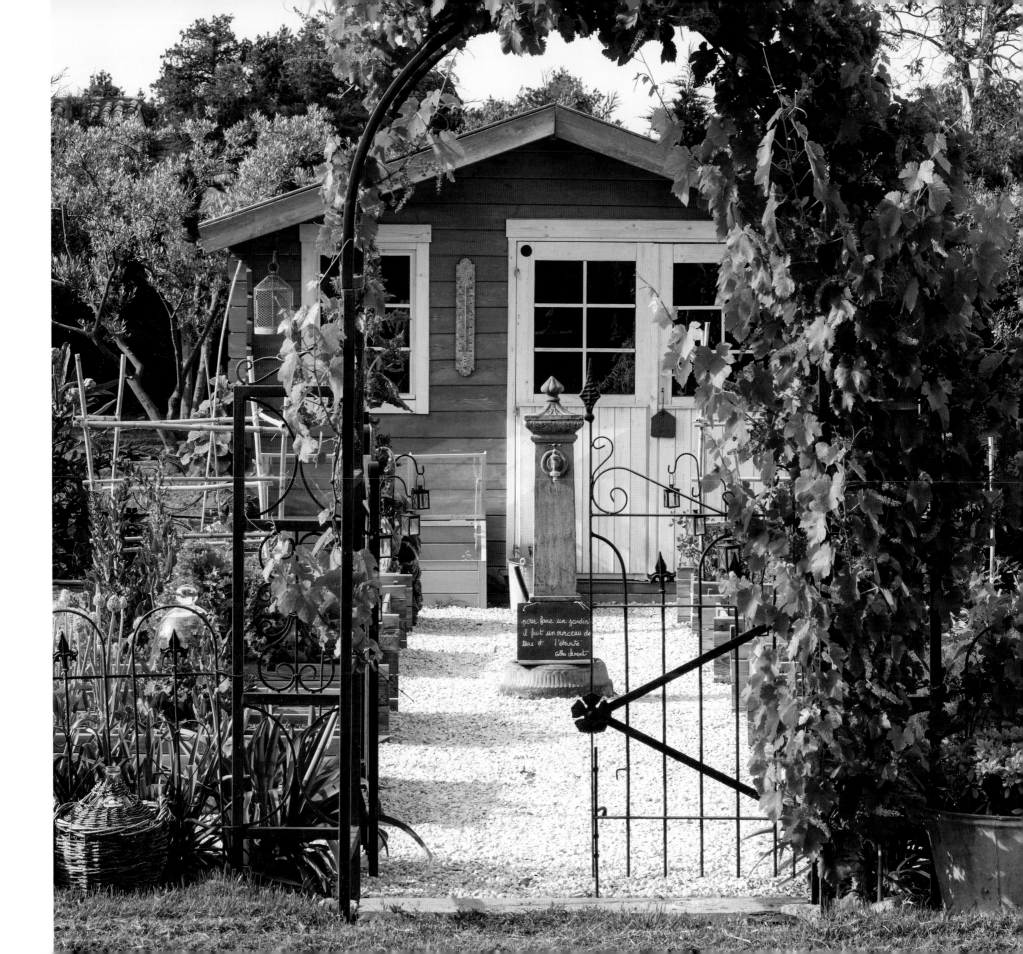

FLUENTLY
FRENCH

The French are known for their love of things with a history, respect for tradition, and sense of comfort, as well as a talent for designing exquisite interiors without spending a fortune. These elements translate into a decorating style inspired by age-old patinas, time-honored materials, natural textiles, handmade accessories, and a passion for flea markets—a custom rooted in nineteenth-century Paris, when *chiffoniers* (junk merchants) migrated away from the city center to sell items the Parisian bourgeoisie had discarded.

Even today, French homeowners pride themselves on furnishing their environs with pieces gleaned from consignment merchants, secondhand shops, and tag sales. These weekly scouting adventures are as much a part of their culture as croissants. The owner of a chic but cozy home near Avignon, Sylvie Sommer says, "Even if I don't need anything, I look forward to the possibilities. There is an endless supply of great pieces with charm and personality, and the price is always right!"

When searching for relics of all sorts, Sylvie looks for items with the textures and styles she favors rather than being concerned with their pedigree. A savvy shopper, she recognizes the importance of keeping an open mind. "Finding the pieces I love is one thing, but

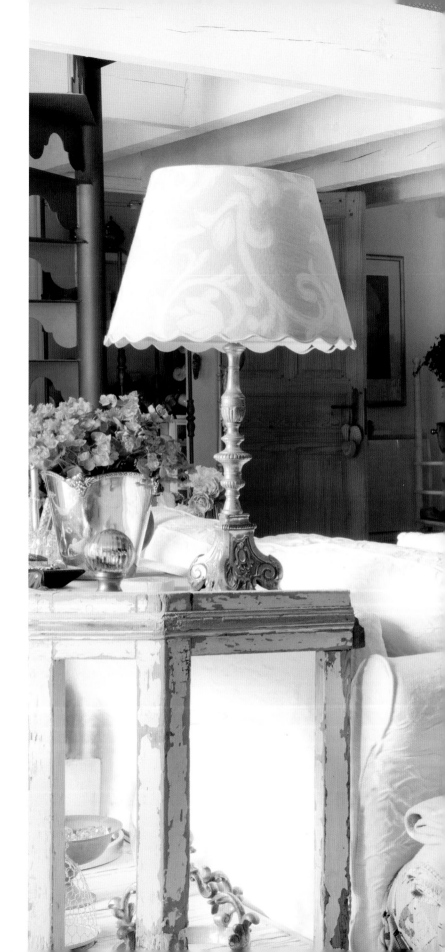

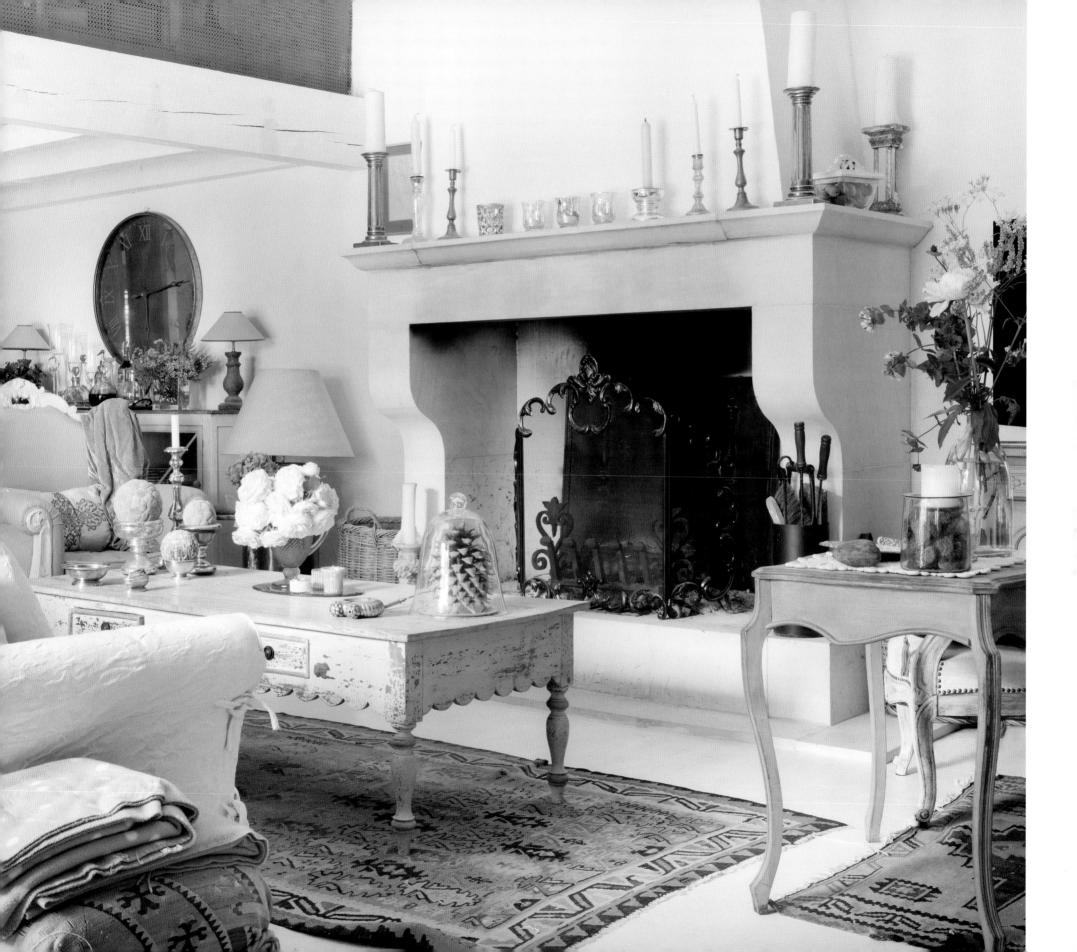

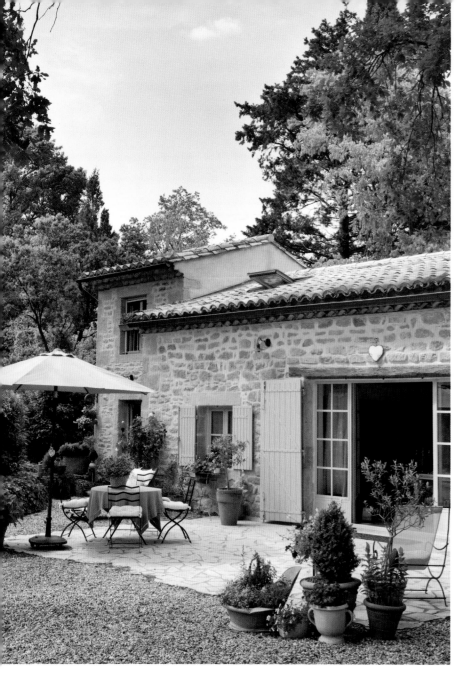

Sylvie Sommer's welcoming home, La Petite Bastide, is decorated in her exuberant style, with tag-sale and flea-market finds dominating the décor. She has an eye for discovering the hidden potential in a pre-loved object.

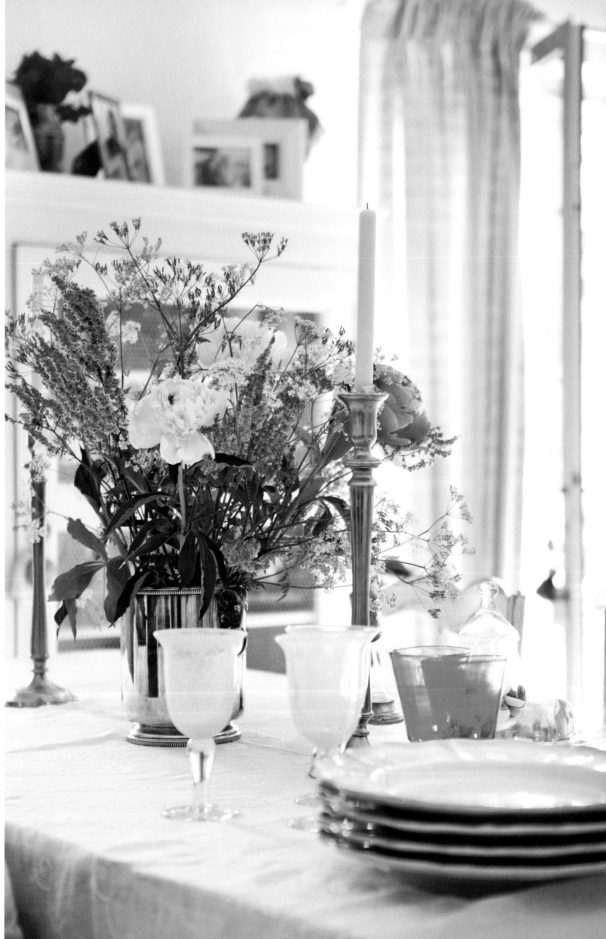

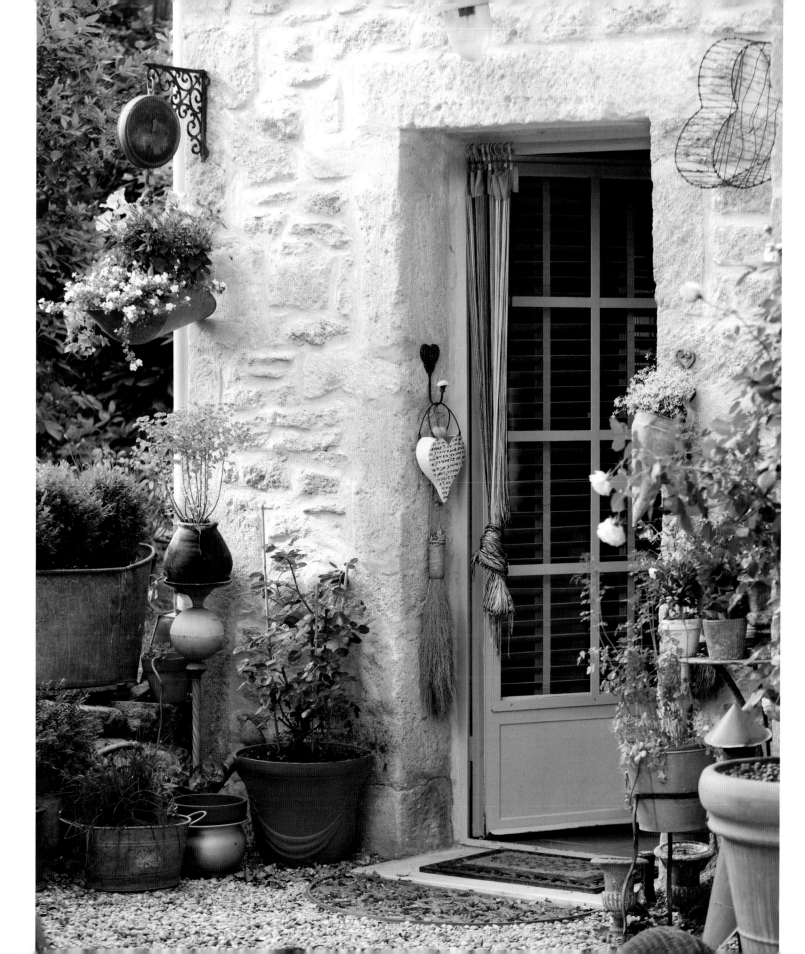

Right: The soft ivory hue of the limestone cottage offers a perfect backdrop for Sylvie's cache of wares, procured on her many treasure hunts. Here, an antique scale finds new purpose as a display for flowers, while a variety of other containers perform the same task, adding to the overall charm of the home and garden.

Below left: In the bath, an old sideboard was refinished and fitted with a round vessel sink. Baskets keep toiletry essentials elegantly organized beneath, while an antique chandelier and a pair of sconces bring refined glamour above. Right: A vintage water bottle doubles as a vase for a cheerful bouquet, freshly snipped from the garden. Opposite, right: Coats of pristine white paint perform magic on a reclaimed four-poster bed. Covered with an intricately stitched quilt and adorned with a collection of beautifully wrought pillows, this cozy spot promises sweet slumber.

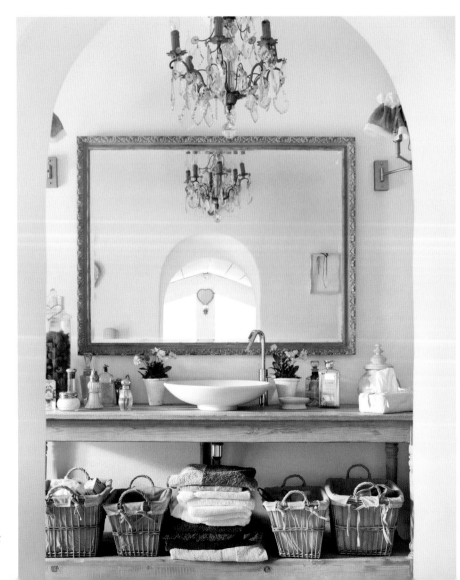

finding them with the finish I want is another," she explains. "Often, they have the right lines but the wrong color or fabric. That's when I do them over."

Some living-room armchairs she found, for example, initially had only dark wood and velvet upholstery in common. Undeterred by their appearance, Sylvie bought them on the spot and then transformed them to suit her design scheme, using her go-to techniques of painting and reupholstering. "When putting together a room, periods and styles are irrelevant," she maintains. "What matters is creating an inviting look layered with character and personal style. There are no hard-and-fast rules—except one: the desire to give an old piece new life, even if it means giving it a new look."

Sylvie's inherent talent for implementing this principle is evident in her home. With its soothing palette and imaginative décor, it is a tribute to simplicity, elegance, and ingenuity.

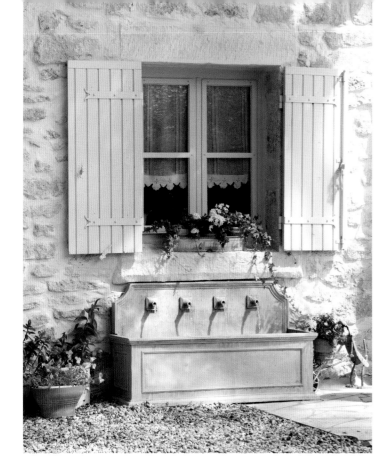

"When putting
together a room,
periods and styles
are irrelevant. What
matters is creating an
inviting look layered
with character and
personal style."

—Sylvie Sommer

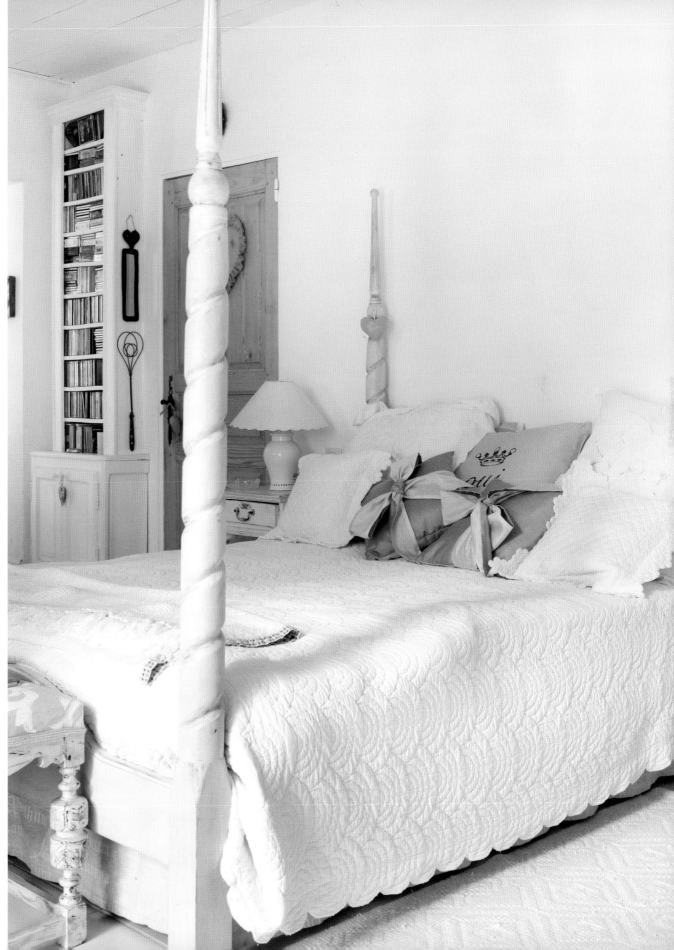

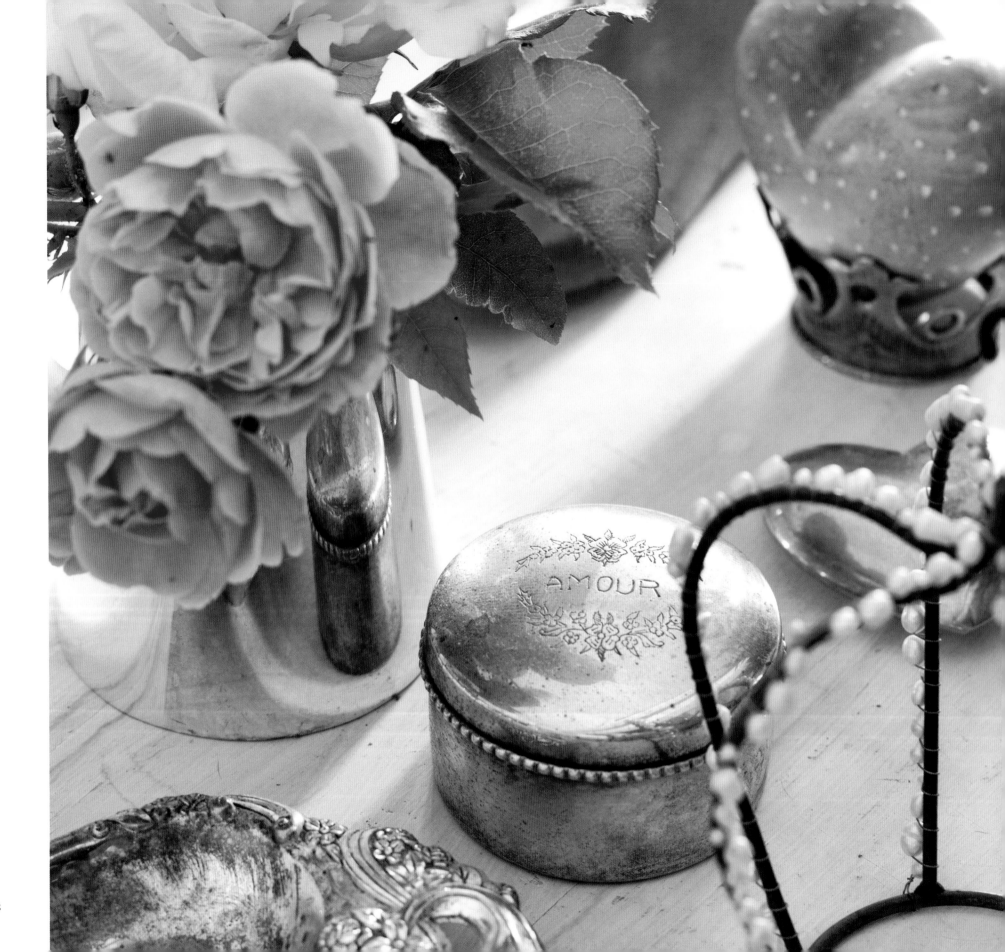

Above left: Proving that even tiny spaces can be utilized, Sylvie, a needlepoint enthusiast, set up a little sewing area beneath the eaves, decorating it with a few of her favorite things. Above right: Pen-and-ink sketches hang over a rustic pine chest. Below right: The aromatic fragrance of lavender wafts from whimsical heart-shaped silk sachets.

AN AMERICAN
IN PARIS

Corey Amaro's life reads a bit like a fairy tale. More than thirty years ago, the Californian fell in love and moved to France to begin her new life with the man she affectionately refers to as "French Husband." Upon their arrival, he proudly presented a tiny 7th-floor apartment in Paris's coveted 14th district—and she was speechless at the sheer emptiness of it.

"I stared at it with my mouth wide open," she relates. "There was no furniture, a kitchen smaller than a teacup, and a bathtub with a huge skylight above it." Having inherited her mother's talent for decorating with vintage items, Corey quickly asked if any secondhand shops were nearby.

Eager to accommodate his new bride, her spouse steered her to the country's famed *brocantes* (antiques fairs) and *marché aux puces* (flea markets). "Those were the first French words I learned," she says, "and ones that would hold my heart close to France forever." With her first foray into the markets, she began collecting the "feather-fluff" that transformed her three *chambres de bonne* (maids' rooms) and a hallway into an enchanting and inviting home.

The couple later moved to Provence, where they raised two children, but her devotion to "worn-true objects" never waned. It wasn't long before this house was bursting at the

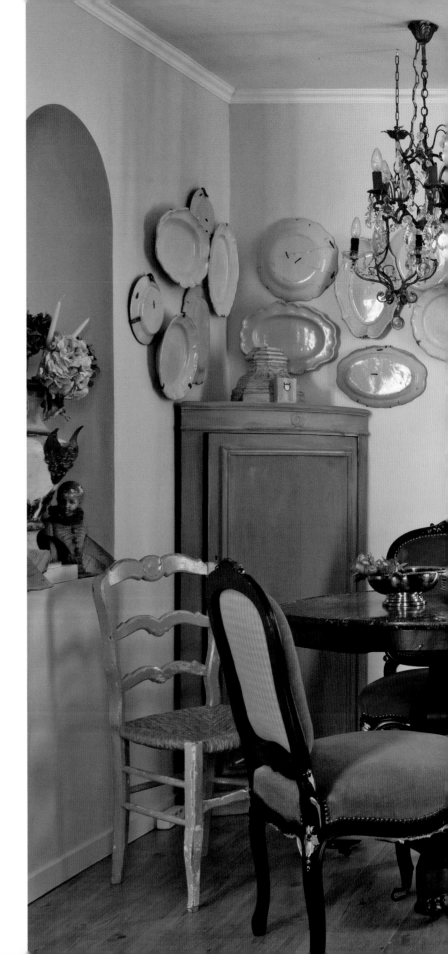

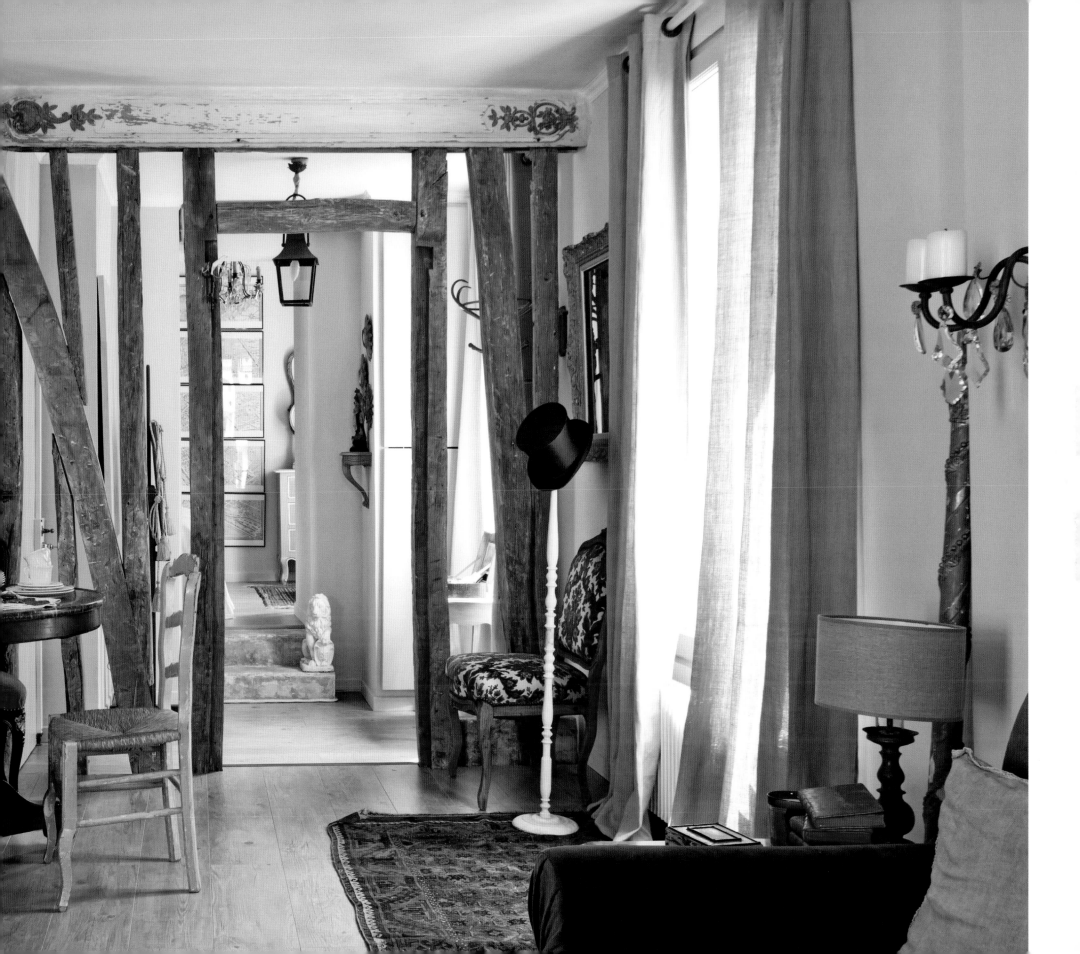

This page and opposite: Corey Amaro designed the kitchen to blend in with the living and dining areas since the three are one open space. She freely mixes periods and textures, valuable items with lesser-priced ones to achieve a bespoke look that defies style boundaries. The rare chinoiserie coffee table and massive crystal chandelier blend beautifully with more modest ironstone platters and pewter pieces. She also collects old maps of Paris, some of which she has framed and hung in the bedroom.

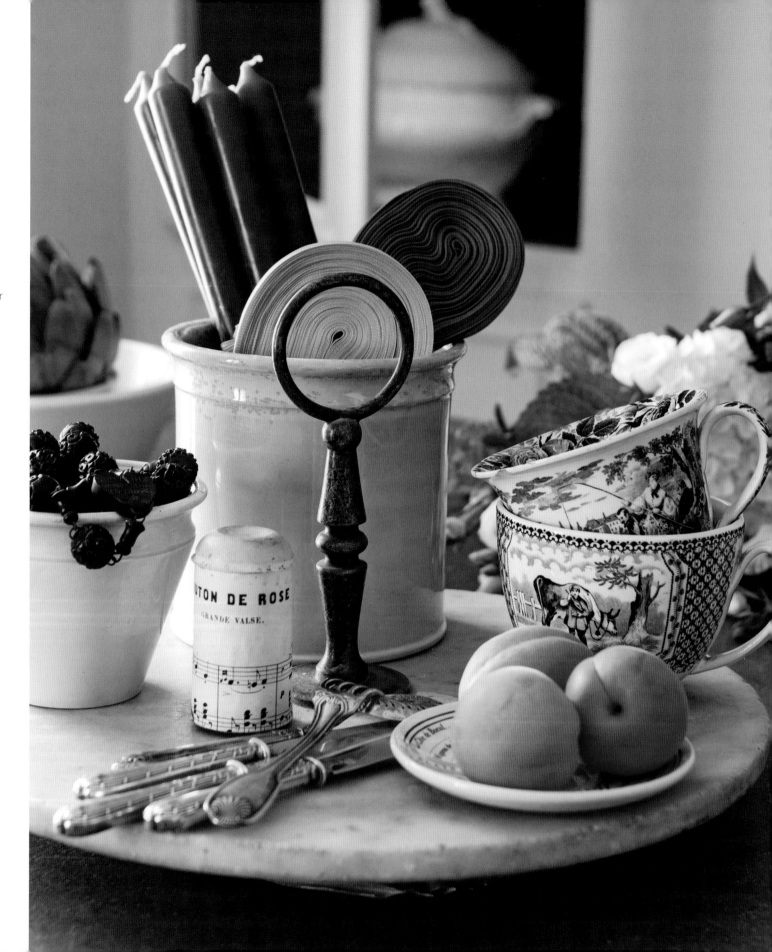

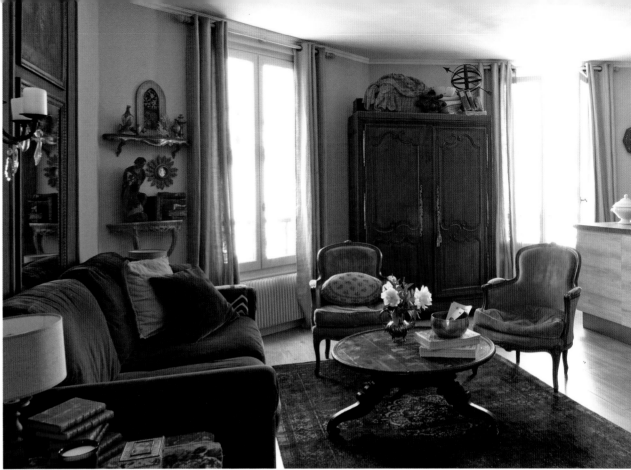

HISTOIRE DE PARIS

LE TEMPLE DE LA GLOIRE

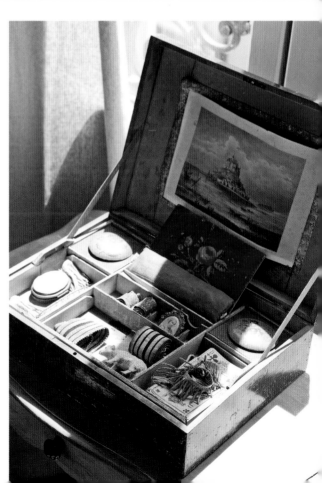

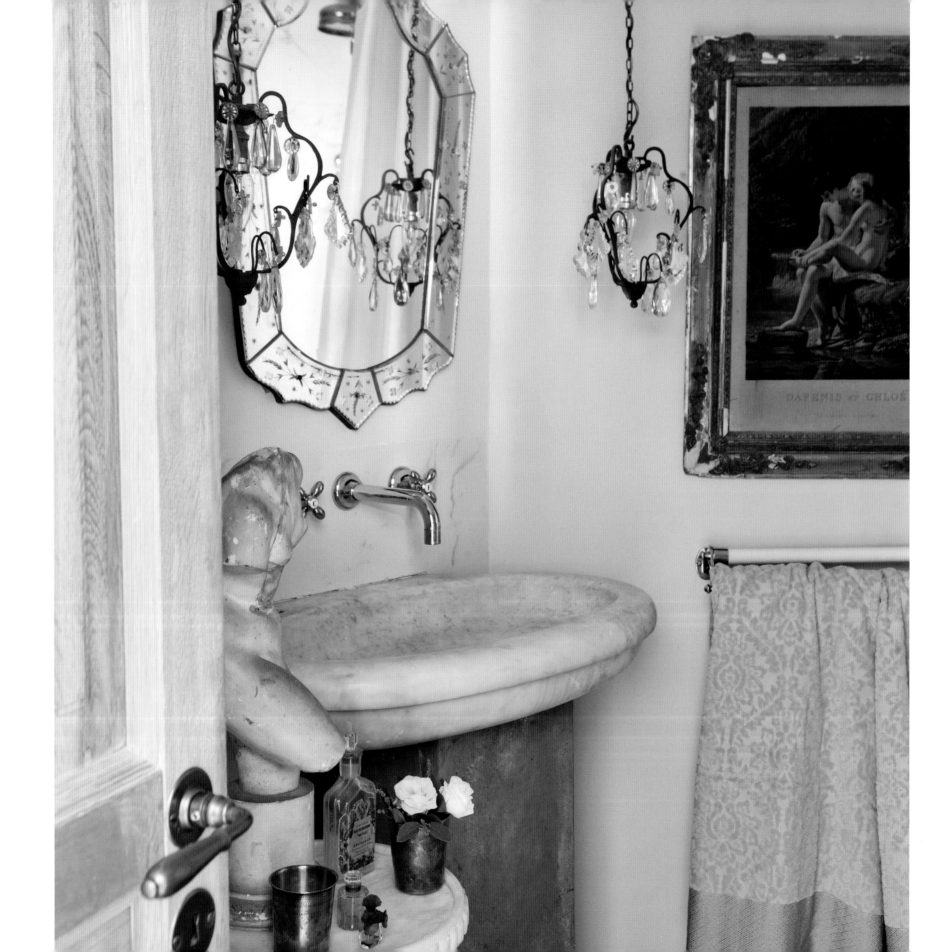

seams with an eclectic assemblage of treasures, prompting Corey, author of the popular blog *French La Vie*, to pare down this acquired inventory through her online shop, French la Vie Antiques. She also leads small groups visiting France during guided experiences where she procures "anything with a sparkle in its eye" for those who share her affinity for bygone Gallic goods.

Corey and her husband recently renovated their current Paris apartment to use as a pied-à-terre when in town. The home is filled with memories—not just hers and her family's, but also those that have settled into the very grains and fibers of all the pre-loved pieces that have changed hands through countless generations. Linens and letters, books and paintings—Corey sees the value in each heirloom, whether it is in perfect condition or bears the cracks and chips of age that cause others to pass it over. In fact, it's the castaways she loves even more. "No one could ever say that I am practical," she says. "But, then, beauty has a heart of its own, doesn't it?"

Opposite: Curated treasures, such as the Venetian-glass mirror in the bath, fill the home with ageless charm. This page: Old-World style prevails in the lone bedroom, where fine antique linens and pillows stitched in needlepoint or appliquéd with remnants of Aubusson textiles garnish the bed.

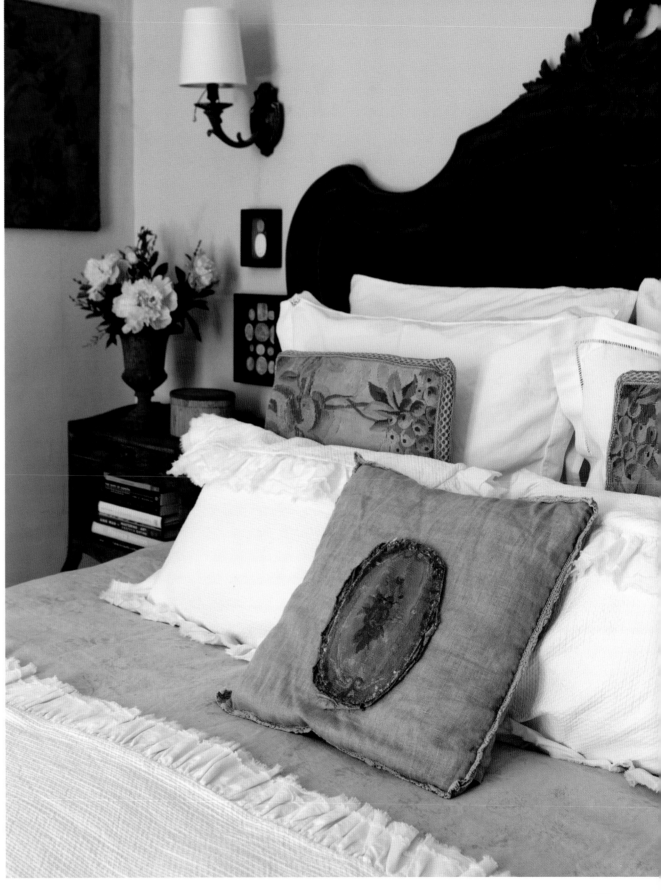

FABLED
GALLIC FINDS

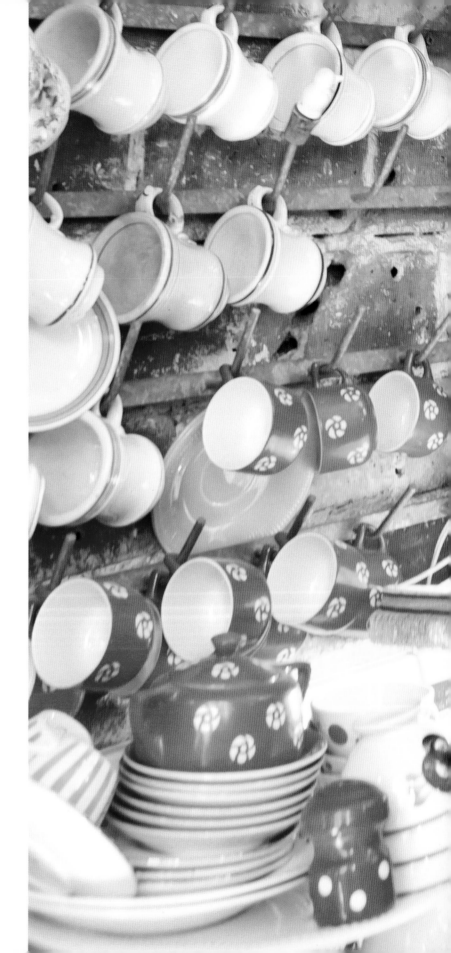

In the heart of the ancient Gallic district of Montmartre—
known today for its quintessential Parisian cafés and boutiques—L'Objet qui Parle (French
for "items speaking") draws passers-by into a fanciful setting that brims with gleaming
chandeliers, baroque mirrors, and exquisite china. So replete is this tiny emporium,
furnishings spill beyond its doors and onto the sidewalk. Amid classic keepsakes are avant-
garde surprises, including weathered marionette puppets and a range of taxidermy displays.

Such intriguing tableaux befit the artistic heritage of the hilltop village. At the turn of
the twentieth century, many of the world's most renowned painters maintained studios in
the area. Although the neighborhood declined following the golden era that brought the
likes of Salvador Dalí, Claude Monet, and Vincent van Gogh to its cobbled streets,
L'Objet qui Parle proprietor Guillaume Bernard has witnessed a revival in the community
since opening his shop more than three decades ago. Among his clientele, a number of
photographers, sculptors, and theatre directors come calling in search of authentic period finds.

Formerly a fashion designer, Guillaume shifted his focus to antiques in the 1980s and
found immediate success by participating in a prestigious Paris flea market. A few years
later, he secured a permanent home for the business but took several months more to give

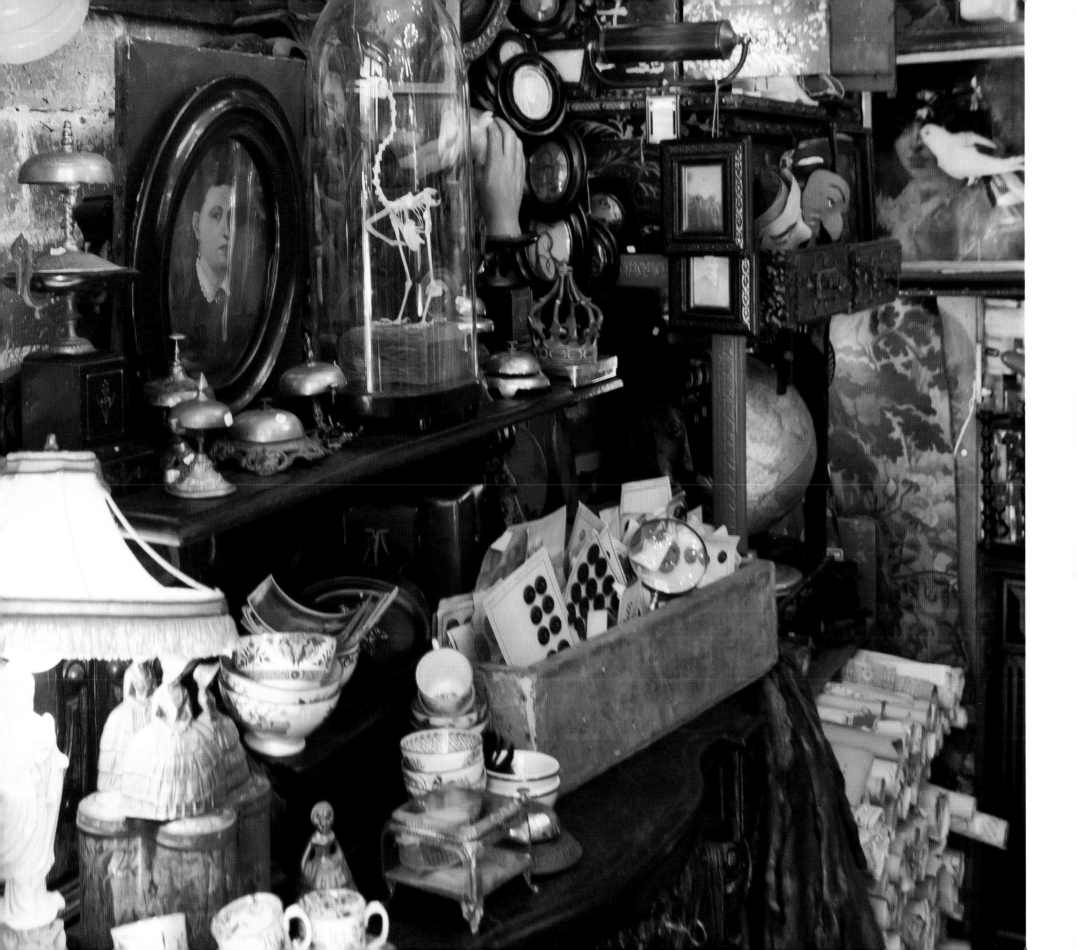

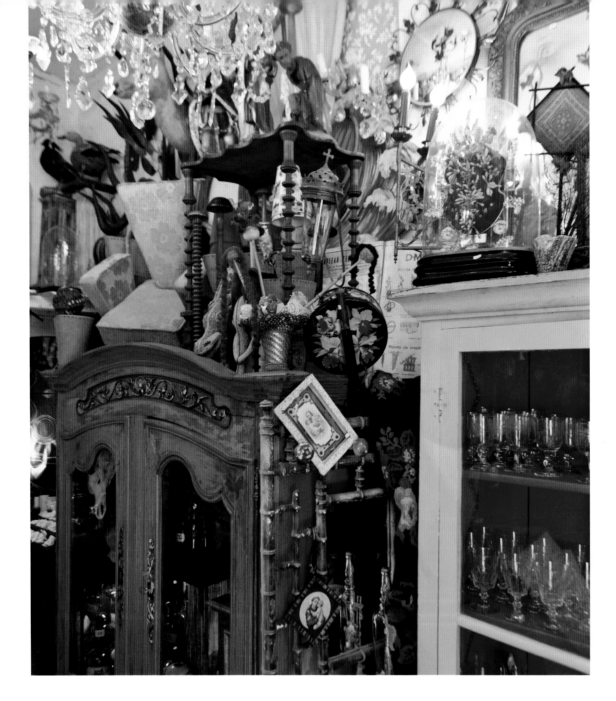

L'Objet qui Parle patrons often appear transfixed—standing completely still and silent—as they attempt to absorb the contents of this brimful shop in the Montmartre area of Paris. Proprietor Guillaume Bernard takes pleasure in scouring the French countryside for antiques unmarred by the passage of time. Beaux-Arts paintings and triptych mirrors keep company with crystal chandeliers and kilim rugs, not to mention an impressive array of dishes, glasses, and silverware.

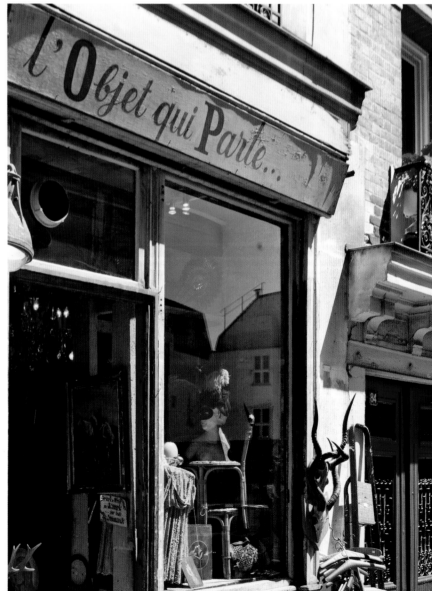

it a proper name. Supporters ultimately suggested L'Objet qui Parle—a moniker that reflects their sentimental attachment to the store's wares. "Objects tell stories and evoke their own memories for each person," the Frenchman explains.

Guillaume's girlfriend, stylist Catherine Malaure, arranges the vignettes that captivate locals and tourists alike. Customers looking for a unique conversation piece quickly discover something to talk about in the shop itself—a one-of-a-kind cache of treasures that will not soon be forgotten.

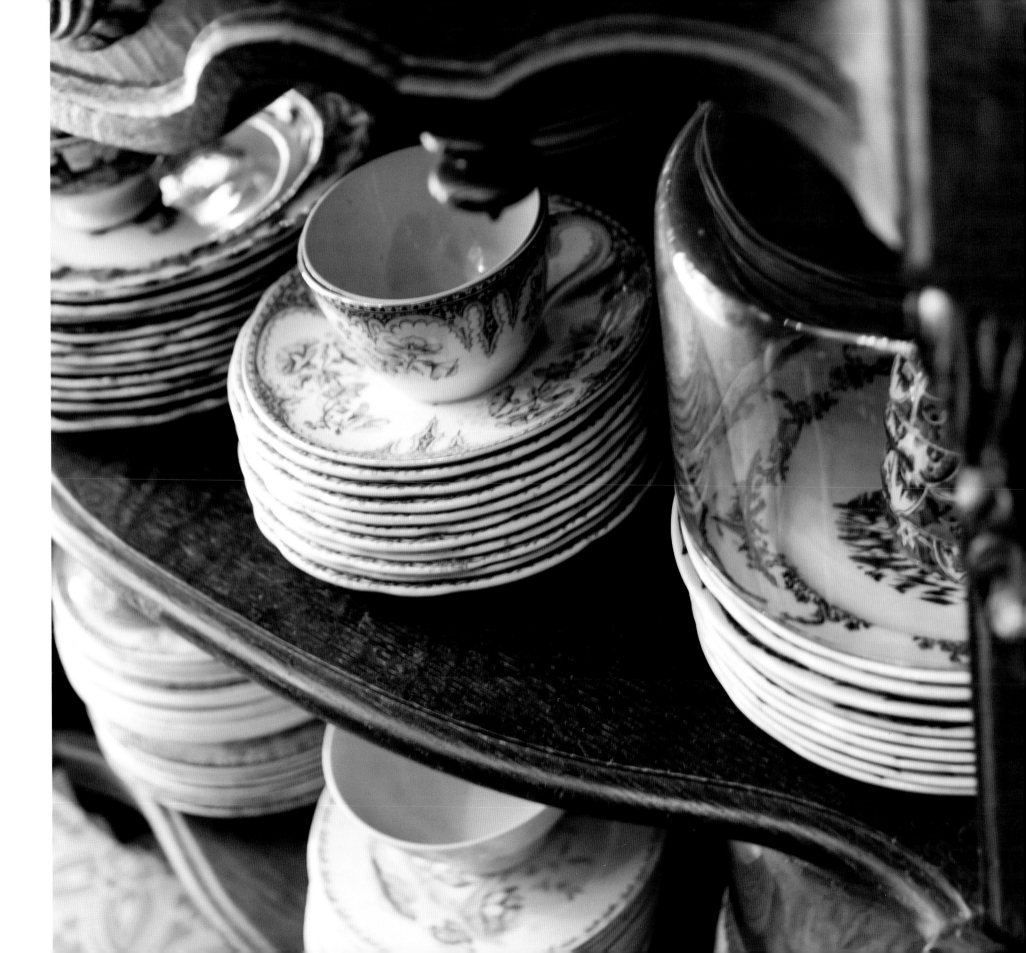

The Venice of Provence

Just a few kilometers from the Sorgue river's source in Fontaine-de-Vaucluse, the translucent waters branch into two equally crystalline streams at the Provençal town of L'Isle-sur-la-Sorgue. The river once served as a moat to the long-gone ramparts that protected the village, and it was the heart of industry for residents. Artisan mills sprang up along its banks, turning out paper, textiles, and more.

Moss-covered waterwheels still turn in L'Isle-sur-la-Sorgue, and quaint flower-box-lined pedestrian bridges cross the canals that give this lovely burg its nickname, "Venice of Provence." Grand mansions, once belonging to wealthy merchants, remind visitors of its past, but these days, there is a different draw, one that turns the town into a carnival every Sunday of the year.

Second only to Paris as an antiques hub, L'Isle-sur-la-Sorgue is best known for the sprawling market that spills from the town center each weekend. Savvy shoppers will arrive early—the *brocante* is in full swing by 9:00 a.m.—and pack their patience, as this weekly event attracts huge crowds enticed by the sheer number of offerings.

Though patrons will find plenty of treasures, along with Provençal-inspired wares, among the more than three hundred stalls, they will also discover bins holding crusty baguettes, fresh produce, and wheels of cheese. After making their purchases, buyers can wander through the town's winding streets, where tempting outdoor cafés offer ideal spots to refresh and reflect on the day's favorite acquisitions.

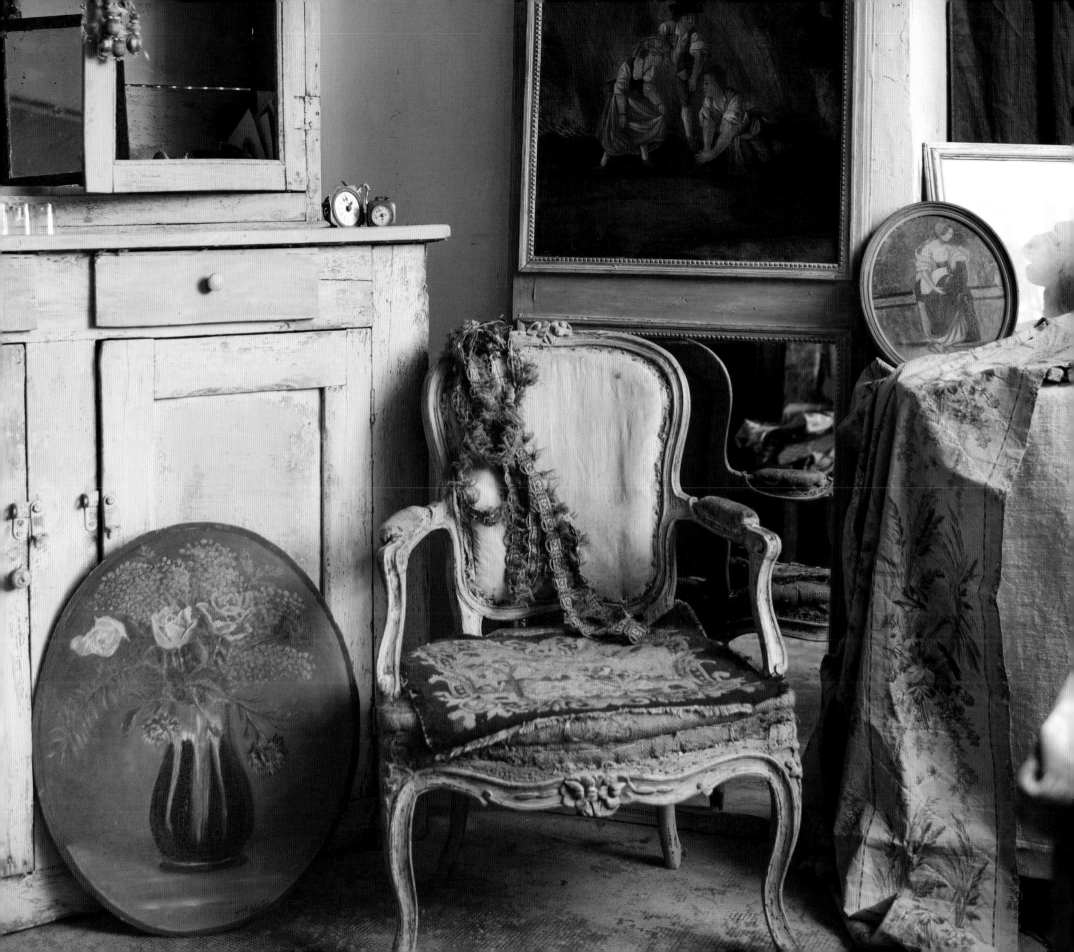

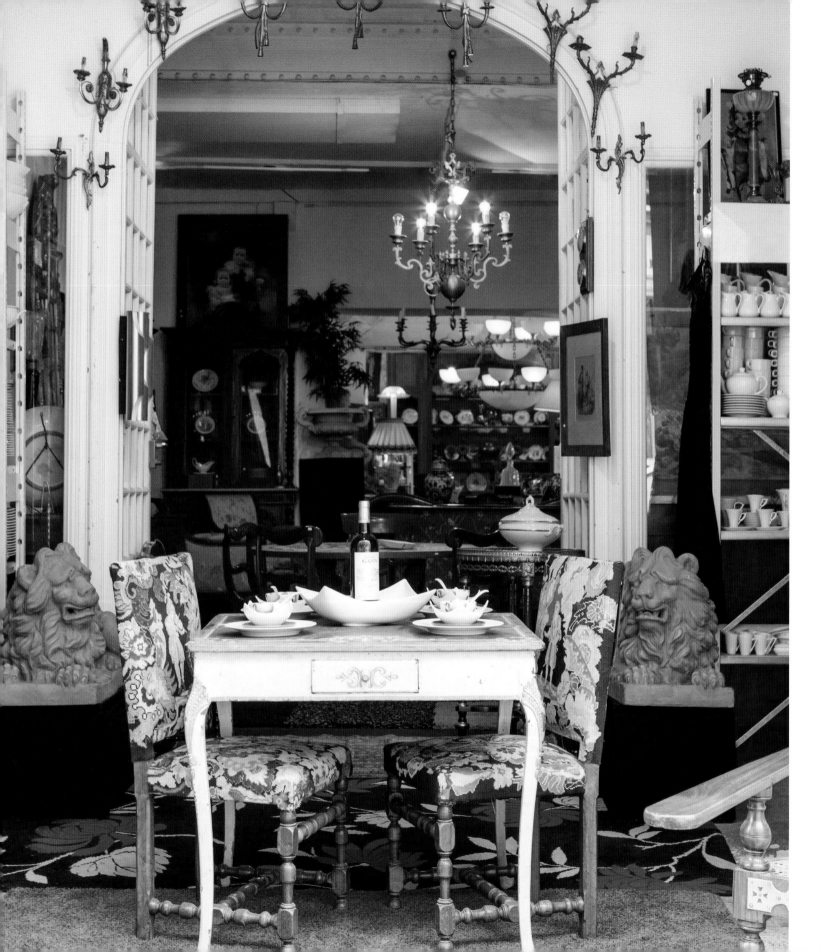

Favorite Sources

Culturally reimagined, Bordeaux has emerged as a shopping mecca. The Chartrons district, often referred to as The Village, has become a haven of bohemian treasures. Twice a year, the neighborhood hosts the city's oldest flea market, the vast Brocante des Quinconces. Opposite: Along Rue Notre Dame, renowned for its antiques dealers, find troves of china, furnishings, botanicals, and art at Pipat Antiquités (above left and below left) and Hors Saison (this page, left). Opposite, right: The République quarter of Marseilles brims with shops, including Acanthe Antiquités.

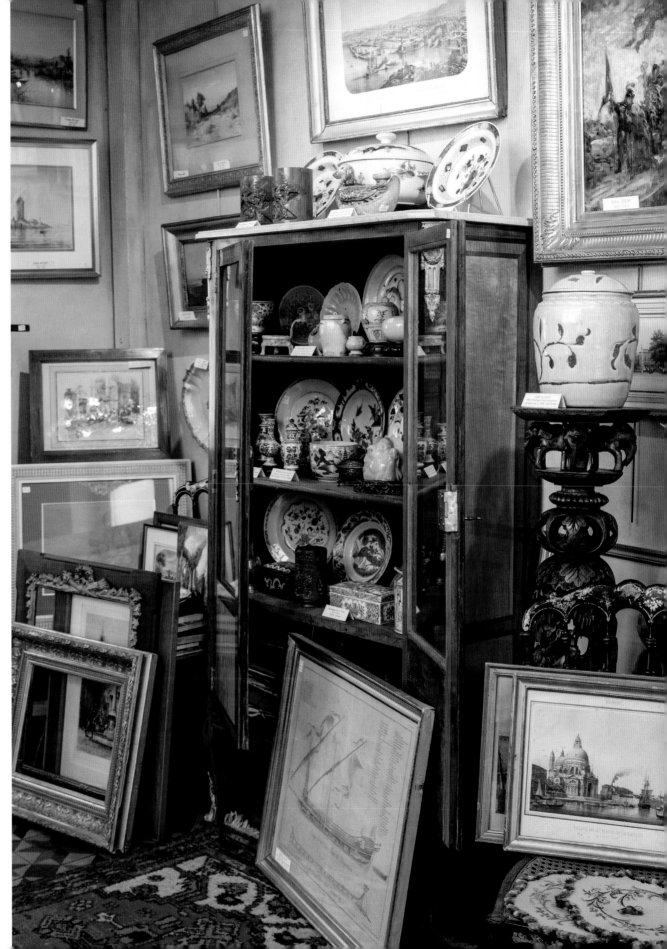

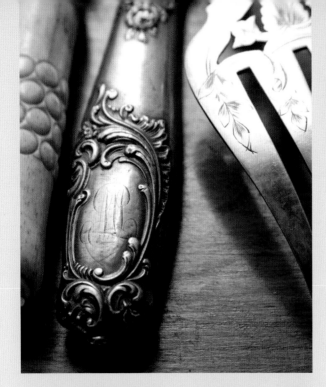

Le Petit Cabinet de Curiosités

Mélanie Aussandon's passion for timeworn treasures began when she was just a little girl. "My childhood bedroom was furnished with antiques—even the bedding and curtains my mother fashioned were vintage textiles," she says. "When I graduated from high school, I wanted to go on vacation to the United States. My parents gave me some old things to sell at the *vide-greniers* (flea markets), and I made enough to pay for my trip. As long as I can remember, antiques and I have walked hand in hand."

After completing studies in art history, it was a natural progression for Mélanie to open her own shop. Le Petit Cabinet de Curiosités is located in a centuries-old apartment building in Aubagne, a small village in the South of France. The rooms are decorated with a collection of Provençal wares handpicked and arranged by Mélanie, including charming aprons and hats. Her sources include estate sales from châteaus and convents.

"Antique oil paintings of the Mediterranean are what I love most," she says. "My roots, my culture run along the shores. I dip my hand in the bounty that this landscape offers me. I am fortunate to live in such a place that allows my passion to be my livelihood."

Mélanie also specializes in eighteenth- and nineteenth-century gilded mirrors, textiles, crystal chandeliers, and religious artifacts. "My clients want authentic antiques that have traces of old patine and history," she says. "They trust my eye to read the story that such pieces have left behind."

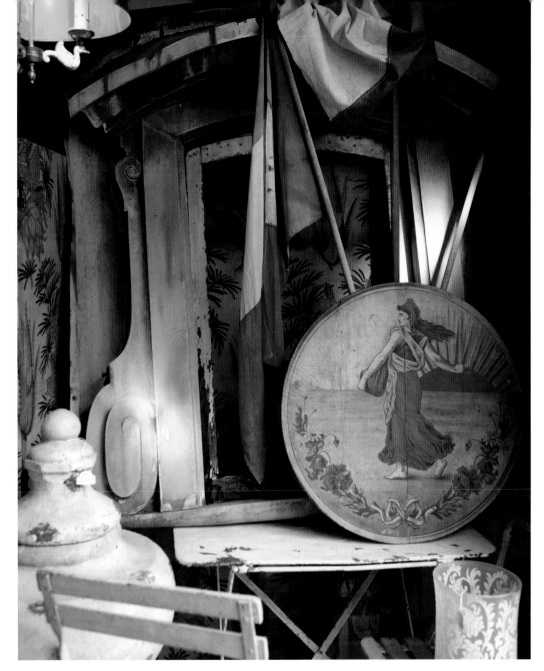

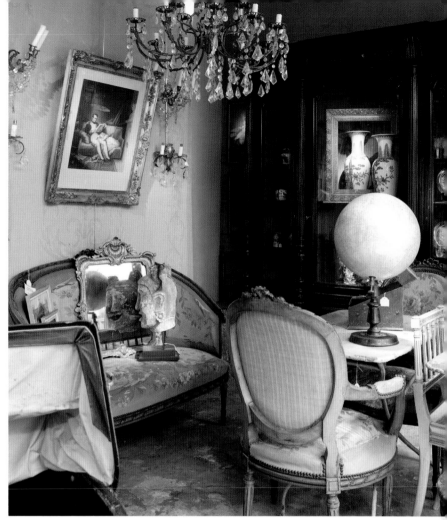

Above, left and right: Brimming with a covetable selection of nineteenth-century antiques and decorative furnishings, Paris's L'Avant-Cour is an owner-described "joyful mess" where patrons can browse finds from the world over. Below right: Shoppers who adore French country ambiance will be in heaven at EW, a neighboring store that is covered wall to wall in all things vintage, from enamelware and tableware to old samplers, linen, and lace.

195

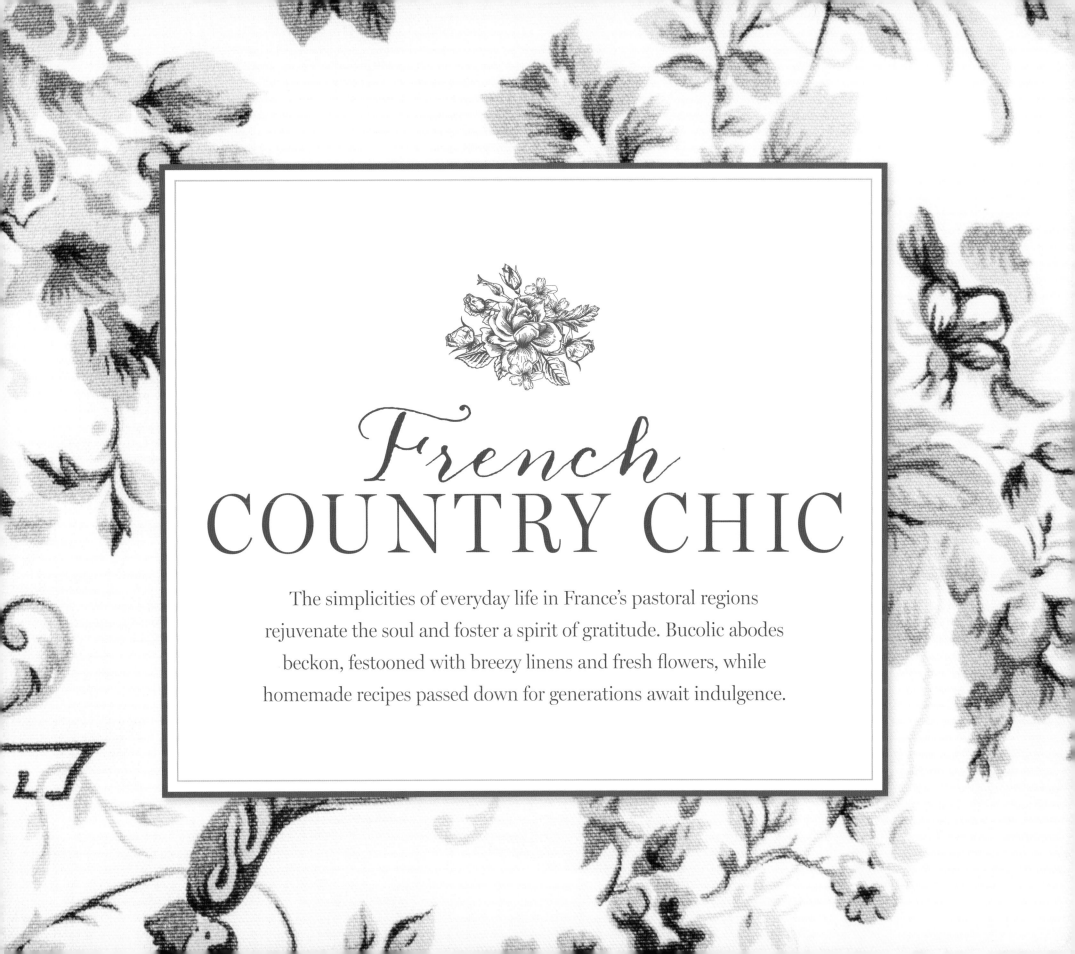

French
COUNTRY CHIC

The simplicities of everyday life in France's pastoral regions
rejuvenate the soul and foster a spirit of gratitude. Bucolic abodes
beckon, festooned with breezy linens and fresh flowers, while
homemade recipes passed down for generations await indulgence.

VINTAGE FRENCH CHARM

When she spotted the feed sacks at an antiques market, Brenda DeWitt knew that she had found the centerpiece for Chelsea Cottage. "I wanted the space to be beautiful and durable. I wanted guests with children and dogs to feel comfortable," she says. "That is why I love feed sacks—they are sturdy yet inviting."

Repurposed as curtains, pillowcases, and lampshades, and used in the dog bed that Brenda created, they are just one example of her eye for the possible. After she and her husband, Tim, bought their 1940s bungalow, they tore down a dilapidated detached garage in the backyard to make room for a guest cottage and an oak-shaded courtyard. Now, the welcoming retreat houses a trove of found objects and salvaged furniture that echoes the soft and subtle reds of the feed sacks and makes the place feel like home.

Whether distressing the front door to achieve the perfect patina or reupholstering armchairs she bought for a song, Brenda realized the Gallic charm she was looking for with her own two hands. The DeWitts did most of the work themselves—from drawing up blueprints to building the countertops and hanging the tongue-and-groove walls.

Because of the couple's hands-on approach, no corner of the 20x20-foot structure is wasted, and each design decision sings with purpose. A plate rack displays and stores the cheery dishes used by guests during their stay, for example, and an old metal washbasin finds new life as a sink.

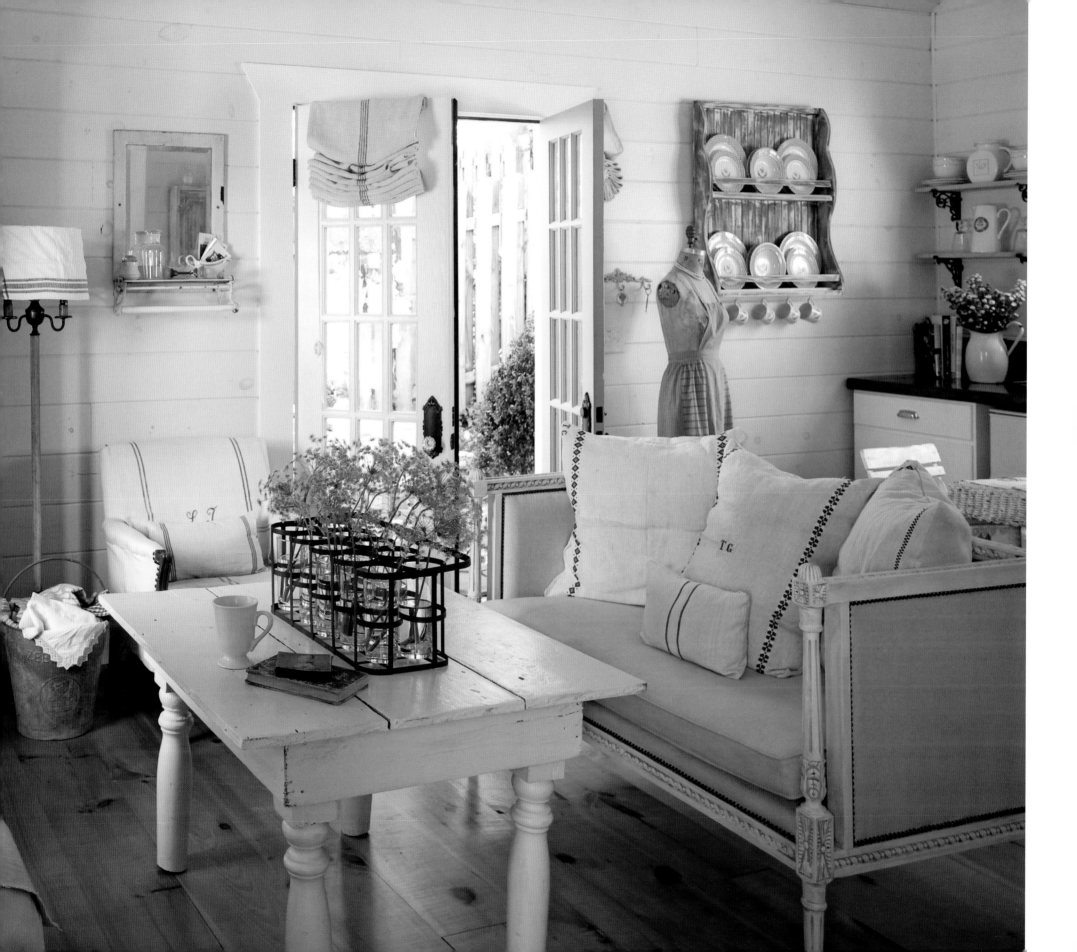

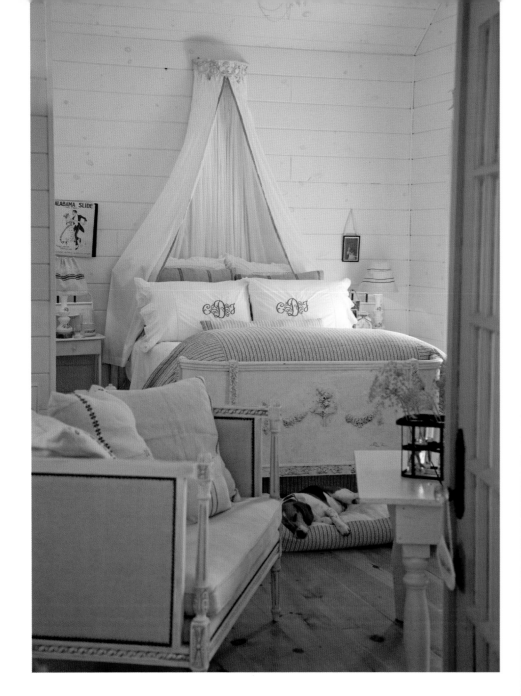

Left: A white palette with red accents ties together this room's furniture, linens, and found objects. The bed's crown is a simple shelf turned upside down. Below: A collection of antique French textiles, fresh from the clothesline and scented with sunshine, are ready to put away.

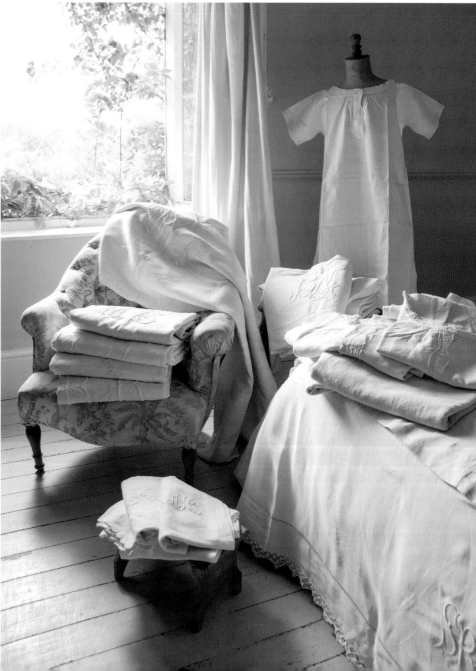

"The floors are pine, so they will age beautifully. I like things that are worn but lasting," Brenda notes. "I don't care if dogs run across the floor, or if a friend in high heels scuffs it—that gives a place character. I love the imperfections."

The pine floors and found pieces bestow the cottage with a cozy warmth, while the linens, high ceilings, and large casement windows keep the space open and airy.

"For me, a cottage should be a sanctuary," Brenda says with a smile. "When the outside world is crazy, we need somewhere peaceful to go."

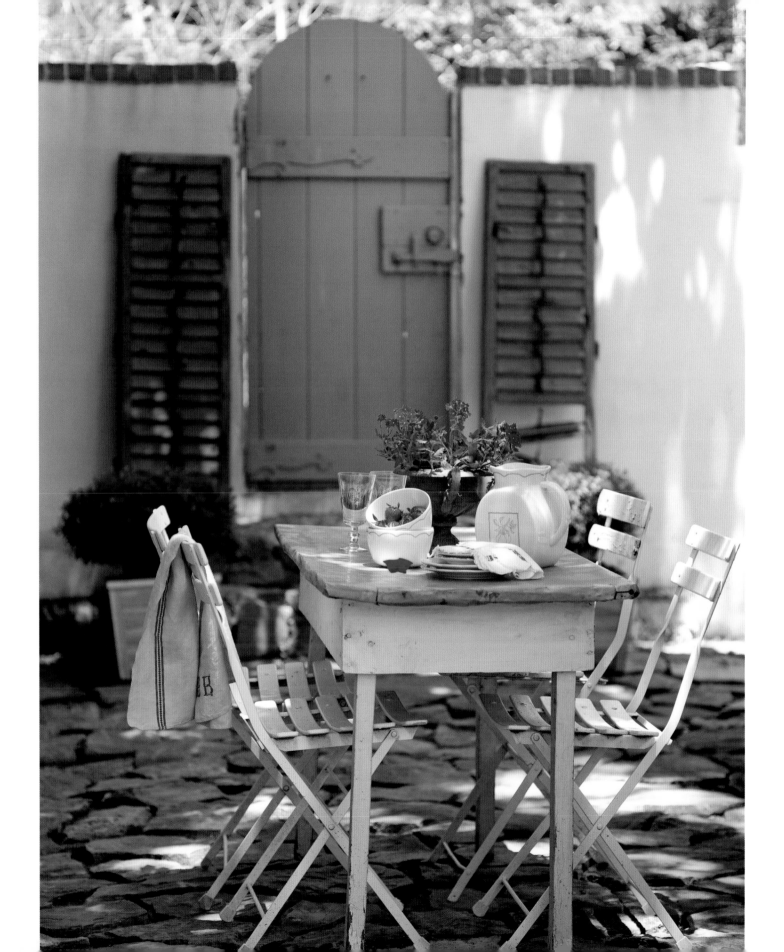

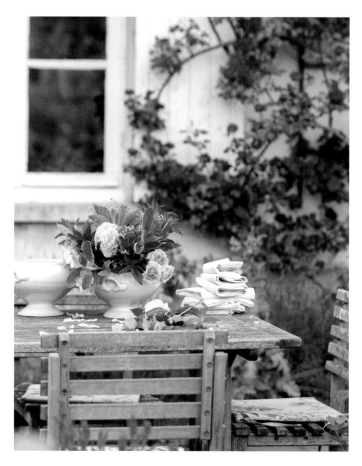

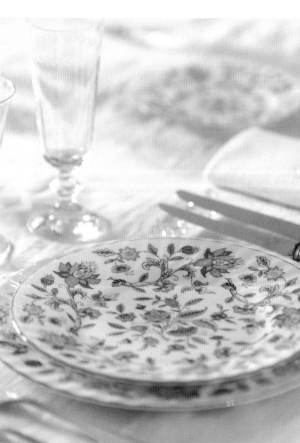

Opposite, clockwise from below left: European grain sacks, with their cheerful red-and-white color scheme, can be used for a variety of accessories, such as this monogrammed pillow. A pair of white ironstone pitchers offers the perfect impromptu vessels for sweet bouquets gathered on an afternoon stroll through the countryside. Stitched on linen, the tone-on-tone portrait of a hen's life cycle is a charming accent piece. Mounting a vintage shelf below a bathroom mirror allows for the display of an eclectic medley: wine corks, a glass doorknob, and vintage photos tucked in a gravy boat. Pretty floral china turns an everyday dinner into a special occasion, as does serving even the simplest of meals outdoors in the garden.

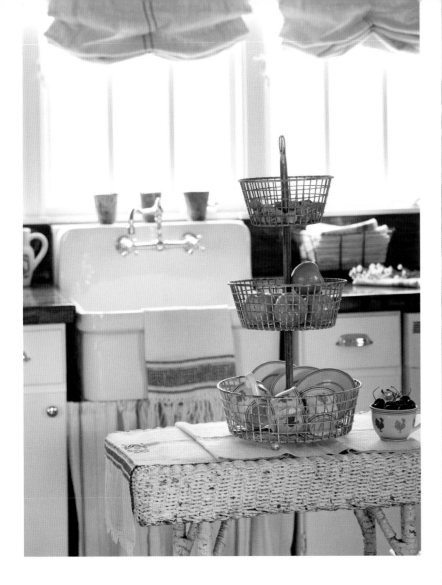

Opposite: *Brocante* devotees rejoice when coming across vintage feed sacks, which can be used for everything from pillow shams to shades for antique, china-based lamps. Old photographs add instant charm to any space, especially when hung with a simple loop of twine. This page, above: In the kitchen, more grain sacks appear as a table runner and window shades. Dishtowels and curtains are hung to create a storage space beneath the sink. Right: Rambling roses clamber up a trellis beside the front door, almost hidden behind a delightfully overgrown cottage garden.

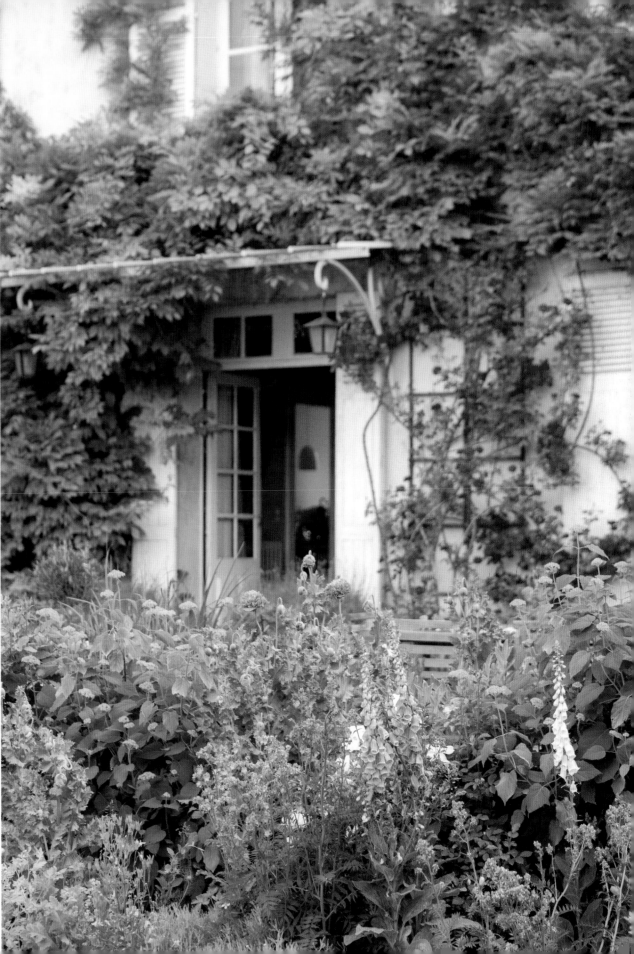

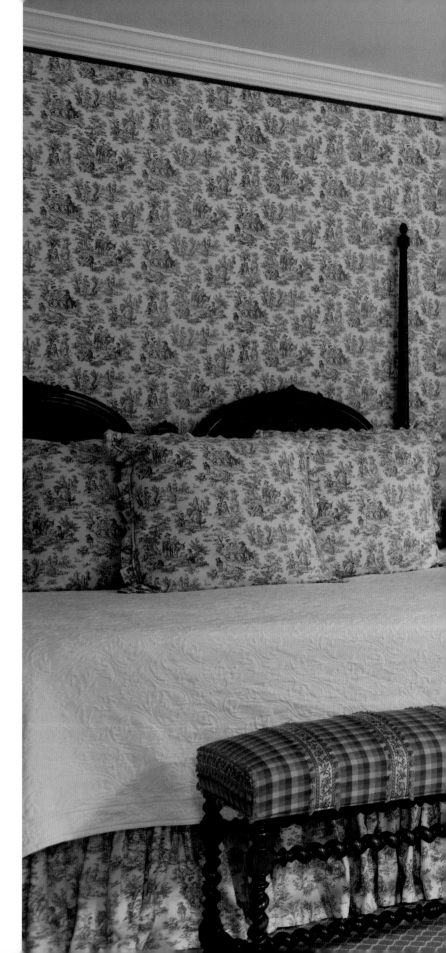

TOILE DE JOUY

Captivating storytellers, toile patterns have been adored the world over for their romantic imagery featuring flowers, fauna, and idyllic scenes of genteel country life. These elaborately patterned fabrics claim a rich history almost as storied as the scenes they depict. The craze began quickly when the first printed cottons were imported from India to France in the sixteenth century. Lightweight and washable, these wildly colorful block-printed indiennes were met with an exuberant fervor that virtually paralyzed the French fabric industry. So imminent was this threat of competition that, in 1686, King Louis XIV commanded an embargo on the importation of all cottons and issued a decree to arrest anyone who violated the ban. Despite these deterrents, the quest continued to flourish in secret.

When the ban was lifted in 1759, the coveted printed cottons eventually rebounded from their scandalous beginnings, and French factories regrouped in hopes of fulfilling the demand themselves. Christophe-Philippe Oberkampf was one of the first to manufacture these block-printed textiles in France alongside the crystalline river Bièvre in the town of Jouy-en-Josas; hence, the expression *toile de Jouy*. It was only a matter of time before the industrious Oberkampf adapted the faster and more precise copperplate printing method,

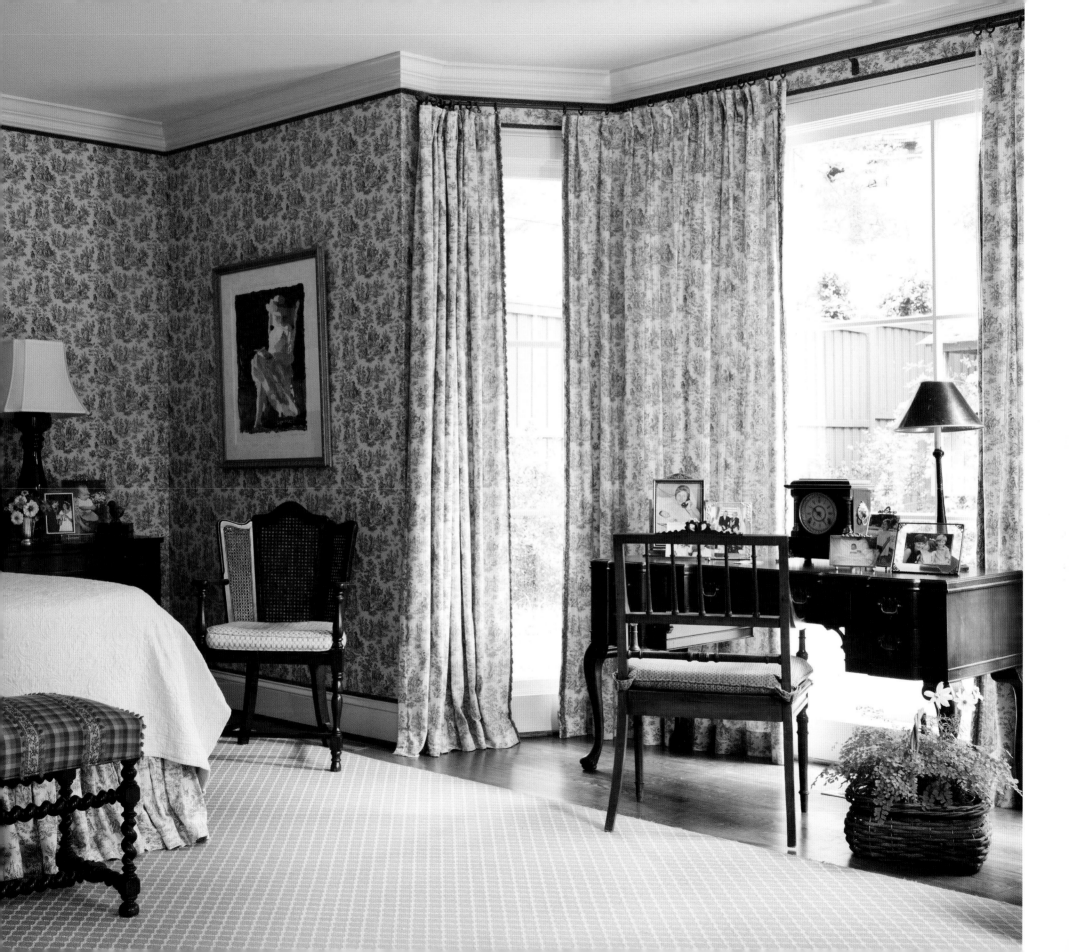

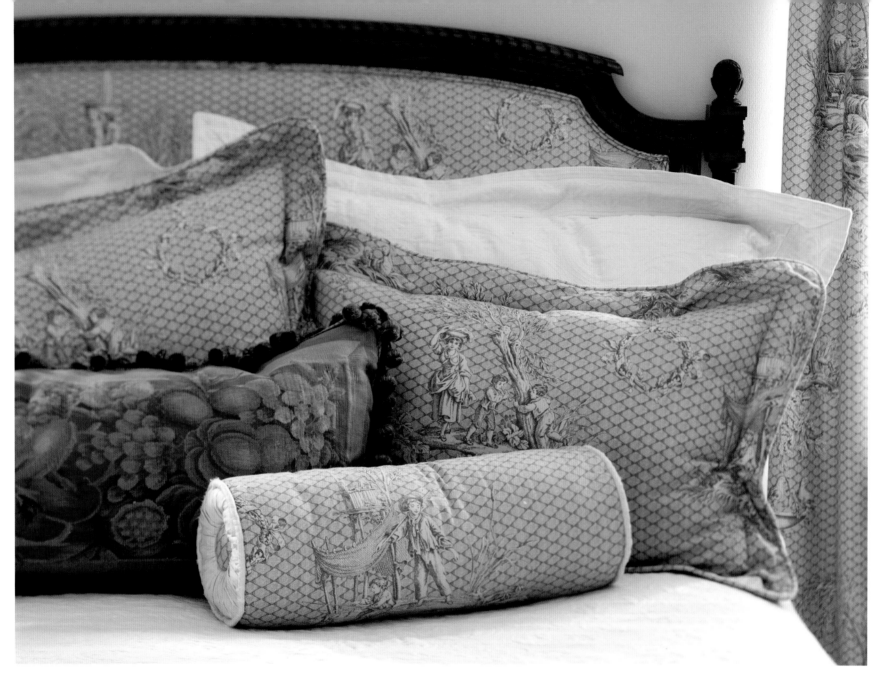

This page: The neoclassical-style toile print by Marvic Textiles, Les Enfants in Olive and Ecru, illustrates bucolic scenes on a diamond-patterned background. Opposite, right: Toile trimmed with silk tassels, fringe, and cording cultivates a distinctive regal style.

a technique already implemented in both England and Ireland that produced sharper engravings with expertly rendered variations of shading and light. This process paved the way for commissioned artists to design extensive patterns depicting elaborate themes and historical events with detailed human subjects and complex scenery.

Not surprisingly, toile motifs continue to proliferate in the modern age with playful compositions and more traditional presentations continuing to enchant homeowners who want to wrap their interiors in provincial charm.

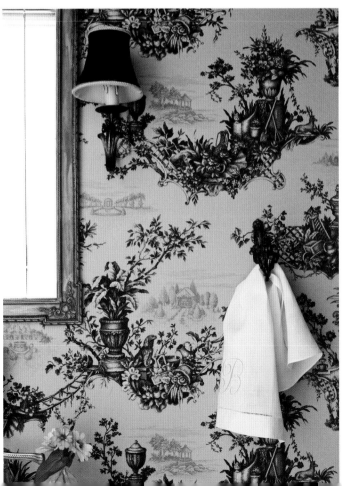

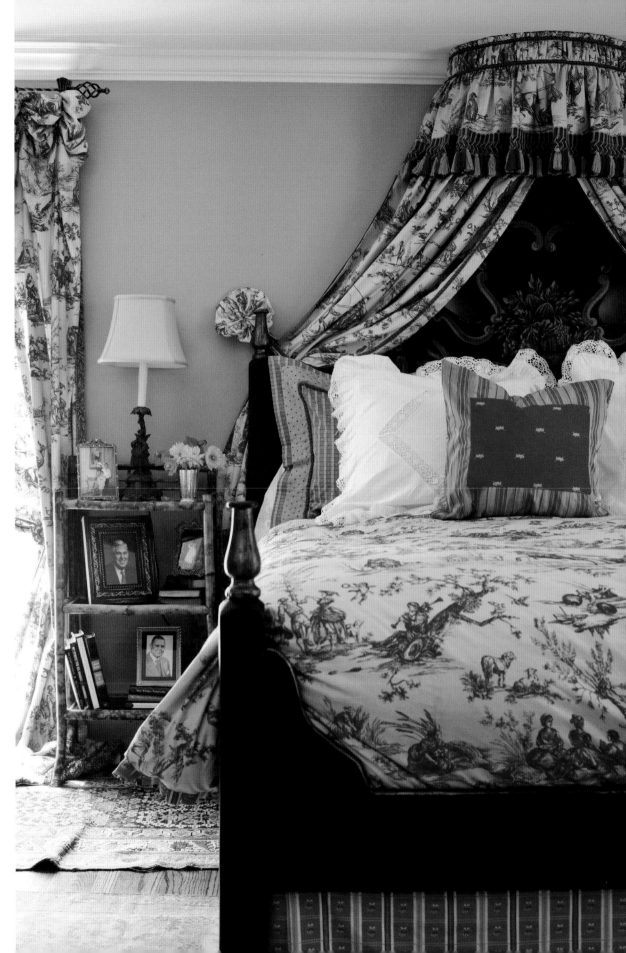

A PROVENÇAL FARMHOUSE

Pretty ruffled curtains dancing in the breeze, a bed dressed in gingham checks and ticking stripes, the crisp contrast of red-and-white table linens—French farmhouse style relies on mixing a gallimaufry of elements for its enduring cheerfulness and charm. Born as much from necessity as intention, the blend of time-weathered furniture, easy-care fabrics, and nature's own accents embodies a relaxed and comfortable feel that instantly puts one at ease. It's no wonder this look has been adopted in dwellings far beyond the hills and valleys of Provence.

The décor for a Gallic farmhouse is not purchased en masse, nor does it resemble a furniture showroom. Rather, it is collected over time, the result of serendipitous finds during Saturday afternoon strolls through *brocantes*, heirlooms handed down from beloved relatives, and bespoke items that are handmade, handstitched, and definitely one of a kind. Whether the price of an item is dear or quite inexpensive matters not at all. What's important is that the object is loved.

This style may be characterized by a medley of descriptions, but the appearance is anything but hodgepodge. Old World mingles with Art Deco, chipped paint looks at home beside chinoiserie, silk meets burlap—and it is all united with vases of fresh flowers and the lingering fragrance of lavender.

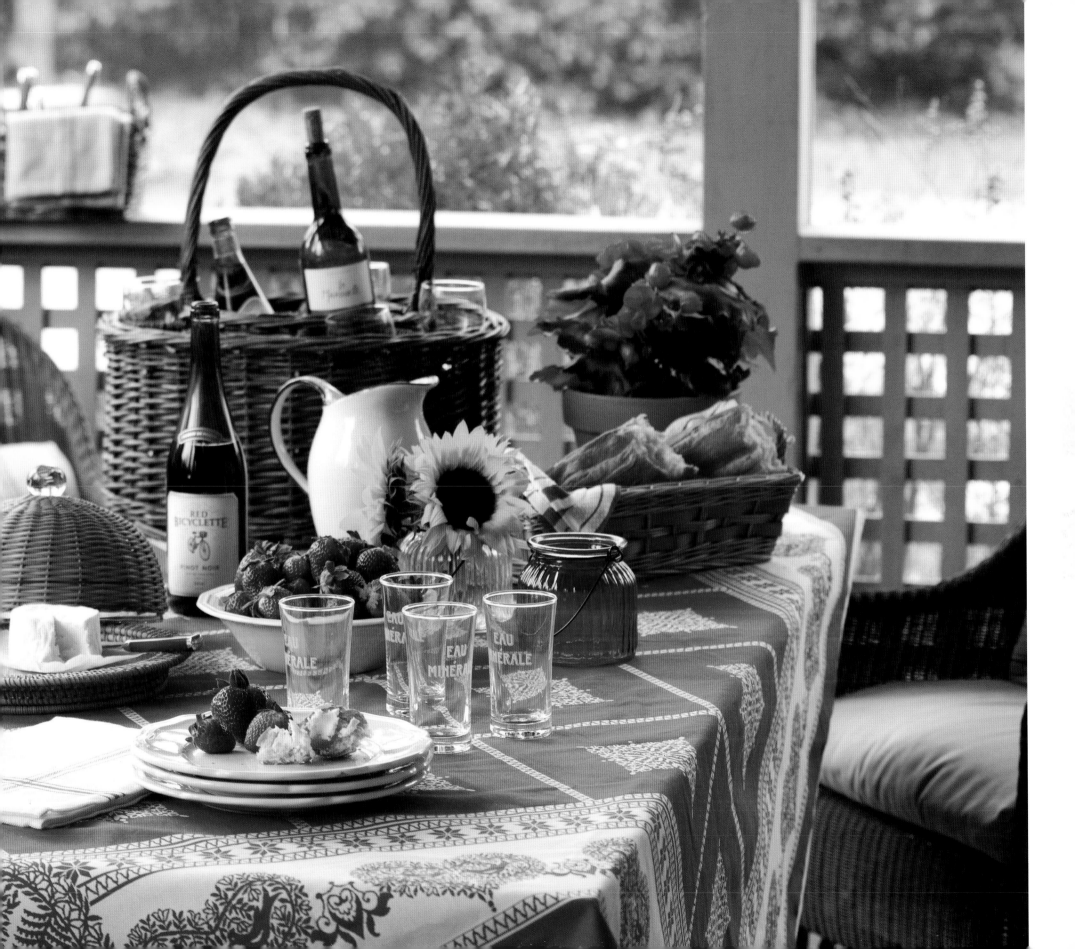

Right: A sumptuous assemblage of pillows creates a landscape of enchanting motifs for the French-country boudoir, while a claret-hued matelassé coverlet and the top sheet's stylized border provide vivid splashes of color. A simple white sham, with blanket-stitched edges and an embroidered avian trio, adds beaucoup charm. The distressed ivory finish on the bedside table is a hallmark of farmhouse design. Opposite: A bright bouquet of sunflowers, whether freshly plucked from the fields or purchased from a flower shop, brings a vibrant note to any gathering.

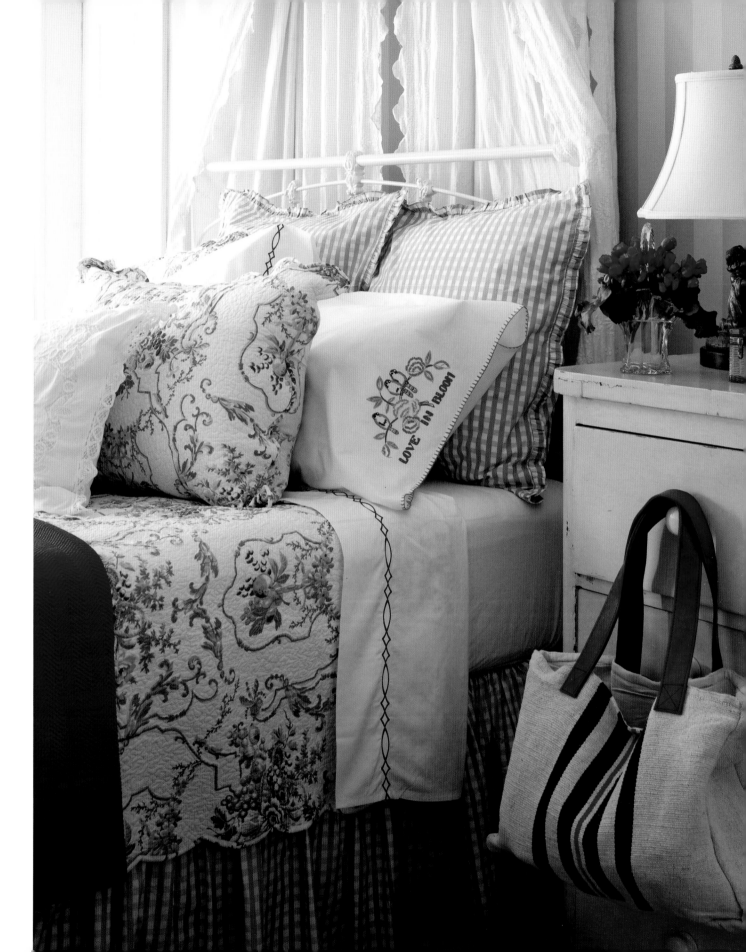

"Surely charm
is what characterizes
a French interior."

—Daphné de Saint Sauveur

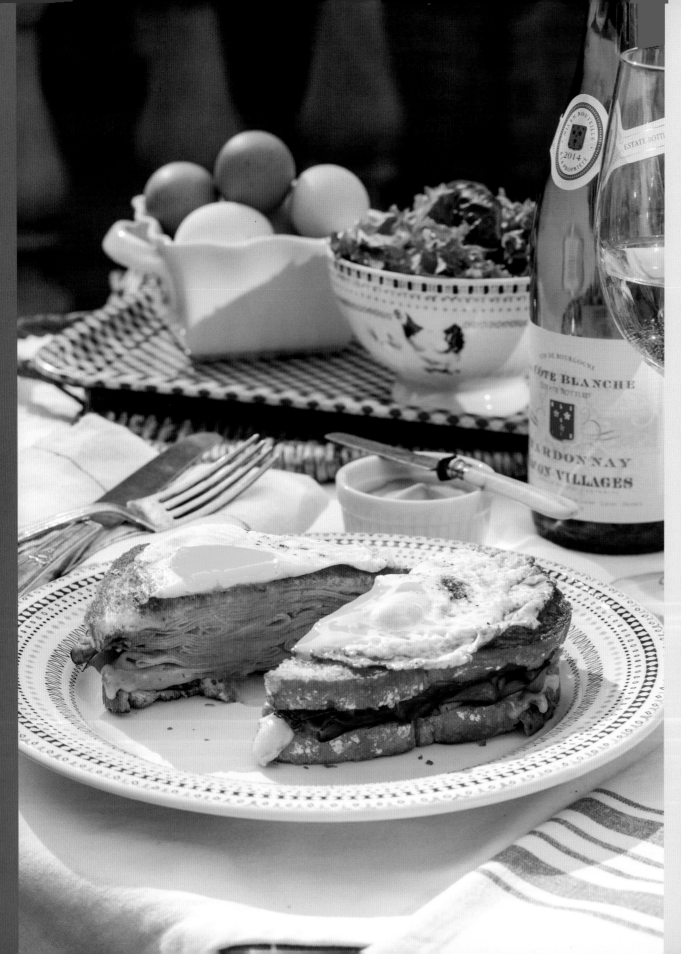

Croque Madame
Makes 1 sandwich

1½ teaspoons Dijon mustard
2 slices thick country sourdough bread
1 teaspoon coarse-grain mustard
2 ounces deli-sliced Virginia ham
1 slice Comté cheese*
4 tablespoons butter, divided
1 large egg

1. Spread Dijon mustard over one bread slice. Spread remaining slice with coarse-grain mustard. Top first bread slice with ham and cheese. Top with remaining bread slice, spread side down.
2. In a small nonstick saucepan, melt 2 tablespoons butter. Add sandwich and cook, turning to cook each side evenly, until bread is toasted, cheese is melted, and ham is warm throughout, 3 to 4 minutes. Remove and set aside.
3. In same pan, melt remaining 2 tablespoons butter. Add egg; fry, sunny side up, to desired degree of doneness, about 2 minutes. Place egg on top of sandwich. Serve immediately.

Gruyère cheese may be substituted, if desired.

Smoked Salmon Pâté
Makes approximately 1 cup
Adapted from a recipe courtesy of Georgeanne Brennan

¼ pound smoked salmon
6 tablespoons crème fraîche
3 teaspoons minced fresh tarragon
½ teaspoon grated lemon zest
1 teaspoon fresh lemon juice
½ teaspoon freshly ground black pepper
Garnish: fresh tarragon

1. Break salmon into pieces, and place in a bowl. Add crème fraîche, tarragon, lemon zest, lemon juice, and pepper; mash together with a fork until a thick paste forms.
2. Pack pâté into a crock or bowl. Serve immediately, or cover and refrigerate for up to 4 days. Garnish with a sprig of tarragon or a sprinkling of minced tarragon leaves, if desired.

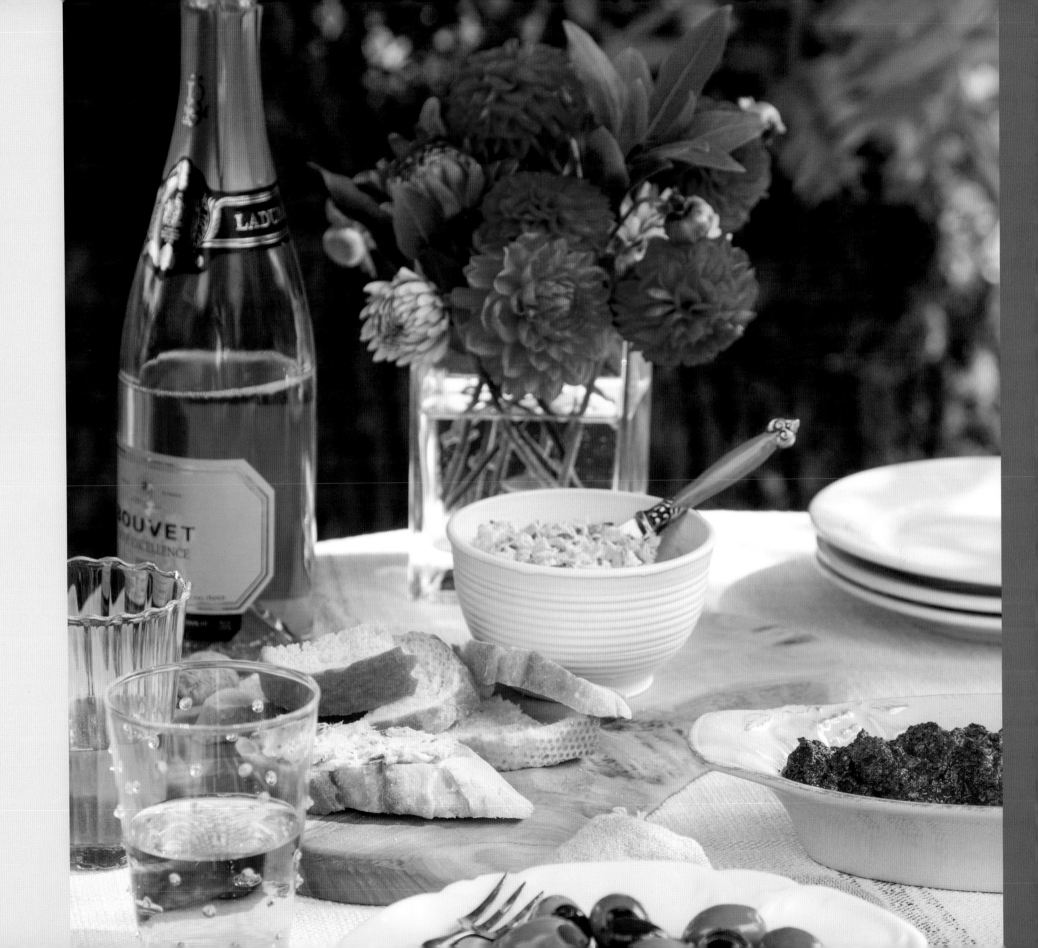

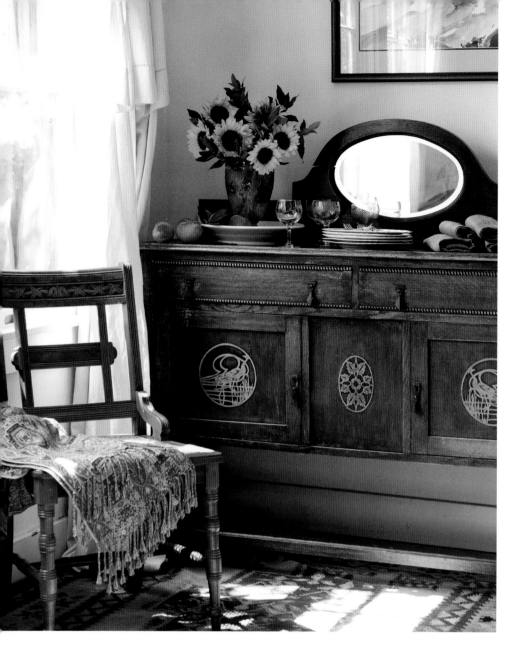

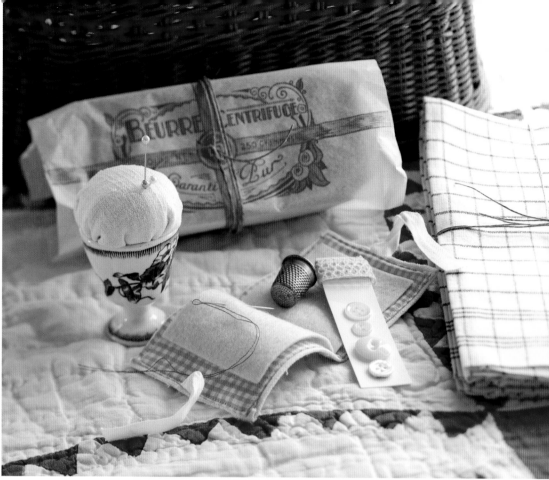

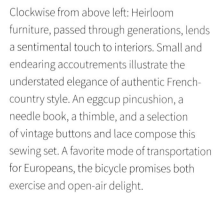

Clockwise from above left: Heirloom furniture, passed through generations, lends a sentimental touch to interiors. Small and endearing accoutrements illustrate the understated elegance of authentic French-country style. An eggcup pincushion, a needle book, a thimble, and a selection of vintage buttons and lace compose this sewing set. A favorite mode of transportation for Europeans, the bicycle promises both exercise and open-air delight.

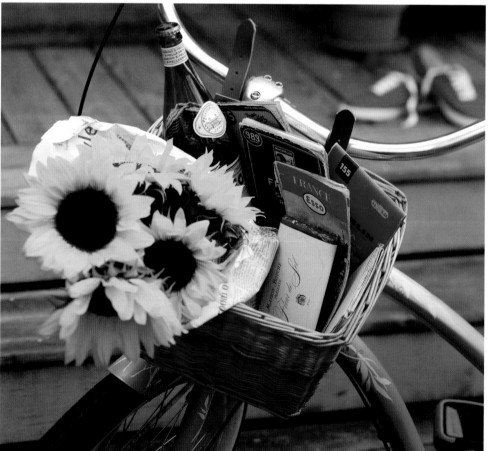

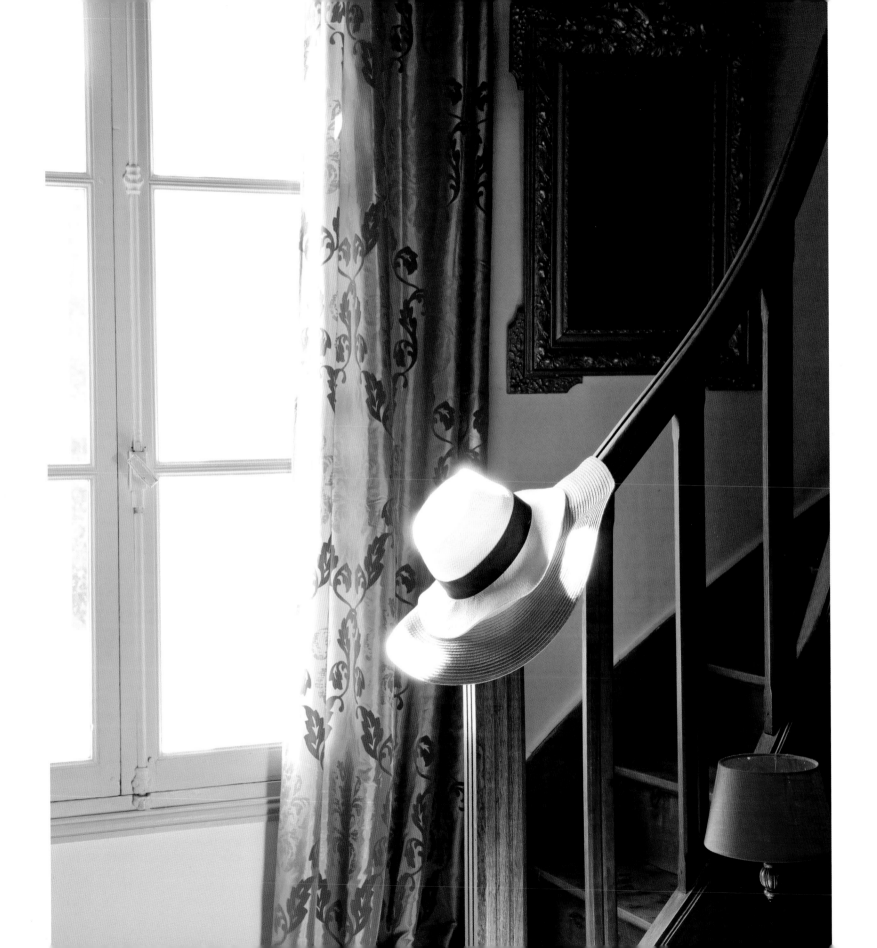

RITUALS OF VILLAGE LIFE

Curious pedestrians wander down a narrow cobblestone street as it winds its way through one of the hundreds of villages sprinkled across the French countryside. It's market day, and baskets of ripe apples and nectarines share space with freshly harvested asparagus and fennel. Some stalls offer locally made cheeses or perfectly baked baguettes, while others have precariously stacked piles of vintage teacups and plates or racks of clothing.

Even more important than the items for sale is the intermingling of neighbors and visitors, the good-spirited haggling over prices, and the catch-up conversations that bring people together. The slower pace of life in a village lends itself to connection. There is more time to gather with friends over a good meal, to partner with nature in a garden, to appreciate the importance of community spirit.

Since most of these communes date back centuries, history is an ever-present part of villagers' lives, whether it's the ancient church in the center of town, a limestone house where the same family has lived for generations, or medieval walls that hearken to the days when that sort of protection was vital. Old is better than new here, heritage is a worthy bequest, and respect for the past is a common thread that weaves throughout these enchanting villages of France.

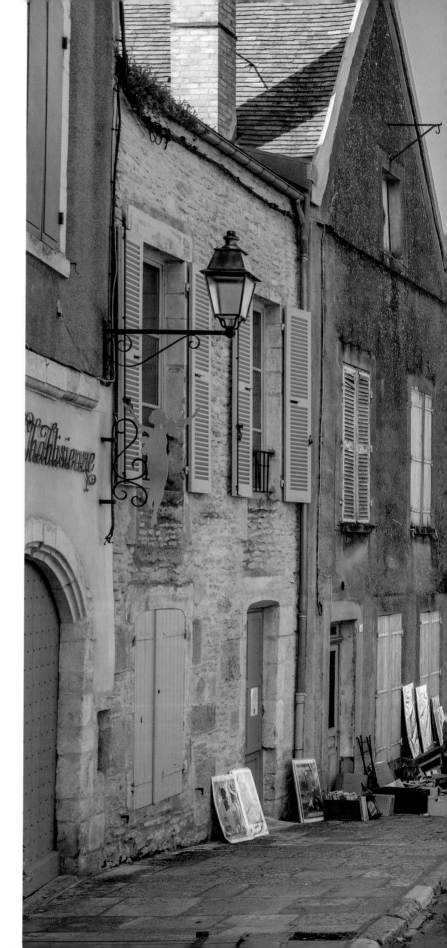

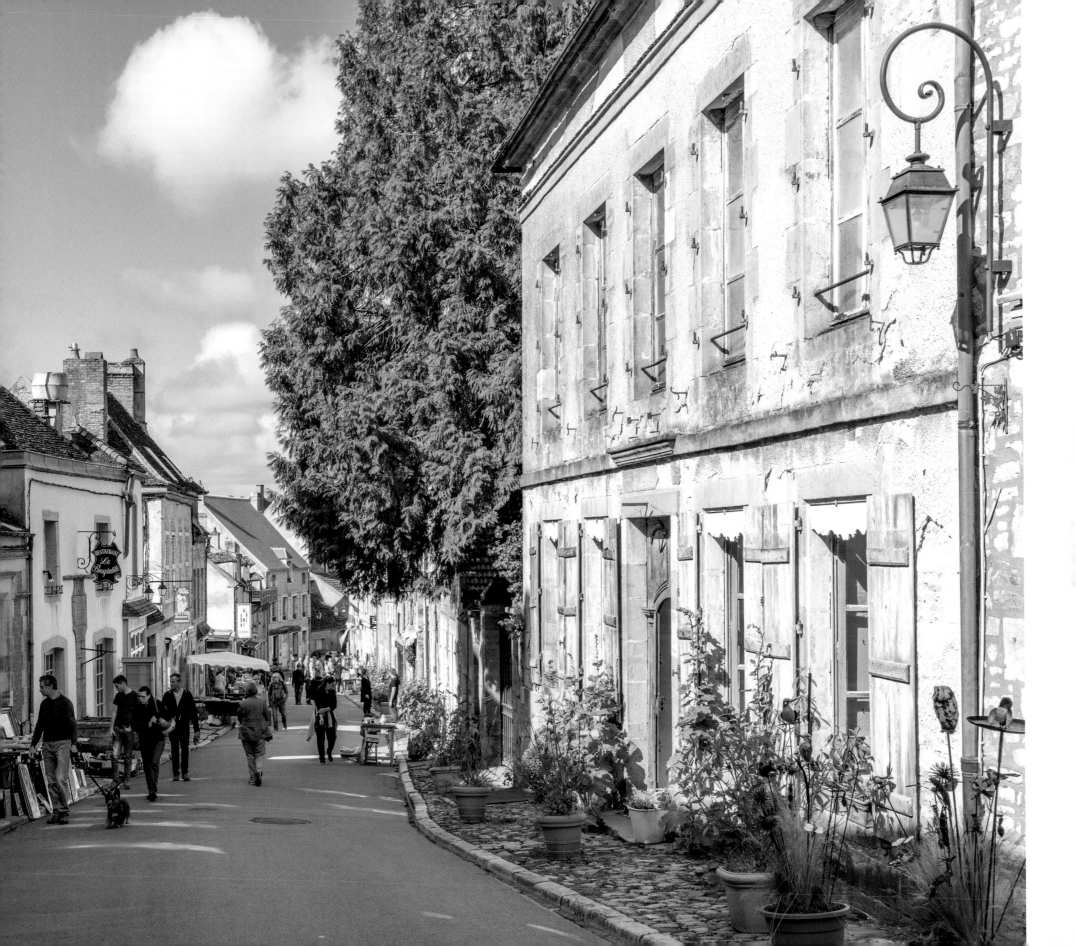

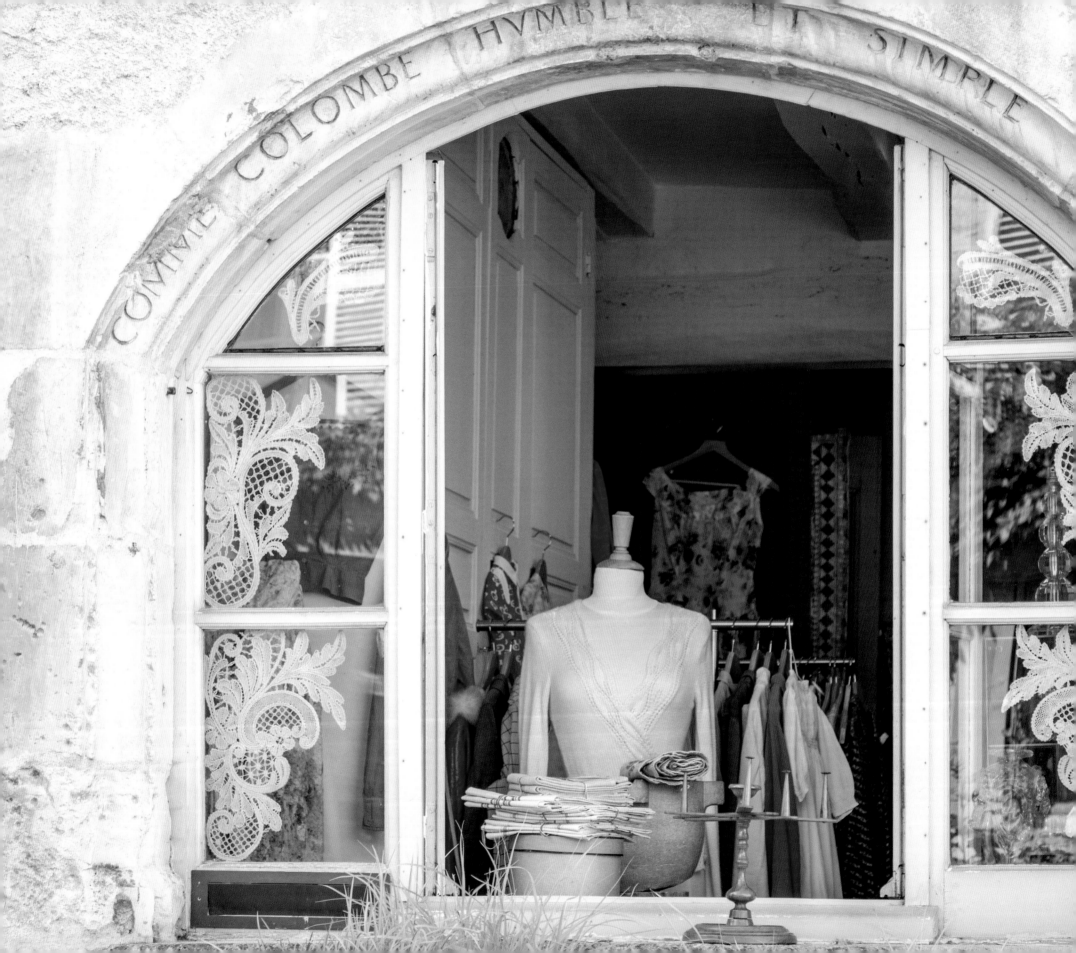

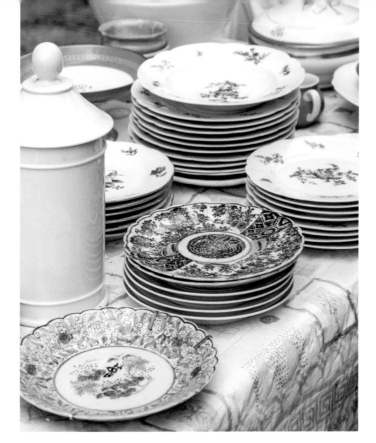

Opposite and this page: Few things compare to a leisurely day spent perusing the local shops, whether it's a search for vintage clothing or for orchard-fresh peaches to bake a scrumptious clafoutis. *Brocantes* display an amazing pastiche of wares, offering everything from antique furniture and impressive artwork to everyday items, like the terra-cotta pots making a convivial statement in this shutter-framed window, below right.

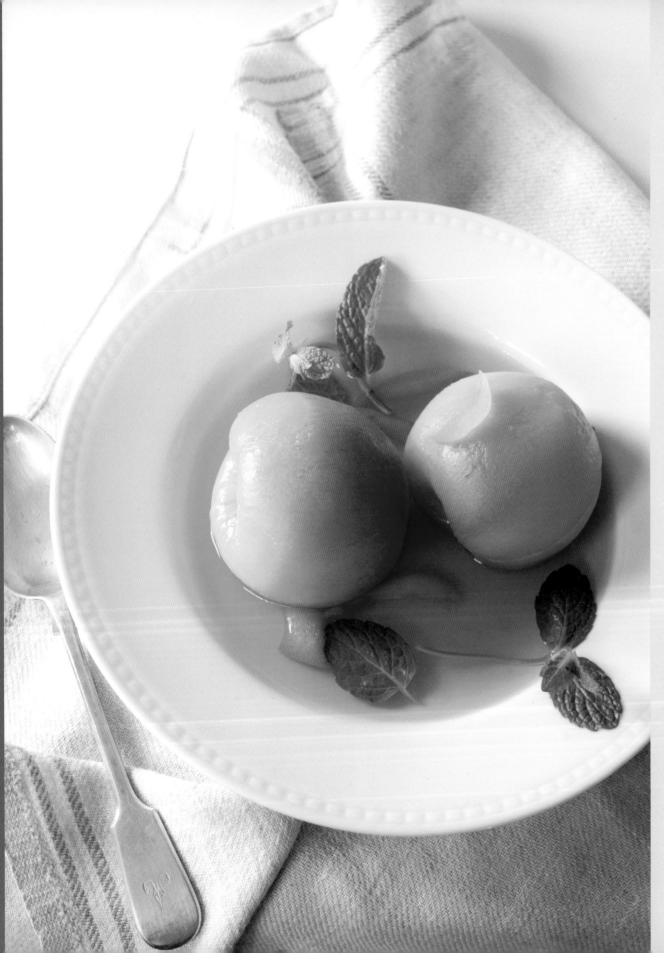

Rosé-Poached Peaches
Makes 4 servings

1 orange
1 lemon
1 (750-ml) bottle rosé wine
4 cups water
1 cup granulated sugar
8 small peaches
Garnish: fresh mint sprigs, orange peel

1. Using a vegetable peeler, carefully peel orange and lemon into strips. Juice orange and lemon.
2. In a large saucepan, bring wine, 4 cups water, sugar, orange juice and peel, and lemon juice and peel to a boil over medium-high heat, stirring until sugar is dissolved. Remove from heat, and place peaches in mixture.
3. Return saucepan to medium-low heat. Bring mixture to a simmer, being careful not to let mixture boil, and continue to cook until peaches are tender, 25 to 40 minutes, depending upon ripeness of peaches. Remove from heat; let cool to room temperature.
4. Using a slotted spoon, gently remove peaches from poaching liquid. If desired, remove skin from peaches by cutting an X on the bottom of each and slipping skin off.
5. Spoon 2 peaches onto each of 4 dessert plates. Spoon poaching liquid over peaches. Garnish with mint sprigs and orage peel, if desired.

Right: France's famed Burgundy region may be best known for its wine, but it is the area's history-steeped hamlets that pique the interest of those who prefer a bouquet of a different kind. In the charmingly unchanged storybook village of Châteauneuf-en-Auxois, cobblestone lanes connect quiet, flower-filled neighborhoods where a trove of small shops and outdoor cafés await exploration.

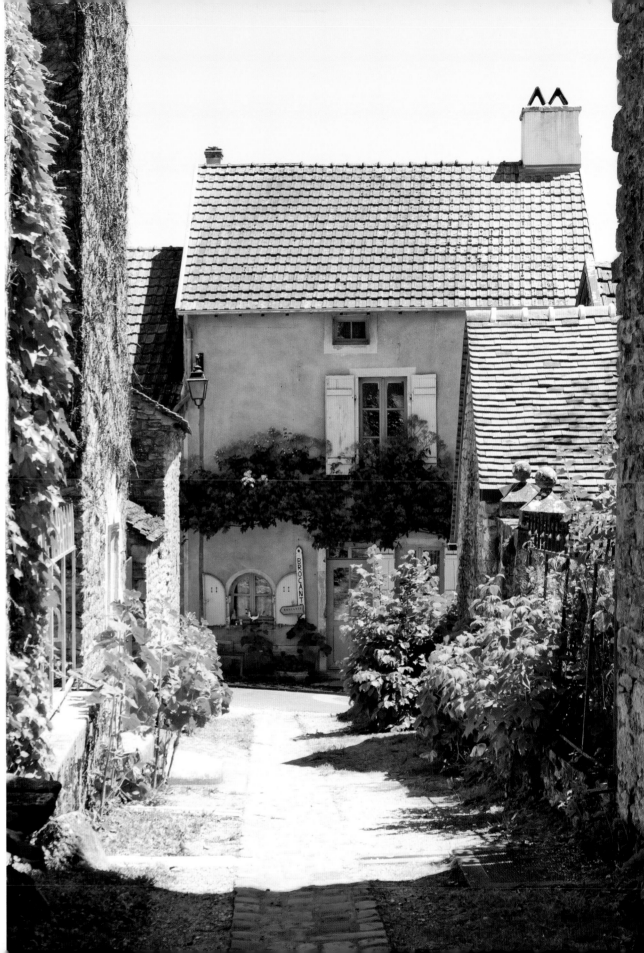

LA VIE QUOTIDIENNE

With the rising sun and Chanticleer's crow comes a new day in the Loire Valley. In the kitchen, breakfast preparations begin with mixing, measuring, and pouring. Bowls and jars work in and out of rotation as do hand-loomed linens. Every day these utilitarian items turn out a fine performance, and every day the appreciation grows, for they epitomize pretty practicality. Though this scene and similar ones hearken back to days gone by, the pieces have endured the test of ages, and the same sentiments are still embraced.

Collector and antiques dealer Staci Thompson fell in love with once-common French ceramics many years ago. "I took advantage of local classes and lectures," she says, "and they challenged me to consider looking at everyday things in new ways." While on a buying trip in Paris, Staci noticed a stack of ceramic dishes and picked them up for a closer look. "People used them routinely, but they were made by hand; they were special. At that moment, I became obsessed," she says.

From the end of the seventeenth century into the nineteenth century, ceramics—wares made of clay or fusible stone—saw an increase in both production and technique. Almost every household used them, especially the durable and inexpensive yellowware. Often these same homes contained napkins, towels, and tablecloths made from hand-loomed linens. "I look for the ones that have embroidered monograms because that lets me know they were

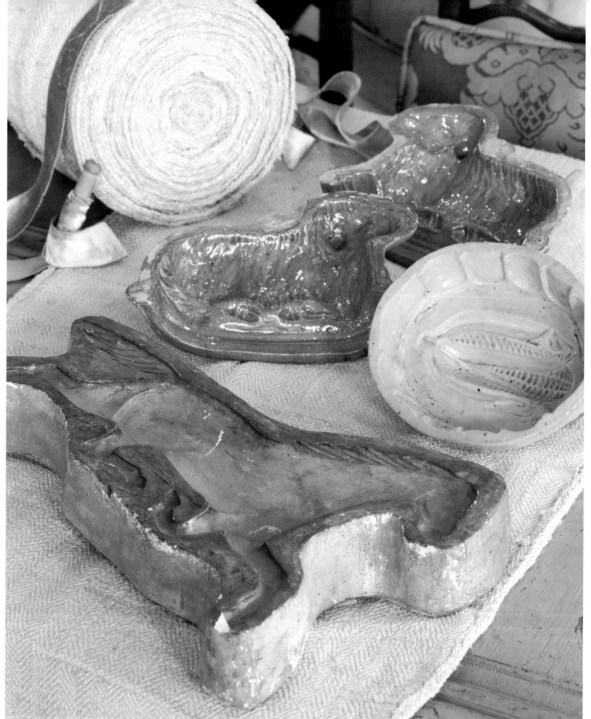

personal to someone once upon a time," says Staci. Her collection of French household wares includes stacks of napkins, along with hand-painted ceramic eggs, hand-dyed ribbons, wooden shoe moulds, and bread plates. "These were once beloved, and I believe they should be used again—so I do, every day."

Buckaroo

Images from the Sagebrush Basin

KURT MARKUS

A New York Graphic Society Book · Little, Brown and Company, Boston

Publication of Buckaroo *has been generously supported by US WEST, Inc.*

International Standard Book Number: 0–8212–1678–3
Library of Congress Catalog Card Number: 87–61448

First edition

New York Graphic Society books are published by Little, Brown and Company (Inc.).
Published simultaneously in Canada by Little, Brown & Company (Canada) Limited.

PRINTED IN JAPAN

Foreword

From the beginning, we used western art and photography in US WEST's advertising and collateral material, and we quickly realized that you can't take short cuts with the western image — you have to go for the best.

Kurt Markus is one of the best. His photography attests to that, but there is something more — his love for the people and places he photographs, plus a kind of determined patience, a steadfastness. Kurt is like his photography — not detached, but calm and direct. In a crowd, he concentrates on a single person, a single conversation.

But I had never read Kurt's words until I read the manuscript for this book. As usual, I had put it off. But one February morning at 3:00 a.m., I went down to the kitchen, made coffee, picked up Kurt's manuscript, and read it to the end.

Lois came down at five and I turned to Kurt's passage about the sixty horses rushing past Mike Merchant's camp on Poverty Basin. "Read this," I said. Then I watched to see if the words would cause her to catch her breath as they had mine. They did.

Going into Kurt's words, for me, was like cooling down. Like having time to think and feel. Like seeing real things and taking the time to let the wonder come up slowly afterwards.

People write about the western spirit, but I'm not entirely sure what it means. Perhaps it has something to do with the individual, with respect for others, and with making do with honest tools. At its best, I would guess it has more to do with work than romance. But whatever the western spirit is, I believe it always leaves room for dreams, of being able to see a long way, that each day has the possibility of opening up into — I don't know — something like hope.

"The cowboy West," Kurt writes, "has drama, light, a rare purity. And when the sun comes up, cowboys ride out into it."

Ride out into it.

John Felt
Vice President, Public Relations
US WEST, Inc.

for Maria

Introduction

I was not born to ranching. I was born a daydreamer, and I know of no slot for one of those on any ranch.

At times I am saddened that I am not what I photograph. Always the observer, seldom the participant, what I am made of remains unanswered. My distance protects me, physically and emotionally, from getting as busted up as I ought to sometimes. Which is why you're not going to get the whole truth from me. I have entered into an unspoken, unwritten, and generally inscrutable pact with the people I have photographed and lived among: if I promise not to tell all I know about them, they will do the same for me. In most cases, I have more to hide.

My consolation is a simple-heartedness I would not exchange. The greenest cowboy alive has my respect, and I have no problem whatsoever photographing people who are possessed with the determination to do what I cannot. The awful truth is that I love all of cowboying, even when everything has gone wrong and it's not looking to get any better. Sometimes I especially like it that way.

This book has been inside me from the start, from the day Charlotte Hill picked me up at the Lakeview, Oregon, bus depot and drove me to the MC and her husband's crew and country. That was April, 1979 — not so long ago, actually, but long enough for nearly every outfit I've been on since to have changed considerably. And I'm not saying the changes have been entirely on the downward slide. It's just that life in the Great Basin is different now, and that this book speaks of an era when you could cross railroad tracks to get to the wrong side of town in Elko, Nevada. The wrong side is still there; it's the tracks that are gone.

The writing that follows is pulled from various sources. I retrieved some passages from 3 x 5-inch notebooks I pack in my pocket wherever I go and in which I sometimes write. One of the allowances I gave myself when I began these journals ten years ago was that I would not return to them in the future and demand anything, but that was a shallow lie to myself. In recent days, I dug through them one by one, all twenty-eight of them. The only things I was able to salvage from the wreckage of those tormented years of scribbling were a few scraps, and I include them here to bring a moment or two of immediacy — what it was like then, as it happened. Although I'm not especially proud of my sloppy working methods and casual attitude toward the past, I make no apologies, either, for not being a historian. I hold the rather shallow opinion that history is now; it shouldn't be surprising that my tools are cameras and those sweaty, stained notebooks. I write to fill in the holes left by the pictures.

Which brings me round to a proposition I scrapped when work on this book began more than a year ago. I had wanted to include certain photographs because they contained a person, an action, or a place I believed was key to the region. I changed direction when I confronted the enormous number of photographs I had made.

That, and the knowledge the photographs would someday be removed from the book's protective context and custody. And from mine. The camera, I've discovered, is an instrument of serendipity, and it takes its own pleasure with things and people apart from my best intentions and desires. So, this is not a record of the best buckaroos throwing the best loops. There are transients and home-guards in here, Christians and not, teetotalers and tosspots, families, loners, ranch owners and common help, men and women, boys and girls. If you find more pictures of bars and their keepers in the book than photographs of churches, that fact says more about me than about the land or its people.

Buckaroo is the first of a three-book series; *Cowpuncher* (ranch life in the Southwest) and *Cowboy* (ranch life in the Northern Rockies and Great Plains) will follow in the coming years. *Buckaroo* leads off because the Great Basin has never received the attention it has deserved for so long. And it is the region I went to in the beginning and kept returning to, long after it was photographically necessary. I sometimes refer to these Great Basin buckaroos as cowboys, and in many instances the two words are interchangeable. But outside the Great Basin, cowboys are generally not called buckaroos, unless, of course, they have drifted out of their home country.

In the last couple years I have become as drawn to the fringe of cowboying as I am to its heart, so you'll encounter photographs without buckaroos. The landscapes are places where cows live; the people either serve buckaroos in special ways (bartenders, cooks, cobblers, madams), they make the tools of the buckaroo trade (spurs, bits, saddles, rawhide ropes), or they speak of the life through art. My selection of pictures is purely subjective and in no way pretends to be inclusive.

How can I properly thank those I have photographed and who have fed me, put me on their good and most gentle horses, and have, in countless ways, invited me into their lives? Well, I thank you all as you thank a friend: with all that is in me.

Eleanor Caponigro has shaped this book with kindness and sensitivity. Russell Martin was the editor I have always wished for. To them both, my appreciation for their talent and for their companionship.

Buckaroo would not have been published were it not for the generous support of US WEST. I have been given the freedom to risk not pleasing everyone, and for that I am ever in debt. With that freedom, I carry a great responsibility to mirror US WEST's commitment to the people of the West. In particular, I wish to thank Jack Sommars, who believed in the project from the start; John Felt, for his tough mind and large heart; Jack MacAllister, for sticking with the cowboy spirit. Fred Senn at Fallon McElligott has also selflessly encouraged *Buckaroo's* publication.

Pentax Corporation has loaned and given me cameras and lenses; thanks, Art Nolan and Joe Graham, for everything. Barbara Hitchcock at Polaroid has seen to it that I've been supplied with plenty of their wonderful film.

Thanks to Dick Spencer I got my start at the *Western Horseman* magazine. It's a start I'm proud of.

I hope these pictures prove that all of the adventure has not yet been beaten out of the West, nor has it been thoroughly civilized. It is a remarkable space. I can extend my arms and, on the one end, touch its past and, on the other end, its future.

Kurt Markus
Colorado Springs, Colorado

Buckaroo

I found out quickly that the cowboy West isn't a uniform blend from Texas to Montana. There are pockets of cowboying, each with its own distinctive texture of dress, gear, language, and technique.

The West breaks into three groups: buckaroos (Oregon, Nevada, Idaho, and California), cowpunchers (Texas, Oklahoma, New Mexico, Arizona), and cowboys (Montana, Wyoming, Colorado, the Dakotas, Nebraska, Canada). As certainly as I have made my boundaries, cowboys draw their own; some are not going to like the company I've put them in. But they will at least get the drift of my thinking, and most will agree, yeah, it's like that.

❧ Discovering the buckaroos was, for me, a shock. Why had no one told me about them? Why had they been kept a secret in a country that held the cowboy as its national image?

One thing about most buckaroos, you sure as hell notice them. They look a lot like the cowboys Charlie Russell painted: open-crowned hats with short, flat brims; long ropes, often of braided or twisted rawhide; colorful scarves tied at the neck; high-heeled boots; slick-forked saddles and eagle-bill tapaderos nearly touching the ground; bridled-up horses packing silver-mounted spade bits; big-roweled spurs, also silver-mounted; jinglebobs; vests and dapper jackets from secondhand stores. And pride, plenty of pride.

In buckaroo country there is a "Californio" tradition of *mañana*

horsemanship, the movement of a young horse from snaffle to hackamore, to two-rein, to bridle, which, if all goes smoothly, takes years. There is no room for shortcuts in the system because omissions will show up later.

To many buckaroos, cows are something you train horses on. You are a horseman first and a cowman second. It is an attitude that controls their lives. It isn't surprising that buckaroos put everything they have into gear.

❧ The talk around the bunkhouse shifted to Rick Bates. Someone questioned Rick's chances of finding a woman when he insisted on wearing wrist cuffs, a hat with a horsehair stampede string, and a floral-print wild rag the size of a tablecloth.

The world has moved too far to understand anyone retreating into the past, he commented.

❧ The wagons and cavvy left headquarters after the noon meal. The caravan climbed away from the meadows that flanked either side of the South Fork of the Owyhee. The abundant rain from earlier in the season had turned the higher country green, green as an emerald. Away from us were the Independence Mountains topped with snow. Harold Smith was leading in the chuckwagon,

Jim Koepke followed in the bed wagon, and John Adamson rode point on the cavvy while Mike Thomas and Harley Kelly kept stragglers moving.

High cumulus clouds skittered through the sky. Where there were holes between them, the sun shone and threw cones of light on the sagebrush. Once, when Smitty had reached the top of a grade and had stopped to let Pinky and Doc and the two wheelers blow, one of the cones fell on them.

The spotlight stayed a moment, then ran down the mountain.

❧ "Once this country gets inside you and takes hold," a buckaroo remarked while we were trailing cows on a road cutting across Independence Valley, "you may never fit in anywhere else."

❧ More than a million acres and thirty thousand head of cattle. Enough country to get a horse turned around in and enough livestock to keep the kinks out of a long catch rope.

When the Z X changed hands in the late 1970s, owner Bill Pendola bought up the neighboring Viewpoint and threw the giants together. The union was a remarriage. They had been together before in the early days.

But like any other ranch, grand or tiny, the Z X is a story of people, not houses or barns, or even bloodlines, however impressive or historical.

❧ The roll-your-own cigarette sticks to his lower lip in one corner, and when his mouth moves, the cigarette magically stays where it is. The whole character of him seems made up, every turn of him created for our pleasure, as if his life had been cleverly written and rehearsed. His missing upper teeth. The store of chewing tobacco in his trailer refrigerator, maybe ten full rolls; the bright green plastic Hawken cans seem right for him, matching the assortment of colored strings, wire, bones, and Peruvian trinkets he's hung everywhere. His saddle and bridles.

I remember him as a man on the edge of falling apart: all that he had was torn, or mended. A strong wind or a day of careless inattention and he could be spread out over half the Spanish Ranch.

Yet he's a smooth figure horseback, durable as hell, and can handle a rope and knows cattle and men. He hasn't tired of helping a younger man, which says a lot, and Bill Kane tells me he's invaluable with his kids — takes them fishing and baits their hooks and keeps them in constant view.

❧ Cowboys have worked the style angle well and long and have now, after all these years, got it down good. So well, it seems, that you'd think they invented a code. A code for all to abide by and enforce and pass along and to give the appearance of orderliness. But out there lurking in the sage and mesquite and cedars are deviants who won't be classed by other cowboys, and particularly not by clerks publishing definitive cowboy studies. Cowboys are as different as the stars are from the sky.

❧ I sat outside with Harold Holbrook and watched him turn steaks on his cut-in-half barrel barbecue. The day was dissolving, and the dusk was silent. We could look down at the 7J buildings and out past to the desert.

Harold spoke of his first marriage. "She left to get groceries and never came back. Hugh was nine years old. When we both realized she was gone for good, Hugh asked, 'What are we going to do, Dad?'

When he looked to me for an answer, he knew I was as lost as he was. 'I don't know,' I said, just to fill the silence."

One buckaroo was writing a letter; another was reading. Except for a yellow-red light glowing from lanterns inside their range tepees, Mike Merchant's camp on Poverty Basin was dark and asleep. The night lay motionless; the sky, clear. The wrangle horse moved nervously inside the panel corral, stopping sporadically to nicker, presumably to the unseen cavvy grazing or resting in some far corner of the horse trap. The horse was probably the herd-bound type that frets when separated. Or he was privy to an event about to happen, an event too subtle or distant to be received by human antennae.

The sound began small and muffled. It was there, but then it wasn't. It enlarged, becoming solid, constant, distinct. And growing. Thunder? There were no clouds, not even on the horizon. The noise was making its way to camp. Lights started up in the tepees, and anxious heads popped through canvas flaps to have a look into the blackness.

Sixty saddle horses stormed by. Like the agile flight of birds, they moved as one, bending directions without a change in velocity, and were gone.

You might easily slip into believing that cowboying skills are all that matter. Not true. What is true is that you are embraced to the measure of your character. If you can make people laugh, that, too, is currency. Who you are, apart from what you can do, is trading material to be swapped for savvy.

The other prevailing deception is that you necessarily get better with experience, that it is a straight-line curve which plots ability on one axis and time on another. Do it once and see improvement the next time around. Pepper bucks you off this morning, but he'll have a harder time getting you on the ground when his turn comes again. Pretty soon you'll stay with him. Same way with roping. Throw a ton of empty loops today, and by the end of the week you'll be catching calves by two legs more times than not.

But everyone has ridden with men who have given themselves over to buckarooing for twenty or more years and who've shown little improvement with age. They won't become good hands, not now, not if they were reincarnated as buckaroos in their next lifetime and given a fresh start. What these survivors have learned is how to protect themselves, a not so small ability that is, for the most part, noticed but not greatly admired.

The buckaroos with the great reputations have both physical and emotional substance. They came into buckarooing good (they were so good so soon it was spooky) and just kept climbing until you privately shook your head the times when their rope caught when you were sure no one could catch. They were always a jump ahead, no matter what the game; you couldn't find a hole in their armor. They made you smile, but seldom laugh from the belly, because even their humor had a weight and depth that made you search for meaning.

If they have a weakness, it is the absence of a weakness. When they get old and cannot work, they will never allow themselves to be cooks or chore boys; they will have to disappear.

A reviewer of my first book, *After Barbed Wire*, commented that he found the pictures suprisingly quiet, as if quiet was an emptiness, a void. Cowboys are men of action, are they not, and where is the action of their myth?

There is action. It punctuates a day almost like a seizure: it takes

hold suddenly, and then it is gone. The bucking horse rides, and the wrecks with ropes are flame-outs in space; *poof!* they happen, usually at a distance seen by the wide-angle lenses of Instamatics that dramatize nothing and rinky-dink everything.

Buckaroo life is a blotter of quiet. That "out there" desert soaks up your mind, your soul, all that you have and are, until you are of that desert, not in it or on it. Then you are lost always and forever, as they say, and you cannot go to hauling America's loads over interstates or dig holes outside cities with D–8s without bringing along your loss, the sense that the desert is in you but you are not in it, and you know damned well you ought to be.

What drives you from the desert is that the desert takes and does not give. It sits you down and lays the rules out, no doubt about it. This is the way it is. You can be ambitious or lazy; it makes no difference. There are no eight-second buzzers telling you it is over, no trophies, no ribbons of merit, no retirement. Only the desert and you, one-on-one.

❧ Mike was shoeing a blue roan when we left this morning, and when we got back from riding a fence line, checking for holes, he had the horse thrown and tied, still trying to get a second shoe on. The horse fought and kicked his foot loose whenever Mike began nailing the shoe. At each outbreak, Mike swore and beat the horse on the ass with his shoeing hammer. John walked coolly to the spot where Mike was straddling the horse and said: "Mikey, looks like you're not in harmony with that horse." And then he walked away.

❧ Cowbosses make outfits.

Whenever I think of the ZX Ranch out of Paisley, Oregon, Ray McLaughlin comes to mind.

Buckaroos came and went, but the McLaughlin ZX always had a good crew. Inside the door at the headquarters barn, a few of the men kept a ledger of how many times they'd worked for the outfit. They used a hot iron to burn their names on the wall, and above the names, notches. They would quit, or they would be fired, but a few months or a few years later they would be back.

It doesn't take much to rough up a cowboy's pride; something as seemingly harmless, say, as riding in front of a man is sufficient cause. It's like the slap of an empty glove: everybody understands the meaning and consequence of the gesture. Ray could make a buckaroo feel large, or he could cut his legs off at the knees, and do both with a few well-chosen words or simple actions. Whatever Ray said or did, it was noticed.

❧ The alarm rang at 2:30 that morning. Time for her to get into the kitchen and build a noon meal for the branding crew. Jerrod — Joi and Hank's one-year-old son — would still be asleep when they carted him and the pots, cooler, and throw-away utensils to the truck for the nearly two-hour drive to the spot where the Fish Creek wagon was camped. The sun was cracking through a slot in the mountains when the truck pulled alongside the cookshack and stopped.

Horses were caught and saddled, and Joi watched as the men trotted off, the horses fresh, Hank out in front.

They gathered maybe four hundred cows and their calves and pushed them into a wire trap. Joi was there, waiting; Jerrod squirted about, and she labored to keep him out of the way.

When the irons were hot, the branding began. Joi ran the vaccinating gun. When Jerrod got tired and hit that condition in which a child can't be pleased, Joi held him in her free arm while she ran from calf to calf until Jerrod finally gave up and went to sleep.

She was blackened with sweat and dust when the last calf was worked and turned loose late that afternoon. The men unhobbled their horses, yelled the cattle out of the trap, and began the long trot back to camp. From the pickup, Joi smiled weakly and waved, overtaking the riders and spilling them off the rutted road and into the sagebrush. Jerrod stood on the seat and waved, too.

The day was not yet over, but the look on the men's faces said it had somehow already slipped into memory, and the bloody-shirted buckaroos only slightly raised their arms to the boy.

When Easter Sunday rolled around, everyone at the ranch was talking about the dance and potluck dinner at the Taylor Canyon Club, although not everyone was going. "No sense having any fun," one of the buckaroos said, "and then coming back here. I'll just stay miserable."

The wrangler boy, Homer (not his given name, but what everyone called him; the name stuck because he openly disclaimed it), lost no time cleaning up for the party. Shower, shave, clean clothes top and bottom, new wild rag, pressed vest, town hat. Homer had been commenting about his abilities on the dance floor all week, but his comments drew blank stares. "Who gives a shit, Homer?" Bates asked.

As much abuse as he'd piled on Homer, Bates couldn't shake the young man's attention and near-hero worship. "How do I look, Rick?" Homer asked as Bates charged through the wash area, still in his work boots and Chihuahua spurs.

"Hell, Homer, everyone can see you're no buckaroo," Bates replied. "You look like you got money."

It had been dark for a couple hours by the time four of us squeezed into the cab of the pickup and left for Taylor Canyon. In good conditions it would take about an hour to make the trip.

Snowing as hard as it was, we knew we were in for a long, slow haul to the dance.

T. J. Symonds was driving. Next to him sat Homer, smelling heavily of sweet cologne. Beside Homer was Dave Corlew, who had flown in from Nashville; Dave is the road manager for the Charlie Daniels Band, and a week on the YP was his strange way of escaping life on the road. I sat next to the passenger door, thankful there were no gates to open.

As we struggled to the top of Chicken Creek Summit, we knew that if the snow continued to fall as hard as it was, we weren't likely to return at three or four in the morning. But at least we made it, we all thought, as we pulled up alongside one of the vehicles in front of Taylor Canyon. We would worry about getting back to the ranch later.

Three buckaroos from the IL were at the bar when we stomped the snow off our boots. Band equipment (a couple of amps, a guitar or two, drums, not much else) was being scooted around in the back; a long table at the side of the room had a red and white checked cloth draped over it, ready for the casseroles and homemade desserts that would be offered later in the evening. A dimly-lit pool table sat idle. If you'd had any experience at all in Elko County, you could look the place over and predict the future. A fight, possible; one or more customers passed out under the benches, very likely; a night that would be relived back in bunkhouses, certainly.

The band was called "Creed" by the four members of the band. Everyone else called it "Crud." When they first formed and played Taylor Canyon, they were "The YP Three," but the addition of a new player necessitated a change, although somebody said they should have taken a name that couldn't be easily tampered with. They tuned up for what seemed like forever but finally launched the festivities with "House of the Rising Sun."

As we shortly learned, the song was one of the few the band

knew from beginning to end. Other songs would die slowly, losing first the vocals, then the guitars, and finally the drums. No matter. The tight space reserved for dancing was jammed as long as someone in the band was working. Kids danced. The very young and the very old danced, often together. Because of the cold outside, the dogs were allowed in, and they crossed the dance floor now and then. Homer danced, but as Bates had prophesied, nobody noticed. There were no good or bad dancers at 2:00 a.m. at Taylor Canyon, only dancers and non-dancers.

Tom Young, the owner, finally turned off the lights and yelled at the several remaining buckaroos to get the hell out, he was closing. Twenty minutes later, we were standing outside looking at five inches of snow on T.J.'s rig. Dean Tobias and Reva were in their foreign compact with the engine running, waiting for someone to follow them over Chicken Creek Summit. "We'll keep an eye on each other," Dean said as we pulled out.

Maximum speed was a slow crawl; visibility was next to nothing. The wipers slapped at the snow. It wasn't long before Dave and Homer were as slumped as their bodies could slump and were, for all purposes, dead. It fell on me to keep T.J. from nodding off at the wheel. If he was half as tired and dizzy as I was, it was going to be a full-time effort to keep the two of us awake.

I kept a conversation going for the first several miles out along the valley floor but ran out of things to say and questions to ask. So we took up singing to each other, which worked for some reason. We didn't care what we sang, as long as it kept our mouths and our brains working. Between us we had a larger repertoire than "Crud"; and we even started making up songs. I remember T.J. singing about himself and a few tough horses. Christ, I thought, this is getting weird. "Are you all right, T.J.?" I broke in. My eyes caught his, and we both laughed across the two lifeless bodies. We were going to make it.

Cowboying, when it is practiced by artists, is beautiful to watch. The roping and bronc riding, they can be appreciated by almost everyone. But there is another layer of ranch work that is not obvious to the unknowing eye.

We're talking now of cowmen versus cowboys. We're pointing to the heart of the matter, not the style — much as everyone loves style. A cowman's concerns are the ranch and the herd, and if he's the foreman, the crew. Cowmen may not always look flashy, but they are the kind of men you instinctively go to in a crowd when you don't know anyone and want to talk to the man in charge. You can spot them in ways that are beyond description: you see their positions by the way other buckaroos move around them.

Leading a crew of buckaroos has to be one of the most demanding jobs in the history of bossing. All flaws in judgment are duly recorded and stored away. There is no room for error, even with all that room.

Been with Tim and Ed Bacon at the 25 Ranch the last couple of days. Slept on the bunkhouse porch. Rolled my bed out on an old spring frame that sagged almost to the floor. Dogs kept racing around in the night, running right by me, scaring the hell out of me a couple of times. Something would draw their attention in the yard, and they'd go from lying down to all-out speed in a few scratching, clawing seconds. Rained. Didn't help this hacking cough I've cultivated.

Old Harry Wagner has been at the 25 forever. His skin has no color, and he looks like he could drop dead any moment. He's the outfit's choreboy now, but I hear he was quite a hand in his day.

Tim McGinnis and Ed Bacon spoke of him, said it was rumored he had maybe a hundred thousand dollars in cash salted away in

coffee cans somewhere. Said he simply collected his checks and sometimes went as long as a year before he'd cash them. Never bought anything except a few essentials: a few items of clothing, cigarettes, vodka. Hardly ever left the ranch. Harry is funny as hell, though, with a dry sense of humor. He told me that whenever he looks in the mirror lately he says, "Hi! Harry."

"Doing that really pisses me off," he added. "But I can't seem to stop."

The TV in the bunkhouse had stopped working, but because it was the buckaroos' responsibility to get it fixed or buy a new one, a battle of the wills ensued to see who'd cough up the money. Tim and Ed were certain Harry would miss his daily fix of soap operas too much. Harry, no doubt, thought he could easily outlast two young cowboys.

In the meantime, Harry put a small radio on top of the heater next to his bed and passed the hours listening to the Battle Mountain station. But Harry didn't just listen, he *looked*. He sat on the edge of his cot and stared at the radio as if it were a TV set that had been turned on, the volume working, the picture to appear momentarily.

�臥 Finished work in darkness. Used up our horses, for sure. It was a beautiful, rich day, though. The sun was the only thing in the sky; then a half moon appeared as we finished moving the cows across the meadows. A pink-red-violet sunset came down on us as we trotted back to the Meechum. Geese honked and flew overhead. A coyote sang. I worried that our horses would fall because the road was smooth and frozen; but Rick didn't even seem to notice when his horse lost his footing now and then. It was all just straight ahead, let's get home.

I hardly missed not having a noon meal, so fine was this day.

When the cows didn't want to move, it was okay by me; I could pull up for a moment and see the velvety covering of snow on the mountains and how its whiteness contrasted with the blue and red of the fading sky.

Later, while we were sitting around the stove, Dick Gusky treated his once-frostbitten feet with something called Icy Hot. He said it soothed the itching that comes every winter.

�臥 It was nearly dark when Ross, Joni, and I loaded up in Ross's Blazer and left for the Winecup. The back window of the Blazer was broken and couldn't be rolled up; as we drove, the freezing air was drawn inside, and we huddled close to the heater. Ross pulled off the road after a few miles and draped his tepee over the rollbar to keep us protected from the draft. There were no clear radio signals, so Ross entertained us with poems, both his own and the classics by Robert Service and Bruce Kiskaddon.

Before supper, Joni prepared bottles for the leppy calves, and we walked out to the pens to feed them. I crawled over a fence with the warm container in my hand and waded through the deep, powdery snow to a shed where a calf cowered in darkness. I coaxed him forward by standing motionless. He grabbed hold of the nipple and sucked till I thought the sides of the jug would collapse.

🌡臥 The Winters camp at the IL Ranch has a large, fenced trap, a one-room line shack set on blocks, and a small, wire corral handy for keeping a horse when the camp is occupied a few weeks in the summer. When the wagon is working the area, the camp man joins the branding crew, and when the wagon moves, he stays to watch the cattle and keep them from drifting back to headquarters.

After a couple weeks alone on the desert, men with previously normal personalities have been known to begin talking to themselves. With no one to prepare meals, some almost quit eating, refusing even to heat canned goods. Working a camp job is not like retreating to a lighthouse or lookout tower for a summer of scholarly reading and writing in that tranquility urban people say they hunger for, and that they believe the cowboy has.

⚜ There were things she wasn't saying. But her eyes were worlds, and through them you could see into places she protected, which took in a lot of country. If the eyes didn't always talk in language you could fully understand, the meaning somehow still seeped through.

So she raised the kids. Taught them, too, from correspondence books, in a classroom she fashioned out of secondhand school desks, a flag, and a chalkboard that someone had previously disfigured with paint and crayons. Each day she would religiously put aside chores and thoughts of solitary comforts and stand before her children with a pointer and a govenment-approved lesson plan. Occasionally, when the two children were bent over their books, a recurring thought passed before her: the world seems to have gone one direction and me another.

Friends and ranchers in the area knew her not only as a woman first and always but as good help horseback. In fact, it was common knowledge that she was better with a horse and rope than many of the young buckaroos passing through northern Nevada, but no one said so aloud.

⚜ Somebody tell me Nevada isn't a hard son of a bitch. The land, the people, the whole shitaree. Randy Stowell has got the operation to match the country: rawhide as hell. Get old-timey, draw the strings up tight, work your ass off for any bonus you can get. Don't cut the bull bag off, slice it because the bag will heal up, fill with fat, and you got maybe half a pound on the animal when you ship. "A couple hundred steers times half a pound," Randy says, "times sixty cents a pound, and it starts to add up." If Randy Stowell can't make a few dollars running cows nobody I know in winter-feed country can.

⚜ Spent the day with Bryan Neubert. Trailered our horses to Lamoille, where we connected with Alex and Federico. The ranch was selling off some cows, and the men worked together to cull the bottom end.

"Isn't this the old bitch that tried to jump through the window at the barn?" Denny asked as Alex drove a cow to the outside of the herd. "I think this heifer's the crazy one we pulled back from the dead, isn't she?" Bryan said, referring to a second one.

Almost every animal that came out, and many that stayed in, carried stories with them.

⚜ New Year's Day. We stopped back in at the Cowboy Bar so I could get my overshoes, but we didn't leave for several hours. Jerry and Randy were there, and we played pool, kept the jukebox fed, and watched as someone dismantled the Christmas decorations and took them, one by one, outside. It was kind of depressing to watch. Jerry told the man removing the bells and tinsel and red ribbon he was going to set his beard on fire if he didn't quit.

⚜ A ranch manager's wife told me once that if I had spent more time driving around the ranch with her husband instead of riding and drinking with the buckaroos, I might have learned something useful.

There is an easy comfort given to believers of the Western dream, knowing that cowboys are, at this very moment, galloping around somewhere, roping sick stock, and sleeping out under the stars. Why this kind of trivial knowledge should make a difference in anyone's life is a mystery.

The more experience cowboys get, the more their world can shrink. Men they once admired, diminish; knowing is the beginning of knowing too much. The bigger the country, the bigger the appetite for seeing new country. Cowboys, like anyone else, are seldom satisfied with their lives.

The moon is blocked by dark clouds over the Rubies. Instead of heading back into Elko tonight as I had planned, I am sleeping by the side of the road, the side doors of my van open to the night. It is mid-July, and the breeze feels good. The thick smell of sagebrush brings to memory the crews I've ridden with and photographed, crews that have long since scattered and will never be together again.

Rode Buster today, a tall sorrel with a snip and one hind sock. Bryan said Buster was older than he was. Said Fritz Marek started him when he worked at the IL many years ago. Good horse, easy to ride, and surprisingly light and sensitive after all the miles the old boy has covered and the riders he's packed.

Saw a wide-open stretch of the IL and skirted the Owyhee Canyon at one point. Could see the Bull Run Mountains at the YP, snow-capped and soon shrouded in low clouds.

Now I'm in my bedroll at the IL bunkhouse. The generator which supplies power to the headquarters chugs and sputters in the shack next door. Out here, all these miles from nowhere, you'd think at least there would be peace and quiet. My alarm clock ticks. Jerry Cross is bunked across the aisle. Roy, Bryan, and Tim are at the Desert Ranch, all of them hit hard by flu.

When you get paid, or when you roll your bed and say the hell with this job, you go directly to the Commercial Hotel, to the back bar. Maybe you pick up a six-pack at Taylor Canyon Club on the way to town, but you don't have a drink inside. No, you've done that before, and you never made it to town.

The Commercial is a lot like the bunkhouse. Working class people hang out at the Commercial. Sometimes, so do a bus load or two of blue-haired ladies in town on a package deal from Salt Lake, but this is not a destination resort for the prosperous. The marquee says "Now Appearing The Matys Bros," but the Matys Brothers are always appearing.

Buckaroos go to the Commercial for purposes of all sorts. Drink, of course; hunt a new job; see who's in town; get out of the goddamn sun or the goddamn snow; cash a payroll check; take a hard look at the waitresses and barmaids; buy a bus ticket out of Elko, forever.

It takes a strong will to keep a small outfit from turning into a farm. A ranch of two hundred cows tests that will daily. And when a rancher thinks only of cows and shrinkage and calf-crop percentages, he'll think of ways other than horses to do what he needs to do. And when he quits horses altogether, he takes to wearing baseball caps, short-sleeved shirts, and brogans. He walks the bridge from one life to another.

It is night, I'm driving, and I see lights across a valley. There are maybe two lights showing through a blackness that yields only dense shapes: earth, mountain, sky. The ranch lights are the yard-arc-type, very heavy duty and penetrating.

I see the lights and think about the lives pinned down under them. What are those lives doing now, at this moment? Are they a family and are they asleep? Is a child awake, dreaming? Has there been love made, and was it rough, sober, kind?

The lights are people, and my imagination gives them faces. They are ships at sea, but they do not move.

Jack's Creek, Owyhee Desert. We're holed up in this trailer for a day while the wind blows and snow races by. The horses are humped up around the lee side of the trailer, and a couple ponies have their butts pressed to the grill of the pickup for protection.

It's been storming nonstop since we left the seeding on Tuesday. You'd think it would have let up a bit in those four days, but, damn, it just keeps at it, all seriousness and purpose.

It was a never-ending battle to keep the cows on the trail. They'd be lined out one minute and off into the sage the next. The bulls were the worst offenders. I wished several times that I had had a rope in my hands instead of the cameras I was packing.

Felt sorry for the baby calves in the drag. One little black baldy — must have been less than a week old — needed to be coaxed every step. Each morning after we gathered and got moving, there he was in the very tail end, frosted over and barely walking. No one yelled at him like they did at the cows. "Come on little fella," they would say quietly.

Dark was on us when we turned the cows loose the first day and closed the gate on the trap and trotted down a gravel road to the camp at Wickahoney. The small trailer the outfit used for a portable cookshack was parked by the side of the infrequently traveled road. Light from inside the trailer filled the open doorway where Dick Gibford, our cook, stood. We unsaddled at a tin shed and turned the horses out in the corral for the night. Supper was tortillas, beans, steaks, and a good salad. Dessert was a dish of orange-flavored Jell-O laced with canned peach slices. Dick apologized as he dished out the mixture, which ran from the paper plates onto the Formica table top, stranding the peach slices as if they were beached fish. "Don't know what went wrong," Dick said to the crowded table. "The package said chill and serve. I thought I had left it outside plenty long."

Butch, Andy, and I unrolled our beds in the shed, where we slept well and warm, safe from the wind. Butch's Blue Heeler pup, Skeeter, howled after we bedded down, so Butch got up and let him inside. The dog added an illusion of warmth to our space, the primitive notion that man and animal were in this mess together and that we humans might profit from the animal's instinct to survive.

It was snowing hard when we jerked the saddles from our horses at the end of the next day's drive. I rode Slim, a nice-handling bay. I wondered if we would pitch the bed tent in the storm or squeeze into the cookshack trailer.

Tom tried to make space for my bed, but it was going to be so cramped no one would be able to sleep, so I unrolled my bed under the pickup, beside the saddles and Butch's pup. I put my overcoat and boots in the cab and crawled quickly into my snowy cave, wearing everything I could put on. Throughout the night Skeeter kept nuzzling my head, wanting to crawl inside my bed.

We awoke to more of the storm. We had picketed the horses on a nylon rope stretched between the truck and a fence across the road. One of the horses got tangled up in the line while we were saddling, but Tom and John talked the horse out of what could have been a big wreck. We rode in snow all day, but the cold wasn't sharp,

and the wind barely blew.

Monasterio camp. Bedded down in the small, three-sided barn. Colder inside the stone house than here in this open-air hutch. A very tough day. My feet have been numb since I crawled out of my bedroll at 4:30 a.m.

Last night we trotted back out to the basin to kick back any cows that had drifted, to "tuck them in," Tom said. We rode in moonlight, a momentary break in the storm. It was like riding into a Frederic Remington painting. The moon was bright enough to cast shadows.

Tom decided to grab a couple of granola bars in lieu of breakfast this morning and made a hurried run at the cows to see if he could get them contained before daylight. He was worried that the cows had left the country and that we'd be all day just gathering and getting them back to where we had them yesterday.

Went through what they call Lost Valley today and trailed the cows to the other side of Dollar Butte. Rocks were littered across the land in such uniform patterns that it appeared as if an ancient people had placed each stone. Juniper Mountain was snowy and visible in the far distance.

We walked and trotted back to the house, sloshing and splashing our way where the cows had made a boggy lane. The last day of the drive Slim got crippled. He had his front foot wedged between rocks, and when he moved to walk out, he twisted his knee badly. Afoot, I led him back to camp. Don't know how many miles, but plenty, the rocks and ice making each mile seem like ten.

When we were ready to leave Monasterio for home, the truck wouldn't start. It was snowing as usual, and Tom dreaded the inevitable — crawling under the truck and removing the fuel pump. I gathered a plastic sheet from the barn for us to lie on under the chassis. Tom got the pump off, and with it gas shot on his face and got in his eye. Finally got the truck started.

Made a big circle bringing the horses out with Andy. Left Slim behind; Tom was sure he'd find his way back home when he mended. When we got to the road and found no sign of the tractor and truck having passed by, we waited with the saddle horses. When they didn't show after nearly an hour, we headed back down the road we had just traveled. Andy rode ahead to see what had happened to Tom and Dick. He came back with the report that "they've got both vehicles buried." The eagle-bill taps on his saddle were frozen, and they clacked and slapped in the heavy wind.

Tom radioed for a truck from headquarters. What should have taken a morning, took us all day.

Ogden, Utah. First bath in a week. Can't get enough hot water to suit me, even though I've taken two baths in about two hours. My room in the motel is nice enough, but I wish I were in the barn at Monasterio in my bedroll, listening to the horses jockeying for position at the wire entry and at the window. I miss the sound of their jaws working on the scraps of hay and grain.

One night, when we were all in our bedrolls and the kerosene lamp had been extinguished, I commented on how pretty the country had been, in spite of the weather. I said it was very big country and that it had presence. I asked if anyone took the country for granted, didn't notice it anymore.

Tom spoke. "One thing never changes — what it is like to ride out before the sun comes up, in the dark. You can feel the cold when you ride in the valleys and notice how the air gets warmer when you trot back up. You can feel the country change under you."

❧ No doubt I have fallen into what has to be a photographer's dream, and I sometimes wonder why no one has spent a lifetime taking pictures of cowboys.

The cowboy West has drama, light, a rare purity. And when the sun comes up, cowboys ride out into it.

Images from the Sagebrush Basin

2. *LS Ranches, Montello, Nevada*

3. *Maggie Creek Ranch, Carlin, Nevada*

4. *MC Ranch, Adel, Oregon*

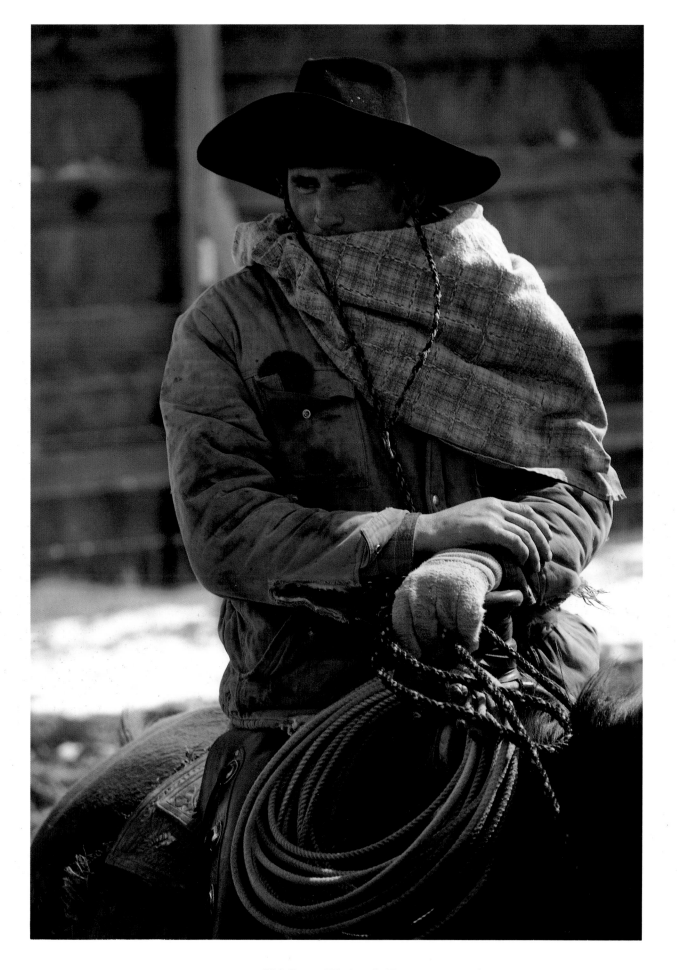

5. *Rick Bates, YP Ranch, Tuscarora, Nevada*

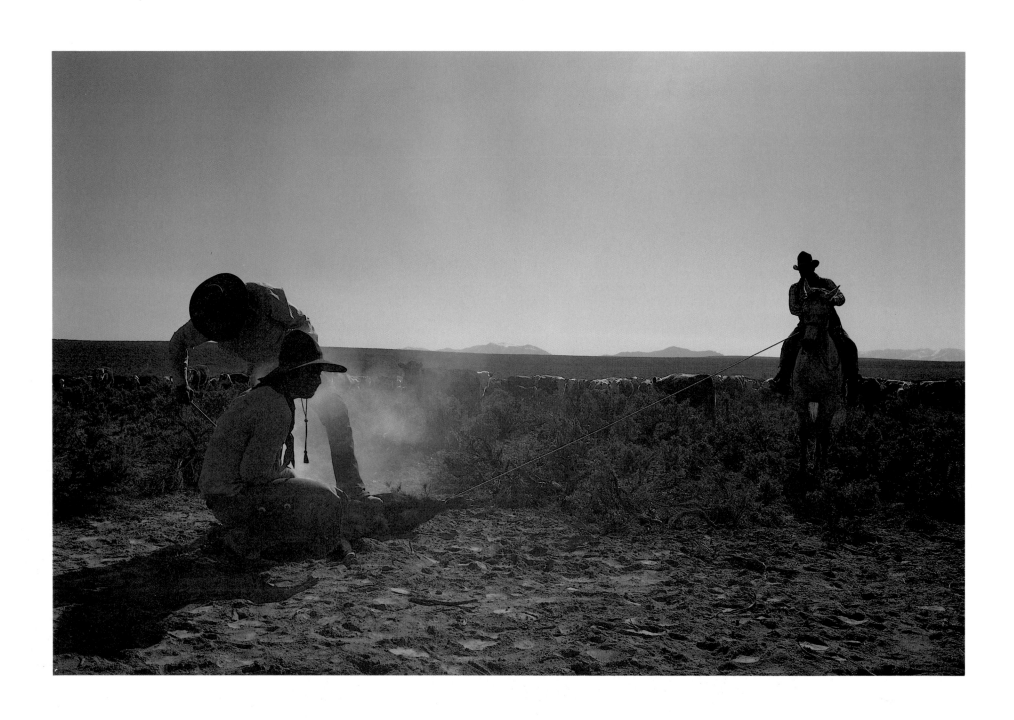

6. *IL Ranch, Tuscarora, Nevada*

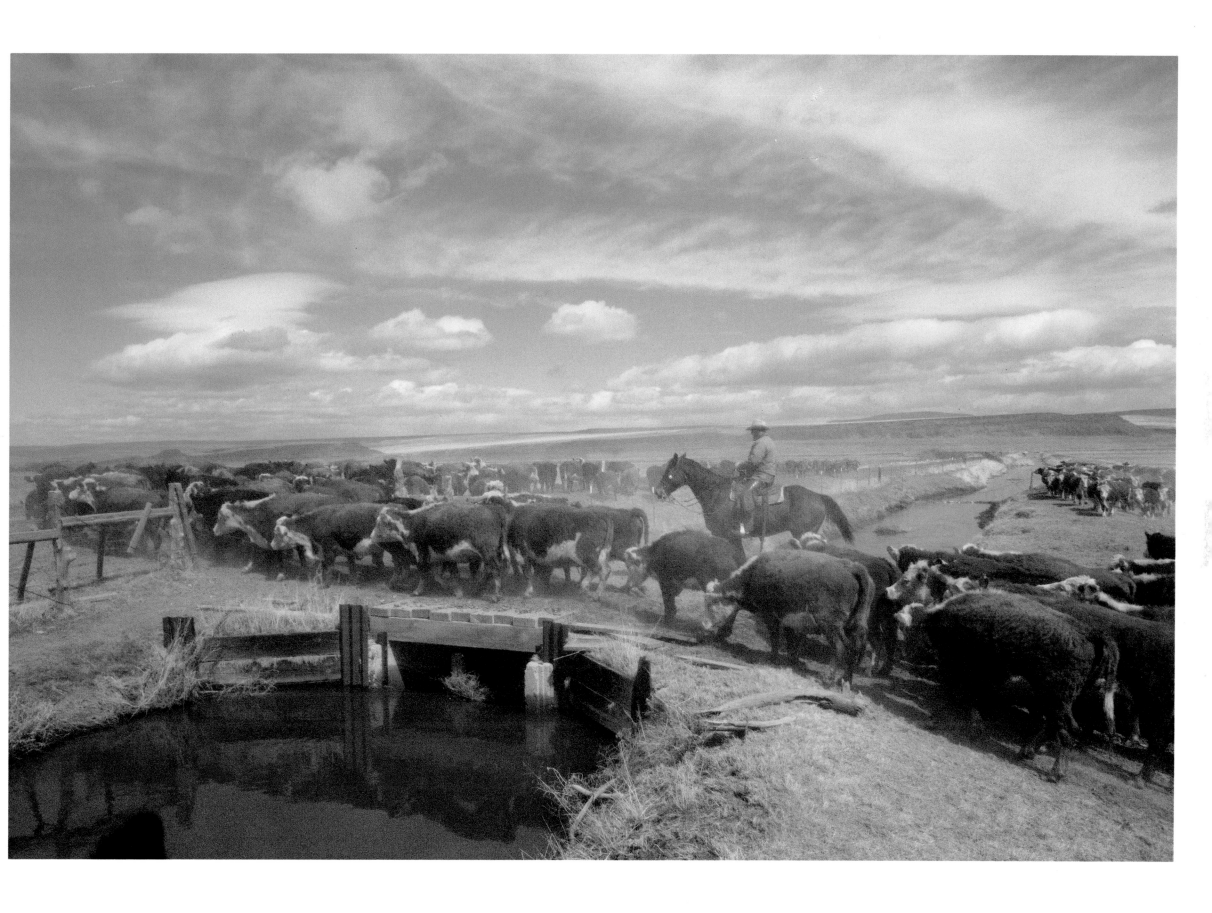

7. *MC Ranch, Adel, Oregon*

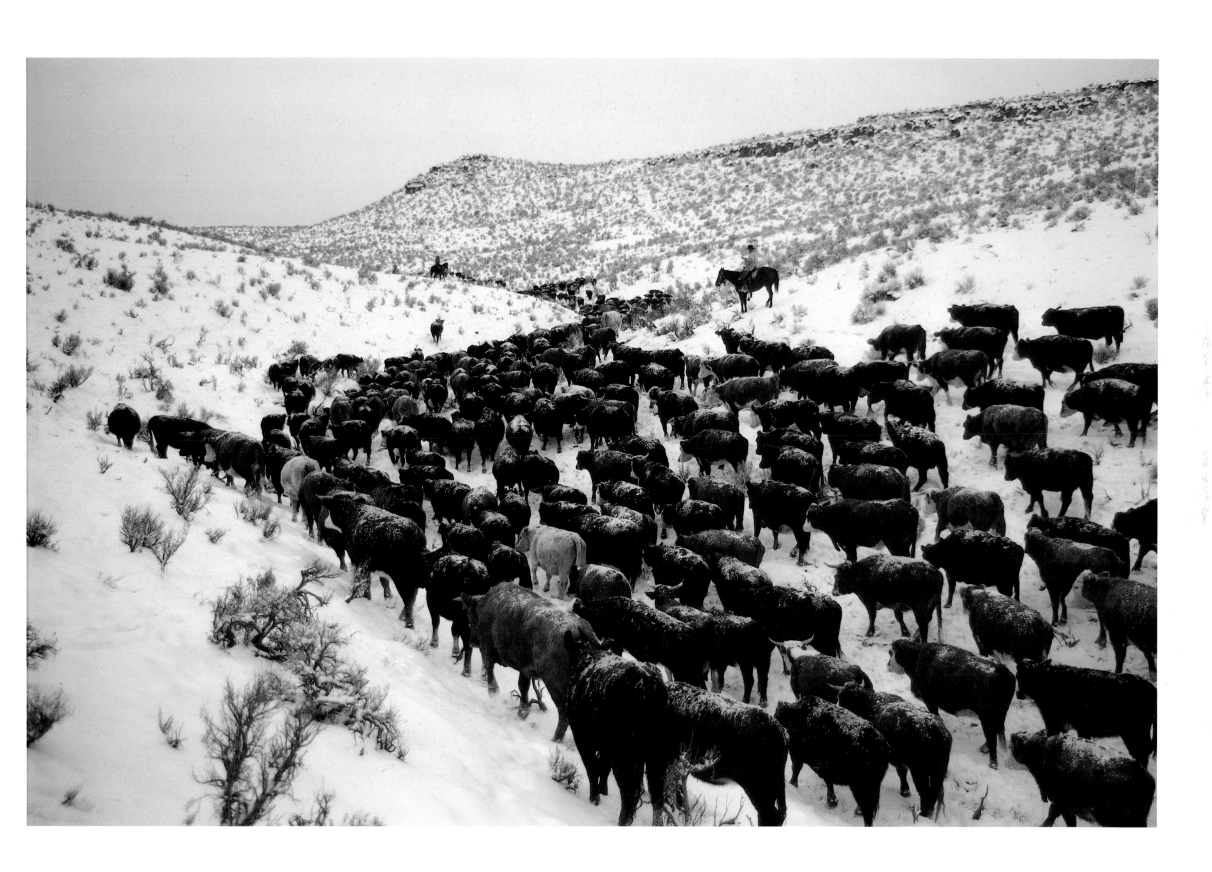

21. IL Ranch, Tuscarora, Nevada

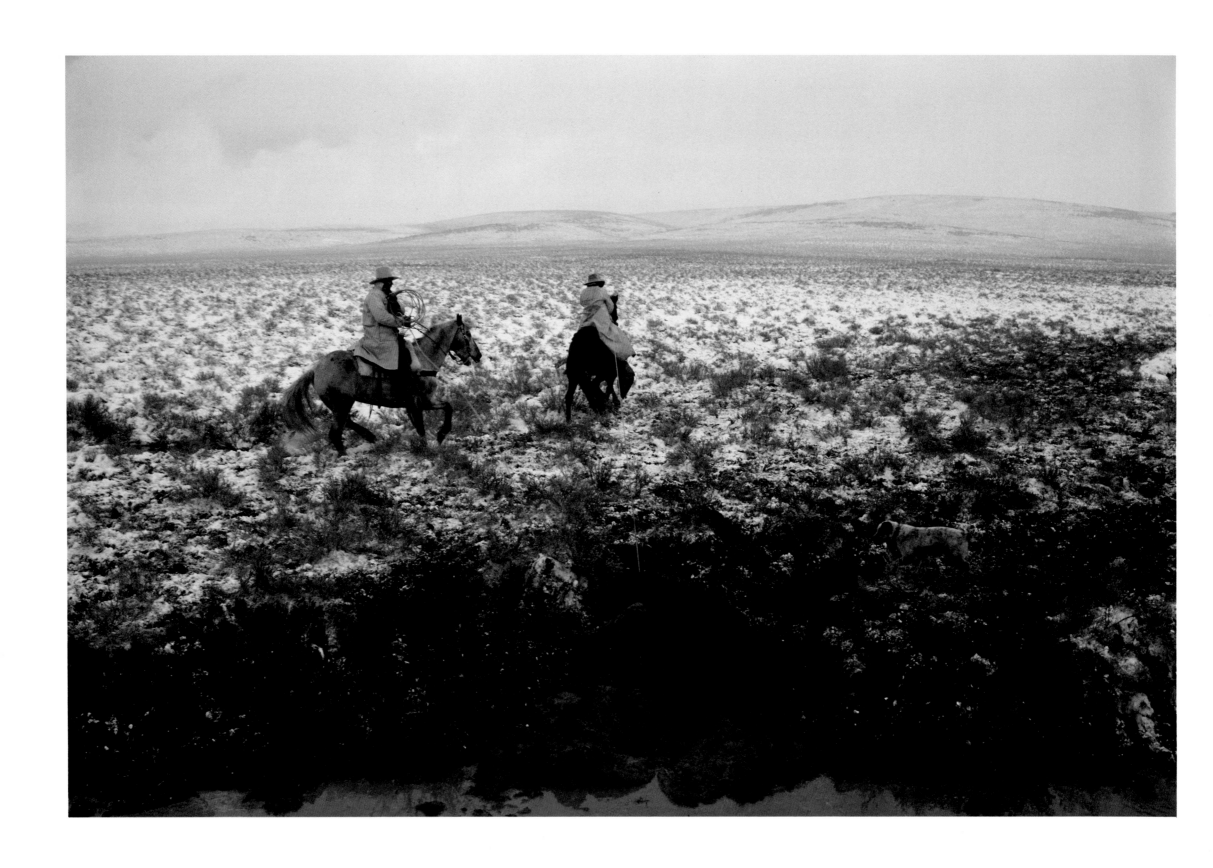

22. *Big Springs Ranch, Bruneau, Idaho*

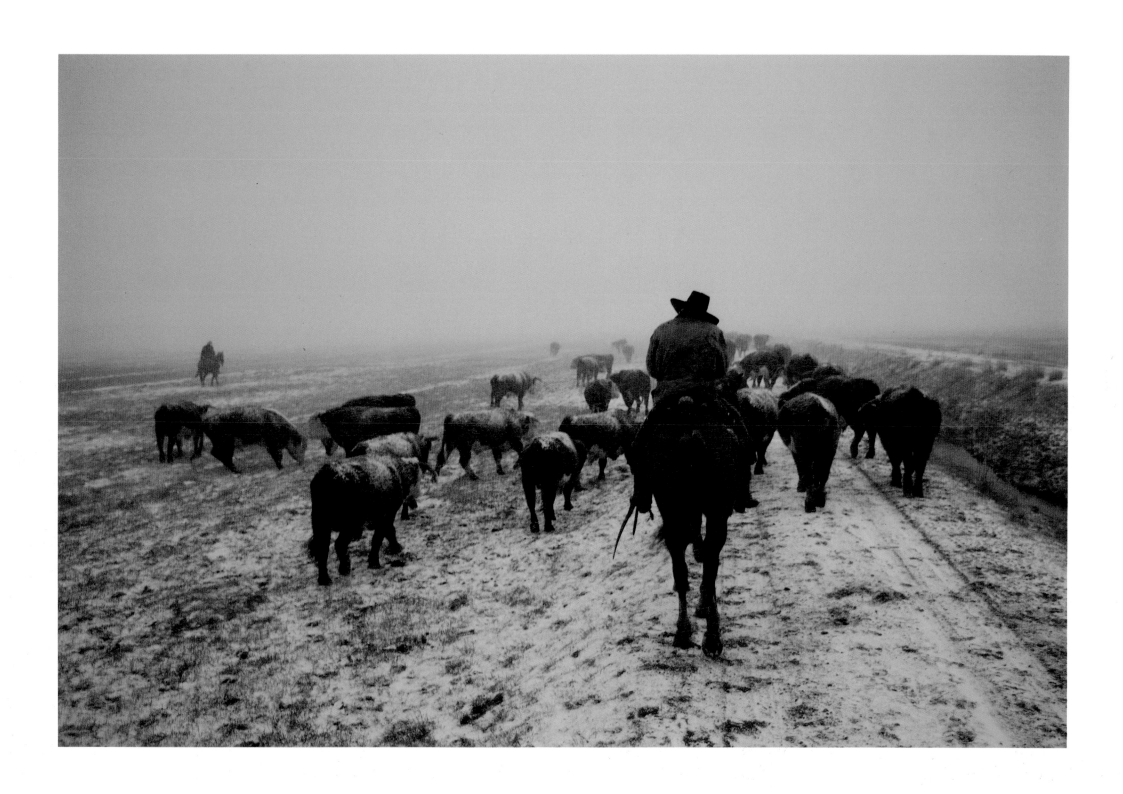

23.　*YP Ranch, Tuscarora, Nevada*

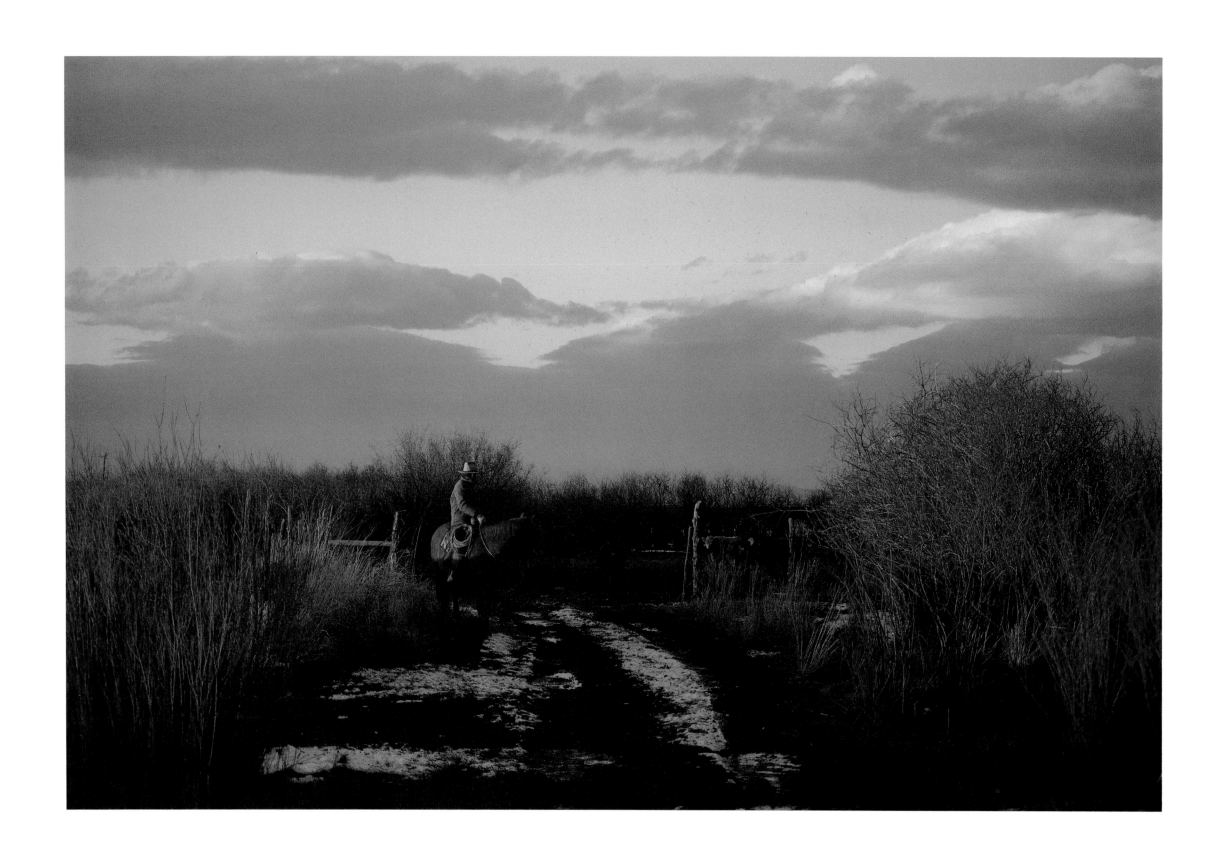

24. *6 Bar Ranch, Lamoille, Nevada*

25. *Jeff Hudson, T Lazy S Ranch, Battle Mountain, Nevada*

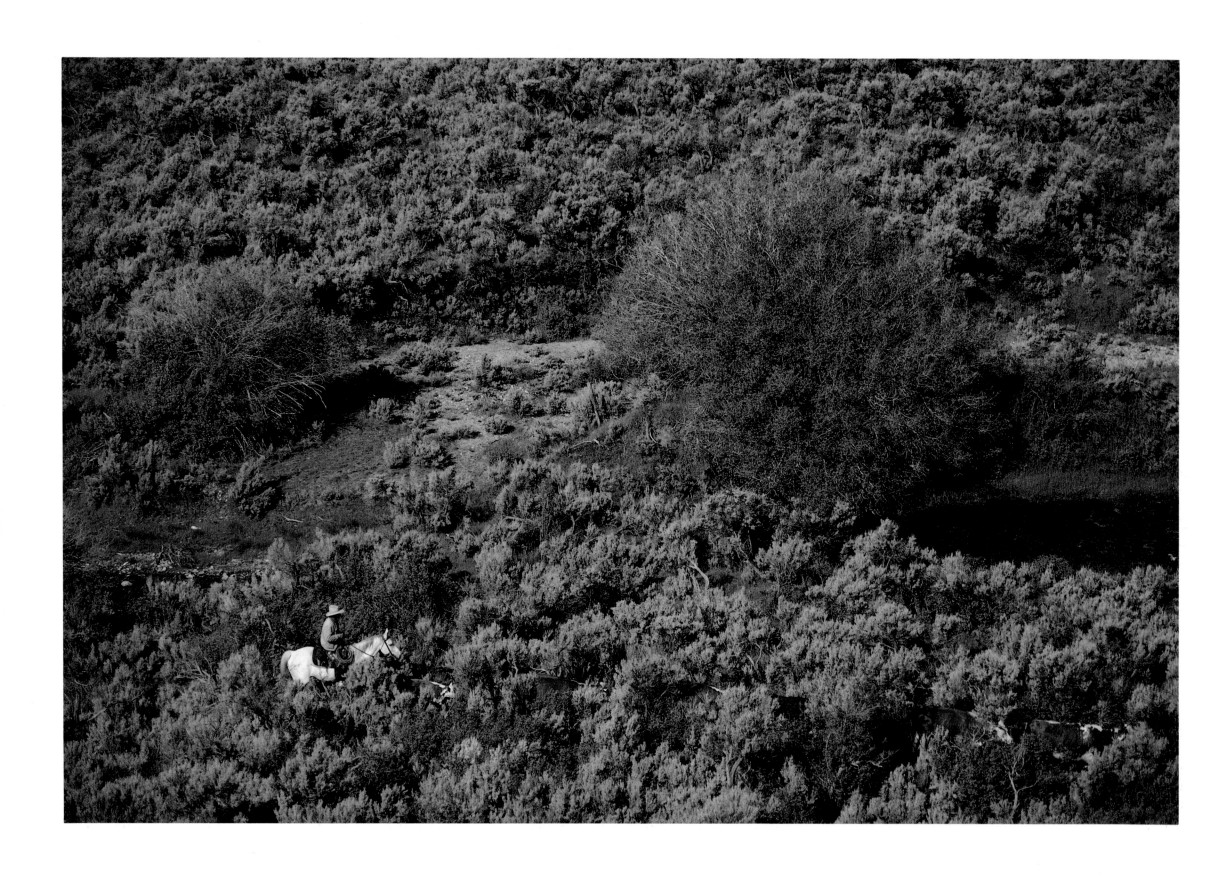

26. *Spanish Ranch, Tuscarora, Nevada*

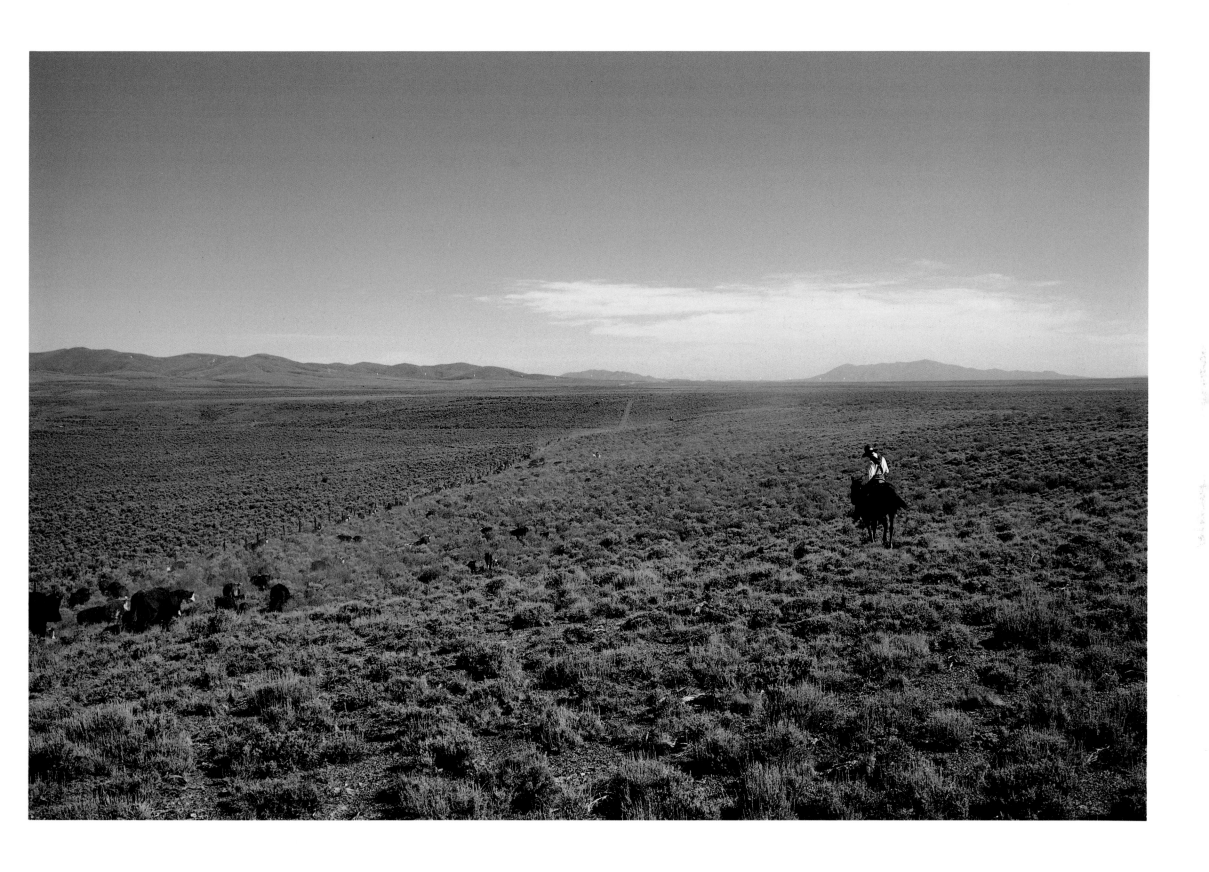

27. *LS Ranches, Montello, Nevada*

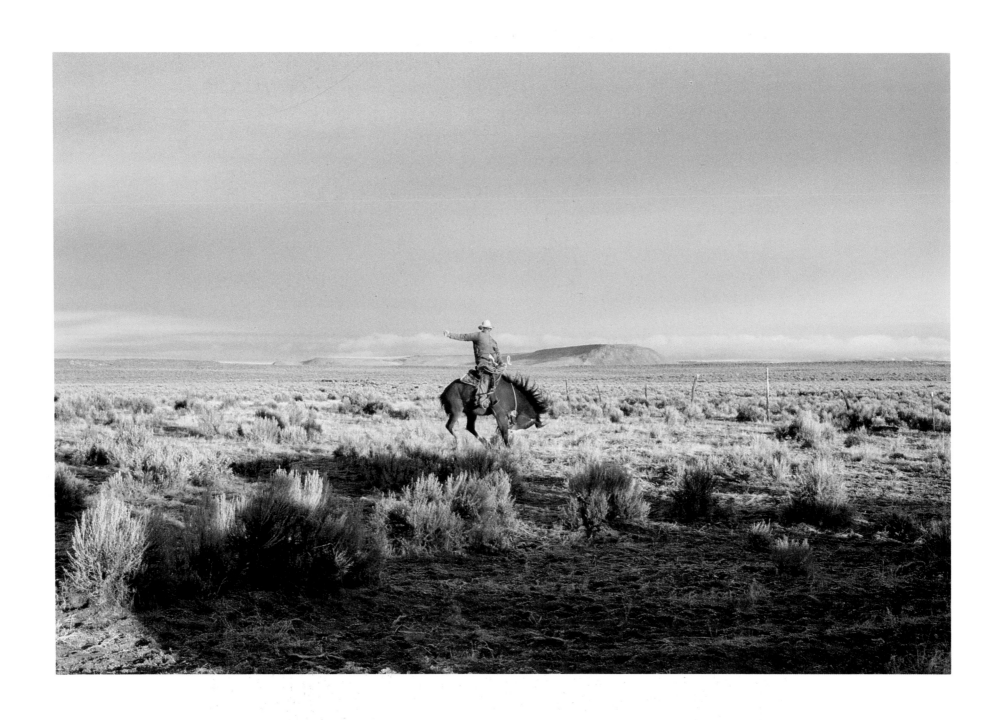

28. *M C Ranch, Adel, Oregon*

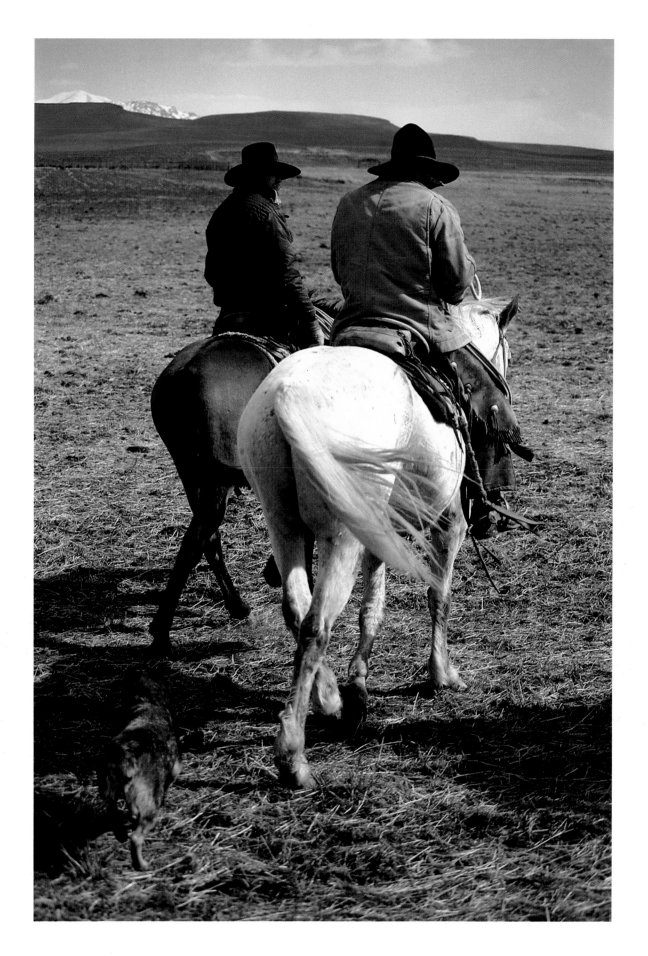

29. *YP Ranch, Tuscarora, Nevada*

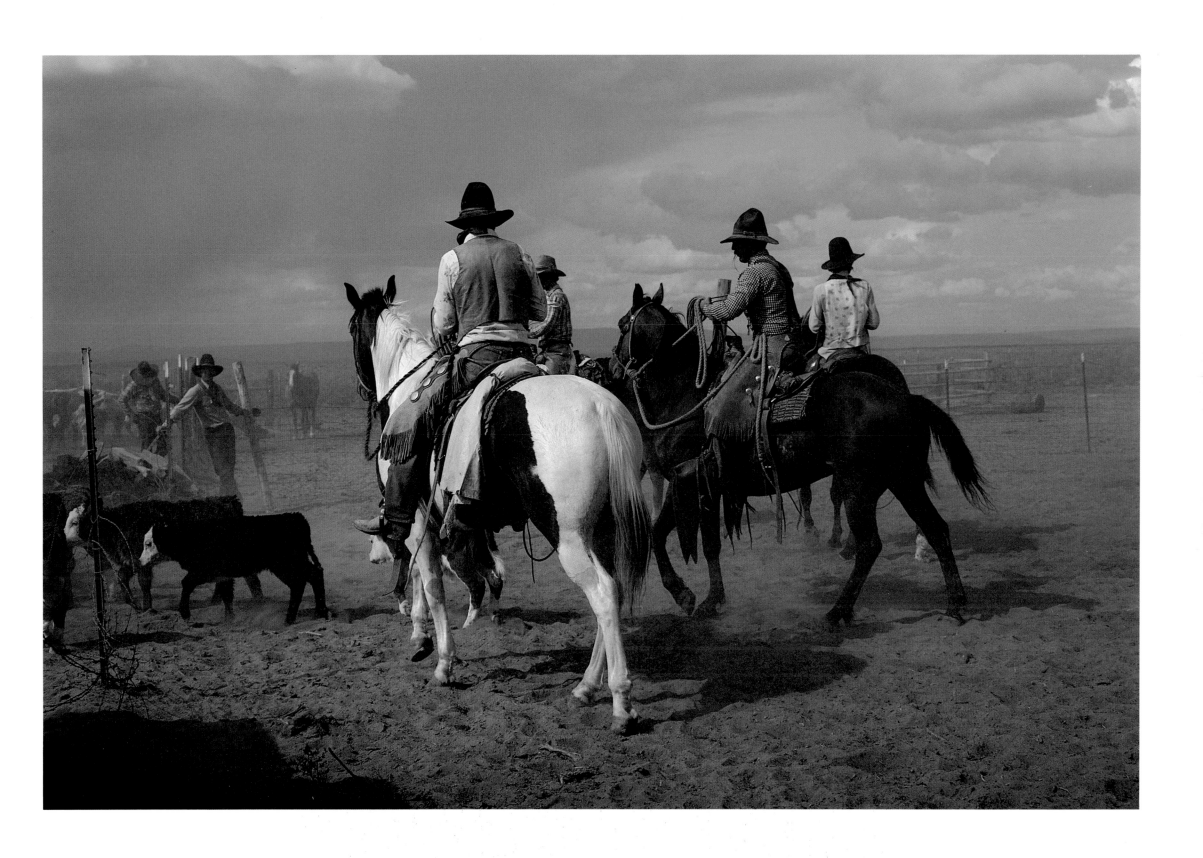

43. *ZX Ranch, Paisley, Oregon*

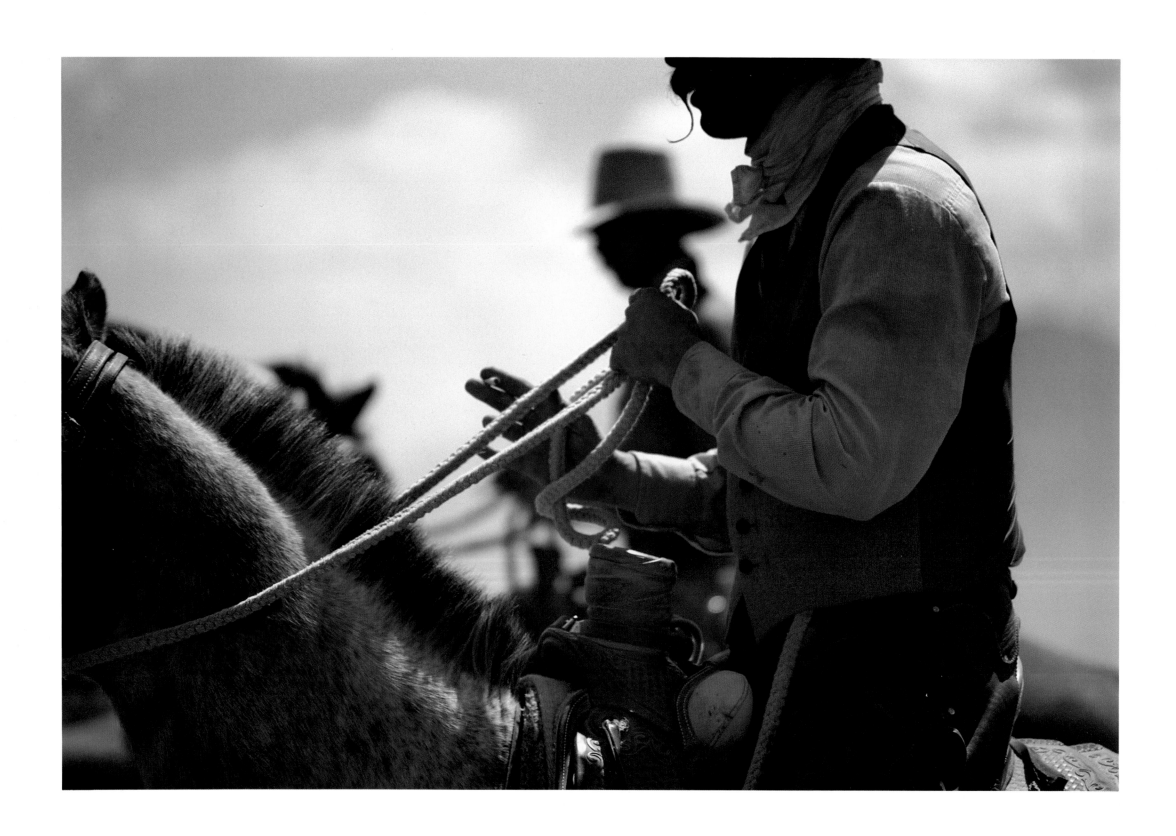

44. *Russell Ranches, Eureka, Nevada*

45. *Russell Ranches, Eureka, Nevada*

46. I L Ranch, Tuscarora, Nevada

47. *YP Ranch, Tuscarora, Nevada*

48. *Maggie Creek Ranch, Carlin, Nevada*

49. *Merlin Rupp, Rock Creek Ranch, Frenchglen, Oregon*

50. *Randy Stowell, rawhide braider, Stowell Brothers Ranching, Pie Creek, Nevada*

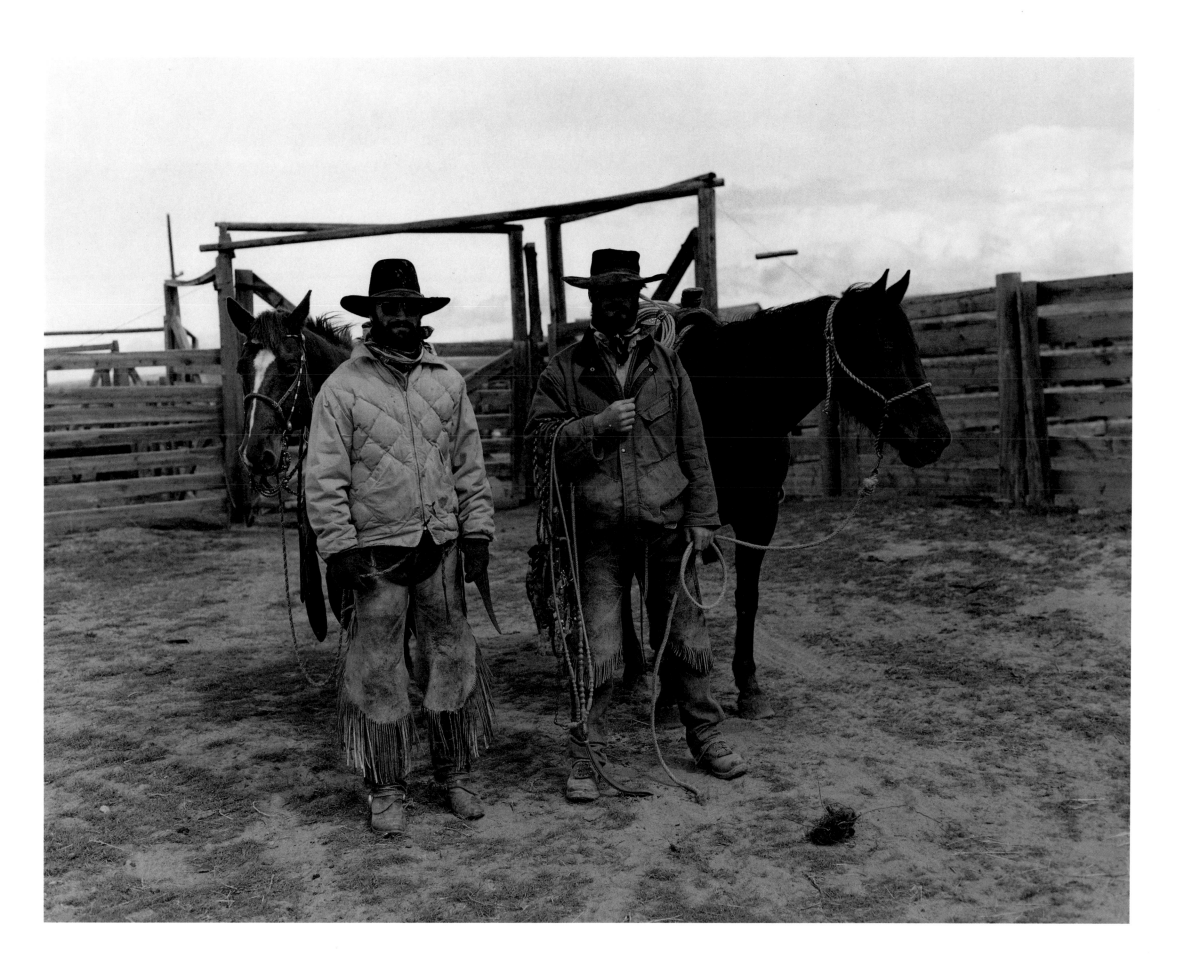

51. *Martin and Terry Black, Ace Black Ranch, Bruneau, Idaho*

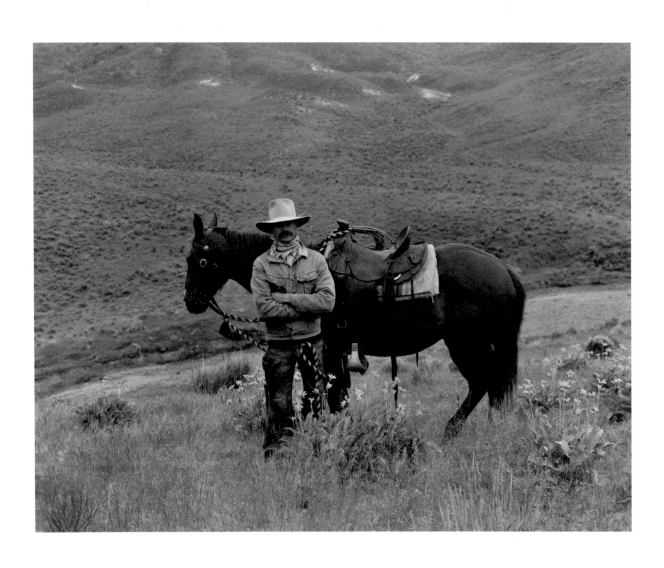

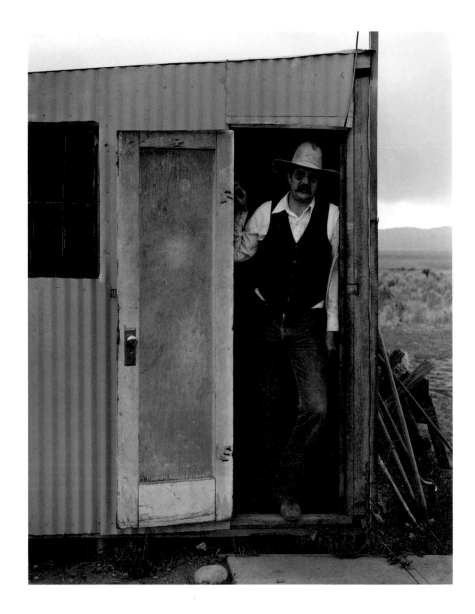

52. *Scott Brown, saddle maker, Elko, Nevada*

53. *Mark Dahl, bit and spur maker, Deeth, Nevada*

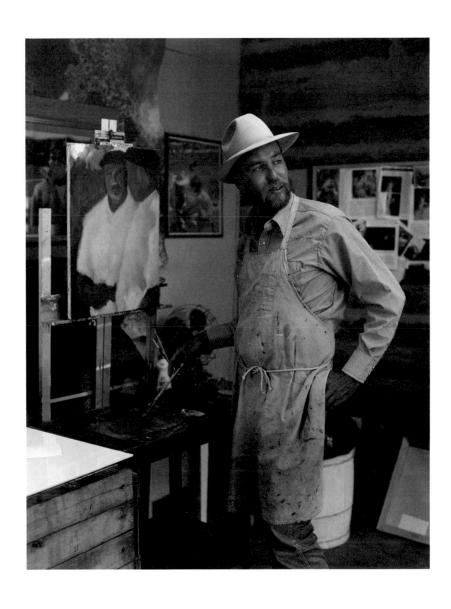

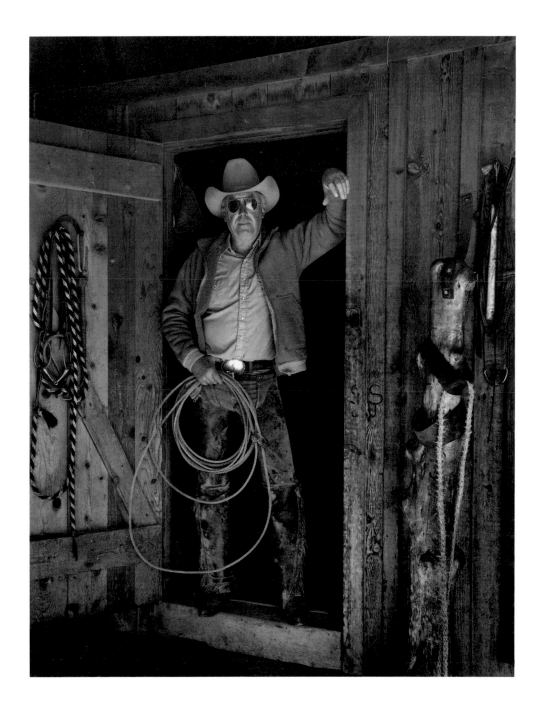

54. *Jim Christison, artist, Pinson Ranch, Golconda, Nevada*

55. *Jack Swanson, artist, Carmel Valley, California*

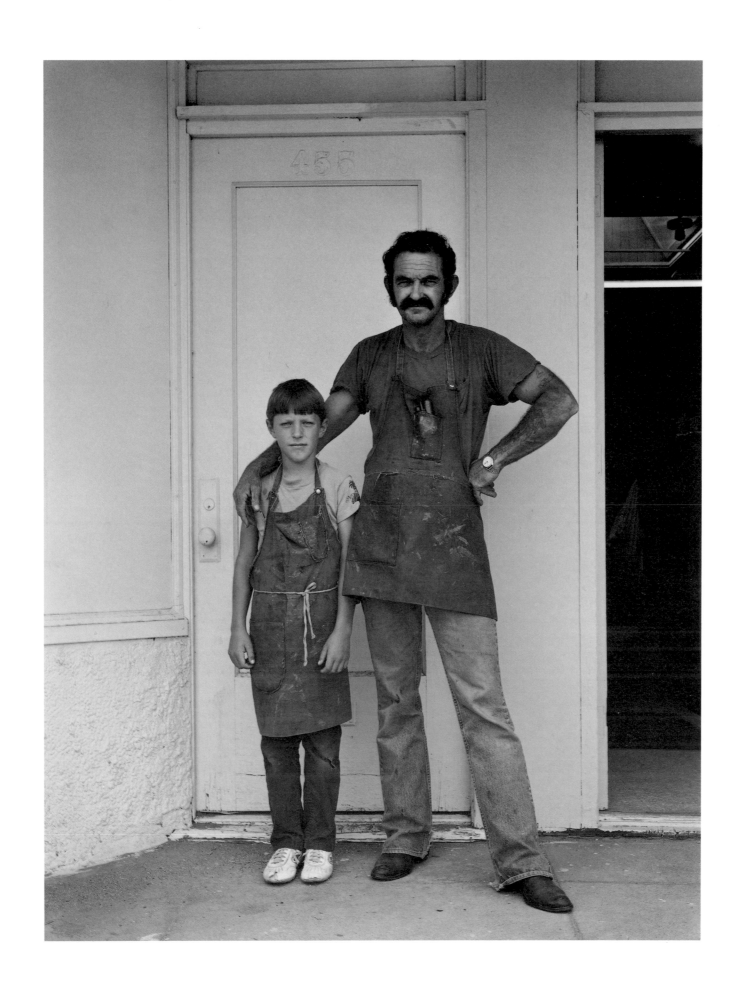

65. *Clyde Gregory and Clyde Jr., cobblers, Elko, Nevada*

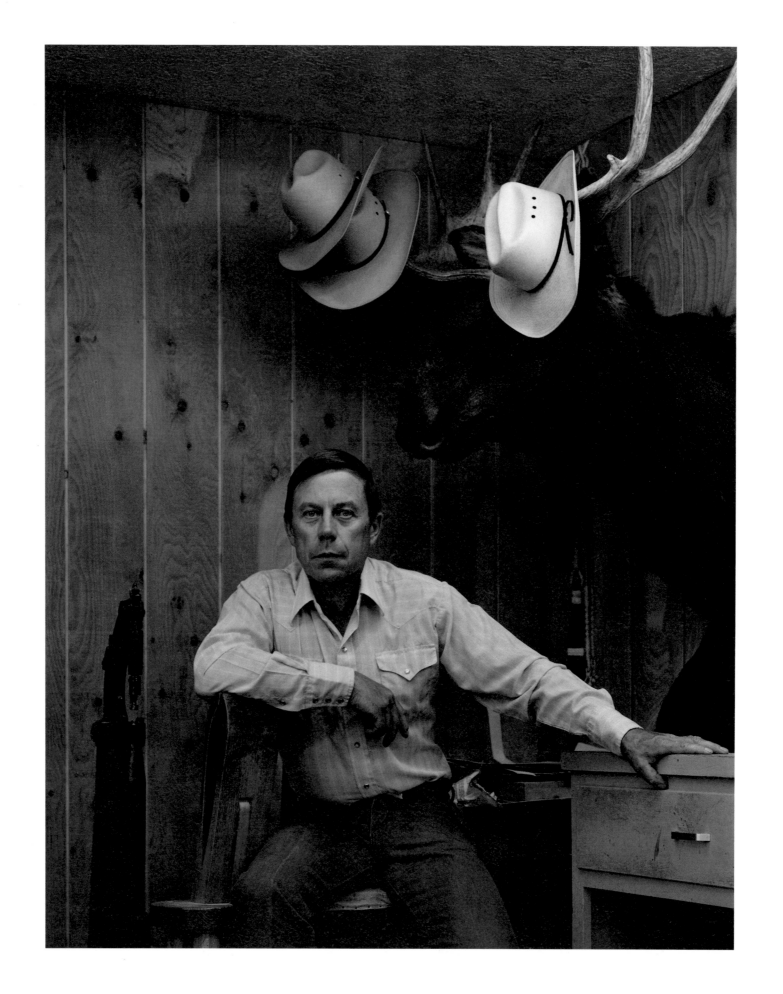

66. *Dale Harwood, saddle maker, Shelley, Idaho*

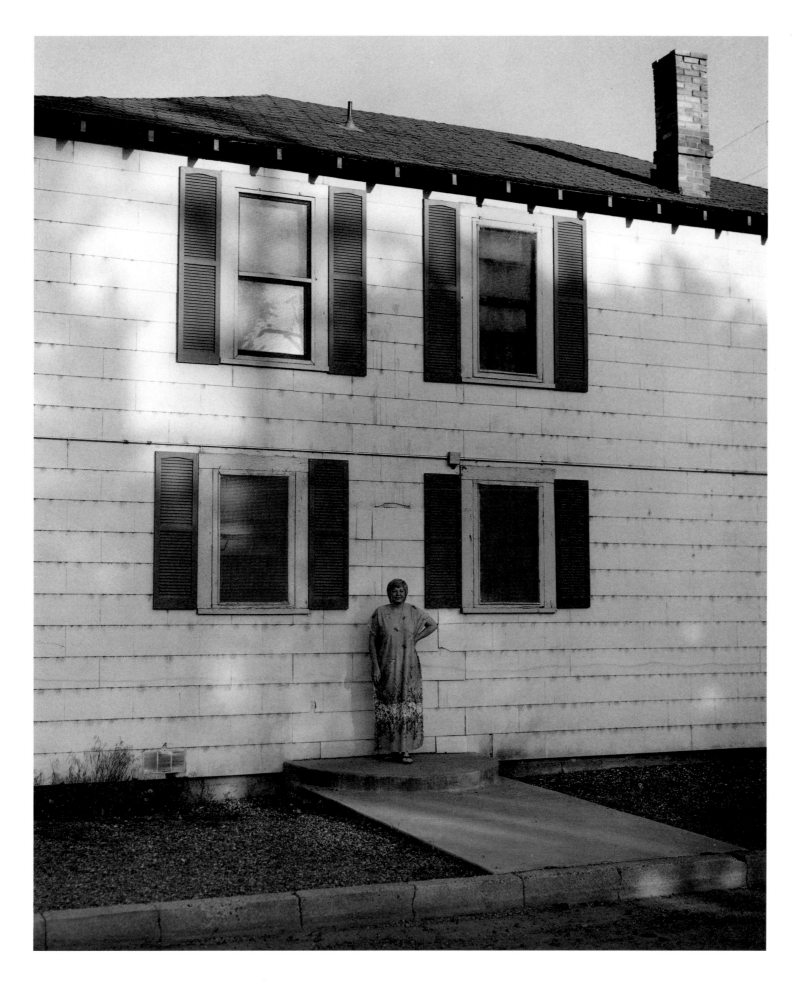

67. *Mona Gammel, madam, Club Mona Lisa, Elko, Nevada*

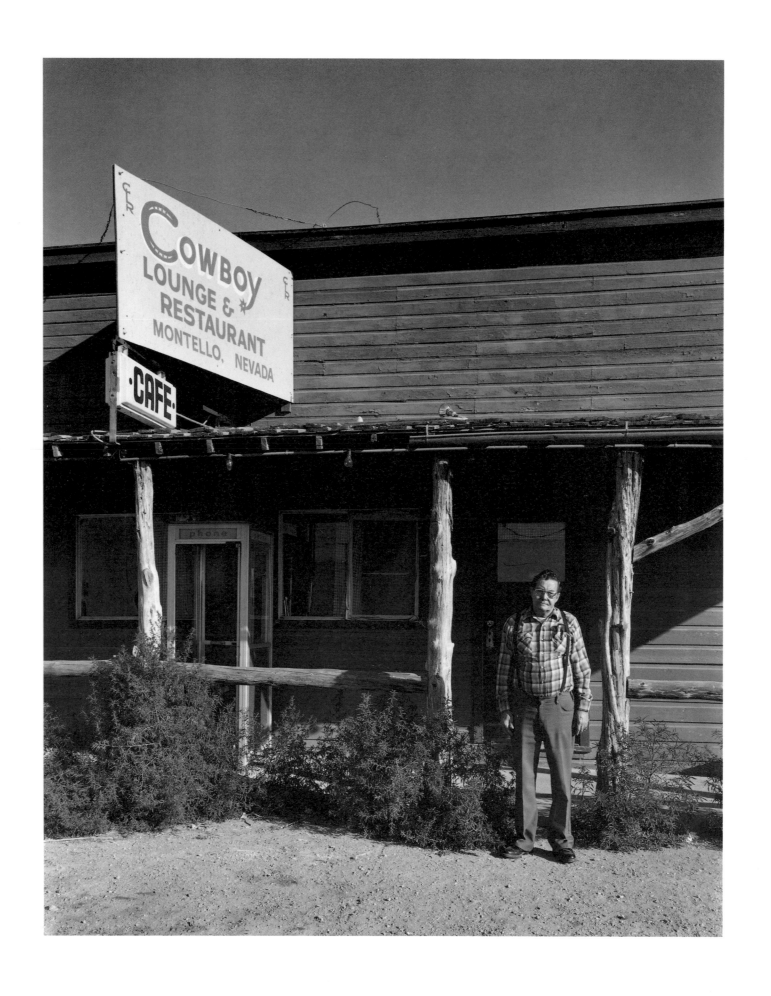

68. *Ken Thornton, proprietor, Cowboy Bar, Montello, Nevada*

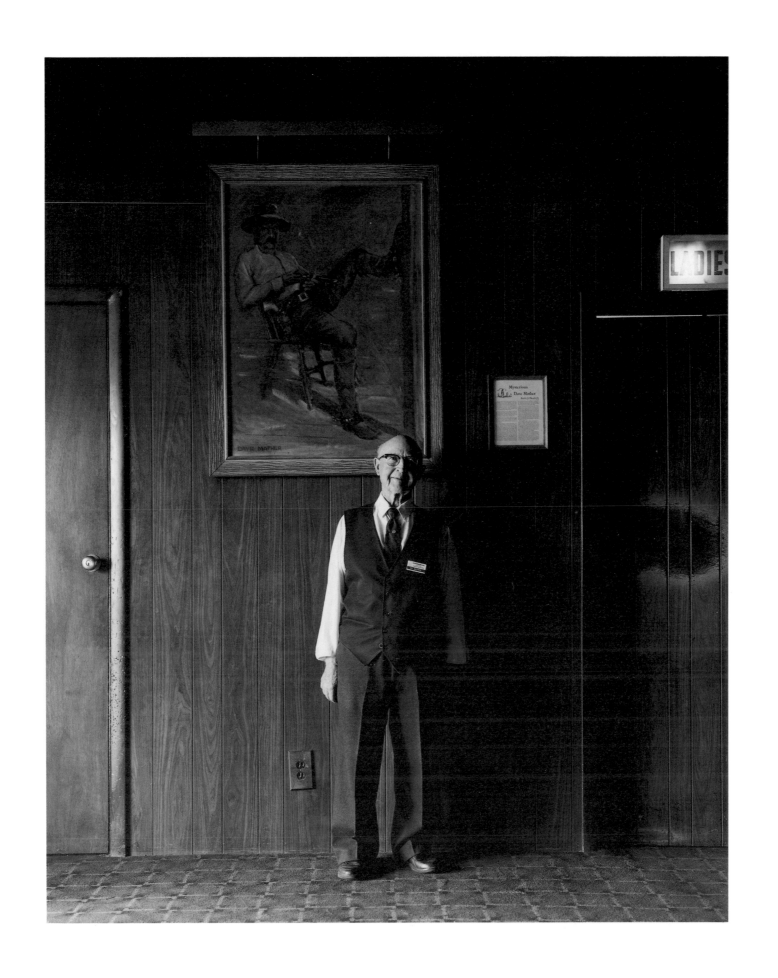

69. A. R. "Shorty" Miglioretto, bartender, Commercial Hotel and Casino, Elko, Nevada

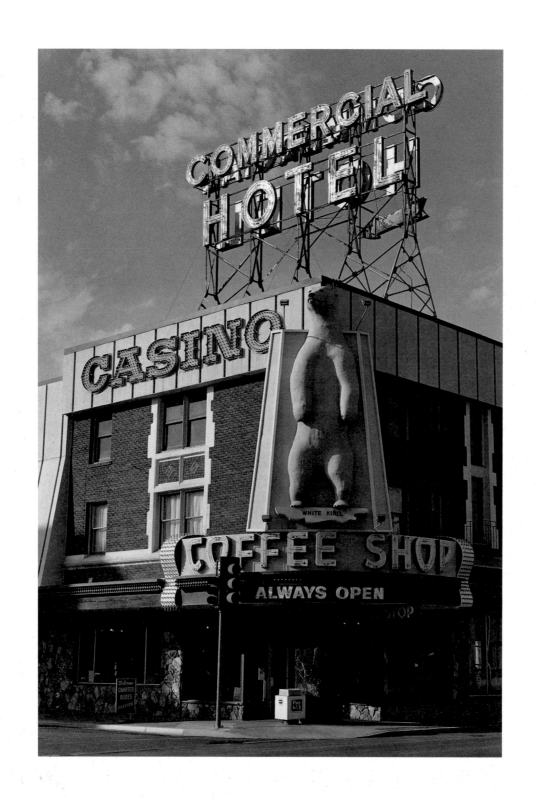

70. *Commercial Hotel and Casino, Elko, Nevada*

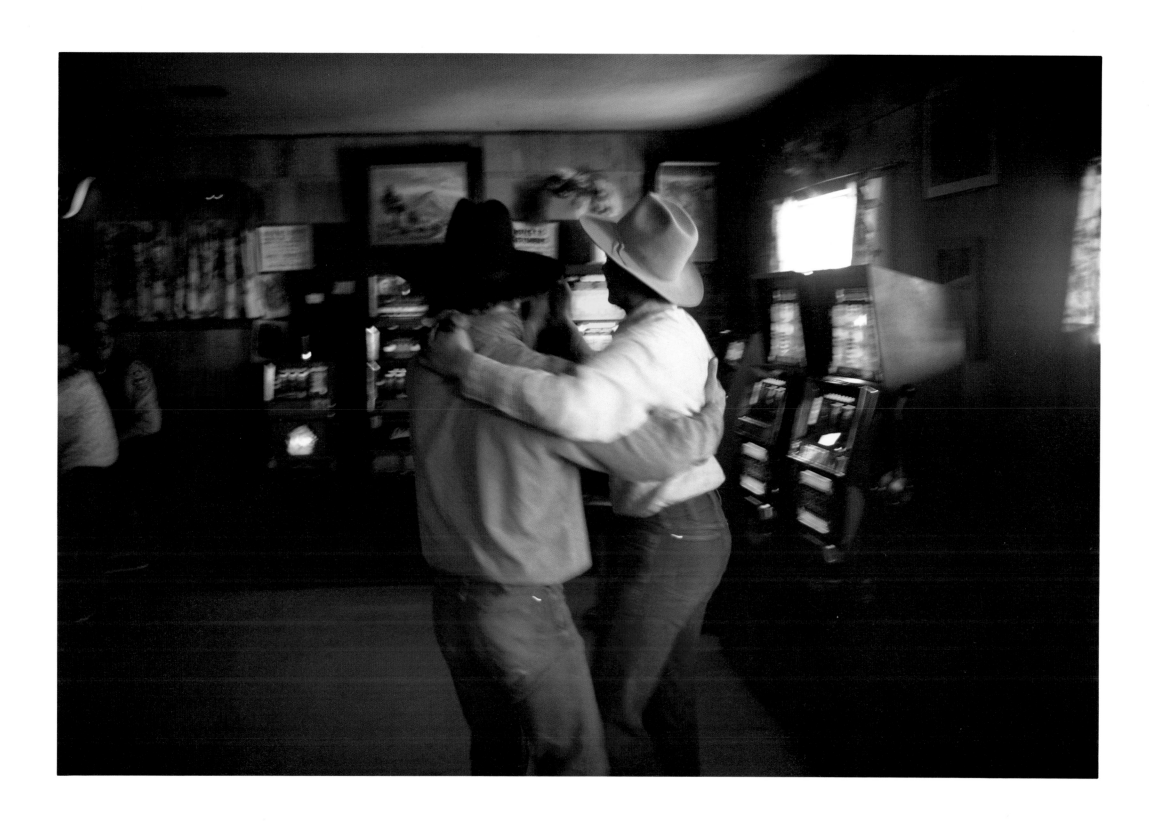

71. *Cowboy Bar, Montello, Nevada*

72. *M C Ranch, Adel, Oregon*

73. *YP Ranch, Tuscarora, Nevada*

74. *Big Springs Ranch, Bruneau, Idaho*

75.　*Andy Tingstrom, Big Springs Ranch, Bruneau, Idaho*

81. *IL Ranch, Tuscarora, Nevada*

82. *Gil Litchfield, cook, Spanish Ranch, Tuscarora, Nevada*

83. *Russell Ranches, Eureka, Nevada*

84. *Stowell Brothers Ranching, Currie, Nevada*

85. *25 Ranch, Battle Mountain, Nevada*

99. C–Punch Ranch, Lovelock, Nevada

100. IL Ranch, Tuscarora, Nevada

101. IL Ranch, Tuscarora, Nevada

102. *Russell Ranches, Eureka, Nevada*

103. LS Ranches, Montello, Nevada

104. *LS Ranches, Montello, Nevada*

113. *Kueny Ranch, Fields, Oregon*

114. *Collins Cow Company, Jordan Valley, Oregon*

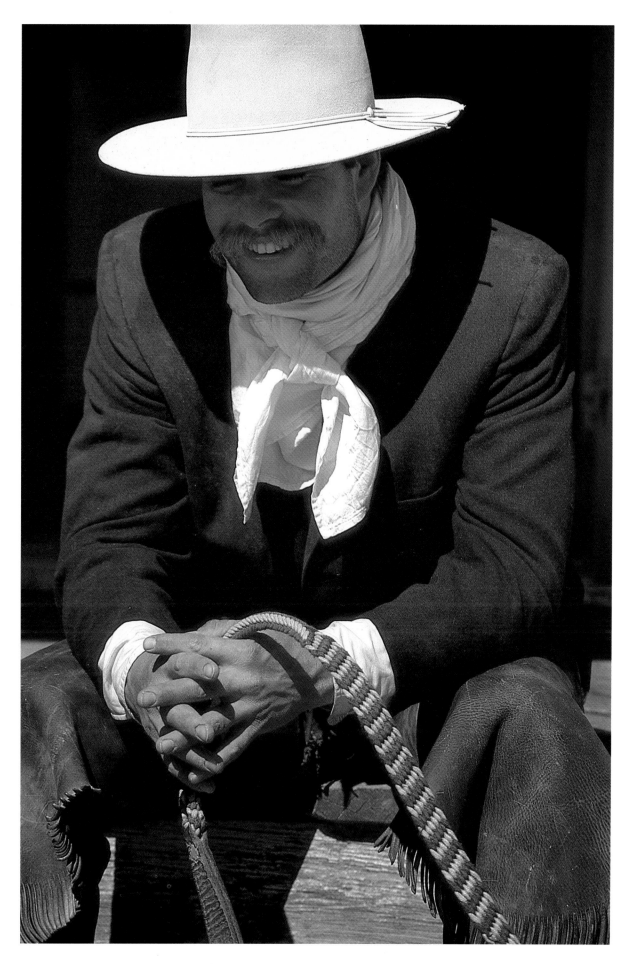

115. *Adrian Simms, Russell Ranches, Eureka, Nevada*

116. *Spanish Ranch, Tuscarora, Nevada*

117. *McDermitt Stampede, McDermitt, Nevada*

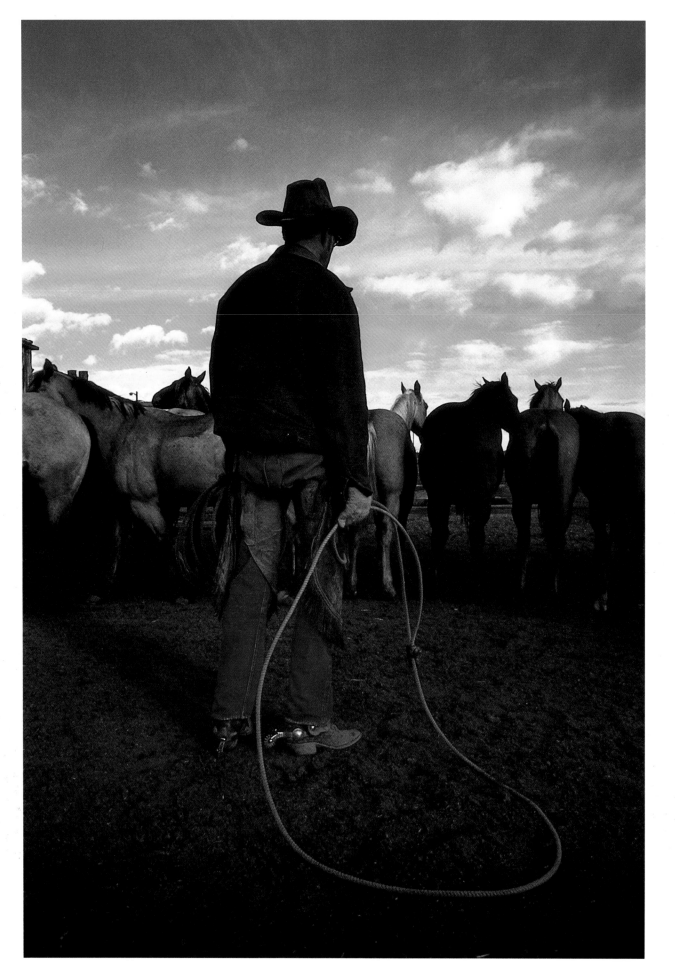

118. *ZX Ranch, Paisley, Oregon*

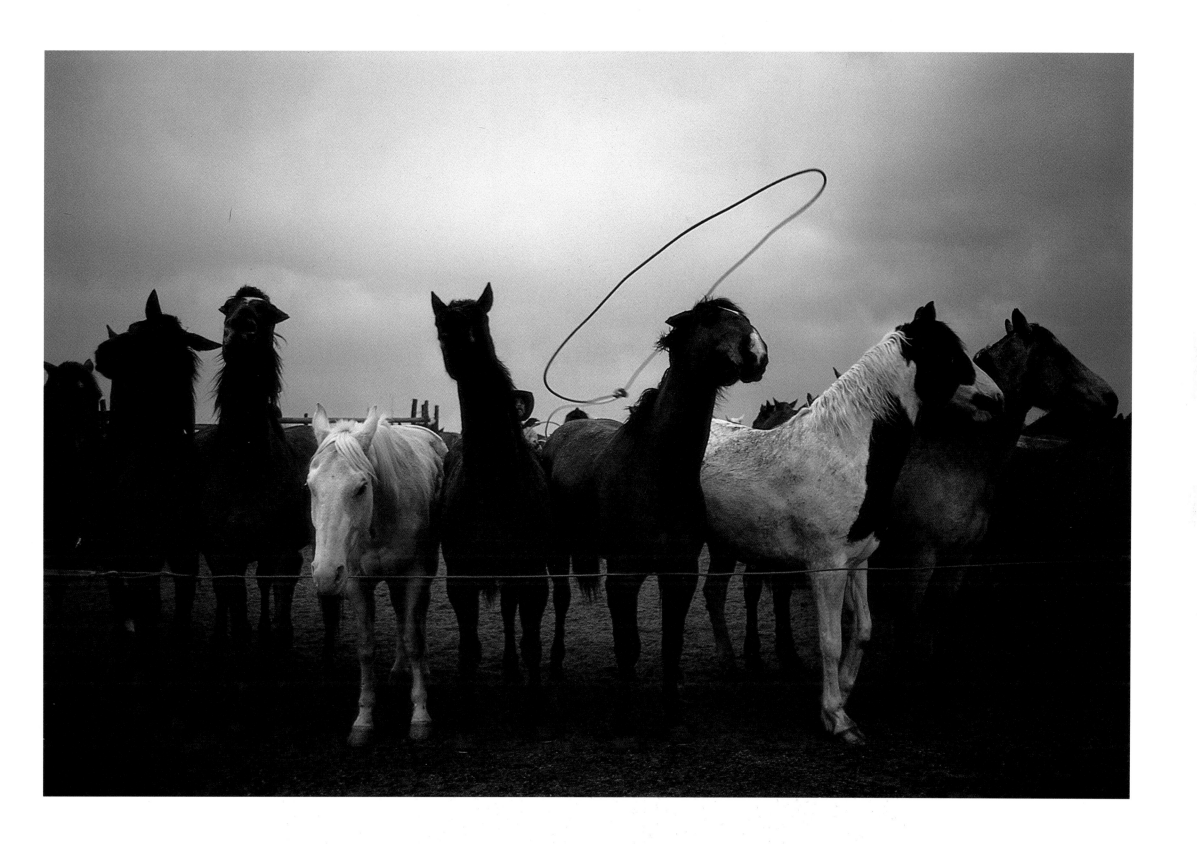

119. *ZX Ranch, Paisley, Oregon*

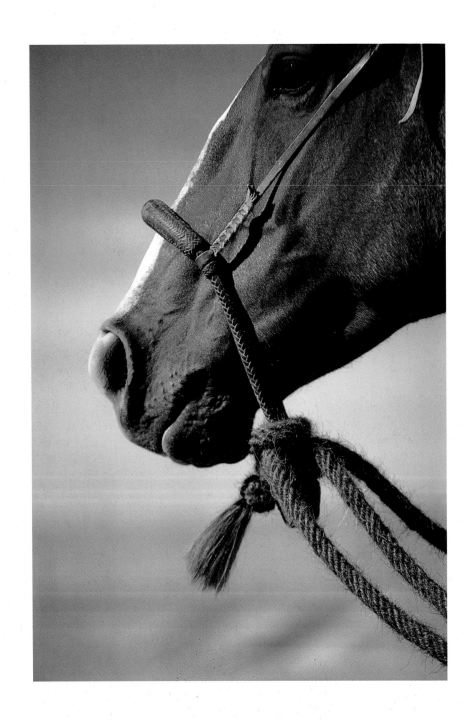

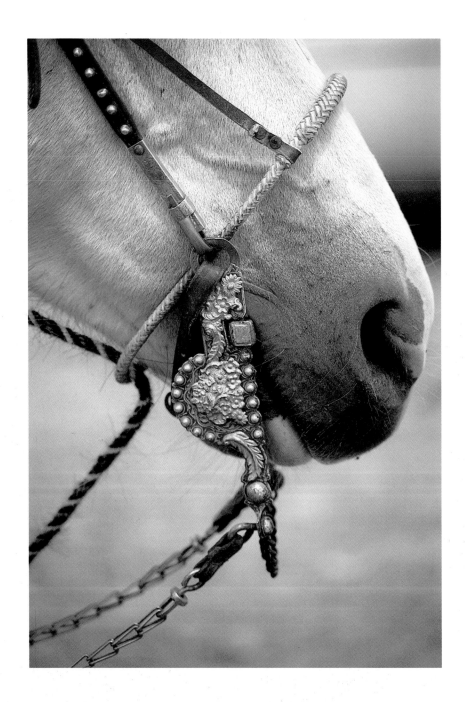

120. *Elko County Fair, Elko, Nevada*

121. *McDermitt Stampede, McDermitt, Nevada*

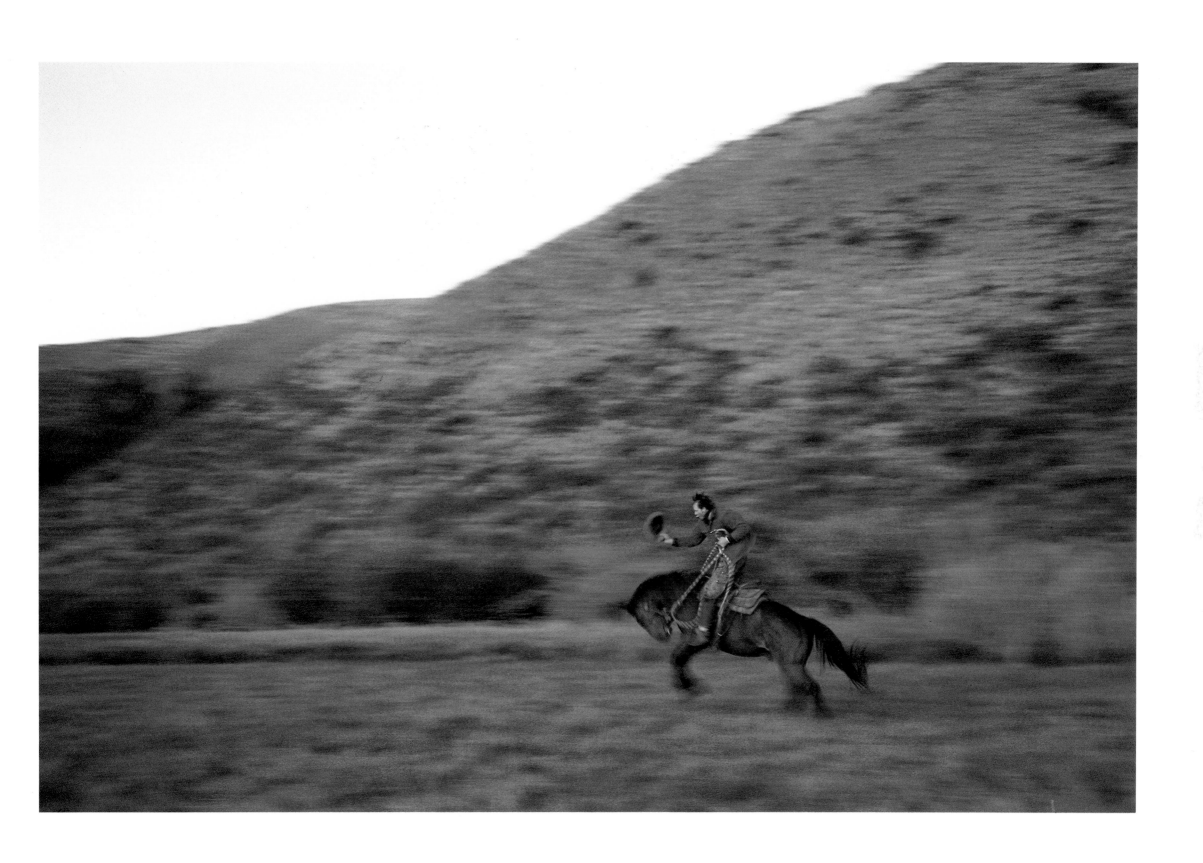

122. *L S Ranches, Montello, Nevada*

building, inside there's a stuffed bear in a glass cage. There's nothing sacred about polar bears in Nevada, though, and the outdoor bears have been climbed, painted, and partially clothed. Now and then they've suffered attacks from bow and arrow hunters, and they've been shot at from passing vehicles and by distant sharpshooters.

72. *MC Ranch, Adel, Oregon*

The front door of the Jack Creek Camp cookhouse opens out to a few small buildings, sheds, and corrals — and the Guano Valley, a long, sage-covered floor walled in on the east by cliffs and flanked to the west by rolling hills. Jack Creek is occupied from spring till fall, when the cows are turned out on BLM permit country.

The cookhouse is a typical ranch building in the Great Basin. Seen apart from its function, isolated, there's not much to recommend it. But after a day horseback in the snow and mud, stepping inside the simple, but warm, shack is like walking into a mansion.

80. *Louis Cabral, Tres Piños, California*

Louis Cabral was still in his early teens when he buckarooed for the great Miller & Lux. He later transferred his skills as a horseman and teamster to the rodeo arena, where he performed as a Roman rider and a daredevil, jumping horses over parked Cadillacs and through flaming hoops. His wife and sons became part of the show, and together they toured the country.

Although Louis's wife and one son have died in the past few years, Louis continues to perform. His business card reads: "Spectacular Roman Riding Jumps Presented by the Wildest Roman Rider in the Business."

93. *Harold Smith, IL Ranch, Tuscarora, Nevada*

When he punched cows in Montana and Wyoming, the big outfits were still in abundance, and he worked for just about all of them. The lifestyle that the big outfits afford — being horseback, camping out, the companionship of a cowboy crew — is something Harold Smith has never let go of, and when there wasn't enough range in Montana and Wyoming to suit him, Smitty and his late wife, Nida, drifted into the Great Basin, where he worked for the McLaughlin ZX in Oregon and later the IL in Nevada.

94. *Vern Chidester, wagon cook, IL Ranch, Tuscarora, Nevada*

"All wagon cooks are drunks and winos, including me," offered Vern Chidester, who had just finished the last of the evening's chores and was ready to turn in. He looked at me, smiled, and pulled a bottle of Jim Beam out of his bedroll. After a drink for each of us, the bottle was put away. Cooking for the big outfits was Vern's second career; he had spent most of his seventy-three years in the merchant marine, in galleys.

95. *Fritz Marek, Spanish Ranch, Tuscarora, Nevada*

When Bill Kane ran the Spanish Ranch wagon, the buckaroos packed everything they needed for the day's branding — irons, syringes, blackleg syrum, dehorning spoons, and matches to start a sagebrush fire. The irons broke in half so they could be rolled in burlap and tied on behind a saddle. No trucks for carrying propane, vaccinating guns, or water coolers and no trucks to break down, get stuck, or consume gasoline.

96. *Maggie Creek Ranch, Carlin, Nevada*

While cowboss Gene Campbell applies the outfit's horseshoe bar brand to the calf, John Peek and his horse hold the calf by the hind legs. The calf's front feet are held in what is known as a "deadman." A stake is driven in the ground near the branding fire. Attached to the stake are two short lengths of nylon rope; between the segments there is a cross section of rubber innertube. The function of the rubber is to dampen the pull on the calf from the man horseback in order to prevent injury to the calf and also to make sure that when the calf is released, it is released cleanly, able to trot away with no legs caught in loops.

101. *IL Ranch, Tuscarora, Nevada*

The snaffle bit and the McCarty are two items of gear that are particularly buckaroo.

The snaffle is a gentle bit. It works primarily on the corners of the mouth and not on the bars of the jaw or roof of the horse's mouth as do many other types of bits. And the simple construction of a snaffle makes it almost impossible to damage or bend.

"McCarty" is an Anglicized version of the Spanish word *mecate*, meaning rope. Horsehair McCartys are preferred by most buckaroos, but horsehair tends to kink up and get stiff in cold, wet weather, so soft nylon rope in either solid or mixed colors is popular for everyday use, especially in the winter. McCartys come in 22-foot lengths, which is enough rope to form closed reins of adjustable size and a lead, or "get-down" line. The lead comes in very handy any time a buckaroo needs to dismount (open a gate, doctor a cow), have both hands free but still keep hold of his horse. And should a man get bucked off or have a horse stumble and fall, the end of the McCarty he tucked into his pants or through his chap belt gives him a final chance of holding on to a horse that might run off and leave him — not good if he's alone and several miles from camp.

The lead can also be used to hobble a horse.

102. *Russell Ranches, Eureka, Nevada*

An old axiom from the days when many outfits pulled a team-drawn wagon dictates that when camp is set up, the wagon tongue always points north and the flaps of the range tepees face east.

Some ranches provide tepees for the crew if the men are asked to camp out, and some outfits carry a bed tent in which everyone can unroll their beds and be out of the weather. But if a buckaroo wishes to have a measure of privacy, he should carry his own tepee.

103. *LS Ranches, Montello, Nevada*

Camping out with the wagon has its good and bad moments. Rotten weather, time away from families, and missed conveniences are on the negative side of

the wagon ledger. On the plus end are a few hours of leisure. A typical day of branding can begin before 4:00 a.m., but everyone is sometimes back in camp by the noon meal and free to nap or read for the rest of the day. By twilight most buckaroos are in their tepees, asleep.

Outfits that trailer out from headquarters every day, gather and brand, and then trailer back, spend considerable time bouncing around in pickups. And if they get back to headquarters with a couple hours of daylight remaining, there's always something else that needs doing.

105. Big Springs Ranch, Bruneau, Idaho

Buckaroo ropes vary in length from 50 to 70 feet, depending on a buckaroo's preference; some buckaroos pack as much as 90 feet.

The most common diameter for nylon ropes is ⁷⁄₁₆ inch; a "scant" ⅜ths is also used. Rawhide ropes come in four, six, or eight "plaits," or strands, which can be braided or twisted, as shown in the rope John Aquiso made and has lashed to his Harwood saddle.

The closed reins of the McCarty are tied up around the horse's neck to keep them out of the way. Even a horse that is hobbled, such as John's is, can lunge or gallop and get his front legs through the reins.

108. Russell Ranches, Eureka, Nevada

Buckaroo spurs sport silver inlay, ornate heel bands, large rowels (with or without jinglebobs), and wide straps with a big, silver concho. The topic that's sure to bring out the worst in anyone who cares to argue about it is whether spurs should be buckled on the inside or the outside. Buckaroos buckle on the inside.

109. Z X Ranch, Paisley, Oregon

Lace-up boots, or "packers," as they are often called, are more commonly seen today than they were ten years ago. The pair Billy Smith is wearing were custom made for him by a shop in California and have fancy stitching on the uppers.

Packers have made a comeback because the price of custom pull-ons has risen higher than many buckaroos can afford. That and because packers are more easily put on and removed when they're wet.

110. Whitehorse Ranch, Fields, Oregon

It is unusual for a buckaroo to pack a sidearm. More often, a holstered pistol can be found in a pickup. The weapon is needed when the camp or headquarters needs to butcher a beef or when an animal is crippled and needs to be destroyed.

Larry Marriott has tied a pigin' string around his holster for additional security. Men who wear a pistol will normally keep it on their left hip, so that when they're roping, the pistol will be out of the way of the dallied rope.

Larry's cantle board sports three ornamental, diamond-shaped silver plates. The back of the cantle is a favorite spot for placing conchos, name initials, and brands to personalize the saddle.

112. Stowell Brothers Ranching, Pie Creek, Nevada

The stirrup Randy Stowell has his walking-heel, lace-up boot pushed into is a popular, buckaroo style. Bell-shaped stirrups come in different widths and covered in different metals.

The wide stirrup is used by some buckaroos only in winter, when they need extra room to accommodate overshoes or insulated boots. Others, like Randy, prefer to ride "bells" year-round, either because they ride with low heels (a walking heel can easily be pushed through an oxbow stirrup) or they like the full support of a wide stirrup.

116. Spanish Ranch, Tuscarora, Nevada

The "mustache" knot in this horse's tail is helping keep brush, snarls, and mud out. A horse that swats at flies or wrings his tail out of nervousness can snag that tail — if it is ungroomed — on a buckaroo's spurs, and then the wreck is on.

117. McDermitt Stampede, McDermitt, Nevada

The function of the choker Bob Wroten has draped over his horse's neck is to help hold his cinch, and therefore his saddle, in place when he has something roped or when he's traveling in rough, up-and-down country. This distinctive piece of buckaroo gear is heavier — and fancier — than most chokers, but the idea is the same.

118. Z X Ranch, Paisley, Oregon

It is customary on the big buckaroo outfits for the boss — and sometimes his second-in-command "jigger boss" — to rope horses for everyone in the crew. The style in the Great Basin is to teach the horses to come into the rope corral and stand with their chests to the rope; no milling around is allowed. As the cowboss and the jigger step into the "ropes," the buckaroos call out the name of the horse they want caught for the day: "Skunk!" "Shu Shu!" "Searchlight!" "Twinkle Toes!" As each horse is caught and led to the edge of the corral, a buckaroo will come forward with a halter, rope, or bridle to claim him.

120. Elko County Fair, Elko, Nevada

This supple bosal of braided latigo leather is complemented by a well-made McCarty of coffee color. The single wrap in the hackamore knot indicates that the horse is extra responsive to the rider's hands. When the reins are dropped, the bosal falls away from the horse's face and jaw and serves to tell the horse he's doing what the rider has asked.

121. McDermitt Stampede, McDermitt, Nevada

This rig of Bob Wroten's may look like something strictly for show, but it's what Bob uses whenever he rides a bridle horse, be it at a branding or out in the brush making a circle. Or when he's at a horse roping, such as the annual McDermitt Fourth of July Stampede.

The bit is a one-of-a-kind, with plenty of custom silver work. The rawhide cavesson works both to keep

a horse's mouth closed and as a guide for the lead McCarty that Bob is using. The horsehair McCarty runs from the horse's neck (where it is tied in a bowline), through the cavesson, and into Bob's belt or is tied in a coil to the saddle just below the horn. A bridle horse is never led by the reins, but by the gentle pull on the McCarty.

125. *Maggie Creek Ranch, Carlin, Nevada*

Most buckaroos would prefer to go with the cavvy when camp is moved; if they're lucky, someone else will have to help the cook pack the chuckwagon. Once the horses get lined out, they will keep trotting until they are asked to stop, and a buckaroo is more or less free to enjoy the day. The boss will be happy if the horses are not pushed too hard and if they arrive in good flesh and not all drawn up.

But the job can go wrong. Maybe there are just two buckaroos moving the seventy-head cavvy, and one of them gets bucked off not long after the drive has started. The loose horse bolts to the middle of the cavvy and with the riderless saddle flopping and banging, scatters the bunch in three directions, all the horses at a high lope.

It's going to be a long day.

126. *Russell Ranches, Eureka, Nevada*

When a buckaroo is sent out to bring in the cavvy, he does so in a hurry. The boss doesn't want to have the crew standing around flat-footed, waiting for horses.

Wrangling horses is usually a chore that's rotated through the crew, unless the outfit is big enough to hire someone specifically for the job, in which case the "wrango boy" also day-herds the horses not being ridden and keeps them on good feed.

Some horse traps cover several hundred acres, and wrangling can take over an hour. Rough country — thickets, rimrock, drainage — doesn't help, nor do rascal horses who repeatedly hide out away from the main bunch. A man who's just hired on and is sent out to wrangle will probably ask how many horses he should be bringing in and will try and get a count when he thinks he's got them all gathered and moving to the ropes.

Although he wants to holler the horses in at a brisk clip, he doesn't want to push the horses too hard when they get near the corral, for fear of knocking down a horse's hip or crippling the horses on the outside as they're funneling into the enclosure.

Acknowledgment: Nevada buckaroo Kent Craven provided invaluable assistance during the preparation of the Notes on the Photographs. Thank you, Kent, for your insights and expertise.

Designed by Eleanor Caponigro
Text edited by Russell Martin
Composition in Diotima by Meriden-Stinehour
Printed and bound by Dai Nippon Printing Company, Ltd.